Publisher's Acknowledgements

Special thanks are due to the **Marian Goodman Gallery**, New York, and the **Lisson Gallery**, London. We would also like to thank the following authors and publishers for their kind permission to reprint articles: **Lynne Cooke**, New York; **Ian Tromp**, London; **Editions du Regard**, Paris; **Chapter Arts Centre**, Cardiff; **The South Bank Centre**, London; **Carnegie Museum of Art**, Pittsburgh, and the following for lending reproductions: **Artangel**, London; **Camden Arts Centre**, London; **Chisenhale Gallery**, London; **Galerie Durand-Dessert**, Paris; **Konrad Fischer Galerie**, Düsseldorf; **Jochen Gerz** and **Esther Shalev-Gerz**, Germany; **Antony Gormley**, London; **Government Art Collection**, London; **Musée d'art moderne de Ceret**; **National Gallery**, London; **Open-Air Museum of Sculpture**, Middelheim, Antwerp; **Thomas Schütte**, Düsseldorf; **Tate Gallery**, London; **Nina Williams** *née* **Gabo**, Kent; **Whitechapel Art Gallery**, London. Photographers: **S. Anzai**; **Kristien Daem**; **Richard Deacon**; **Marc Domage**; **Dorothee Fischer**; **Frans Grummer**; **Ralph Hinterkeuser**; **Lisa Harty**; **Jorge Lewinski**; **Freddy Le Saux**; **Attilio Maranzano**; **Pierre Mercier**; **Toru Misawa**; **Dave Morgan**; **Helge Mundt**; **Sue Ormerod**; **Tom Powel**; **John Riddy**; **Tore Royneland**; **Ianthe Ruthven**; **Adam Rzepka**; **Sadamo Saito**; **Etienne van Sloun**; **Stephen White**; **Gareth Winters**; **Edward Woodman**.

Artist's Acknowledgements

I would personally like to thank Iwona Blazwick for her invitation to do this book and to thank Gilda Williams, Ian Farr, John Stack, Clare Stent, Stuart Smith, Veronica Price and everyone else involved at Phaidon for their hard work on the production of something so clear from the murky depths of my archives. I would also like to thank Marian Goodman and Nicholas Logsdail as well as Elizabeth McCrae and Maria Prodromou at the Lisson Gallery for all their help and support, especially in the gathering and sorting of photographs and documentation. It's a privilege to have Pier Luigi Tazzi, Jon Thompson, Peter Schjeldahl and Penelope Curtis be engaged with one's work and I thank them deeply for their texts. Many photographers have produced the images we have used in this book; I want to thank all of them for their time and attention. I should like to record my debt to Mathew Perry, with whom I have worked for more than ten years and whose contribution has been immense. Similarly, Derek Eversden took me seriously when I asked his company to make the steelwork for *Blind, Deaf and Dumb* and thus began an association which has borne many fruit. These two I can never thank enough.

All works are in private collections unless otherwise stated.

Phaidon Press Limited
Regent's Wharf
All Saints Street
London N1 9PA

First published 1995
Second edition, revised and expanded 2000
© 2000 Phaidon Press Limited
All works of Richard Deacon are © Richard Deacon.

ISBN 0 7148 3949 3

A CIP catalogue record of this book is available from the British Library.

Printed in Hong Kong

Design: SMITH

cover, **Plant**
Epoxy resin, nylon net, glass fibre
37 × 78 × 36 cm

page 4, **Bikini**
1992
Aluminium, wood, epoxy resin
165 x 1200 x 350 cm
Installation, Documenta IX, Kassel

page 6, **Stuff Box Object**
1970-71
Performance work

page 36, **Kiss and Tell** (detail)
1989
Epoxy, plywood, steel, timber
176 x 226 x 170 cm
Collection, Arts Council of Great Britain, London

page 88, **Keeping the Faith**
(detail)
1992
Beechwood, epoxy
75 x 175 x 170 cm

page 98, **Artist's studio shelf**

page 168, **Tickle Him Under There**
(detail)
1994
Stainless steel
28.5 × 210 × 95 cm

page 192, **Richard Deacon and Bill Woodrow**
Invitation card, 'Only the Lonely', Chisenhale Gallery, London
1993

Jon Thompson Pier Luigi Tazzi Peter Schjeldahl Penelope Curtis

Richard
Deacon

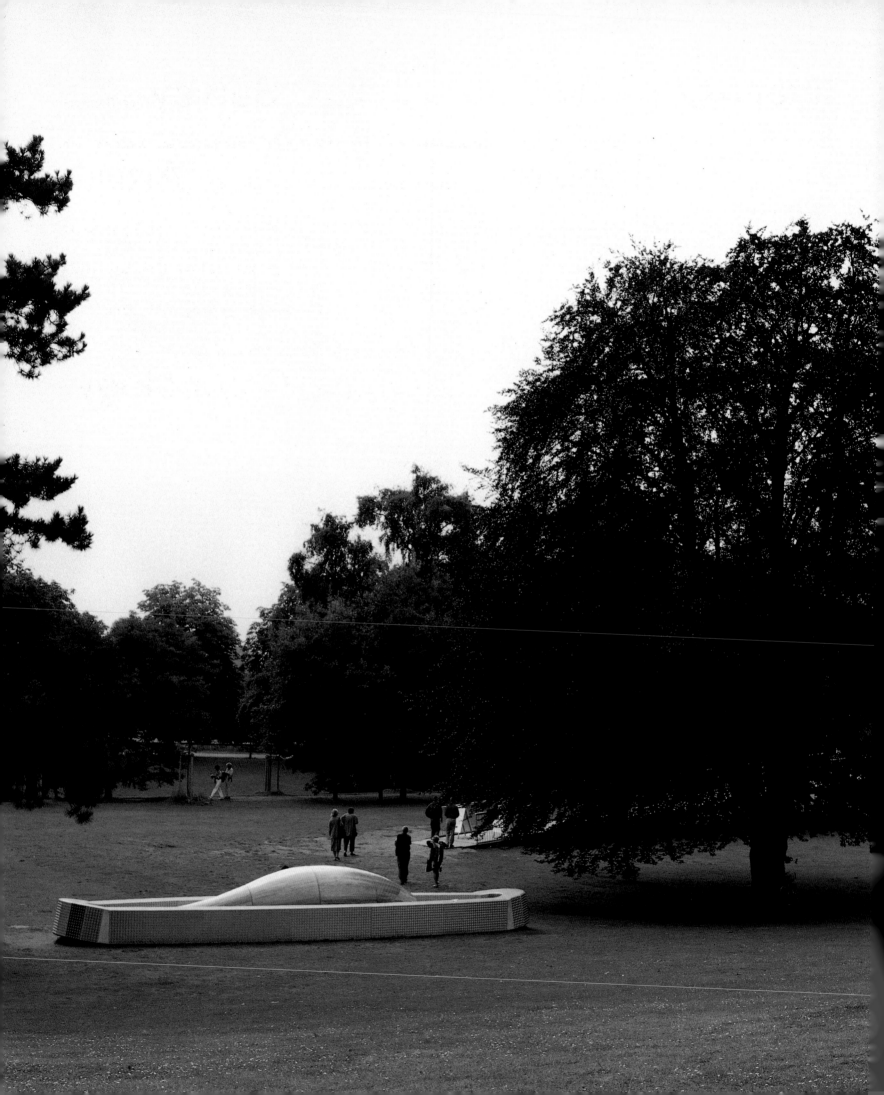

Contents

Interview Pier Luigi Tazzi in conversation with Richard Deacon, page 6. Survey Jon Thompson

Thinking Richard Deacon, Thinking Sculptor, Thinking Sculpture, page 36. Focus Peter Schjeldahl Deacon's Faith,

page 88. Artist's Choice Mary Douglas Purity and Danger, 1966, page 98. Artist's

Writings Richard Deacon Selections from Stuff Box Object, 1971-72, page 110. Artist's Statement, 1982, page 114.

Silence, Exile, Cunning, 1986-88, page 116. What Car? Correspondence with Lynne Cooke, 1992 page 120. What You See Is What

You Get, 1992, page 132. Design for Replacing, 1987, page 138. Design for Factory, 1993, page 139. Reading: A Propos de Toni

Grand, 1993, page 140. In Praise of Television, 1996–97, page 144. Interview with Ian Tromp, 1999, page 158.

Update Penelope Curtis The Interior is Always More Difficult, page 168. Chronology

page 192 & Bibliography, List of Illustrations, page 209.

Contents

Interview

Pier Luigi Tazzi in conversation with **Richard Deacon, page 6.**

Survey Jon Thompson

Thinking Richard Deacon, Thinking Sculptor, Thinking Sculpture, page 36. Focus Peter Schjeldahl Deacon's Faith,

page 88. Artist's Choice Mary Douglas Purity and Danger, 1966, page 98. Artist's

Writings Richard Deacon Selections from Stuff Box Object, 1971-72, **page 110.** Artist's Statement, 1982, **page 114.**

Silence, Exile, Cunning, 1986-88, **page 116.** What Car? Correspondence with Lynne Cooke, 1992 **page 120.** What You See Is What

You Get, 1992, **page 132.** Design for *Replacing,* 1987, **page 138.** Design for *Factory,* 1993, **page 139.** Reading: A Propos de Toni

Grand, 1993, **page 140.** In Praise of Television, 1996–97, **page 144.** Interview with Ian Tromp, 1999, **page 158.**

Update Penelope Curtis The Interior is Always More Difficult, page 168. Chronology

page 192 & Bibliography, List of Illustrations, page 209.

Pier Luigi Tazzi in conversation with **Richard Deacon**

Pier Luigi Tazzi I would like to start from the distant past. I have always felt that since the beginning of the modern, there was no place for art. Art was mostly an image in the mind, or a precious object. While it was still in the artist's studio it was as yet unborn, and when it was in a private or museum collection, it was the relic of a practice that took place elsewhere, a sort of unknown non-site that was ideologically akin to the concept of utopia. The work of art began to acquire its own space toward the late 1950s-early 1960s and this ultimately resulted in the gallery space. This was a real space which was increasingly defined over the course of the decade and which in a way contrasted with the museum, which was more abstract, separate from the reality of the outside world. Until at least the end of the 1960s the museum was the principal space for art and where art obtained its status. During that time we had a shift from the closed, sanctified museum space to the living, 'real' space of the gallery.

At the end of the 1960s-early 1970s, what first emerged in theoretical discourse was the term 'context', particularly in conceptual art. This term was increasingly defined and analyzed in its specificity; that is, art does not acquire its meaning in and of itself but in relation to the context in which it is set and brought into action.

When the gallery space came to lose its primacy and at the same time its effectiveness, the term 'context' emerged again but in a different way. Context is no longer intended as it had been in the discourse of conceptual art, but now points to a dissolved area where the work of art is placed although it does not define the context by virtue of its presence. At the same time, there is a demand today for context, a need for context. What I want to ask you then is, when did you start to take the context into consideration not only in the production of the work but in its very constitution? What do you mean by context?

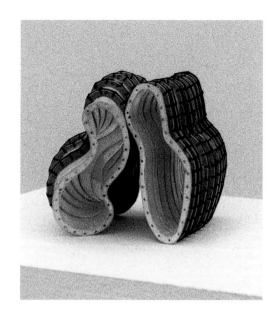

Richard Deacon **At the start of the 70s, when I was a student, I was confused about the category of things I wanted to make. I wanted to make something and that involved the manipulation of materials, but the models that were on offer seemed to involve making plans and carrying them out. I felt that this was the wrong procedure. It was also a time when there was a lot of interest in time-based work and performance, so I combined the two interests and started making performance based work which involved the manipulation of materials over a given period of time. The notion that how you do something had relevance to the thing that you do was a very early part of my work. I used photographs to document it but I became much more interested in description as a means of documentation. It had time in it in a more interesting way than a photograph. At some point in the middle of the decade I abandoned using a performance base with all its connotations of documentation and reproduction, though there are certain elements which carry through from that. These works often extended over a period of time and involved the creation of materials. I found the vehicle cumbersome and thought that it was possible to condense those concerns into a single object. Somehow I changed the way I looked at what I was doing and began to think of my previous work as a training in how to make objects, learning how to avoid making plans. Also in the context of making performance I found myself uncomfortable with my personal presence. I felt that I didn't need to be there. That describes how I think about sculpture, about making my work ever since. Somehow that 'I don't need to be here' is a good way of describing**

Art for Other People No 3
1982
Vinyl
35 × 140 × 35 cm

Installation, Tate Gallery, London
1985
l. to r., **Falling on Deaf Ears No 1**
1984; **For Those Who Have Ears No 2**, 1983; **On the Face of It**, 1984

Zeitweise (Now and Then)
1993
Painted mild steel
340 × 1,240 × 650 cm
Mexicoplatz, Vienna

titled Sculpture in Two Parts
3
dboard, paper, epoxy resin,
ton thread
× 20 × 16 cm

the kind of autonomy that I think the work should have.

Tazzi What startled you most about your physical presence?

Deacon **At the time, I thought that the reason I was there was as an agency to enable the work to be made. I wanted a certain kind of equality between myself as an agency and the material as an actor; I thought that my uncertainties, my doubts and my decision making, that somehow 'me' was the performer in a kind of autobiographical sense which I found uncomfortable. I suppose the honest answer would be that performing that way seemed to say things that I wasn't planning to say. It made the work personal in a private rather than possibly expressive sense. Another possible reason was that I didn't need the audience. I was perfectly happy in a performance situation entirely by myself. If you don't need the audience then you don't need the documentation, so what you have at the end is what you intend to make, that's the full logic of it. I was quite happy with that for a while and then, ten years later, I decided that the sculpture I was making and the gallery which was its location were problematic. Your description of the work being unborn in the studio and already dead when it arrived at the collection was very good. The gallery developed this in between status of 'this is when the work lives'. If that's the case then in some sense the gallery determines the work. The museum legitimizes it and the gallery enables it, or causes it to be. Obviously a lot of the conceptual artists' position was precisely to do with articulating the ways in which the gallery does that. To follow the argument through removes any need to do anything at all, because the gallery causes and the museum justifies.**

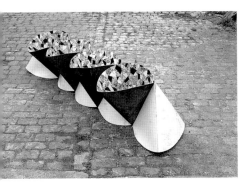

Tazzi This is strange, you stopped performing because at a certain point you recognized that you didn't need an audience. But what the gallery space was offering was a stage without an audience, where the audience was not necessary because the stage in itself, the gallery space, was the place.

Deacon **Yes.**

Tazzi So in the gallery space you don't need an audience.

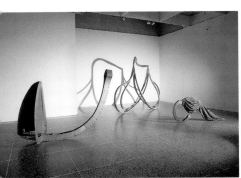

Deacon **It's implicit.**

Tazzi Yes it's implicit, it's already there. The stage, the sacred place is there. I think that your decision, and that of many other artists, was to confirm the primacy of the gallery space.

Deacon **At some point later I began to wonder whether it was a necessary truth and whether the context was not necessarily defined by the gallery; in fact you could turn it upside down and have the making or the thing that was made define the context. So the gallery was a part but not necessarily the whole. I have often talked about works that I have made on three scales: small, medium size and large works. The small works are domestic, the medium works are gallery size and the large works are public. But there is a continuity between all of them and therefore if you look at context you would look for something that overarched all those three scales. At some**

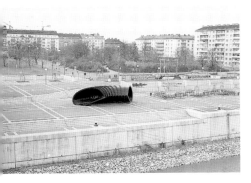

point I wanted to make things that didn't fit inside the gallery. I thought there might be other contexts for the work, other places to put things where they could still function as art objects. Obviously there are lots of places where they probably don't function as art objects. I made some things which were placed out in the park. I found that didn't work, it was just taking one thing and putting it somewhere else, which seemed an inadequate solution. In 1985 I did this show at the Serpentine Gallery with the work *Blind, Deaf and Dumb*, which used a link through the wall of the gallery to a work that was outside. I used the window and the building as a means, and tried to make the architecture be contained by the work, rather than be a container.

Tazzi That also occurred with your contribution to the 1985 Biennale of Paris. It had the same aim in a way. The three works, *Other Homes Other Lives*, *Like a Bird* and *Tell Me No Lies*, were in overt contradiction with the architectural space of the Grande Halle de la Villette. There was a sort of fight between the architecture and your works. The architecture was not the container of the work: there was a sort of dialogue with the architecture itself. Most of the other works in that show were simply contained in a building which falls into the category of industrial archaeology. In your case the contrast was extremely evident.

Deacon **The exhibition in Paris was precisely between having made works which had been placed outside, and my being unsatisfied with that, and doing the work in the Serpentine, where I was more aggressive towards the architecture. Those were intuitive decisions. I removed myself to the outside in Paris, to the exterior of the building; I didn't want to be within the big hall. A part of it was in order to establish a relationship between the work and the building that had some purpose to it, that wasn't temporary.**

Blind, Deaf and Dumb A
1985
Laminated wood, glue
873.7 × 99 × 312.4 cm
Installation, Serpentine Gallery,
London
Collection, Rijksmuseum Kröller
Müller, Otterlo

following pages, **Blind, Deaf and Dumb B**
1985
Galvanized steel
370.8 × 800 × 381 cm
Installation outside Serpentine
Gallery, London

Blind, Deaf and Dumb
Preproduction drawing
1985
Pencil on paper
41 × 56 cm

Blind, Deaf and Dumb
Preproduction drawing
1985
Pencil on paper
41 × 56 cm

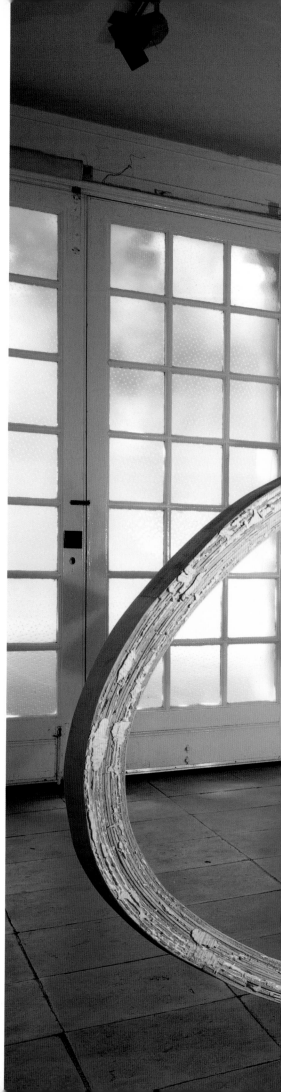

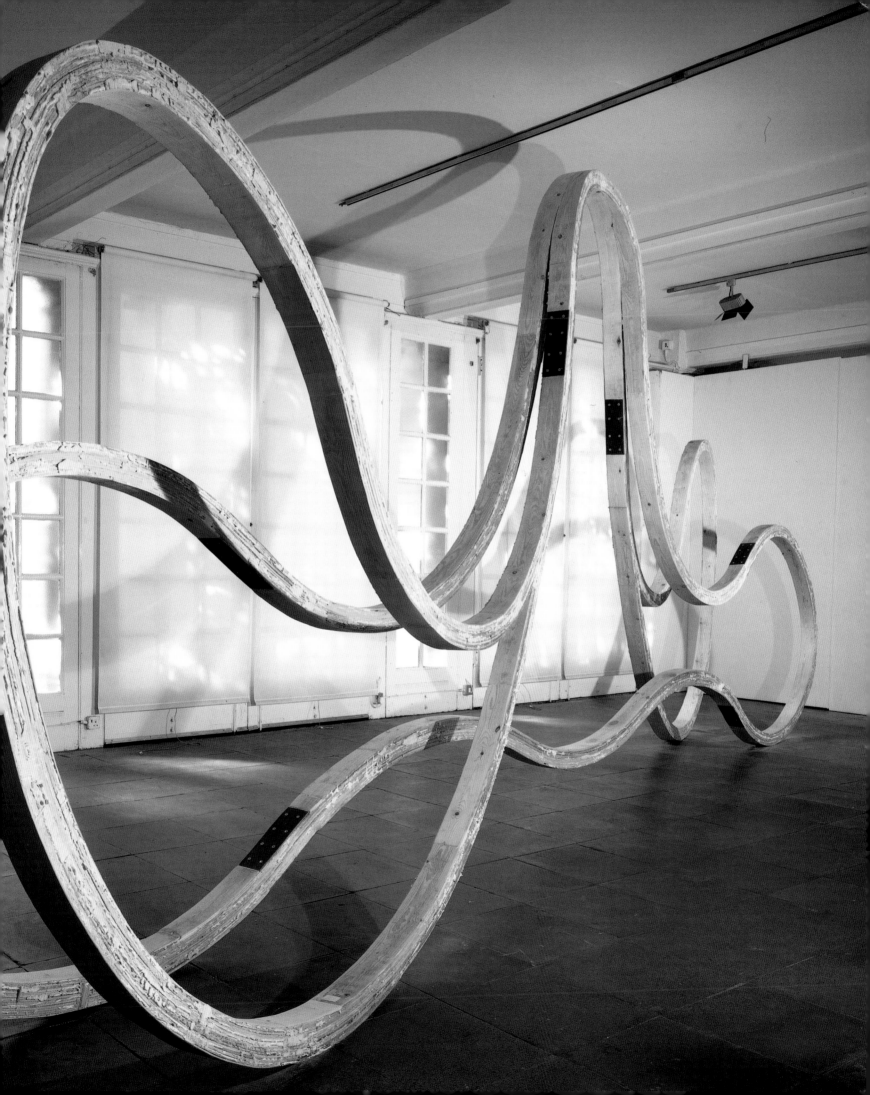

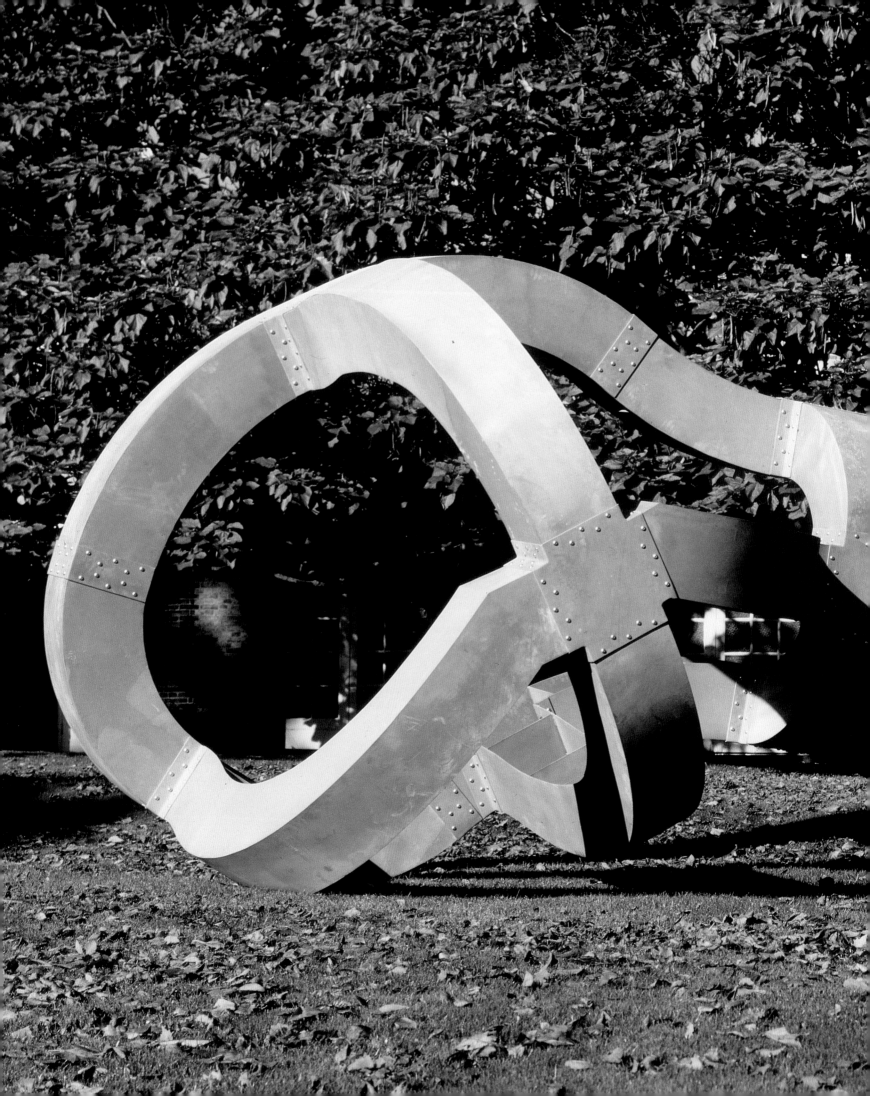

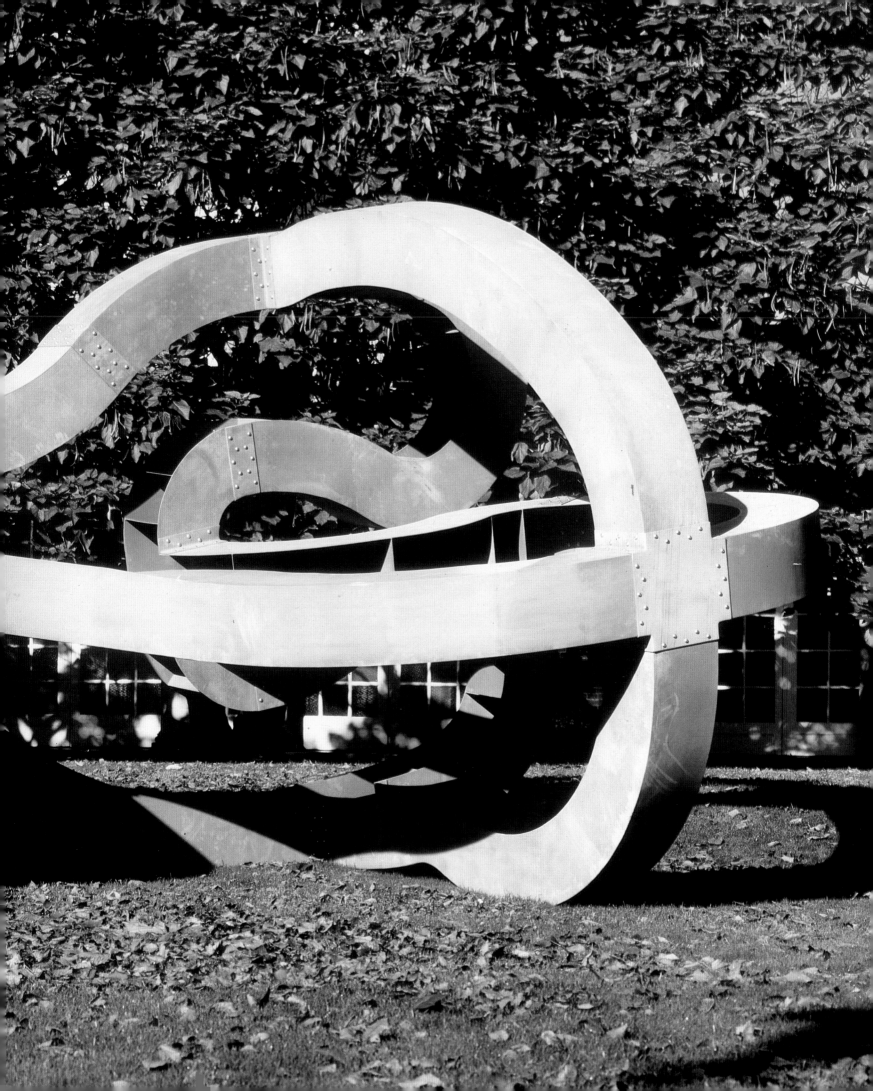

Tazzi In fact one of the feelings I had – it's rather banal, maybe a little simplistic but it might explain something – was that one never knew whether your sculpture came before the building or the building came before your sculpture. There was an overlapping, but at the same time there was no fusion between the building, your sculpture, and the overlapping itself. Also, you were going against one of the most substantial characteristics of architecture: the possibility of opening and closing space at its own discretion. With your work, this possibility is denied. In other words, architecture implies that a given space can be closed. It is not a question of establishing a flexible articulation between aperture and enclosure. The fundamental fact is that enclosure is in any case a possibility. Think of the cave, the first building constructed by humankind, the defence systems brought forth during the Renaissance – all things from which modern architecture is derived. I thought your sculptures were like bars in the door, keeping the door open.

Deacon **Well, that's what they should be. Because I was really unhappy about being given a cubicle in a big space, it was very much a 'fuck you, I don't want to do this, I'd much rather be outside'. What I was starting to say earlier was that autonomy becomes a more important term the longer it goes on. The procedures I had for making work tend to involve a certain kind of wrapping up of space. They became sort of circular motions. The autonomy has to do with that decision, that you don't need the audience, you think that somehow the object should be completely contained, wrapped up in itself.**

Tazzi Thinking about that show in connection with what we are talking about now, I remember other works that had a completely different relationship not only with the architecture, but with the physical, formal and historical context. Particularly Luciano Fabro's work, which was outside trying to haul the whole building in a sort of metaphor of history. Or the work of Ulrich Rückriem, which was completely detached from the building, like a timeless mark of the presence of art or of human action.

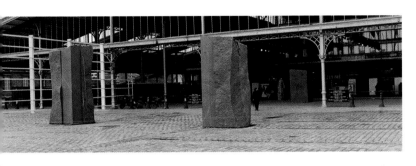

Deacon The reason I started making performance work at the end of the 60s was because I wanted to make, but I didn't know what. I suppose in a way it is still a problem. There is a kind of fixity to Rückriem's work that creates a problematic for me. This isn't a critique of the work; indeed there is a relationship. I wanted to make work that didn't involve gravity in the classical way that Rückriem's work belongs to gravity, with his simple operations on the block. The work is always subject to gravity and place in a very definite way. Material and its manipulation are core areas in what I do. Matter, stuff, are the words I tend to use. Matter is a ground for the work in relation to its existence rather than its weight, or its mass. Weight was always a difficult thing for me. My idea about sculpture was that it was composed of matter but wasn't subject to gravity. This is metaphorical, obviously, but I thought of sculpture as being between me and the world, rather than sitting in the world.

Tazzi In other terms – not artistic terms – the works of Rückriem have to do with erection. It is a phallic work in any case, where the phallus is important as a sign in its symbolic function as an archaeological point of reference and orientation. Rückriem reflects quite closely Jacques Lacan's reading of Sigmund Freud in which the phallus is not a phantom in the sense of being a figure. Nor is it an object, nor the organ itself. It is a simulacrum, a signifier whose prime meaning is 'to be or not to be', to be there, to be erect with a specific mass, a specific material, worked in a specific – and simple – way. On the other hand you consider the substance of the phallus independently of its function as a signifier, or its erection and its erectibility.

Deacon Yes I suppose so. I could put it another way; Rückriem's work is clearly made of material, and the material sits in the world. For me, material, matter, is much closer to being human, is much less alienated from being human than that opposition of the physical object grounded in the world. Matter is much closer to language and I wanted to make sculpture that showed that aspect of belonging to the human more than belonging to the world. When we speak to each other we use something that is common, that doesn't really belong to any of us. We can extract meaning from it and use it to signify, but what enables us to do that is its commonality, we all agree on it. I wanted to make sculpture that was being more like that than it was to being fixed. The area I was trying to explore has to do with allowing material to have form and at the same time to be able to be formed. There is a certain indefiniteness or ambiguity to a lot of the things that I do in relationship to what they might look like, and at the same time the great specificity of material and of the substance of the work is clear. The form is clear but there's also a desire for a potential plasticity or fluidity which remains latent. In a sense I have been trying to attach sculpture to perception or to experience rather than attaching it to the world. A contemporary analogy is to talk of a

virus and the way a virus attacks the host. The problematic is to try and make sculpture that is parasitic upon the perception of the host rather than sculpture that is in and of the world.

Tazzi Yes, but when I use the term 'timeless' for the work of Rückriem, I meant just that, to be not against culture but before culture, to go back to a certain archetype, to go back to a certain source. Your work is far more linked to the evolution of language; Rückriem's language is very elementary, whereas your language is much more articulated. What Rückriem is doing is establishing the scan of the language, the primal gap.

Deacon **Yes, possibly. Clearly I don't make work that's primal.**

Tazzi What I find in common between your works and Rückriem's are at least two things. You share what you called autonomy, and this common base, common ground, even if the articulation is completely different.

Deacon **You mean a material base, a material ground.**

Tazzi Yes, that was quite important in the early 70s, that had been achieved.

Deacon **Well, it was something that was achieved, and also something that was made available. It was clearly a gain, or an opportunity. If you look at Donald Judd and Anthony Caro as two artists of very similar age, I think surprisingly for such an apparently restricted artist as Judd, the opening he and others made at the time is very clear. The way I put it, Judd doesn't tell you what to do, but he leaves a lot of things to do it with, whereas Caro tells you what to do. The heritage of Caro is stylistic whereas the heritage of Judd is fundamental.**

Tazzi Caro and even more so Donald Judd have already become part of history, they have already been absorbed in contemporary art, whereas Rückriem remains as yet not digested.

Deacon **Yes, I agree. It's surprising, a good quality. After the Serpentine in '85 there was the show in the park at Sonsbeek in '86 and through the city of Münster in '87. The curator of Sonsbeek, Saskia Bos, had a fairly complex idea about a glass house and a floating pavilion. Partly I suppose that her reason for proposing the pavilions was to underline an aspect of contemporary art practice which was denatured and artificial because of the history of the space as an artificial park. For me it coincided with doing a lot of reading about the picturesque in the eighteenth century and the ways in which the world was seen as expressive and signifying. I was also interested at the time in geological history, very ancient history and the intellectual processes in relationship to the investigation of the earth as an ancient geological item. There was a way in which intellectual operations could picture a world different to the world we inhabit, although it's the same place. In the eighteenth century nature disappeared and was replaced by construction, by a human-centred world.**

Tazzi The relationship between city and country was completely reversed.

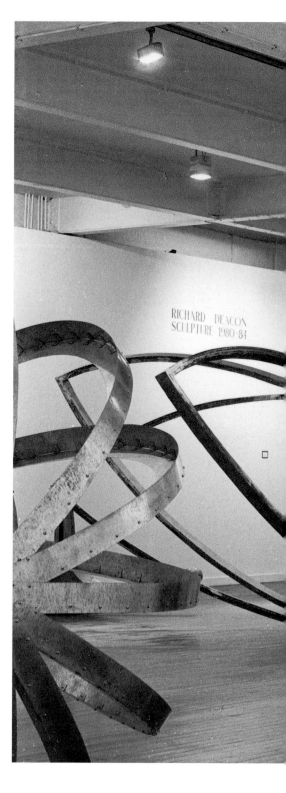

Installation, Fruitmarket Gallery, Edinburgh
1984
l. to r., **Two Can Play**, 1983; **Like Bird**, 1984; **Untitled**, 1980; **For Those Who Have Ears No. 2**, 1983; **On the Face of It**, 1984; **Tall Tree in the Ear**, 1983-84

Donald Judd
Installation, Whitechapel Art Gallery, London
1973

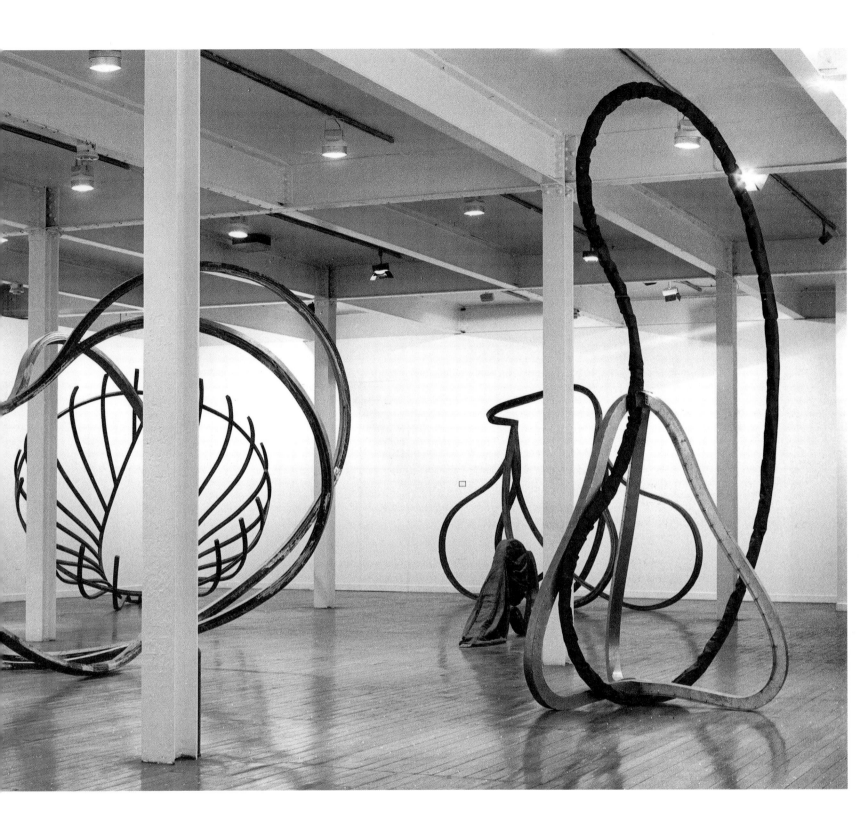

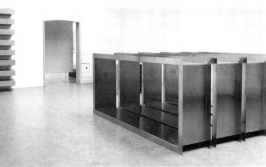

Deacon And the park at Sonsbeek is a representation. My work was a rigid frame, with an undefined element within it but situated in a place, between the war memorial and the villa. In some sense the physical object and the manifestations of ideology within the various elements of the park – its construction, its buildings, the war memorial, etc. – were all pictures, constructions. What I was trying to make the work do was to be equivalent to the park and to the spectator, so there were three elements: the work, the park and the spectator. They were more or less in balance.

Tazzi I found your work at Sonsbeek, *When the Land Masses First Appeared*, extraordinary. It was one of the emblematic works of the exhibition for the relation between the container, the rigid form outside, and the contained shape, the organic free form inside. This relationship was very opposite to the notion of the park, where the natural is the outside world and the design of the park is the inside world. This relationship, in connection to what we were saying before about context, revealed the distance taken from the idea of context as it had been defined by conceptual art. For the first time I could experience through that work something I had not understood before. The context had not been defined by known components and certain elements resisted all definition and categorization and remained unstable. The context had to do with an essence of which you had no knowledge: a sort of first step into outer space, with all its contingent risks. It had the freshness and happiness of a first discovery, like a baby's first word, or like some works from the Italian Renaissance, or in some Impressionist paintings. They have the same kind of dawn, when the day is approaching and everything is pale and bright; the colours are extremely distinct, not attacking your perception, but arriving with the renewal of your perception after a night's sleep and with the morning light. Saskia Bos' project was to create this primeval garden, a kind of Eden. Your work in Münster, *Like a Snail*, was again contextualized in a bureaucratic way, the work of art in relation to the urban context and vice versa. The two were well-differentiated, despite the resulting revelation that the chaos of the urban context opposed the positive affirmation of the work of art. This distinction appeared so evidently there for the first time. But the context, likewise, was no longer open but closed in its definition as an urban landscape. Your work stood in relation to architecture as a complement to an established environment.

Deacon **That's correct.**

Tazzi My reference to the light of dawn was not merely a poetic digression, it was in reference to the title of an early work of Anthony Caro's, *Early One Morning*. This seems a characteristic of British art when it reaches a turning point.

Deacon **Yes, I know that work. To digress a bit, one of the differences was that I knew what I was doing in Münster but I didn't know what I was doing in Sonsbeek. One of the problems for me as an artist and maybe for artists in general is to be in situations where you don't know what you are doing in a productive way. You can't always do that. I think you are correct to say that the intention was articulated and the context was clearly established. To be brief about it, I said 'I want to make a work that is the equivalent of a house'. In practical terms, *Blind, Deaf and Dumb* at the Serpentine Gallery, *When the Land Masses First Appeared* at Sonsbeek, and *Like a Snail* at Münster qualified me in terms of experience to think about and to be offered opportunities to make work in other places. One was in Krefeld, another was in Los Angeles, and there were some commissions that resulted. The work in Krefeld is one of the longest, begun in '88 and finished in '92. Do you know this work?**

Tazzi Yes.

Deacon **I didn't really know what to call it. Sometimes it's quite easy for me to title works, in this case the work is titled in relationship to intention.**

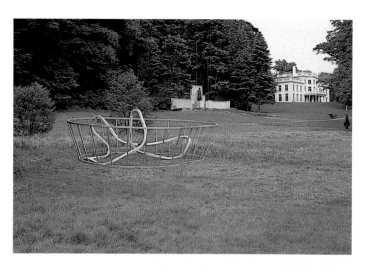

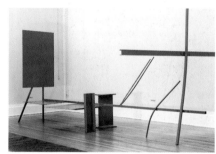

above, **When the Land Masses First Appeared**
1986
Laminated wood, zinc-sprayed steel
225 × 650 × 750 cm
Installation, Sonsbeek '86, Arnhem

left, **Anthony Caro**
Early One Morning
1962
Painted metal
290 × 620 × 335 cm

following pages
left, **Like a Snail A**
1987
Steel, hardboard, timber, plywoo[
500 × 650 × 450 cm
Installation, Skulptur Projekte i[
Münster, Germany
Collection, Tochigi Prefectural Museum, Japan

right, **This Is Not a Story**
1992
Stainless steel
400 × 500 × 300 cm
Waiblingen, Germany

...oove, **Like a Snail B**

...87

...minated wood, aluminium

...0 × 500 × 500 cm

...stallation, Skulptur Projekte in

...ünster, Germany

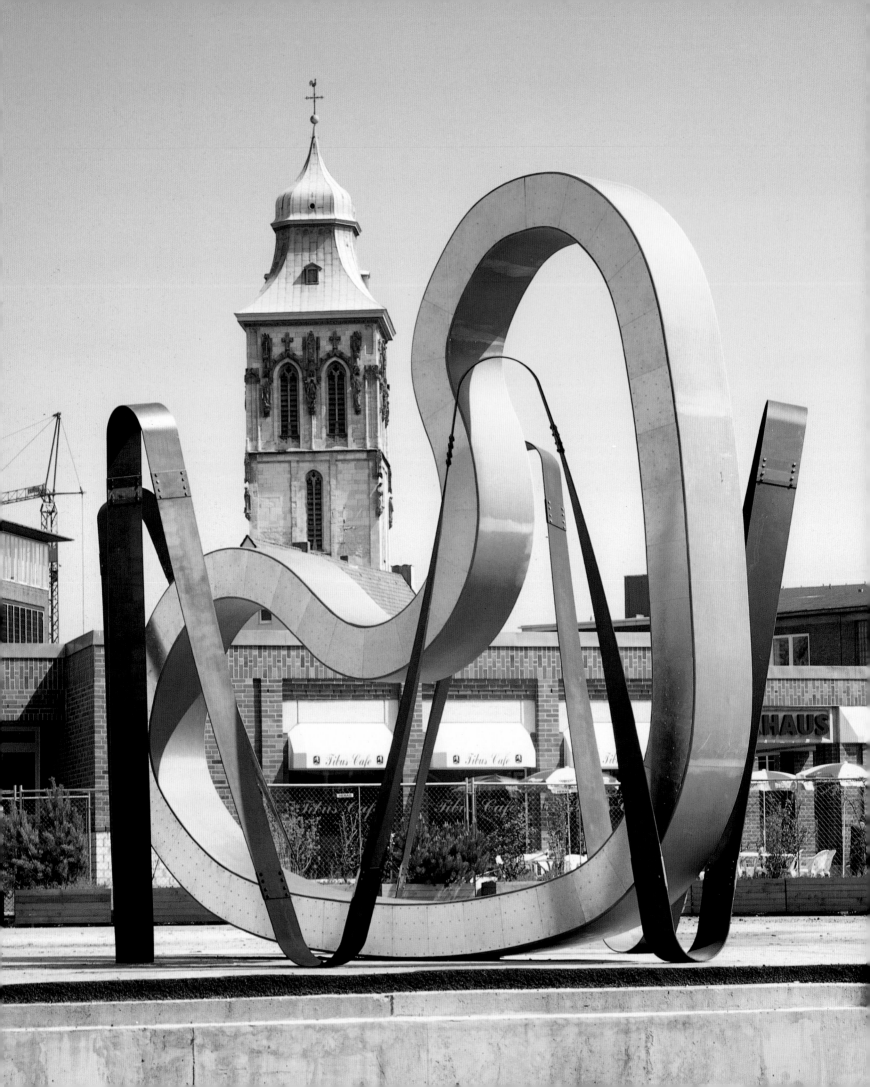

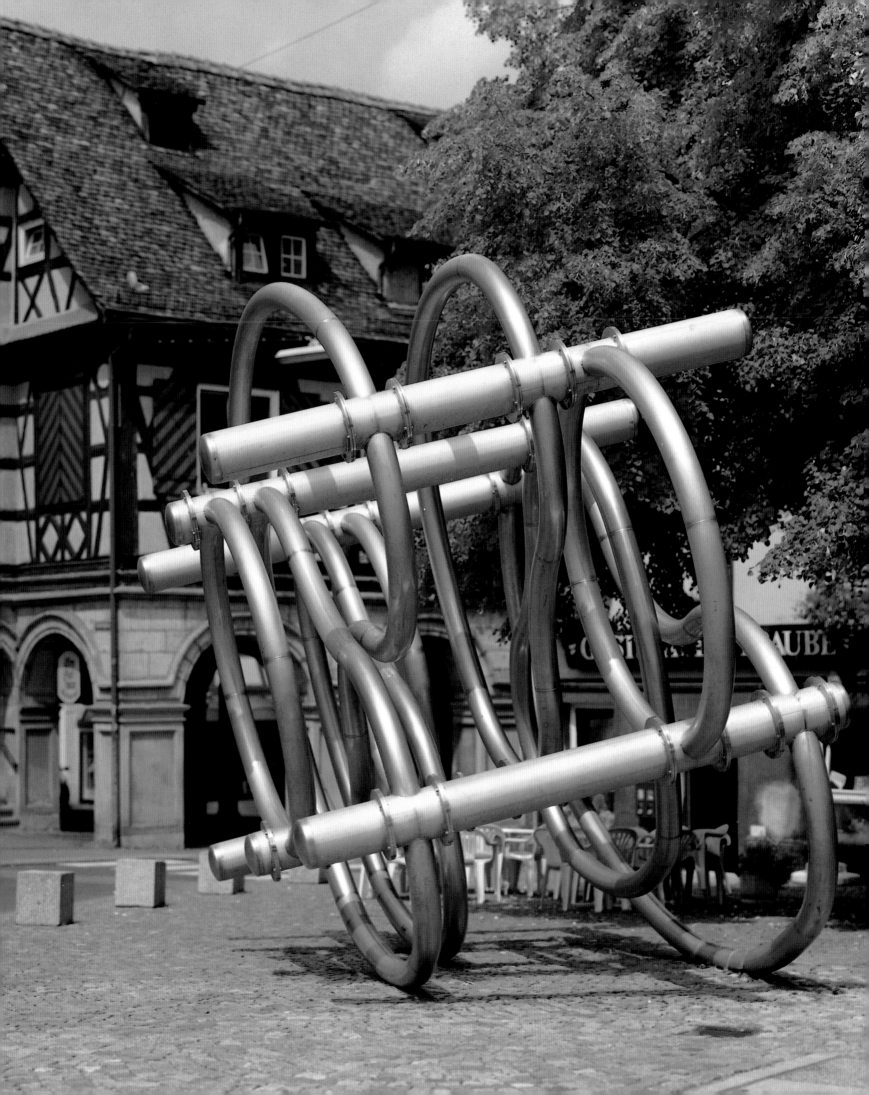

Sometimes work is titled in relationship to image. The work is called *Building from the Inside*. The place that I found and wanted to use in Krefeld was one of those urban spaces which mean nothing, a kind of open space without any real function, where roads met, that happened to define an area of ground. There are various ways you can think about the work as an entrance. I think you are correct to point out that *Like a Snail* in Münster was in relationship to a defined context, the elements were clear. In Krefeld it's a more risky operation because the context is undefined. The attempt was really to make a work which defines the context rather than opposing or establishing it. The place has negative qualities; it's not really the city or the country. There are various rebuilding plans for the area. The meaning of the work comes from the inside; its attempt is to generate the place, rather than the other way round, with the place generating the work. There are lots of dimensions to that: political, social, cultural, the idea about public.

Tazzi Can *Building from the Inside* in Krefeld be distinguished from what is called public art? You cannot consider the Münster piece public art, it was a component of the overall project, but in Krefeld there were links.

Deacon **It's not the only one; there are other works in public places. I have some problems with the term public art; the other term is art in public spaces, and there is obviously a discourse around that. The problem I have with the term public art is that it implies a degree of social engineering, that it is something that is good for you, like medicine or public housing. But at the same time it has a certain freedom, a free availability, the public domain. When I was making *Building from the Inside* for Krefeld I was doing a number of other projects and talking to various people. It was a time in the late 80s when a confusion between the private and the public space came into being, public space got privatized, particularly in Britain. The plaza became an extension of the commercial space rather than a freely available place. It was characterized for me in the late 80s by a car advertisement which seemed to place a car in that public position. Ideologically I began to wonder whether the sense of openness implied in the notion of the public space was a component in the experience of art, and that in some ways sculpture is in the public domain. The work in Krefeld was an attempt to make an opening in space of a particular sort, to create a potential, and to act as a generator for the space that surrounds it. It's not a sign, it's not a logo, it's not a monument. I've tried to use the interiority of architecture as an element, as an appropriated mode. In Krefeld you could say that I was trying to appropriate publicness to the work, and to put that into the experience of what one has as the spectator. One of the limits of autonomy might not be architecture but publicness. There might be a point in which the social context inhibits or provides a limit to the work. I have wanted to make the connection of the plasticity of material to humanness a feature of the work. Therefore in some senses the human and human experience become a determining context. Another way to put it would be to say that if the work implies that it might belong to the social context then that's OK; if it belongs to the social context then it becomes something else. There might well be a point when the work ceases to be sculpture and becomes architecture. What's interesting is the edge between the two, the extent from which you borrow from one in order to enrich or enlarge the experience of the other.**

Nobody Here But Us
1991
Painted aluminium
555 × 505 × 945 cm
Installed, ASB Bank Centre,
Auckland, New Zealand

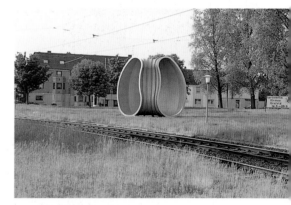

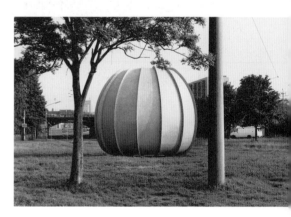

Building from the Inside
1992
Stainless steel
613 × 745 × 370 cm
Voltaplatz, Krefeld, Germany

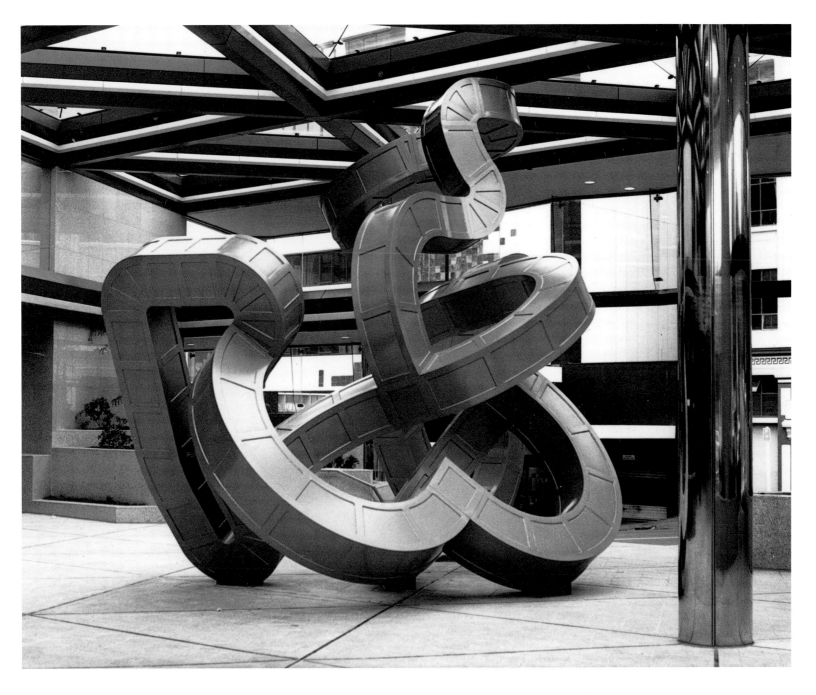

Tazzi There is also another difference between Münster and Krefeld. The context in Münster was connotated by signs and signifiers, whereas in Krefeld the relationship of your work was more with being in an undefined place than with the users of these signs and signifiers.

Deacon **In Münster the context was also established by the fact that this was a temporary exhibition. When you see this or that thing within the city you think, 'oh this is part of the Münster exhibition'. That's the first experience, before you explore the particularities of the work. In Krefeld what makes it particularly interesting is the relationship to other things, to plants, trees, houses, people. So the question of 'what is this', the immediate relationship, is not to an exhibition but to other elements and to other things within the work and to the spectator's own expectations, experiences, history and so on.**

Tazzi In Münster it is a sign alongside other signs. Of course *Like a Snail* in

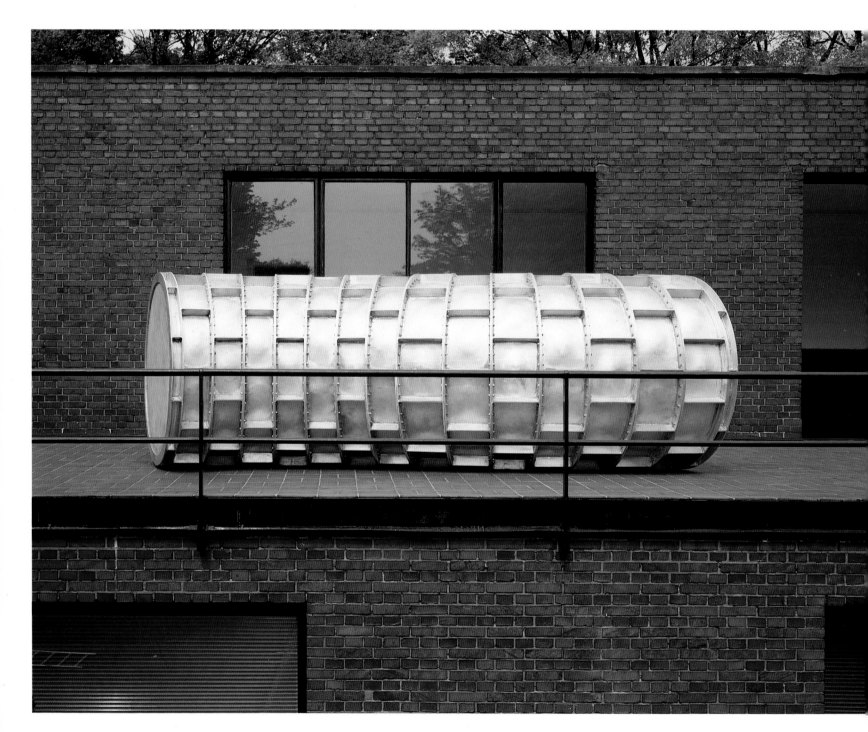

Pipe
1991
Aluminium
142 × 437 × 175 cm
Installation outside Haus Lange,
Krefeld

Münster has a different quality than the other urban signs and this difference is marked by an opposition. In Krefeld the opposition is not so relevant; there is no real opposition, there is a sort of coexistence. In terms of the relationship of art and architecture, your exhibition inside Haus Esters and Haus Lange proposed another series of problems. In that case the relationship was between two disciplines – your work and historically established architecture recognized as being of good quality. It looked more like a laboratory experiment, something done in vitro.

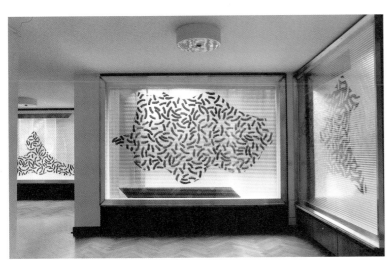

The Interior Is Always More
Difficult (C, E, F)
1991
Paint and vinyl on plastic sheet
with aluminium frames
C, 233 × 361.5 cm
E, 234 × 348.5 cm
F, 233.5 × 272.5 cm
Installation, Haus Lange, Krefeld

Deacon **I think showing what you do is implicit in the act of making art, and there are models for doing it. The exhibition is currently one of the strongest models around. For artists, to make an exhibition is to a greater or lesser extent a continuation of what happens in the studio. Showing what you do is one of the first consequences or elements of the practice. So the basic model is that you make one thing and you show it to someone else. There are expectations on both sides, and that generates the context and has physical as well as ideological dimensions. The relationship between things is a component in how you understand the particular thing, which is what makes group exhibitions somehow more difficult than individual exhibitions, or more interesting. Haus Esters and Haus Lange are two similar buildings both by Mies van der Rohe next door to each other, but they are separate, and to get from one to the other you have to go outside and then inside. One model would be to assume that the transition from one space to the other is mechanical and there is continuity between the two places, that you are just walking down the corridor. I thought the fact that there were two spaces made it possible to use two models of showing. In Haus Esters the model was conventional as it was understood in late 80s art practice: the work was individually autonomous and contained in the rooms. The scale of the work suggested pressing against the container, but nevertheless it was contained. There was a single work which was repeated in the other house to provide a link between the two spaces, and in the Haus Lange the simplest thing to say would be that I wanted to turn it inside out. There was a work outside the front door and work out the back and on the windows. The major work inside was transparent. At the same time the individual autonomy of the works was respected. The intention in Haus Lange was always to put the viewer in the wrong place in relationship to the work, so that it was either in their way or they were unable to get to it. There was no ideal position for the spectator in relationship to the work, whereas in Haus Esters the spectator was correctly located and physically present in relationship to the work. In Haus Lange the suggestion was that you would experience a desire to be somewhere else in order to gain the correct view, or in order to understand. That displacement wasn't intended aggressively, it was an inversion in order to shake the model. There is another model which is broadly constructed around the notion of installation where the physical, social or spatial context has a very strong determining influence on the work but disappears outside of the installation. But I did want to press this exhibition model, in part in order to emphasize autonomy and physical continuity within the spectator's view of the work and to make the building less solid.**

Tazzi This was quite clear, but all that implied a sort of dialogue with the absoluteness and the ideology of form, expressed by the architecture of Mies

van der Rohe. It implied a new reading of history, a relationship with history, with something already there and of historical value. A living artist has to deal with that through his work. In this sense, again the relationship is with the 'other', with the unknown.

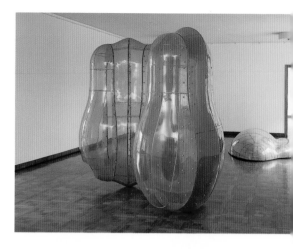

Deacon **The two houses are canonical spaces; their dimensions are as much in the realm of idea and history as they are physical. I'd like it if they weren't appropriated by history, that they continued to vibrate. One of the problems of showing there is that you can celebrate it, ignore it or try and do something else; I was trying to do something which didn't demean the architecture but wasn't awestruck in relation to it. It was ambitious and egotistical in that I wanted to be on the same level as the architecture. In a way the architecture takes you to the garden. The big windows are intended to idealize the garden. The house is almost closed to the street.**

Tazzi And the windows always frame the garden outside.

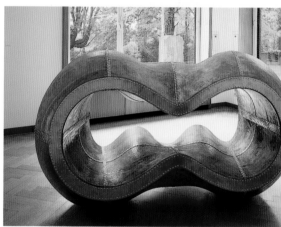

Deacon **By blocking off the windows with screens, a shape was imposed between the house and the garden. From the house you'd see it as in the garden; from the garden you'd see it as in the house. Intellectually I was trying to put something in the way which had to be put aside to be able to see the house. Basically it was an irritant intended to bring forward the house as well as the work.**

Tazzi There was an opposition: you decided to interrupt the transparency which was one of the principal characteristics in Mies van der Rohe's project.

Deacon **The transparency of the big work made of plastic, *Pack*, was 'removed' from the house.**

Tazzi The material was, like other works of yours, very evident. Not only the forms were relevant but the material too, especially because of its translucence.

Deacon **I'm quite clumsy; things aren't as pristine as I tend to think of them; I am less capable than I think, but the work gets less interesting when I get too clean. I think it's a quality in my work that has some value, that the material has a sense of the specific to it.**

Tazzi What was relevant wasn't the transparent quality of the material but the material itself.

Deacon **Yes, it was congealed.**

Tazzi If the reason to use that material on the work inside was because of its transparent quality, the result was a kind of presence. Again, not the function but the substance.

Deacon **Yes, I agree with that. But substance seems more interesting to me than function, it has more depth. The transparency of the plastic work gets converted to a sense of materiality and substance rather than function. Despite the work being transparent it has a physical appearance.**

Henry Moore
Recumbent Figure
1938
Hornton stone
l. 134 cm

Antony Gormley
Three Ways: Mould, Hole and
Passage
1981
Lead, fibreglass, plaster
Mould, 60 × 98 × 50 cm
Hole, 62 × 123 × 80 cm
Passage, 34 × 209 × 50 cm

stallation, Haus Lange, Krefeld
to r., **Pack**
990
elded PVC
17 × 253 × 159 cm
order
991
ood, welded PVC
8 x 335 x 171 cm
ntitled
991
eaten copper
22 × 205 × 91 cm
nstallation, Haus Esters, Krefeld
ollection, Krefelder
unstmuseum

Tazzi Also important to me, considering the peculiarities of the buildings, was that there are no references to the fact that in many of Mies van der Rohe's drawings there are explicit suggestions as to what kind of art – painting and sculpture – his architecture is meant to host. And among the ideal works for his spaces are the sculptures of Henry Moore, which appear quite often. Henry Moore's works are far more dependent on architecture than one would expect. In the ideology of form as confirmed by Mies van der Rohe, the work of art was included as a sort of spiritual element within the rational structure of the architecture. Architecture as a container of spirituality, spirituality represented by the work of art. And Henry Moore followed this guideline.

Deacon **I suppose so.**

Tazzi I have been considering this relationship between Mies van der Rohe and Henry Moore, because in your work you are refusing this concept.

Deacon **Part of the problem with that has to do with spirituality, doesn't it?**

Tazzi It has to do with formalization. In a way a work of Henry Moore needs a frame; even if it's sculpture, it needs a frame. What Mies van der Rohe is generally doing through all his work is to build a frame.

Deacon **Well, in the best buildings there is an extraordinary fluidity of space and ambiguity between interior and exterior, particularly true of the German pavilion in Barcelona. Another way is to say that within that fluidity Henry Moore served a purpose of being solid, like lumps … icebergs in the sea. There are points of concretization within the flow.**

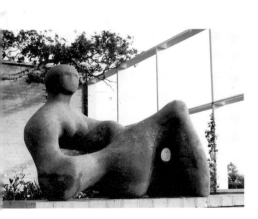

Tazzi In a way the solidity that Mies van der Rohe was searching for had the same character, the same solidity as African sculpture in the eyes of Picasso.

Deacon **Do you mean it was real?**

Tazzi Yes, and they shared the same kind of approach, solidity and spirituality in the same object at the same time.

Deacon **I accept that. The solidity was also in respect of human presence, so they are not humanless lumps. Lumps is a parody; there is some sense that the flux, the flow within the frame is one element, and against that you have something static. Both the frame and the lump are humanly determined.**

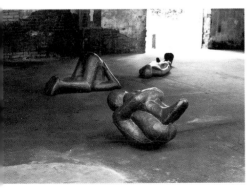

Tazzi In your work the solidity is far more a sort of encumbrance that doesn't allow one to go with the space, which blocks the way.

Deacon **Yes, that's what I mean. The body in my work is used as an encumbrance or obstruction, used as flesh and not used as a sign of transcendence or idealization. Antony Gormley uses the body as a metaphor for the transcendent subject, but at the same time the body is that in which you live. One of the ways in which I intend you to experience my work is as if you are in front of another person and in terms of a relationship to particular bodily sensations. When I began making**

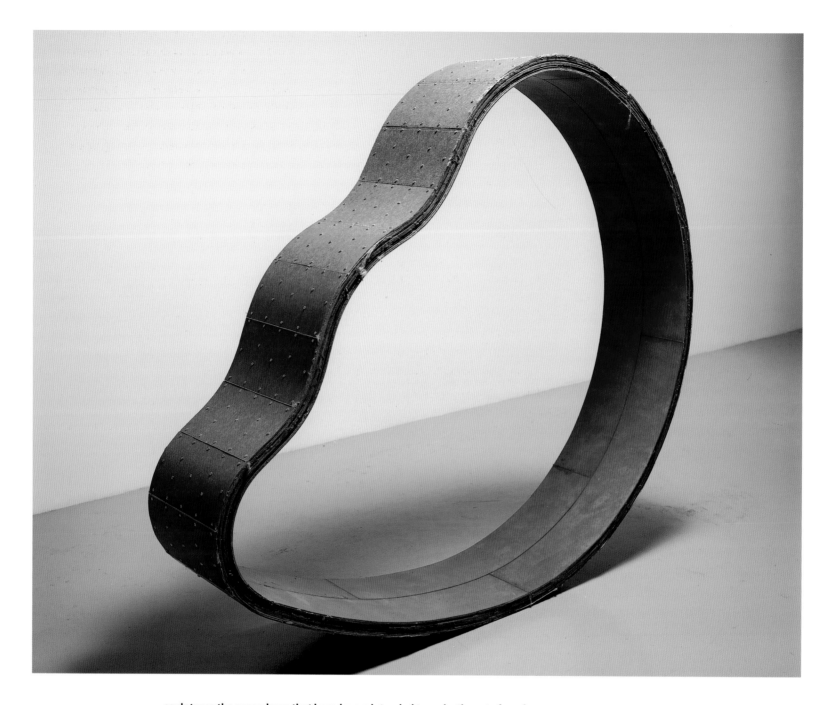

sculptures the procedures that I used were intended to make the act of work create the form and input structure into the material. Structure and material and form were all equally present on the surface; there was no hierarchy between those elements. At the same time the centre was left independent of those elements, so in that sense the ambiguity in the work had to do with the specificities of appearance. I tend to incorporate all those things in relationship to an empty interior.

Tazzi The exhibitions we've discussed thus far all implied a relationship with a context, even if the notion of context has changed and has been modified by the evolution of the work of artists, not only personal evolution but in changing ways of presenting art. How is the relationship with context expressed in some exhibitions, like the one in Oslo, or, more recently, in Hannover? At first glance they looked – especially the one in Oslo – like canonical gallery shows. And you've told me that both of them have been quite important for you.

art and Mind
6
ninated hardboard, satin,
ews
× 230 × 45 cm

Deacon **I've made a lot of things where one work is made for one occasion. I've also done travelling exhibitions which I don't like because there is a balance between place and work which seems necessary to construct. In Hannover and Oslo the work was carefully selected to make a particular ensemble for an occasion. It's normal exhibition making – there is a possibility to cause, permit or prohibit. I make works in many different ways, but obviously there are repetitions, of material, of technique and of form. But individual works also have autonomy.**

Tazzi I don't want to be over-systematic but I feel there are two strains in your work. One goes from the exhibition in Paris and reaches the work in Middelheim, (*Never Mind*), in which there is a recognizable tension between the work and its surroundings. The other emerges through exhibitions like the one in Oslo or at Locus Solus in Genoa. In these it's not an integration but a sympathy with the place; place not only as an architectural feature but also in terms of the aura. The exhibitions at Locus Solus, *Bikini* at Documenta IX, or at Feuerle, where your sculptures were set alongside antique tea pots, all have something in common: the search for an equilibrium between the work of art and its surroundings as something which possesses a peculiar quality – in the same way that the works have a special value for you as the maker.

Deacon **The work on the bridge in Plymouth, *Moor*, would also be within this sympathetic relationship.**

Tazzi By sympathetic relationship I also mean a certain passive attitude, as opposed to an active one: it attempts to be receptive to the surroundings, to be open to the aura, not to signal difference and impose the mark of the artist or of his/her actions. Sympathy then is more as reception than an effort to mark difference, all the while maintaining the autonomy of the work in that particular environment.

Deacon **The question is, what is the relationship between the two modalities and …**

or
90
nted mild steel
0 × 2475 × 350 cm
mmissioned for TSWA Four Cities
oject
toria Park, Plymouth

Tazzi I don't know whether they should be conceived as two strains or two modalities or just a side effect on the part of the observer.

Deacon **If we accept this distinction then I suppose the experience of looking at art has modalities within it. If you take the line from the Paris shows through, there would seem to be a development in the work towards autonomy, to putting the spectator in the position of being equal but at the same time separate from the work, to separate the elements within a given experience: me, the works, the park etc. I think I do work in two ways. It seems to me an intriguing thing and an extraordinary possibility that under the umbrella of making autonomous objects there are aspects of one's experience in the world that are sometimes separated and sometimes coherent, and it is possible to make objects that characterize those two modalities. This is partly a discussion that is prefigured in the twentieth century with abstraction and empathy. There are works from the beginning of the 80s that attempt to do both things at once, works to which you have an empathetic response. I think that in the work I do there is a sense of**

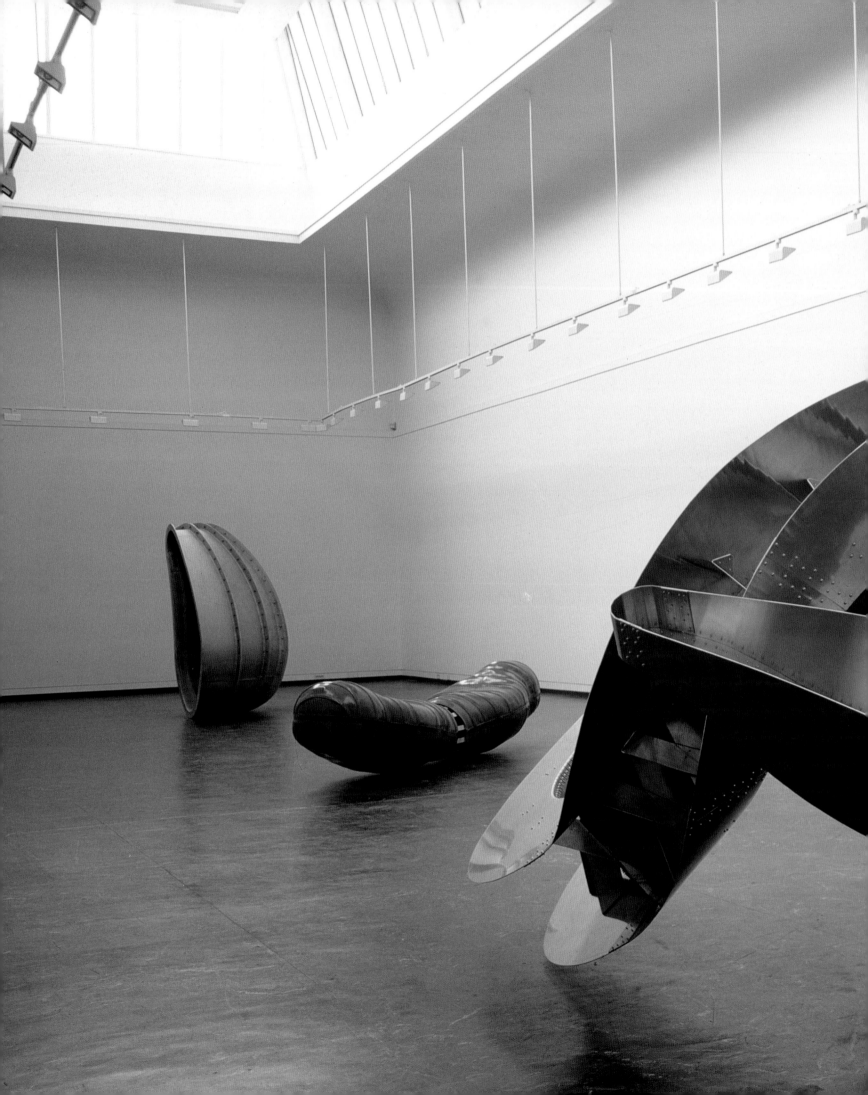

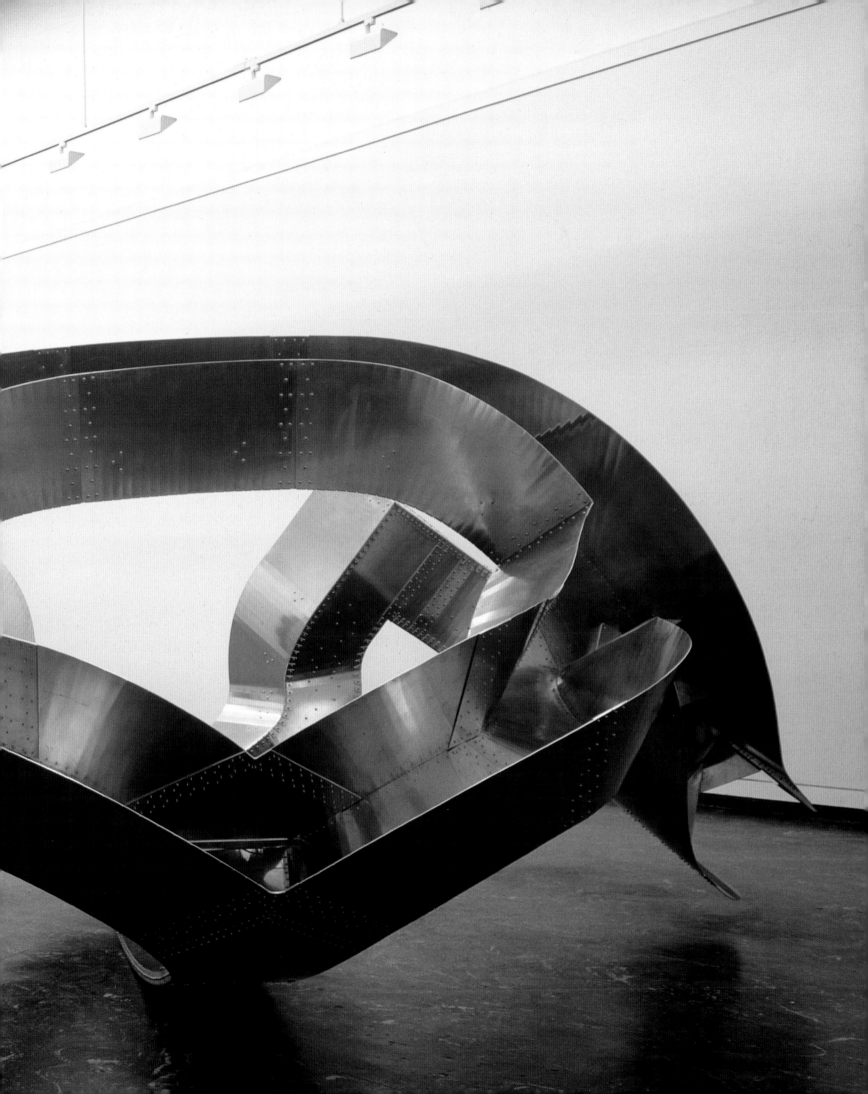

connection between those two modalities. In a puritanical sense, for example, the work in Middelheim, *Never Mind*, has many qualities that I regard as highly desirable in a work of art. The way in which the work of art resists appropriation by the spectator or the place seem to me to be highly desirable features. I am less sure that the harmonious relationship of the work to the space is of the same value. I like Bernini's sculpture very much which surprises me because it has degrees of sensuousness which as a puritanical North European I find myself suspicious of, in relation to something like authenticity. If you enjoy it, it can't really be good. So I have to fight against that element within my character, because it's stupid as a reaction and has nothing to do with it. There is nothing wrong with beauty, and what I would really like to do would be to make work which would put those two things together. It may be impossible because you are trying to put dependence and independence into the same thing. But I would like to fuse those two things together.

previous pages, Installation, Kunstnernes Hus, Oslo
1990
l. to r., **Tear**; **Seal**; **Mammoth**

following pages, **Never Mind**
1993
Wood, stainless steel, epoxy
310 × 765 × 300 cm
Middelheim Sculpture Park, Antwerp

Tazzi The big problem is the condition in which the work of art has to take place. So when I refer to a sympathetic relationship I see an attempt at protecting this modality. In the other modality I see exactly the contrary, the risk of encountering the unknown, the risk of losing control.

Deacon **I think you are right.**

Tazzi This takes us back to the beginning of the conversation, when we were discussing how the term context has changed. It used to be that context was some sort of structure which hosted a work of art, a conceptual device which established a link between the work of art and the world, which in turn was conceived of as a fixed structure. That structure has to protect and emphasize the value of the work of art in itself. Not the value in absolute terms but in itself; the validity, not the authenticity of the work of art. At the end of this *parcours* we find that the context is exactly the contrary: it doesn't protect the work of art but pushes it out of its traditional protection, into the risks of the world. Its systemic structure not only is no longer effective, but some of its components have yet to be defined and some are completely out of control. In a sense this is also the *parcours* through your work; things are always going from inside to outside and vice versa, meeting the void and encompassing it through a great many procedures, without being afraid and at the same time seeking the security of an established place. Ultimately, again it is the problem of what the place for art is now. Since this notion of context has completely changed over the past twenty years, what can the new structure be, the new possibility for coherent articulation, the new framework in which art can be placed? Where might art find its place?

Deacon **But surely the interesting thing is to keep the framework uncertain; if you make a new framework then you establish a new convention. What interests me is to retain an uncertainty within the framework, because then you are dealing with something you don't know. If the framework is determined then really you have the Academy. What's interesting about the disruptions in the context that we've been discussing seem to be as much negative as they are positive. In a sense the consequence of the fracture of the monolithic ideas about history is that modalities for perception have**

alternatives. Authority is broken and values are relative rather than absolute. The very experience of the work of art has a degree of relativity. In some ways I am a very conventional artist and I produce a conventional object. I am attached to an idea about a tradition, but I think that that attachment isn't necessarily one way. It's a means, not a value. So when we were talking about the modalities earlier, to go from one to the other is possibly to say it's all bullshit, to make you feel comfortable with a situation. The problem with relativity is that it's a moving target and enables all things to be made equal and nothing to be determined. That's the stick I have to beat myself with. That question. But it's not necessary if one framework has gone to suggest an alternative, because there may be several alternatives. The difficulty is that if there are several alternatives, that lowers the possibilities in any of them; making judgements becomes more difficult, because there are alternative criteria. You can't make judgements from the same surety because there is always another possible position to take up.

Tazzi The problem is not that we are in the absence of context, but that the idea of context has changed. When this notion first came out the context was defined through analyses. The instruments had a certain credibility and were considered 'scientific'. They had this kind of aspiration to truth in a way, whereas in the current situation what is lacking is this kind of credibility. The instruments of generalization are no longer effective enough to provide an image of the status of things.

Deacon **Yes, but that's a product of relativization. And it seems to me inescapable.**

Tazzi Yes. If we are currently in a moment of mutation then it's time to be very careful about the kind of mutation going on. Not in terms of judgement but in terms of survival. If in 1968, for instance, everybody was talking about how to achieve a better quality of life, today the issue is different: it's life, it's survival. That's completely different.

Deacon **One of the dimensions in the political debate in this country at the moment has to do with morality. The sense expressed by Conservative politicians is that the consequence of 1968 has been the degeneration of public morality. And that this is a crisis of value, a crisis of democratic institutions, a crisis of society. The offered solution is regressive; yet at the same time the crisis is a consequence of the pursuit of values promoted by the same political ideology that now fears the situation which it has created. This has some overlap with what you were saying. In the domain of art practice you are left in the situation in which you have had both models taken away from you at the same time. The collapse of social values associated with the left and a collapse of the moral, individualistic values associated with the right. The resolution of the contradiction will be reliant on a reconstruction of the idea of society or not.**

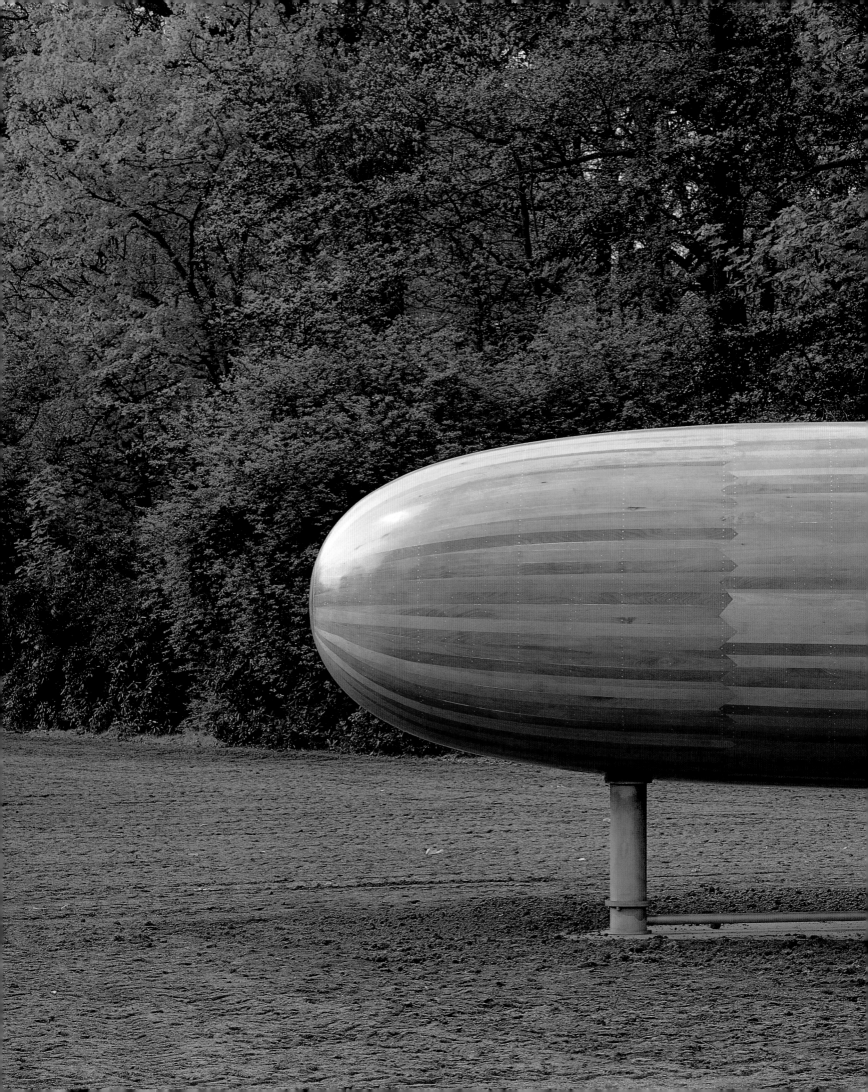

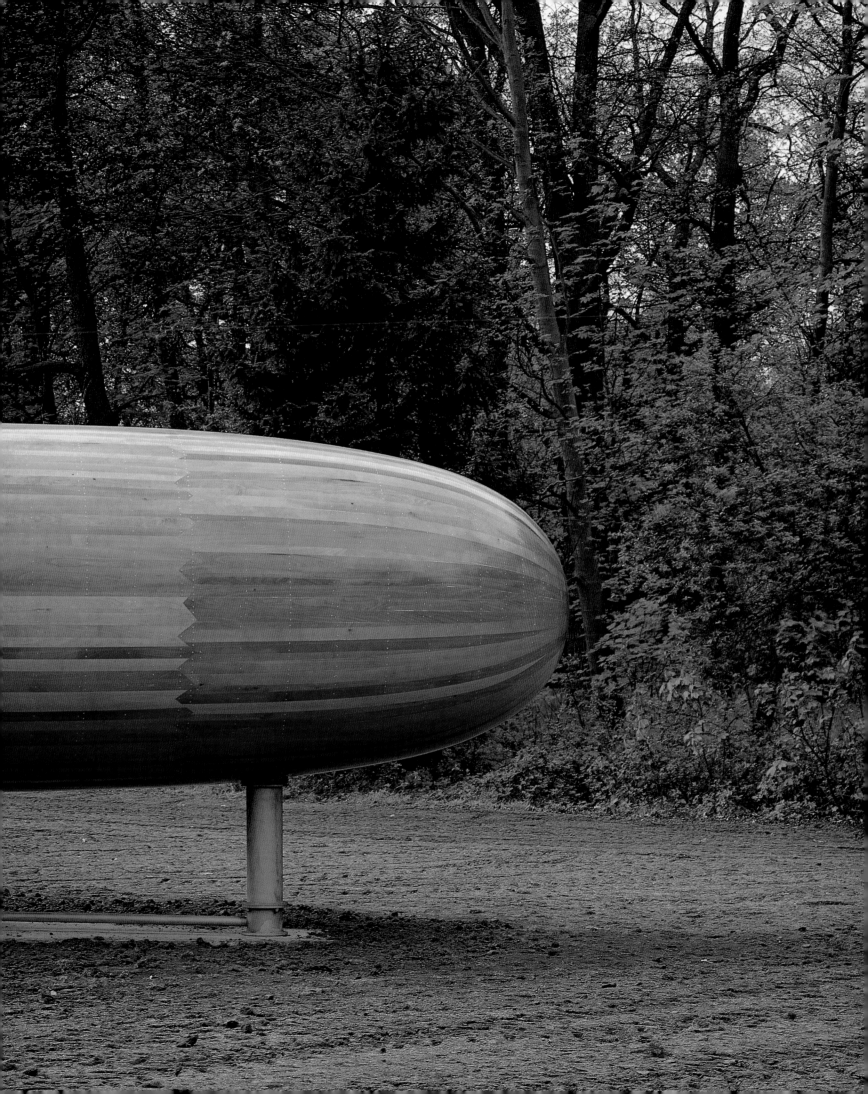

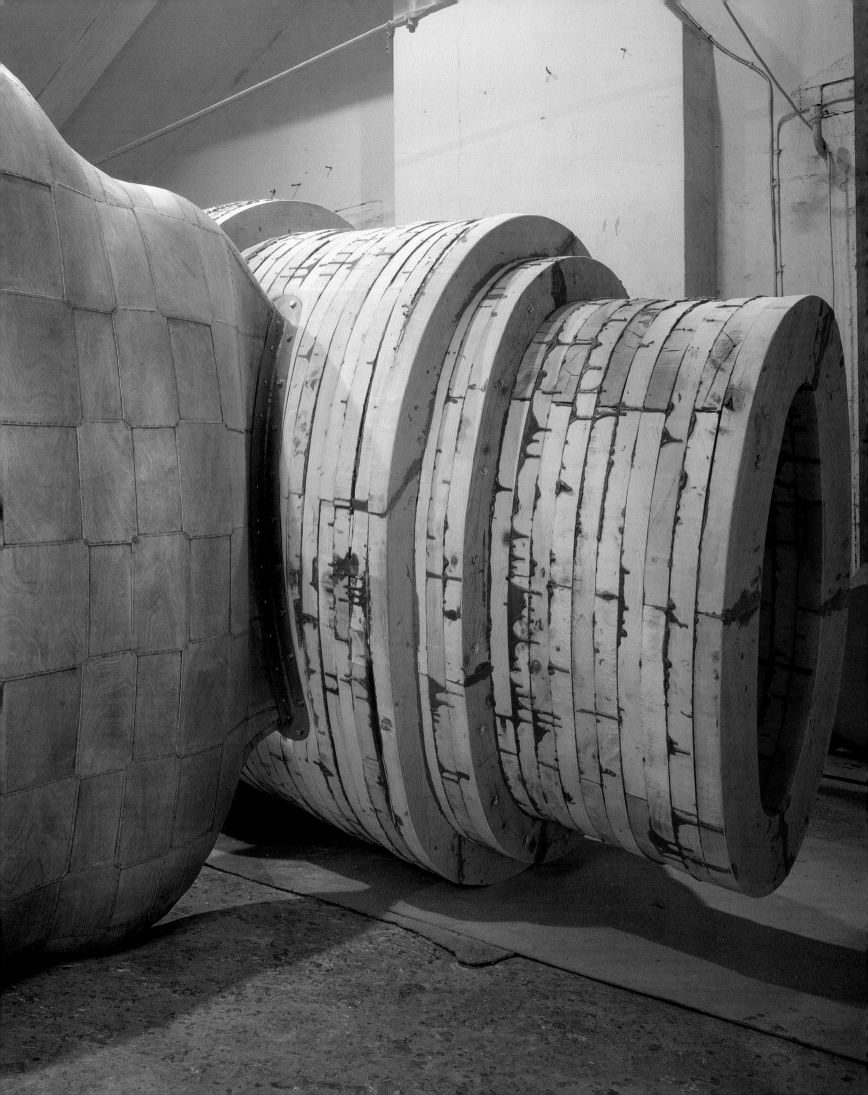

Contents

Interview Pier Luigi Tazzi in conversation with Richard Deacon, page 6.

Survey Jon Thompson

Thinking Richard Deacon, Thinking Sculptor, Thinking Sculpture, **page 36**. Focus Peter Schjeldahl

Artist's Choice Mary Douglas Purity and Danger, 1966, page 98. Artist's

Writings Richard Deacon Selections from Stuff Box Object, 1971-72, page 110 Artist's Statement, 1982, page 114

Update Penelope Curtis The Liberties of Sound, page 188 Chronology

**It's Orpheus When There's
Singing No 3**
1978-79
Pencil on paper
112 × 147.5 cm

**It's Orpheus When There's
Singing No 4**
1978-79
Pencil on paper
112 × 147.5 cm

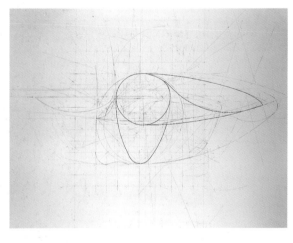

According to Homeric legend, it was Hermes, the messenger of the gods, who invented writing. And the story has it that he first of all confided his invention to Zeus, adding that he intended to make a gift of it to humankind. Zeus, apparently, was not enthusiastic and begged him not to do so, fearing that it would result in the loss of human memory.

For us today, this odd little story with its roots in the pre-textual world, can be seen as an expression of an exemplary fear: that through the all-pervasive power of coded inscription something important has been lost; a sense of connectedness or wholeness perhaps; the deep knowledge of social life which subsists in the community of bodies. The issue framed by this story then, is not simply about the human capacity to recall hard information, but more about writing's tendency to dismember and disperse the human subject. If we can be forgiven the impudence of attributing human thought to the mind of a god. Zeus, who we might take as being all-knowing, was surely never so naive as to have suggested that through the invention of writing, human beings would cease to be able to remember anything at all – the date of the battle of Hastings, family birthdays, or where they had parked the car – but that the regulated space of written language might render some of the shared aspects of human knowledge, immemorial.

This notion of a primal linguistic space – a domain of language which exists prior to the sign – in which the potential for human communication is neither distanced nor over-determined by the constraining rules of syntax, has continued to haunt modern linguistics. Roland Barthes, for example, in a key short article of 1975, *The Rustle*

of Language[1], writes about the possibility of such a space in almost euphoric terms, describing it as an 'expanded' even 'limitless' space, constituted out of the 'music of meaning'. In this 'utopic space', language he argues, 'would be enlarged to the point of forming a vast auditory fabric in which the semantic apparatus would be made unreal' and the 'phonic, metric signifier would be deployed in all its sumptuosity, without ever becoming detached from it ... '. Here, meaning would persist without being 'brutally dismissed' or 'dogmatically foreclosed' by the functional imperatives of the sign. Indeed, to use Barthes' own words, 'it would be liberated from all the aggressiveness of which the sign, formed in the sad and fierce history of men, is the Pandora's Box'.

This dream of returning to a social space formed out of live communicative transactions finds an interesting echo in an early text by Richard Deacon, *Silence, Exile, Cunning*[2], a retrospective reflection on a series of drawings made during his stay in America in 1978–79. Deacon has described this particular year as a 'turning point'[3] in his development as an artist, and the drawings in question, collectively titled *It's Orpheus When There's Singing*, as providing something akin to 'a grammar': as standing in anticipation of the work that was to follow.

In America Deacon had read and re-read Rainer Maria Rilke's *Sonnets to Orpheus* and in the process found himself greatly attracted to the poet's lyric conceptualization of 'being' – grounded in musicality, vocalization and the mobility and independence of the body in dance. This seemed to offer an antidote to the formal stiffness (Deacon's

Out of His Own Mouth
1987-88
Plywood, vinyl, copper
132 × 175 × 83 cm
Collection, Museum of Modern
Art, New York

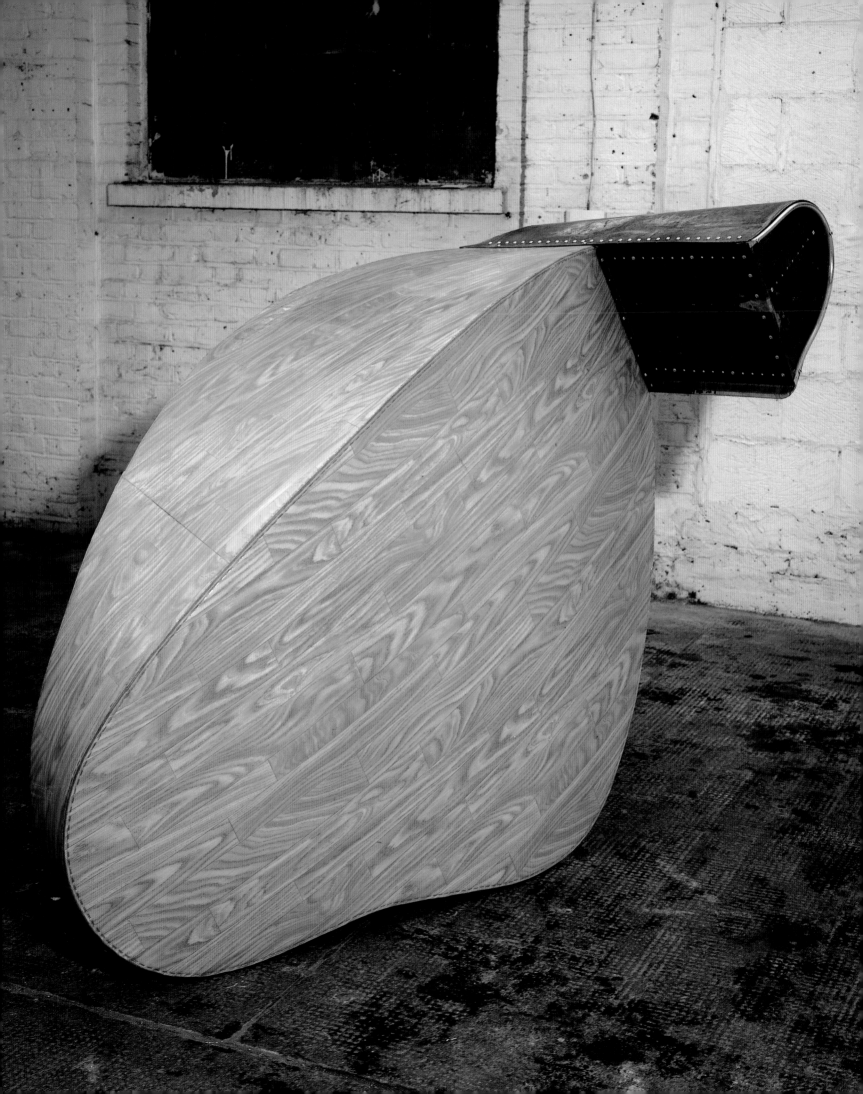

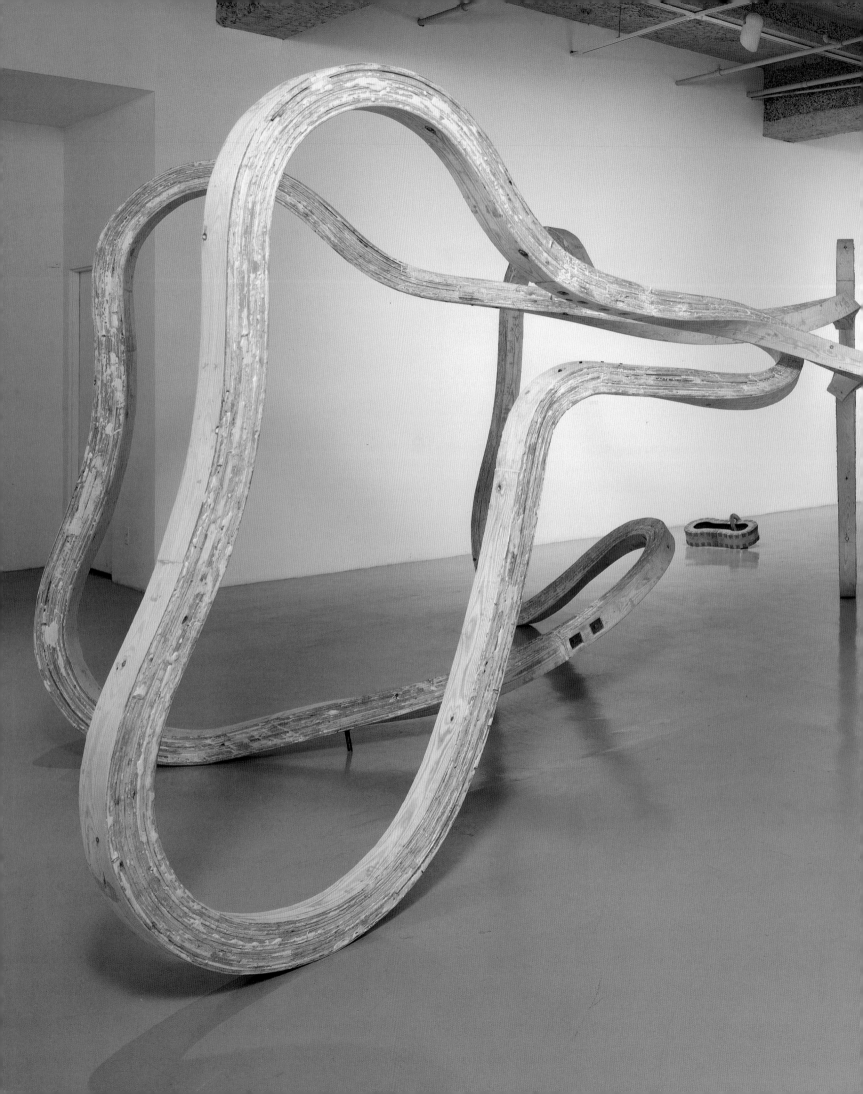

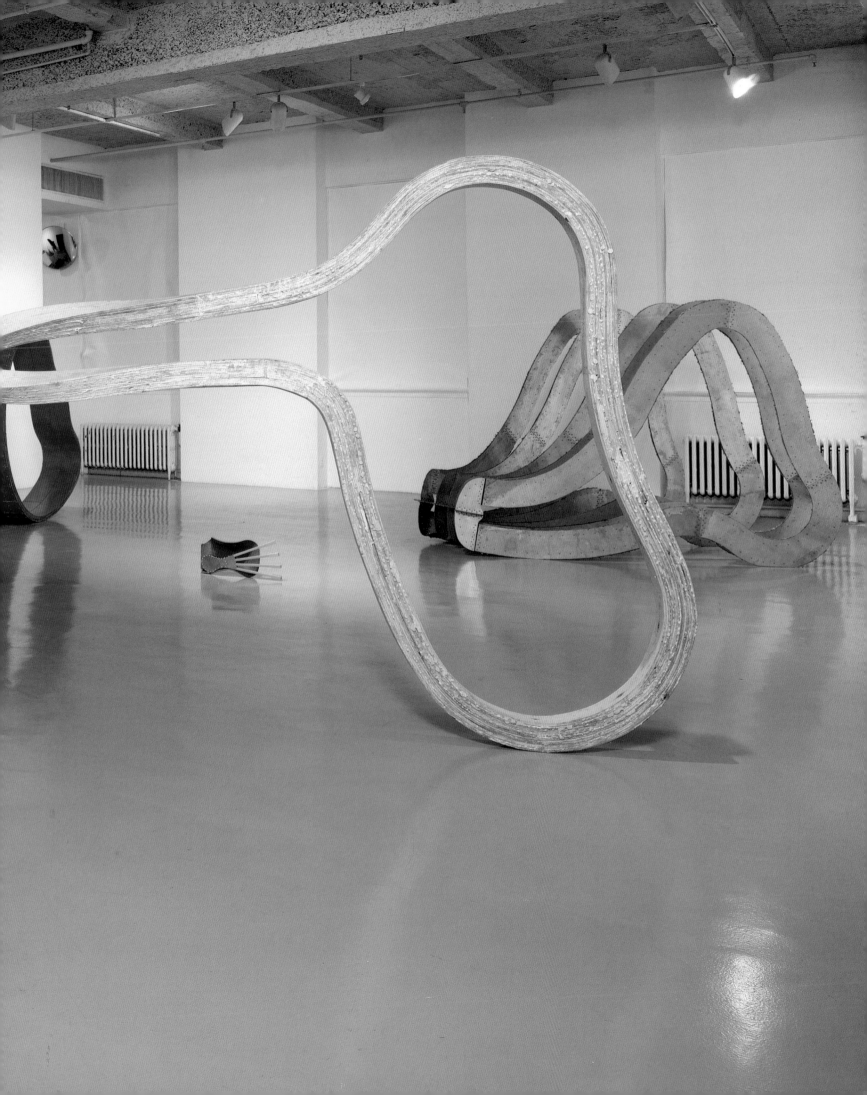

own words) of his earlier sculpture, and at the same time provide for a different way of thinking about the autonomy of the sculptural object.

Significantly, in *Silence, Exile, Cunning*, Deacon situates his practice for the first time firmly within the shared social realm determined by language and he does so by metaphorizing the making of work by reference to the making of speech. 'Since speech is constitutive of ourselves as human', he writes, 'to speak is both to cause the world to be and to be oneself. At the same time, speech is not a thing, but rather it is a product of community, built bit by bit in discourse. Speech is not nature like stone or rock; it is manufactured. To make is also to bring into being, to cause there to be something'[4].

Even though in this short text, as elsewhere, there are real difficulties in the way in which Deacon deploys the language metaphor – drawing for example, even when it is developed into a systematic method, is no more capable of furnishing a grammar than speech – this short extract touches upon three central issues which are important to understanding his work thereafter.

Firstly, by making speech and, by implication, facture – the making of things – a fundamental attribute of human being; and by bringing the making of works of art within this general framework, Deacon is being careful to claim no more for the objects of art than for any other category of manmade thing. There is a strongly egalitarian under-tow to much of his thinking as an artist, and under this rubric, if under no other, he is insisting that works of art enjoy the same status in broadly human terms as newspapers, washing machines,

motorcars and buildings. They are all part and parcel of the one reflexive relationship – that of manufacture – linking the human subject to the world at large. Making the world present to us and ourselves present to the world. It could be that Deacon is guilty of a degree of over-statement here, since the world is present to us in a brute sense even if we do not speak about it or act upon it. But in terms of providing a construction of the work of art which has an unequivocal social dimension – which sees it as arising out of the complex, communicative fabric given to human societies – the point is well made. And this brings us to the second important issue.

Deacon makes it abundantly clear that he sees speech as the vital connective tissue of community. There is nothing exceptional about such a notion, nor is it unreasonable to argue that the making of things functions in a similar way. However, when he then describes spoken discourse as something 'built bit by bit' and goes on to claim that speech is 'manufactured', a curious and highly significant reversal occurs in the thrust of his metaphor.

Out of its very nature, spoken discourse is never unitary. Neither is it constructed piece-meal, sentence by sentence, in the manner of written language. It is a much more fluid and open-ended affair involving a whole range of different modes of physical communication. St. Augustine, in a quotation much loved by Ludwig Wittgenstein and used by him as the opening paragraph of *Philosophical Investigations*[5], puts it very neatly when he states that 'meaningful speech' is 'shown by body movements, as if it were the natural language of all peoples: the expression of the

face, the play of the eyes, the movement of other parts of the body, and the tone of the voice which expresses our state of mind in seeking, having, rejecting and avoiding things'. Before all else, speech is a product of our bodylines, and the inherent human tendency to conviviality. Addressing a colloquium on 'Style'[6], Barthes, in a typically witty aside, described speech as a 'congregation of communicators' beyond the constraints of grammar and the reach of conventional linguistics: the congregational aspects of which 'remained to be described'. Just exactly how speech manages to convey clear and unambiguous meaning, then, is no simple matter. Texts are self-evidently additive, unitized assemblages of a linear kind, subject to the syntactical closure which meaningful sentences demand, and with a locus in the abstract space of the printed or written page. Speech, by contrast,

is more in the order of an 'incarnation' expanding and moving within the social space. Certainly it is not 'built' in any sense; neither is it 'manufactured'. In spoken discourse meaning resides as much in its disjunctions, its truncations and its dislocations – in a gesture of the hand, the involuntary twitch of a muscle or a barely perceptible flicker of the eye – as it does in those oral fragments which, in terms of grammar, happen to be glued together properly: the bits which make immediately transcribably, continuous sense. In this respect, speaking tends to reveal what writing purposefully seeks to hide: the complex and genuinely mysterious, ontological terrain out of which all meaning emerges – the place of language itself.

Viewed in this light we might be forgiven for concluding that writing is perhaps a more appropriate referent through which to discuss matters like 'building', 'manufacture' and the

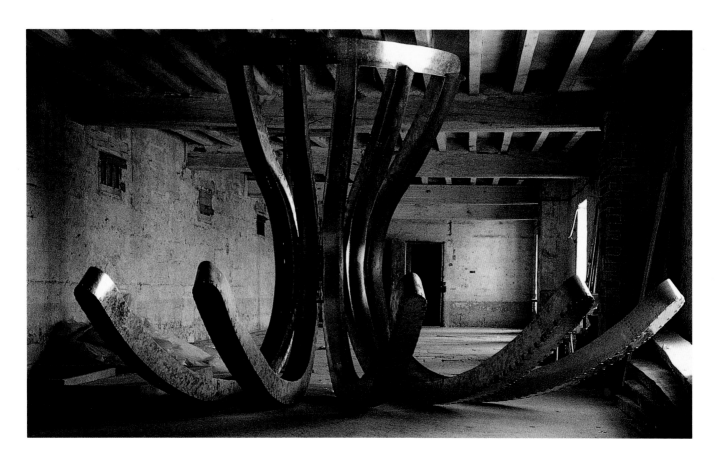

l Me No Lies
84
lvanized steel, rivets
0 × 400 × 300 cm
llection, FRAC des Pays de la
ire, France

'making' of works of art. We might even be excused the suspicion that Deacon is guilty of making spoken discourse over again in the image of his own working practices. But this would be to mistake the serious purpose underlying his statement.

Later writings show Deacon to be very preoccupied with the problem of meaning. Most especially he argues against the two extremes of 'literal' and 'epistolary' meaning: meaning which subsists in a reification of the material facts of the work, as it arises, for instance, in Minimalist sculpture; and the meaning which depends on some kind of secondary text, validated through the person of the artist acting as a ghost author. What is also clear from Deacon's writings is that he wishes meaning to arise from within the bounds of social discourse, and for this he needs a theory of making which is closely tied to the workings of language. The critic and art historian Lynne Cooke, in her essay *Object Studies*[7] – a catalogue introduction to a series of works by Deacon grouped under the title 'Art for Other People' – quotes him, quoting Charles Harrison's book, *Empathy and Irony*.

> Sculpture mediates and models a notion of what the world is like, a belief which owes much of its embodiment in language as its objecthood and its material identity.

Harrison is quite correct of course, but the simple fact of sculpture's 'embodiment' in language might not be considered sufficient guarantee of 'intentional' meaning.

Given that language is the very ground of social being, just how does a work of art – a sculpture in this case – in its specificity achieve common recognition as a 'model' of what the world is like? Is it, must it be, out of the artist's 'intention' to model the social world and to accept the burden of responsibility for embodying its meanings, or might it come about in some other way?

By temperament Deacon would most likely choose the path of intention and responsibility, but like many other artists of his generation who trouble themselves with this question, he can also see the pitfalls that lie in wait along the way. If we are to take on board the general thrust of his metaphor we must conclude that he is particularly afraid of the kind of closure which the intention 'to mean' demands: the punctum; the terminus; the fullstop. Above all he wishes to reserve a space for innovation, and here we can see clearly why he chooses to link the making of sculpture with speaking rather than with writing. In spoken discourse meaning is always open to negotiation, and negotiation, in its turn, serves to situate innovation – the making of new meanings – firmly within the social domain. For Deacon, the space in which meanings are made is a communal space, and the artist's relations to it is an ethical one. It is the very opposite of that free-wheeling space – playground of the ego – in which the artist rehearses and celebrates what Charles Altieri has described as 'the metaphysics of an assumed marginality'[8].

And this brings us to the third key issue raised by this fragment of Deacon's 'Orpheus' text: the problem of 'being'.

Some ten years later, in an interview with the Yugoslavian critic Marjetica Potrc published in

Tree in the Ear
3-84
anized steel, laminated wood,
as
× 105 × 205 cm

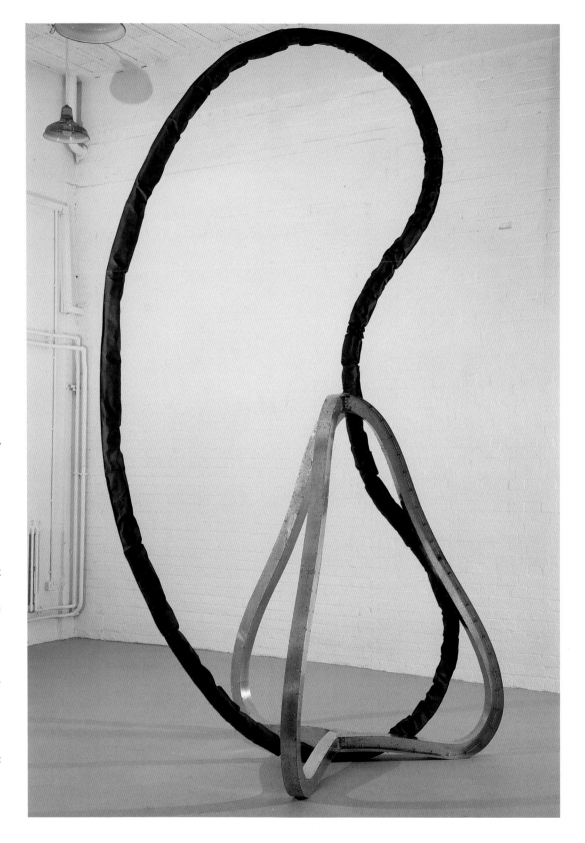

M'ARS magazine [9], Deacon seems to take a very
negative position in relation to the idea of 'being'.
After a brief discussion on meaning in which he
argues that the Minimalists, far from solving the
problems of meaning, had only postponed it, he
goes on to discuss the experience of the work of
art and the relationship of experience to meaning.
He praises the Minimalists for having got rid of
the 'essentialist' notions associated with high
abstraction, and states that for him the question
of meaning is not about identifying the essence
of the work with a metaphysical experience like
'being' and that he tends to view such experiences
as 'contextual rather than absolute'. There appears
to have been a very significant shift in his thinking,
then, from the time that he made the Orpheus
drawings and wrote the commentary *Silence,
Exile, Cunning*.

Closer examination, however, shows that this
shift is not as great as it first appears. Under the
sway of Rilkian poetics Deacon was unavoidably
caught up with the question of 'being', and not just
human 'being' or the 'being' of things in the world.
The very first stanza of *Sonnets to Orpheus* sets the
metaphysical tone of Rilke's whole enterprise:

A tree ascending. O pure transcension!
O Orpheus sings! O tall tree in the ear!
All noise suspended, yet in that suspension what
a new beginning, beckoning, change, appear! [10]

Transcendence, transubstantiation, suspension,
the apparition of change; this is the stuff and
vocabulary of a metaphysical experience of 'being':
the idea that there is something above, beyond or
outside of material circumstances; that matter
might be rendered ethereal, or vice versa; that the

passage of time can be slowed down or even stopped and the exact moment of change – '"being" in the process of becoming' as Plato called it – directly apprehended in the form of a ghostly intimation of a different order of existence. Such notions are the meat of Rilke's poetic vision, and it is hard to imagine a close involvement with the Sonnets of the kind which Deacon describes, which at the same time rejects all of this. Nevertheless, it is possible to detect a certain wariness on Deacon's part as early as the Orpheus commentary.

It shows itself in a confusion or a reluctance to confront certain very difficult questions with regard to the constellation of meaning and representation with autonomy. Writing about the Orpheus drawings in his notebooks[11] he says, for example, 'the drawings are intentionally extremely representational' but that he has 'difficulty in deciding of what they are representations'. And the passage continues: 'This concerns their reference. I have difficulty in corroborating their reference with something. Except I have considered *Sonnets to Orpheus* to be their subject'.

The question which is struggling to surface here is unmistakably that of the work of art's autonomy. How does the intention to represent something square with the desire for autonomy in the work of art? How does the work of art come to represent something other than itself and at the same time remain nothing but itself? And, more pointedly, precisely what order of experience does autonomy represent?

Deacon's preferred solution is to interject the works themselves – in this case the finished drawings – into the space between his intention to represent something and the specificity of the subject – *Sonnets to Orpheus* – in the belief that a representation might, will, has occurred, which in no way depends upon the particularities of the thing represented. It is rather like saying that you can paint a portrait of someone without referring at all to their physical appearance; and so you can, but only by recourse to things invisible. The painting would have to refer to the 'spirit', 'Psyche' or 'being' of that person, where 'being' is manifest through qualities other than their physical characteristics. Picasso's retort when Gertrude Stein complained that her portrait looked nothing like her, comes to mind: 'No, but one day you will look like it'. From Picasso's point of view he had been concerned to represent the 'essential' Gertrude Stein rather than Gertrude Stein as she appeared in front of him. He therefore regarded his portrait to be more 'true' than one based on appearances.

But Deacon is clearly very reluctant to resort to this kind of explanation. As he readily admits, for him it is one thread in a knot of theoretical questions which he finds very difficult to untie. He wishes to retain a more or less strong version of the autonomy of the sculptural object without having to ground this autonomy in a metaphysical alterity like 'being' and 'otherness'. He wants his work to be implicitly meaningful rather than 'textual': and he wants to hold on to the possibility of intentional representation without the sculptures themselves being shaped in any obvious way by what they represent.

In practice Deacon bridges this theoretical lacuna by recourse to two key working principles:

Stuff Box Object
1970-71
Performance work

the belief that work itself – his engagement with the processes and means of manufacture – is its own guarantee of meaning; and that both representation and autonomy are realized in, are determined by and in relationship to context. The model he uses to achieve this theoretical bridging is a theory of language, and here something of a contradiction emerges. Deacon's approach to language seems to bare some of the hallmarks of a phenomenological way of thinking, and in phenomenology the question of language is closely tied to the question of 'being'.

Viewed in the light of Deacon's early student background, the most intellectually formative period of which was in the sculpture department at St. Martin's School of Art between 1969 and 1972, this trace of phenomenological thinking is in no way surprising. At St. Martin's, Deacon worked in what was known as the 'A' course; a course which had been set up to provide an alternative way of thinking about sculpture to the prevailing ethos of the department: the perception-based, formal approach of Anthony Caro and the younger 'New Generation' sculptors. The 'A' course employed 'behaviourist' teaching methods, and encouraged the students to adopt a critical, even a sceptical attitude towards traditional notions of sculpture-making. The result was a wide variety of process-based sculptural work, ranging from performances to object-making which used materials as part of an 'event-structure' to arrive at a completed form. Integral to the teaching of this course was an approach to thinking which went beyond the normal boundaries of art historical and critical material into selective areas of general philosophy, linguistics and psycho-analytical theory. Certain writers and texts were from time to time deemed *de rigueur*, among them Edward Giffin's *Logical Atomism*, Edmund Husserl's *Phenomenology of Internal Time Consciousness* and Maurice Merleau-Ponty's *Phenomenology of Perception*, as well as books by more fashionable writers like Marshall McLuhan, Edward de Bono and R.D. Laing[12]. The approach taken to this material was by no means systematic, rather it served to institute a climate of discourse with its own very distinctive vocabulary.

In this milieu Deacon was engaged mainly with performance work, albeit work which had a strongly material-based aspect. This was the time of *Stuff Box Object*, 1970-71, a work which developed through several different stages; starting its life as part of a communal student project, progressing through a performance phase – during which Deacon took up a foetal position, working inside the box – and ending up as a process-based sculptural object. As the critic Michael Newman has pointed out, *Stuff Box Object* initiates many of the issues and themes which surface in a different way in Deacon's later work, in particular, 'it looked forward to the way in which the sculpture was to become both a literal object and a metaphorical substitute for the person'[13], an aspect of Deacon's work we will need to return to later.

At this time too, Deacon was reading widely in the field of general linguistics and in his last year at St. Martin's wrote a paper linking language with perception, or to be more precise 'speaking' with 'looking' by way of description[14]. A notion which is not far removed from the phenomenological term 'self-showing'[15], part of phenomenology's tendency

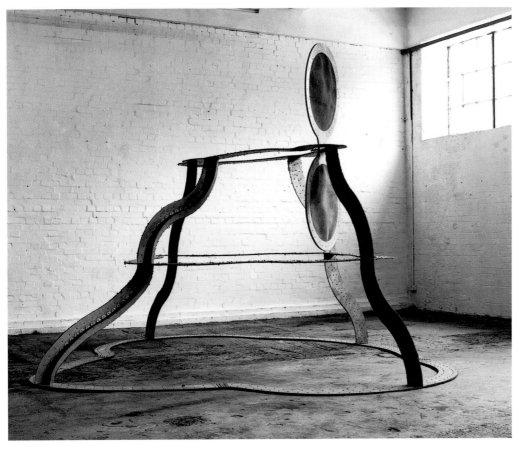

In Two Minds No 2
1986
Galvanized steel, carpet
275 × 405 × 305 cm
Collection, Stedelijk Museum,
Amsterdam

to 'linguifaction'[16]: turning the world into language.

More generally, the period of Deacon's studentship at St. Martin's and his continued involvement afterwards with the studio-based performance group 'Many Deed' was a time of intense material and procedural experimentation as well as searching examination of himself and the social world, including the nature and purpose of works of art. It was already apparent that he was gifted with great practical intelligence: his hands had little difficulty in accomplishing what his mind thought. At St. Martin's he was encouraged to challenge this facility and also to think in more radical ways about the possibilities of sculpture as an interventionary practice. Even so, in the midst of all this questioning and experimenting, concerns began to be established which were to surface in a different form in his mature work. Two are worth

mentioning here: a fascination with the way in which materials behave when they are subjected to repetitive forming processes; and an obsessive preoccupation with the unfamiliar, or more precisely, with defeating in himself the 'denial' which the unfamiliar often provokes. In this respect, a piece like *Speak/Work Performance*, performed by 'Many Deed' in 1974, out of the way in which it used routine, repetition, disruption and play-back, might be considered as something of a model for the formal games and strategies of making which Deacon engages with in his later work. Writing in the Tate Gallery catalogue in 1983 he says of his working method: 'I work with materials in the most straightforward way. I do not make plans. The activity is repetitious … I begin by shaping stuff … I may have something in mind or I may not. There are often radical changes. The unexpected happens. I am never sure whether I finish the thing I am making or whether it finishes with me'.

Underlying these staccato, seemingly very direct statements is a conception of sculpture as both practice and object of a highly provocative, even a revolutionary kind, and it has its origin in the event structure aspect of performance work. It opposes the 'occasion of making' against the more traditional notion of a pre-emptive creative vision; 'serialized fabrication' against ideated sculptural form; 'repetitive action' against original intuition; and the 'condition of possibility' against the intention to reach a particular kind of sculptural conclusion.

To return briefly to the Orpheus text. As we have already observed, there is an important side

to Deacon's thinking which seeks to hold the making of works of art within the scope and reach of a definition of 'normal' human activity. And to this end he invokes the generic category of 'things manufactured'.

Manufacture, the making of things, he argues – and here he means all making, machine-made as well as hand-crafted items; consumer durables as well as sculptural objects – is to 'cause something', it is to 'bring it into being'. Once again, as a generalization, the statement is beyond argument, just as long as we pay no special attention to his use of the term 'being'. If we put any weight at all on the word 'being' the import of Deacon's statement changes. No longer is it a straightforward description but a reference to the existential root of phenomenology as represented by the writings of Martin Heidegger [17]. Looked at from this point of view – and Deacon was reading Heidegger at about this time – it is reasonable to assume that he is implying more here than appears at first sight, and at the same time avoiding an important question of definition: just how do works of art differ from other manufactured things; in what sense might they be said to be special?

By making the metaphorical link between speaking and facture; in claiming that speech is man-made – he is careful to point out, remember, that it 'is not nature like stone or rock' – Deacon would seem to be giving tacit recognition to two and possibly three, quite distinct, notional categories of 'being': being in language; being in nature; and more obliquely, being in culture. These categories, of course, are not unrelated, on the contrary, our construction of the natural world as well as the cultural, is made from within language, since language has no boundaries and so permits of no exterior space. In Heidegger's now classic formulation: 'Language does not need to be founded, for it is what founds' [18]. In this important respect, 'beingness', in as far as we are able to know it through language, is indeed, indivisible. All things, whether natural or man-made, are incorporated into the work and 'being' of language. All things partake in what Michel Foucault has called the 'illusionary inwardness' of language – our subjectivity – and the process of reconciliation this demands of us vis à vis our experience of the external world. But this is to speak of language only on the ontological level: it is to speak of Language with a capital 'L'; the foundational terrain which allows 'languages' to become intelligible one to another. And viewed from this site, to 'bring into being' is neither more or less than to 'bring to consciousness'. The question of how things come into consciousness, how they describe themselves to us – in which particular language or by what manner of usage – is the critical one. Indeed, it is not overstating the case to say that it is this aspect of language which provides the essential ground for the hermeneutic work of all changing and lively cultures.

Ludwig Wittgenstein in the posthumously published fragments *Zettel*, touches upon this question when he writes: 'Do not forget that a poem, even though it is composed in the language of information, is not used in the language game of giving information' [19]. A poem by Sylvia Plath, then, though it uses the same lexicon and rules of grammar as a Government circular explaining how

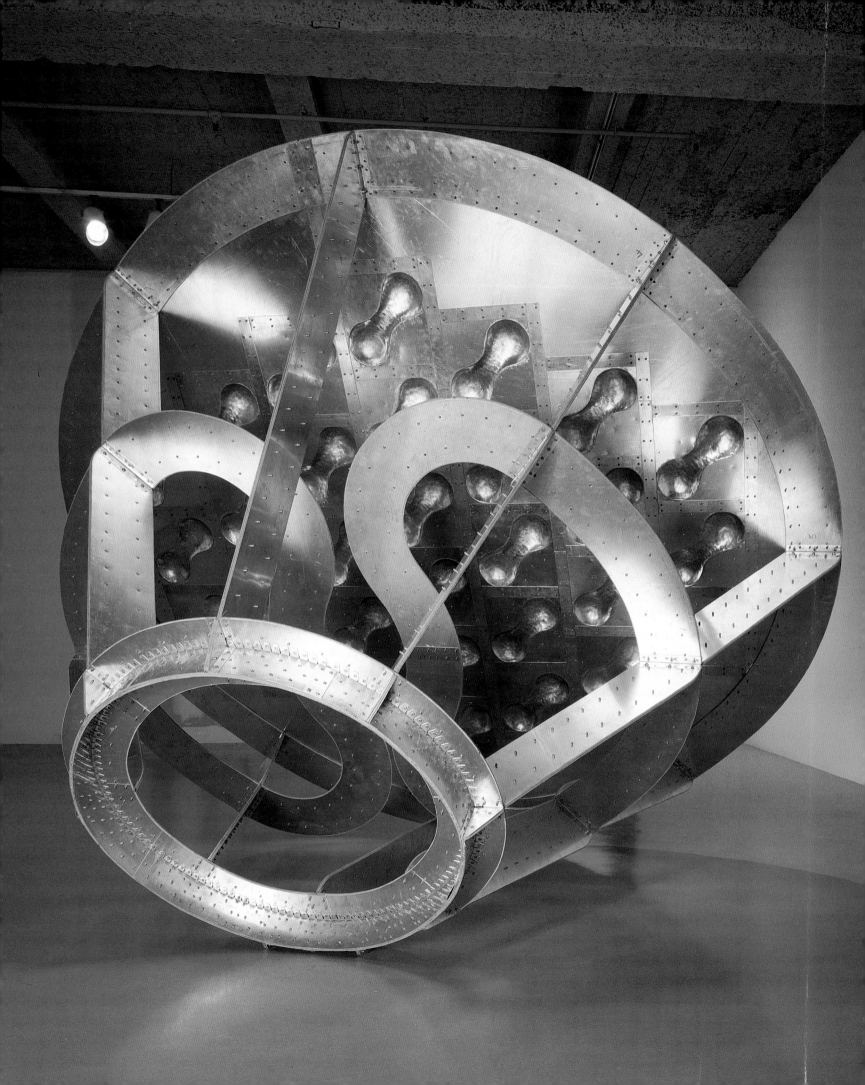

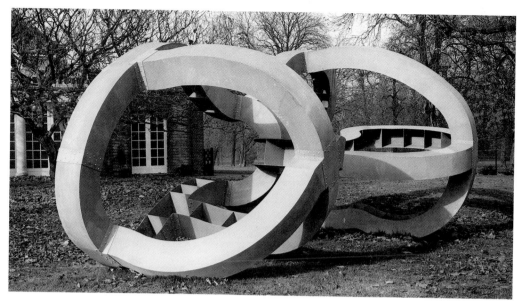

to go about claiming housing benefit, by the way in which it engages with language declares itself to be absolutely other to it. It deploys the panoply of linguistic means differently and for palpably different ends.

As Michel Foucault has argued, although as human beings we are possessed of the strong impression that language is internal to us – an interior faculty of some kind by means of which we negotiate our relationship with the external world – in fact the opposite is the case. Language starts from outside with the world of real things. The word is as much an object as the thing or state of affairs to which it refers, free to detach and relocate itself within new configurations of meaning, and poetic rhetoric depends crucially upon this mobility. The possibility of using many words for the same object; several expressions to describe the same mood or state of mind; new and different ways of speaking about ordinary things such as will lift them into the realm of the extraordinary, is the necessary precondition of the poetic text. Poetry works with, indeed it is a celebration of this arbitrariness in language. While the functional, communicative, administrative text closes down the space between the sign and the signified, seeks to preserve the illusion of a necessary relatedness on behalf of objectivity or clarity, the poetic text opens it up, uses it as a site for the play of individual subjec-tivity in writer and reader alike. Where the rhetoric of the instrumental text pretends a fixed relation between words and world, poetic rhetoric sees this relation as one which must be forged over and over again in the engine of the individual imagination.

To bring the example closer to home, and in a

more complex form. Deacon, who in his notebooks describes himself as a 'fabricator', uses the language – forms, configurations and methods of making and building – we tend to associate with processes of manufacture, technical engineering, furniture construction and industrial pattern-making. His sculptures derive their surface detail from these various processes, which results in a complicated play of what he called 'resonance' and 'equivalence'[20]. They resonate other levels of meaning and refer analogously to other things in the world. At the same time they have a strong sense of identity as autonomous works of art. A work like *Blind, Deaf and Dumb*, for example, one of the two related works made for his Serpentine Gallery exhibition of 1985, looks very much like a piece of industrial ducting; *More Light,* 1987-88, has the appearance of an abandoned piece of space technology; and the sardonically titled *Never Mind*, commissioned for the Middelheim sculpture park, Antwerp (Belgium) and installed in 1993, looks like a huge wooden former of the kind that might be used to spin a large metal vessel or panel-beat something like an engine-housing. However, while they might be said to resemble certain familiar things – while they seem to make connection with objects that we know from other contexts – they do

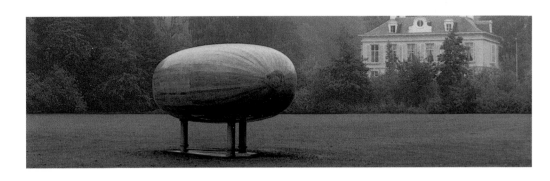

not represent them in a straightforward way. Deacon's use of the term 'equivalence', in as far as it seems to suggest a hyphenation of the word 'representation', is important here. His sculptures tend to 're-present' carefully selected aspects of familiar things as a part of their linguistic array rather than serving to specify the sculpture as a singular representation. 'Equivalences', in this respect, are not authorized directly by the artist, but authorize themselves in the mind of the viewer as a transaction in language. Furthermore, these resemblances or 'equivalences' as Deacon calls them are a function of only one kind of language deployed in the making of the sculpture; we might describe it as a technical or instrumental language. And this in turn is overlaid upon another very different kind of language. This second language we might call 'poetic' language since it is centrally concerned with the aesthetic play of material manipulation and material forms. The ruggedness and immediacy which often characterizes the working of poetic language in Deacon's sculptures – the feeling that they have been wrestled into existence rather more quickly than their scale or detailing would permit – gives to them their very distinctive charge.

To some degree these languages displace and modify each other. The technical language enters the aesthetic domain as a mark of excess; as a decorative overload. And this surplus of technical detail, in turn, serves to de-sublimate the aesthetic and formal aspects of the work, returning it to and holding it firmly within the bounds of human labour. We could describe this transaction as a redistribution of language, a transmigration of

characteristic usages, and in some respects this is precisely what it is. But it is also important to recognize that this is not a simple homogenizing process. The result is never a true amalgam. Redistribution happens across a gap, a fault-line which draws into itself the viewing subject as an active agent in the making of meaning. Most importantly, it is in this linguistic gap that the identity of the object as a work of art – rather than any other kind of manufactured thing – is first negotiated. At the heart of this exchange, the pivot around which this double play of languages is organized, there lies a characteristic argument about the nature of sculptural form. We might describe it as a dialectic between inside and outside as well as between volumetric, spatial structure and what Deacon calls 'lump': the solid, fully rounded, no-nonsense sculptured object.

As we have already remarked, reading Rilke's sonnets and making the Orpheus drawings started Deacon thinking in a new way about the autonomy of sculpture. The works exhibited at The Gallery on Acre Lane immediately prior to his trip to America [21] seemed to be studiedly earth-bound, their form ponderous in its construction and static in the way in which it engaged with space. The several untitled works which followed his return from the States had a very different feel to them. They enjoyed a more active relationship with the floor and with the space in which they stood. Indeed, *Untitled*, 1980, a large, curvilinear, open structure made of laminated strips of plywood jointed with steel, might be considered a seminal work since it manifests many of the procedural characteristics which Deacon returns to over and over again in the

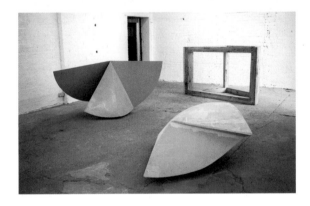

Installation, The Gallery, Brixton, London
1978
top, l. to r., **Untitled**, 1978;
Untitled, 1975; **Untitled**, 1977–78

bottom, l. to r., **Untitled**, 1976, **Untitled**, 1977; **Untitled**,1975

Like a Bird
1984
Laminated wood
Approx. 300 × 600 × 500 cm

ver Mind
93
od, stainless steel, epoxy
0 × 765 × 300 cm
talled, Middelheim Sculpture
k, Antwerp

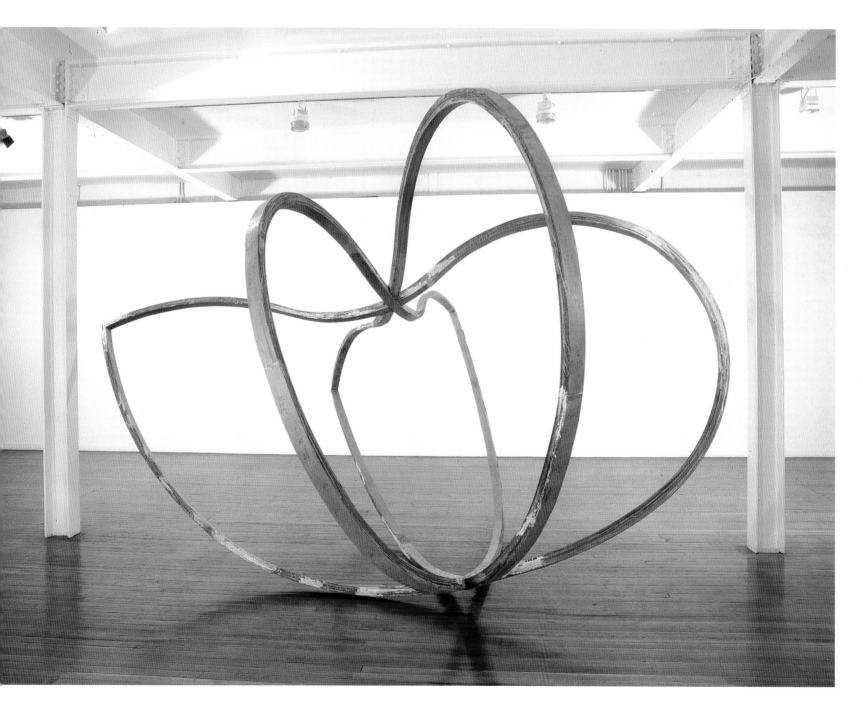

Untitled
1980
Laminated wood
300 × 289.6 × 289.6 cm

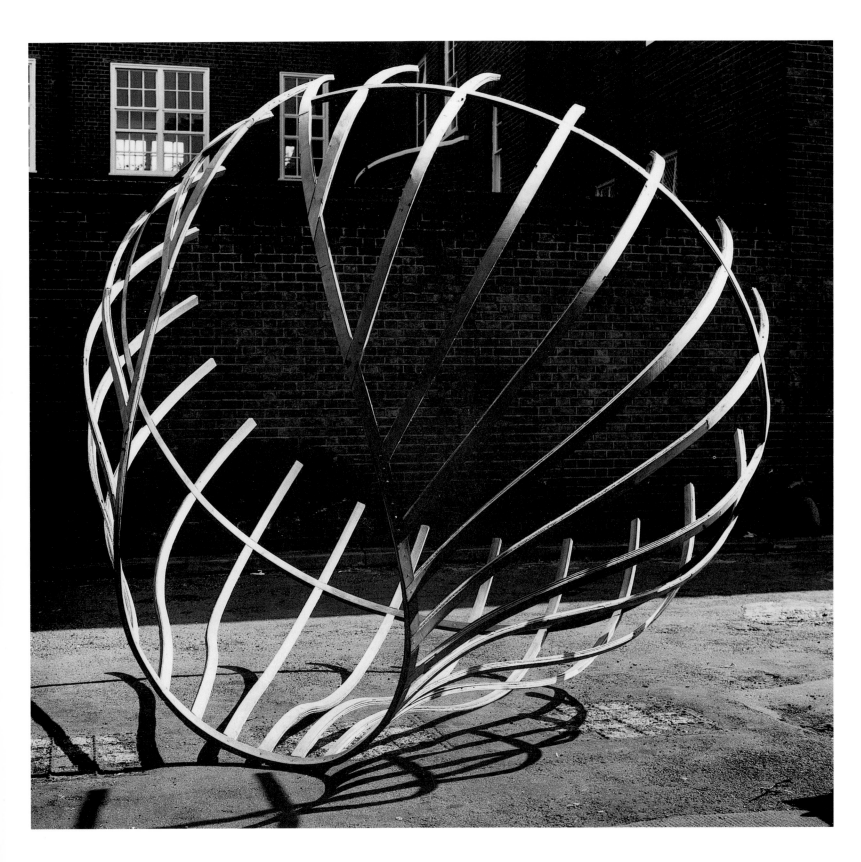

years that follow. It is the first truly open form. It has its own very specific brand of formal integrity. While it sits upon the ground it does not seem to have been built in relationship to it: rather it seems to spring from it. Taken together these qualities make it the genuine precursor of the other great laminated works; pieces like *For Those Who Have Ears*, 1983; *Blind, Deaf and Dumb*, 1985; *Double Talk*, 1987; and *Breed*, 1989.

But this early work, *Untitled*, 1980, is significant for another and perhaps more important reason: it seems to have inaugurated the dialectic of inside and outside in a new way. The work implies a closure but is also possessed

of a strong invitational aspect, reaching out and beckoning the spectator to enter its interior space. The possibility of effecting such an entrance is signalled by a tear-shaped opening – it is almost a schematically drawn vagina. Negotiation between inside and outside is given a distinctly erotic edge, an edge which allows us to approach the question of 'being' from a different direction.

Eros is unmistakably present when 'being' and 'other' are brought into a particular geometry of relationship. It might be described as both a 'coming together' and a 'holding apart'; a proximity in which a distance is integrally maintained. The deep pathos which Eros commands is made up of

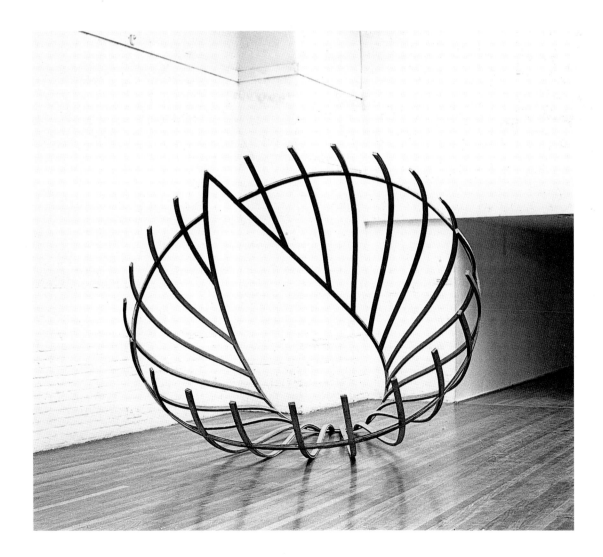

Untitled
1980
Laminated wood
300 × 289.6 × 289.6 cm

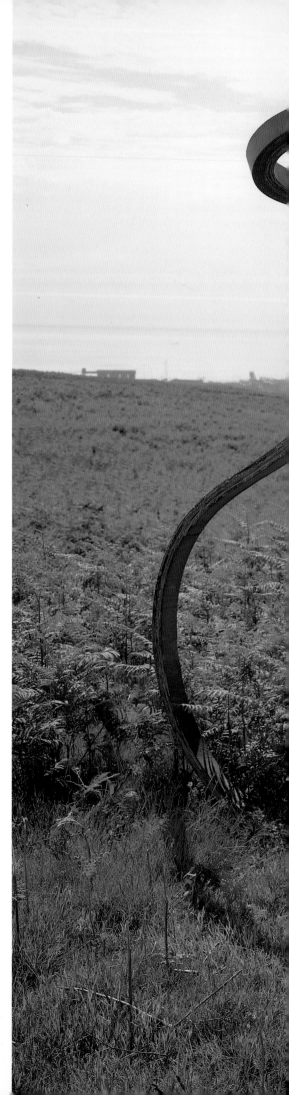

For Those Who Have Ears No 2
1983
Laminated wood
274 × 366 × 153 cm
Collection, Tate Gallery, London

this closeness and this duality. Immanuel Levinas describes this alterity with great precision by means of the linked and hyphenated phrases, 'being-in-one's-skin, having-the-other-in-one's-skin'[22]. The comma stands between, binds together and holds apart. The skin, as container, becomes a site for oscillation and substitution.

With Eros in tow, then, 'bringing into being' goes beyond mere cognition; beyond the selfish pleasure we routinely derive from sensible exchange with things in the world – our own 'being' is implicated. Deacon himself remarks upon this kind of dynamic substitution in an interview with the curator Julian Heynen. The spectator, he suggests, is 'in the position of feeling occasionally outside and occasionally inside the sculpture … the feeling of being engulfed by the object you are looking at does change the subject/object relationships … one has the sense of becoming, on occasion, the object of the sculpture as much as the sculpture is object for you'[23]. 'Engulfed' – taken over by, submerged within – seems to suggest more than a simple switching of the relationship between subject and object: it suggests a dissolving of the distinction altogether. Certainly it proposes a state of being with the work that cannot be encompassed by a term like 'looking at'.

Another way in which Deacon describes this alternating relationship between the sculpture and the viewer is as 'private engagement' and he qualifies this by adding 'as if with another person'[24]. Furthermore he attributes this kind of intimate 'engagement' to the larger sculptures

following pages, **Double Talk**
1987
Laminated wood
245 x 855 x 305 cm

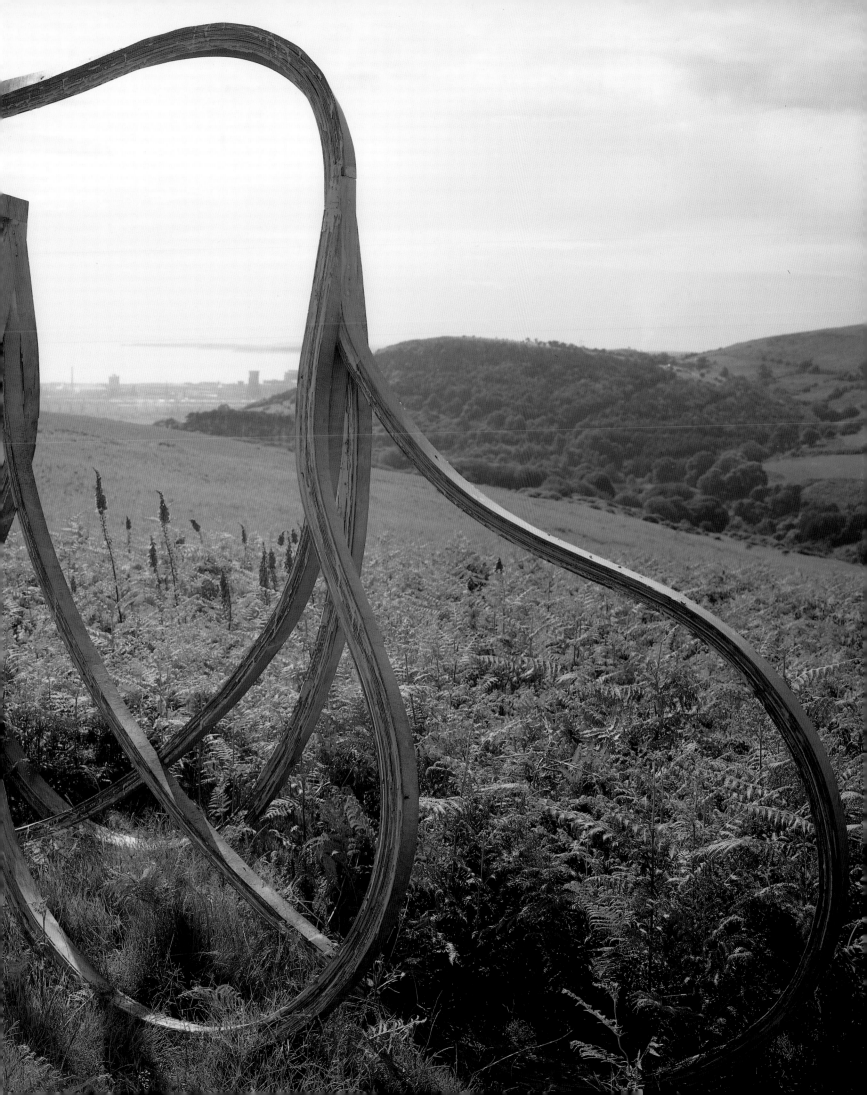

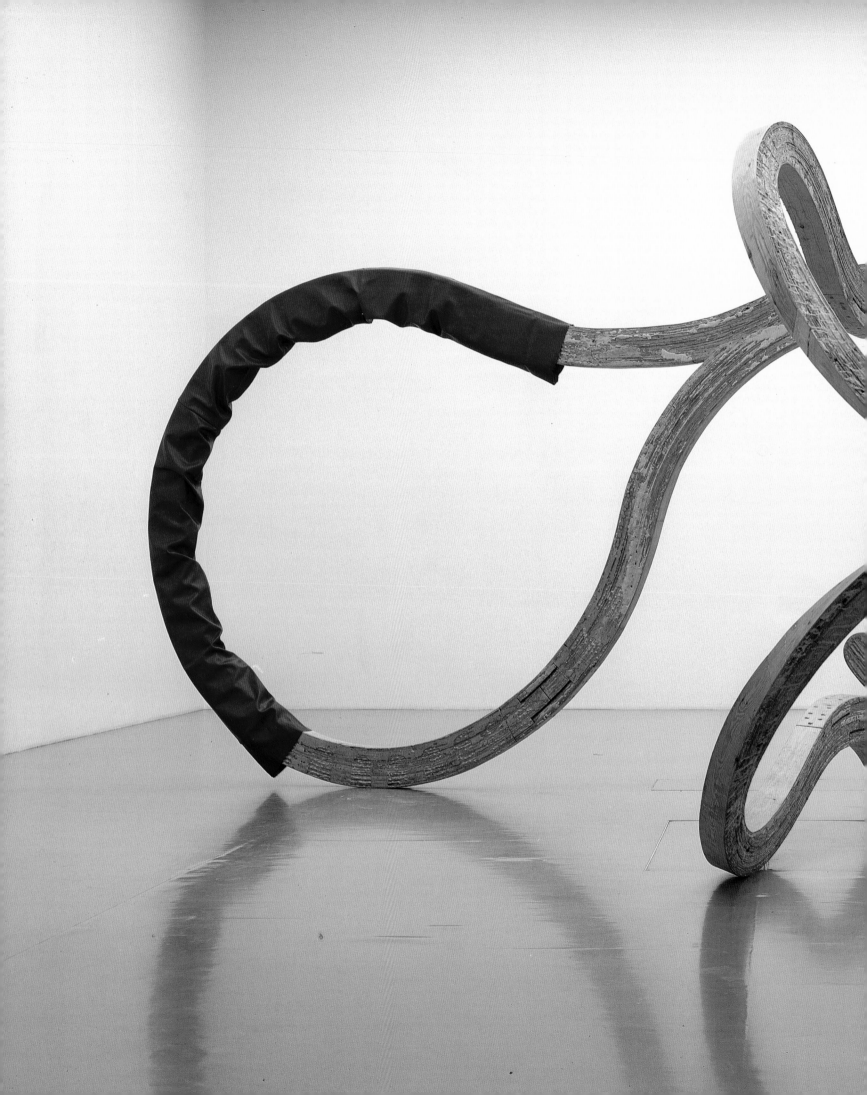

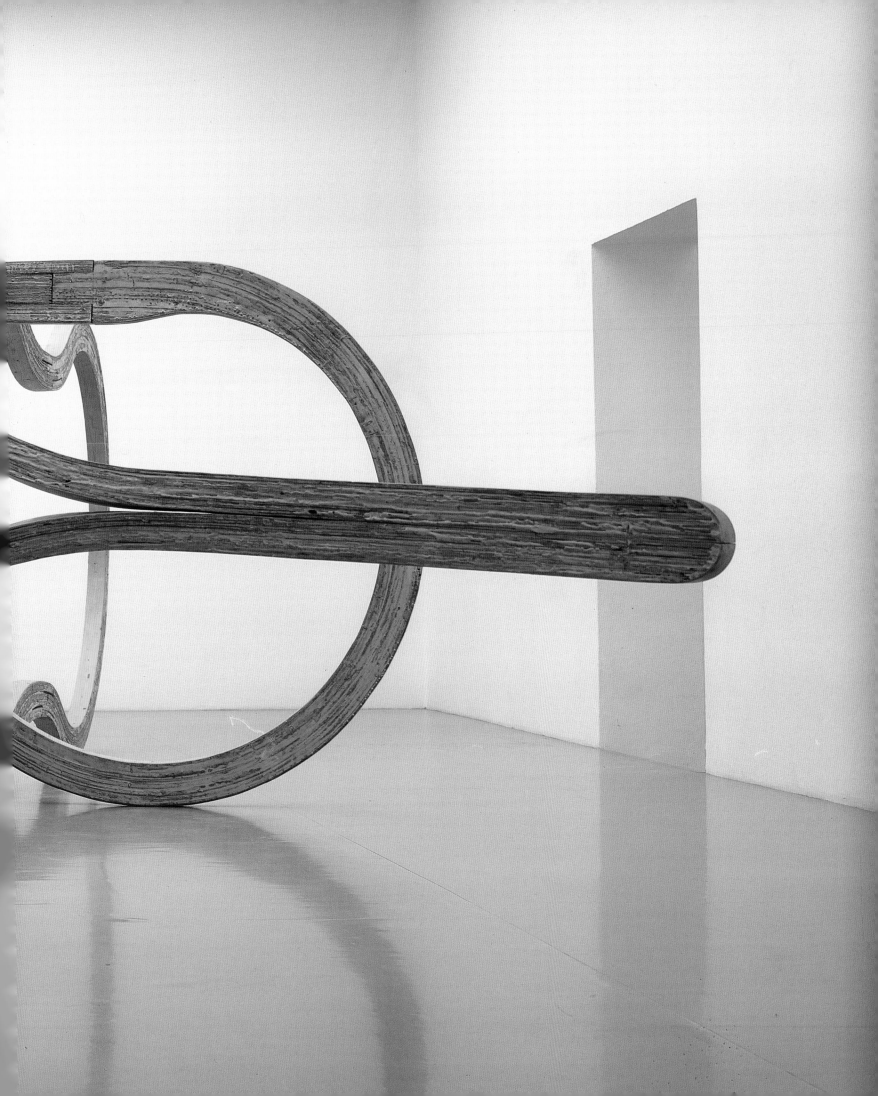

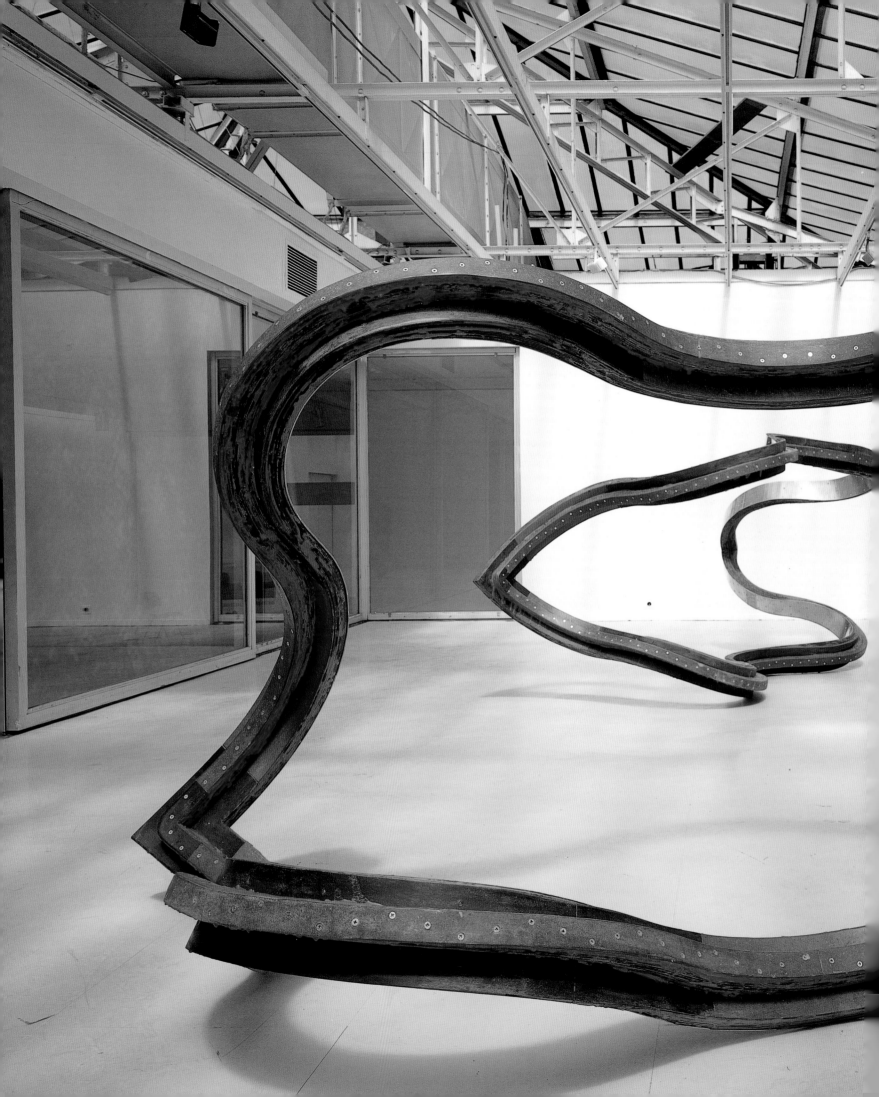

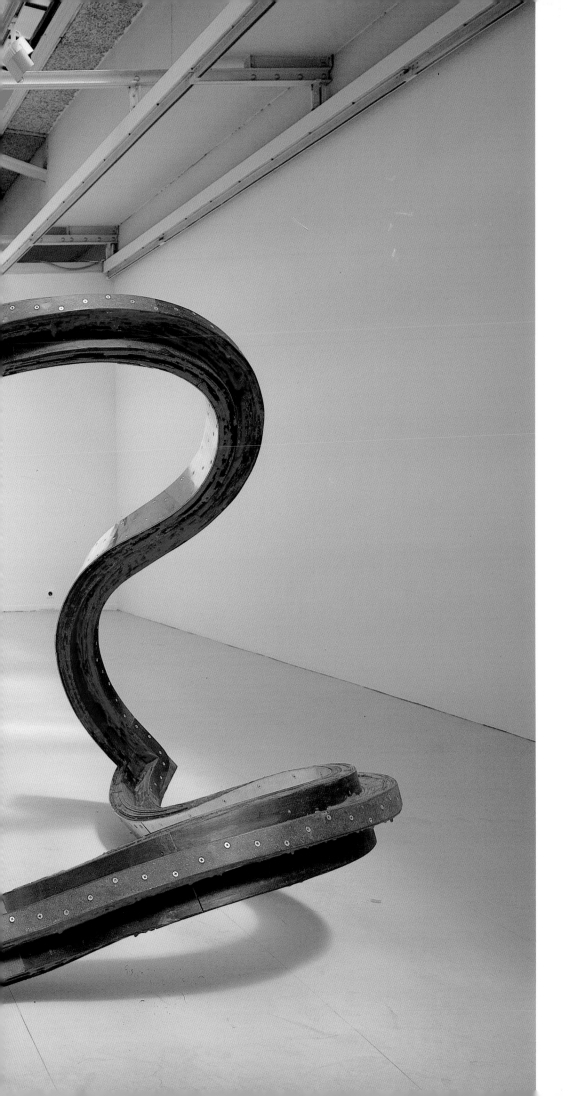

Breed
1989
Laminated hardboard, aluminium,
screws
2 parts, 150 × 520 × 300 cm
overall
Collection, Centre Georges
Pompidou, Paris

These Are the Facts
1987-88
Hardboard, mild steel, carpet,
phosphor bronze
200 × 195 × 133 cm

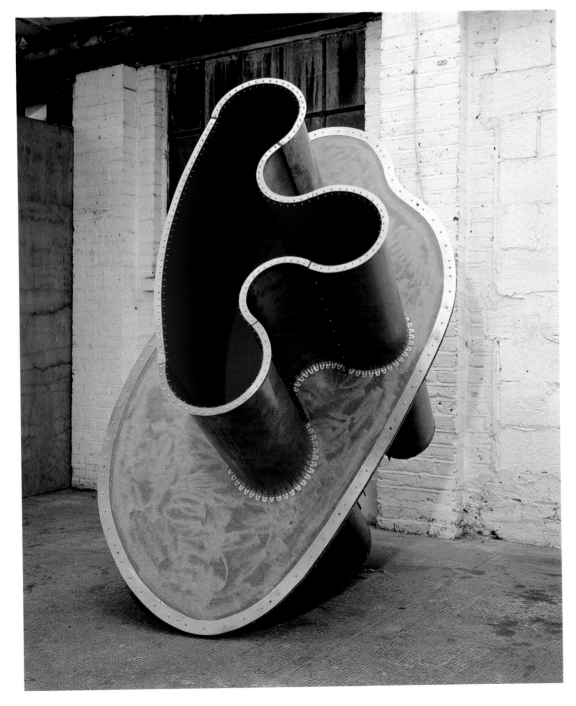

rather than the smaller works which comprise the *Art for Other People* series. The experience offered by these works is more 'public' and has something of the quality of a 'conversation' about it. Once again 'engagement' seems to suggest some kind of encapsulation, a loosing of the self to the work, a wrapping up of the subject/object duality within an experience of solitude; while 'conversation' proposes a more open and objective relationship taking place as part of the discourse of community. This seeming reversal of our expectations with regard to public and private space raises another fascinating question in the domain of language. Is the language of 'engagement' occasioned by the large sculptures the same as that inaugurated as 'conversation' by the smaller ones, and if not, in what sense might it be said to be different? And more pointedly: given the alterity of erotic substitution which characterizes our 'engagement' with the larger pieces, does connective, communally constitutive language enter into the equation at all, or are we in the presence of an entirely different order of discourse?

Significantly, the notion of autonomy in the Orpheus story finds its most powerful representation in the image of Orpheus' decapitation. His head is torn from his body while he is still speaking, and it continues to speak even after it has been thrown into the river. Indeed, Orpheus' voice remains audible long after his head has floated out of sight. Eurydice, the subject of his adoration and his lamentation, has long since shaded away into the gross darkness of the underworld. To whom then is Orpheus' severed head addressing itself and on whose behalf?

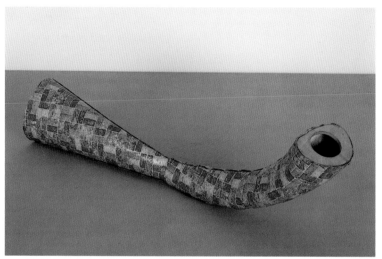

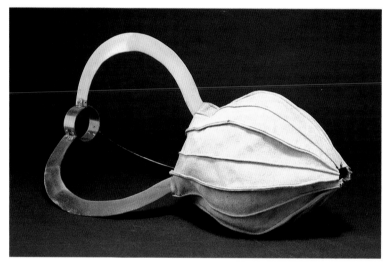

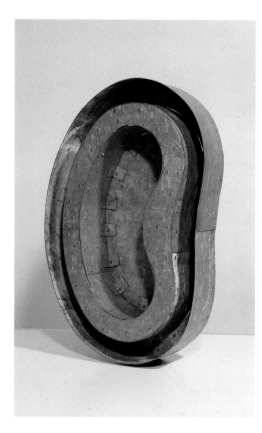

left,
for Other People No 1
2
ne, leather
× 90 × 30 cm

right,
for Other People No 7
3
leum, galvanized steel
× 52 × 13 cm

om left,
for Other People No 2
2
ble, wood, vinyl, resin
× 158 × 33 cm

om right,
for Other People No 6
3
de, brass
× 45 × 25 cm

t,
for Other People No 9
3
anized steel, rivets
× 34 × 11 cm

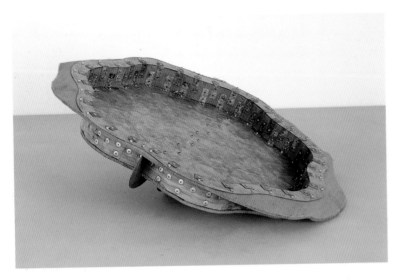

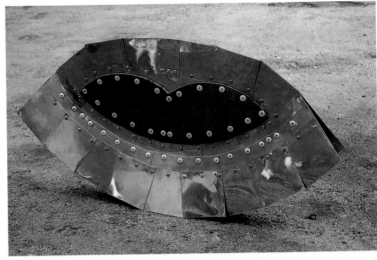

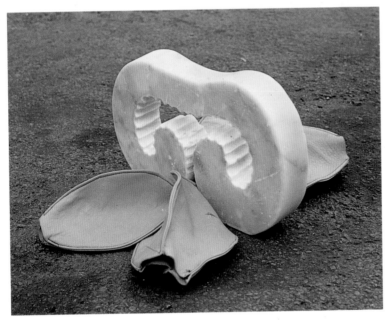

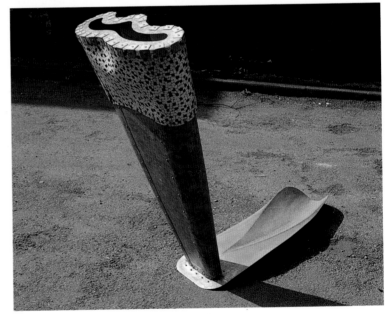

Surely in this brutally separated, continuously vocal head, song, speech, language itself is quite literally disembodied. The voice is driven by its own momentum into the beyond of language, to the outer reaches of reality, to the very edge of the unreal, and there, separated from the community of bodies, it becomes its own delicate affirmation. In this utterly 'other' place, the head speaks sweetly to itself in its own tongue. It has only to convince itself of the truth of its own descriptions: it has only to persuade itself of the validity of those sadnesses and delights which animate its inner world. Thus it is that Orpheus' decapitation represents an extreme form of autonomy within the domain of language: the possibility of an utterance which is 'of' and 'for' itself; a retreat from the language as a routing affirmation of community into the solitary space of one's own 'being'.

The disembodiment which entrance into this solitary place implies is precisely that of an 'engagement' in which the duality of subject and object, the distinction between 'self' and the 'other', is dissolved. From within, this solitude has the appearance of the absolute, but in reality its offer is, in the very strictest sense, that of an 'engagement' which in turn necessitates a 'dis-engagement': we can enter it and leave it at will. It is in this respect the opposite of 'conversation'. Conversations begin and end; they are interrupted or they are concluded. Either way they are sufficient unto themselves; they carry with them no promise of continuity. 'Engagement' by contrast, suggests that there is always something there to be engaged with, something to return to; a different order of discourse, a different quality

of experience. And because engagement is instigated in solitude it can only be shared paradigmatically. We might all have the same experience, but the attribution of 'sameness' can never be tested without recourse to the guarantee afforded by common language and common usage. The encapsulation which 'engagement' works with gives no such guarantee and needs none, so intense is the experience it provides.

Deacon's larger sculptures exercise a very different version of sculptural presence to the smaller works which comprise the *Art for Other People* series. In part, this is out of intention: Deacon intends the small works to function differently; he intends them to occupy the world in a more matter-of-fact way. Lynne Cooke, in her catalogue essay introducing these works, puts it very succinctly when she writes: 'In these small pieces Deacon can be said to be proposing a singular alternative to the homeless state endemic to much modernist sculpture, undermining the social isolation of sculpture as a fine art by seeking out spaces in which the discourse of high art is traditionally absent'[25]. But Deacon's intention to difference is only part of the story. There is something about the way in which he uses scale in conjunction with different strategies of making, which brings the larger sculptures more into the domain of bodily sensation than mental apprehension. Addressing sculptural objects we tend in any case to 'look at' small things and 'look into' larger ones – where 'into' might be taken to mean a peripatetic investigation as well as the movement into or through something. In Deacon's case this 'looking into' is greatly enhanced by the

opposite
top left,
Art for Other People No 10
1984
Galvanized steel, linoleum
40 × 90 × 90 cm

top right,
Art for Other People No 13
1984
Stainless steel, linoleum
47 × 96.5 × 9 cm

bottom left,
Art for Other People No 12
1984
Marble, leather
42 × 35 × 20 cm

bottom right,
Art for Other People No 17
1985
Galvanized steel, linoleum
122 × 152.5 × 46 cm

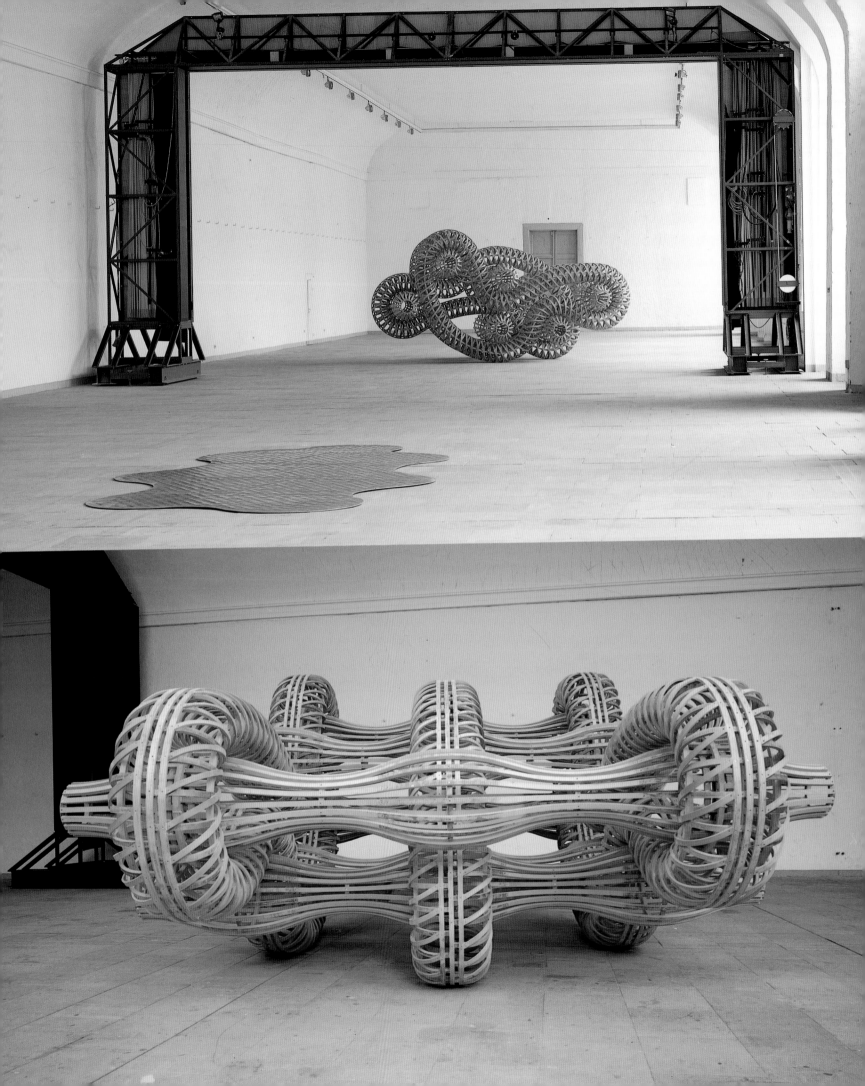

posite, Installation,
nstverein Hannover, 1993
ckground, **What Could Make Me**
el This Way A
93
nt wood with glue, screws,
ble ties
6 × 560 × 483 cm
llection, Sprengel Museum,
annover
reground, **What Could Make Me**
el This Way B
93
ainless steel
5 × 630 × 315 cm

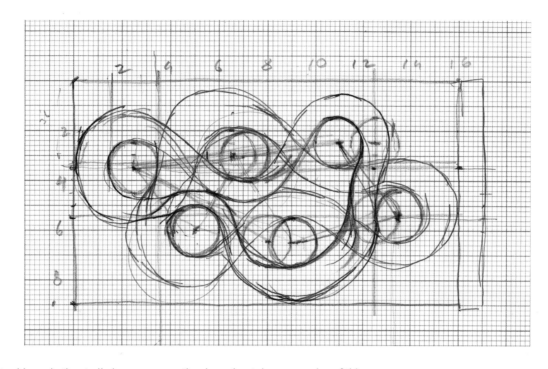

What Could Make Me Feel This
Way A
1993
Pencil, ballpoint pen on graph
paper
21 × 30 cm

way in which he fabricates his work: the studied use of open form as in the elaborately constructed *What Could Make Me Feel This Way A*, 1993; and forms which are self-evidently not solid but are built as a skin, of which the most dramatic example is *Struck Dumb* made in 1988. Even when he chooses to use solid form as with *Distance No Object No 2*, 1989, the mass or 'lump' as Deacon calls it is constructed from the inside out, and its exterior surface – its skin – functions as a graphic record, a mapping of its internal complexities. In one way or another, all of Deacon's larger sculptures describe and articulate an interior space and by doing so invite a particular kind of 'interjection' on the part of the spectator. The viewer is required to make an imaginary journey into the interior of the work, and once this process of 'interjection' has occurred,

once the viewer has taken possession of this interior, then the inrush of contextual material is held at bay and a state of identification is achieved which is more physical than linguistic. As it is with the inward experience of our own body, the viewer is in an important sense 'unvoiced'. Once inside, there is no 'other', there is no one to speak to, no one to hear. Paradoxically, if we are to describe this experience of inwardness, we must first of all withdraw from it, and this act of withdrawal is a withdrawal 'into' the world of constitutive language. For this reason the adequacy of our description must always be in doubt.

We have already touched upon the way in which Deacon's sculpture utilizes the interface between two very different languages – the instrumental and the poetic – and shown how the

posite and following pages,
at Could Make Me Feel This
y A
93

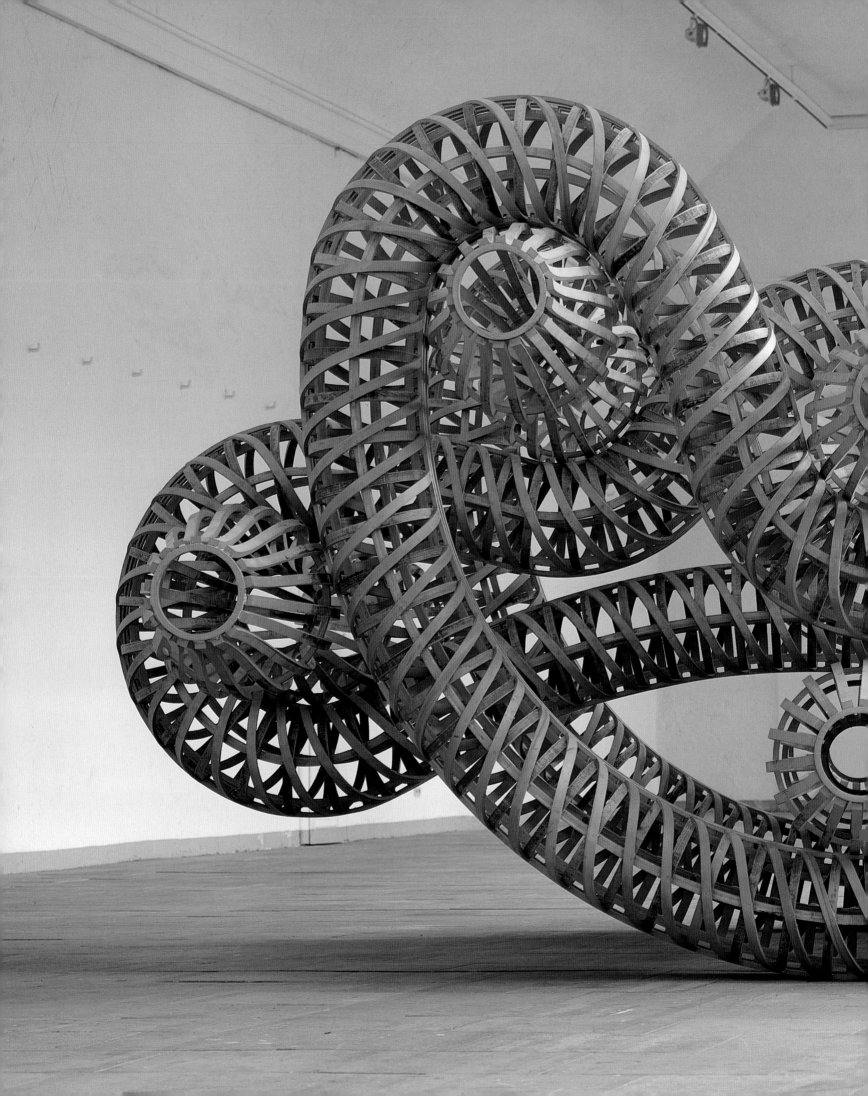

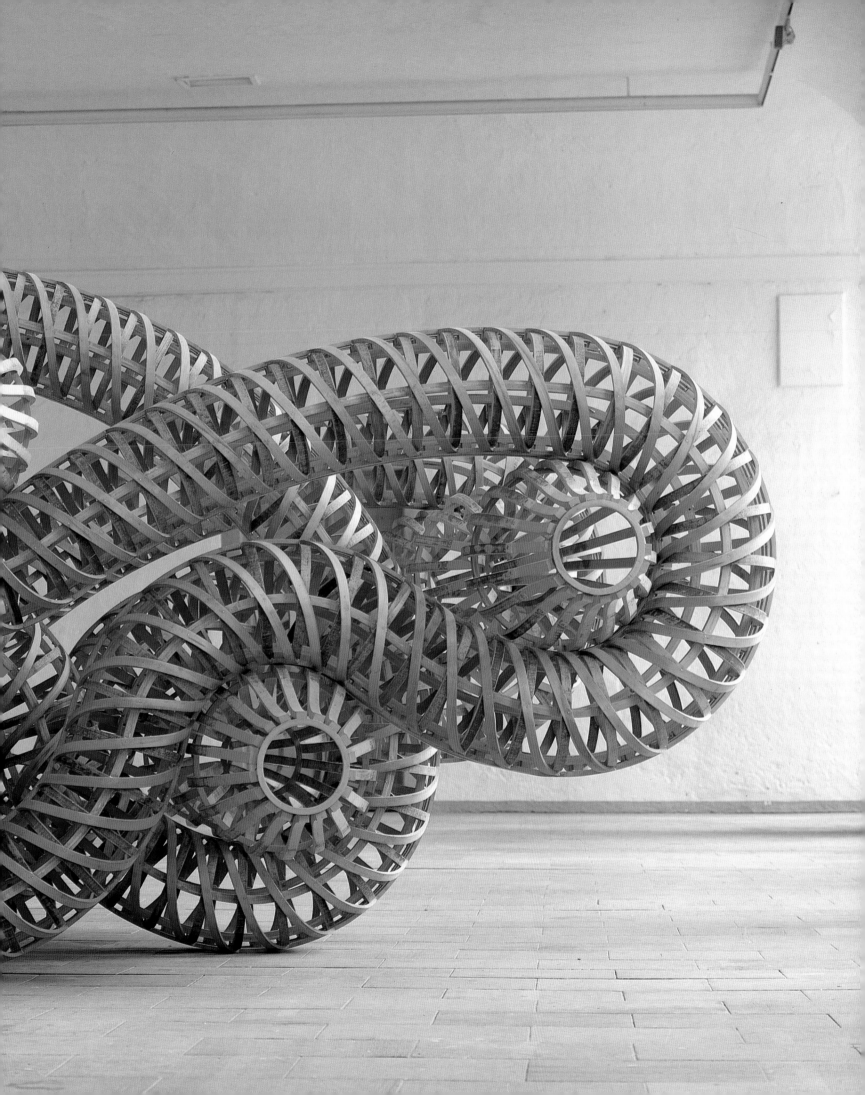

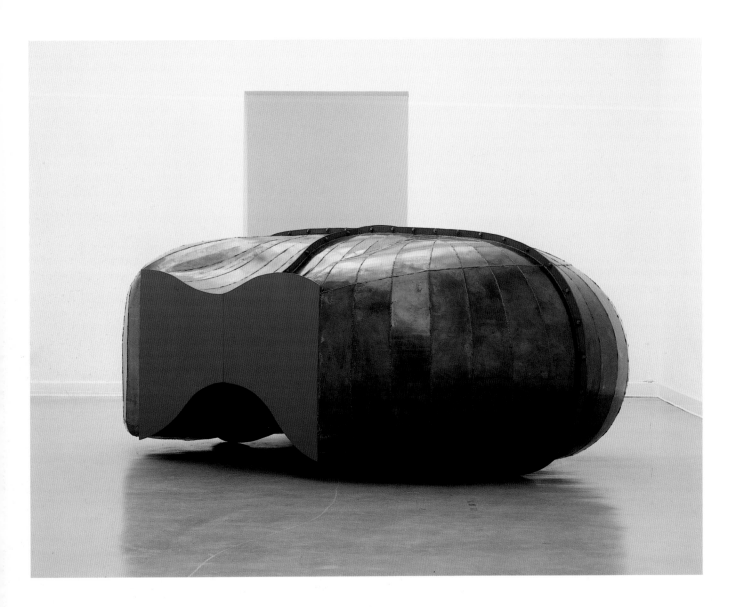

opposite, **Distance No Object No**
1989
Aluminium, glass fibre
163 × 300 × 101 cm
Collection, Museet for
Samtidskunst, Oslo

left, **Struck Dumb**
1988
Welded mild steel with bolts
157 × 392 × 266 cm
Collection, Tate Gallery, London

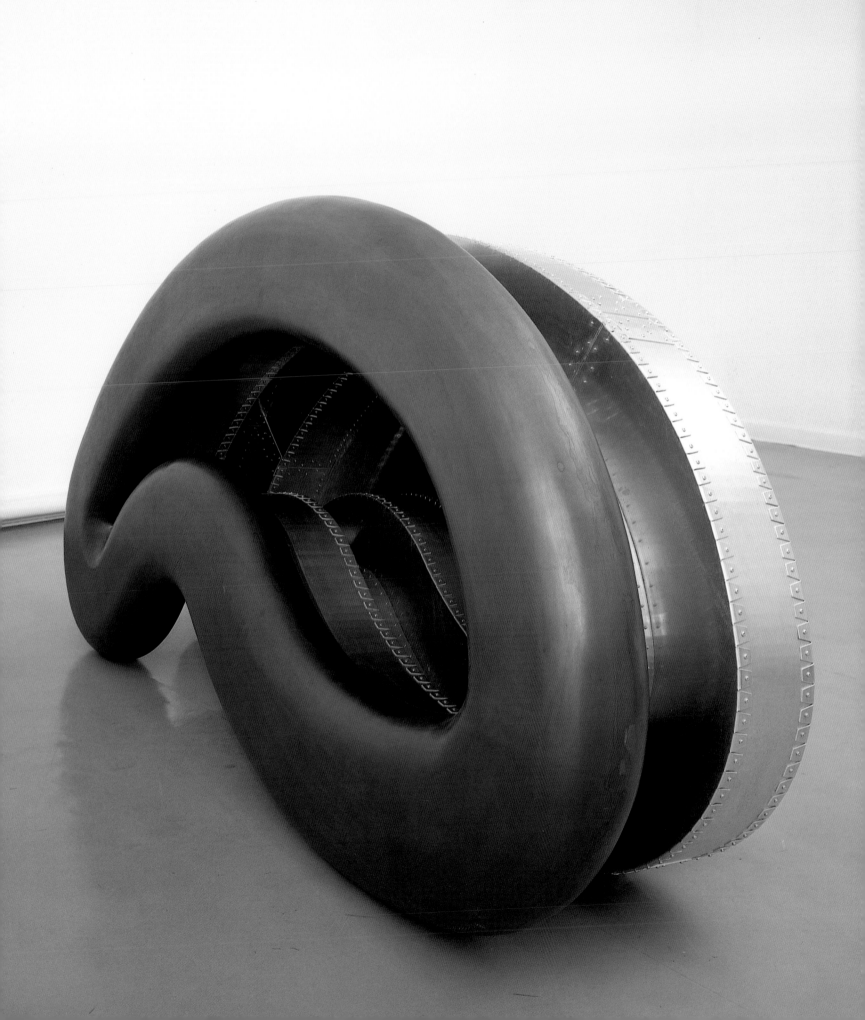

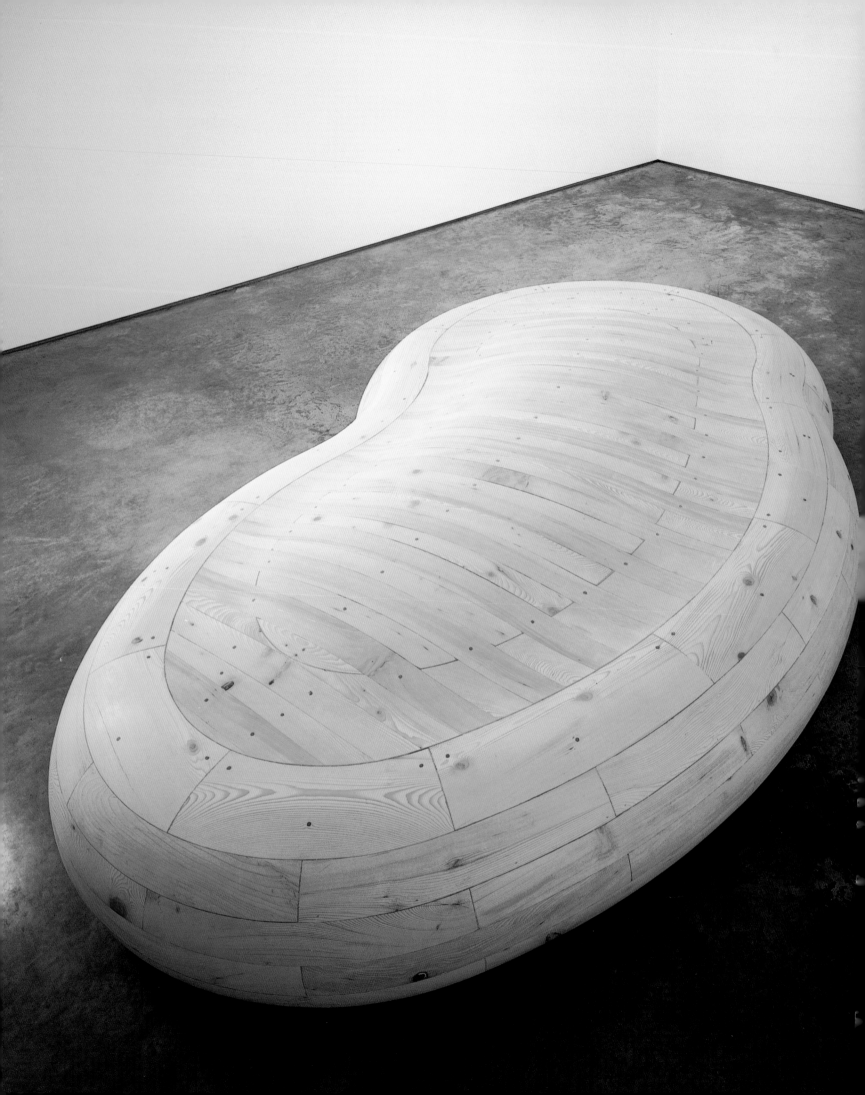

my
2
d
311 × 178 cm
ection, Auckland City Art
ery, New Zealand

identity of the object as a work of art is first negotiated in the gap which opens up between the two. The play between 'inside' and 'outside', so characteristic of Deacon's work in as far as it asks a fundamental question about the efficacy of language to deal with all aspects of our experiencing works of art, tends to function as another, similar kind of alterity. This time it is inescapably an alternating movement between 'being' and 'other': between the eroticized, undifferentiated site of desire – the 'before', if you like, the desire has been put into words – and the social world as it is shaped by and through the intricate play of different languages. Surface detail, the skin and the metaphorizing of the sculpture as body allows for an outwardly inflected reading as well as an inwardly inflected one. The former, by its nature, is highly conventionalized. It is a reading, embedded in context and subject to the normative experiences which context offers. In this sense it serves chiefly to reinforce the notion of sculpture as a public transaction. The latter, the inwardly inflected state of reading, is emptied of customary meanings; it yields up no comfortable assumptions about world, self, or other. Reading occurs in an anachronic space in which the only consistency is an inconstant self and the welter of desires which self represents. But it is important to emphasize that these two types of identification are experienced as an alterity and not as an opposition. Levinas' formulation, 'being-in-one's-skin, having-the-other-in-one's-skin', describes a two-way passage between 'inside' and 'outside'; one that allows for an inner experience of an outwardly apprehended 'other', and conversely, allows us to project the intimate experience of 'being in and by oneself' into some 'other thing' situated in the outside world. This process of exchange is the root and ground of the work of art's autonomy.

While this pressing duality might be described as 'trans-physical', it need not necessarily amount to something 'metaphysical'. Certainly it does not depend upon the transcendent notion of 'being' of the kind that we find described in the opening stanzas of Rilke's *Sonnets to Orpheus*. But it does pose a radical question to the exclusive definition of the work of art, which makes it out to be constructed entirely from within bounds set by socially constitutive languages. Indeed, it suggests that there is a relational aspect to our apprehension of things which precedes language both as a system and sign – in other words in the Barthian sense. If we are to take Barthes' idea of the 'music of meaning' seriously, then it can only be seen as something that we all carry with us as part of our baggage as sensible subjects. Meaning must then be 'caused', must arise out of desire, or, more precisely, out of the ontological joining of 'being' with language as it is first manifest in desire. Furthermore, the work of art must find its point of origin in this triangular constellation. It must speak on its behalf more or less directly and by doing so establish its absolute difference to all other 'manufactured' things.

Paradoxically, this idea that there is something in the presence of a work of art which stands in a problematic relation to the routine constructions of everyday language is signalled most clearly in the way in which Deacon uses titles. He chooses phrases which themselves are

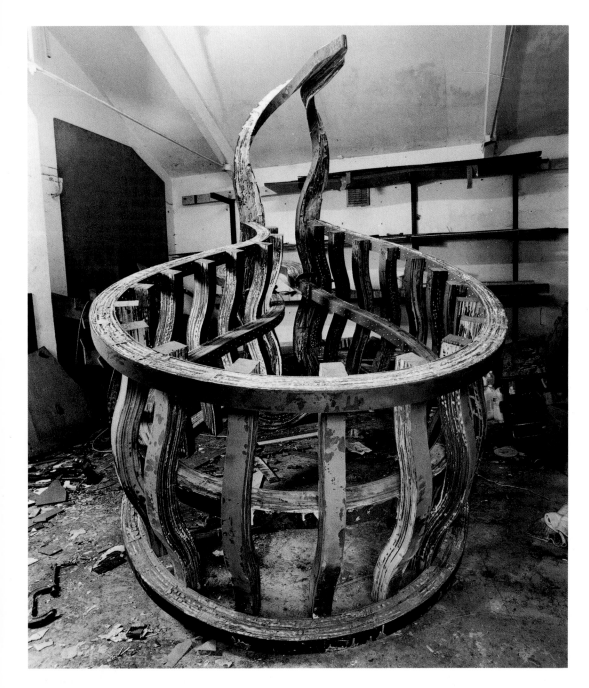

Fish Out of Water
1986-87
Laminated hardboard
245 × 350 × 190 cm
Collection, Hirshhorn Museum a
Sculpture Garden, Washington D

possessed of a high degree of autonomy – verbal asides, figures of speech, vernacular usages – which are immediately recognizable and have an independent, almost closed identity. Deacon's titles tend to produce a quality of silence around themselves. Almost they turn written language against itself through the deployment of a whole battery of closure devices: a rapid and irreversible slide from word into image (*Nose to Nose*); the use of onomatopoeia (*Struck Dumb*, *Double Talk*); tautological doubling (*Feast for the Eye*); cryptic nomination (*Breed*); self-referencing (*What Could Make Me Feel This Way, The Back of My Hand*); contradiction between word and image (*Like a Snail*); and personal asides (*O.T., The Interior Is Always More Difficult J.H.*). Not only do these devices allow the titles to stand to one side of the sculptures they name, but they isolate them in language too. Rather than qualifying the works verbally they function more like an appendix, an addendum or a footnote. They are neither essential to the apprehension of the sculpture nor do they serve to complete its meaning. In fact they occupy a different conceptual space altogether. Once again Deacon seems to be refusing to wrap things up, refusing homogenization. He is quite deliberately bringing things together and holding them apart at one and the same time. The conjoining of word with object is offered, but it must be negotiated by the viewer as a part of their engagement with the work: and this time the negotiation is between language and its 'other' – the 'before' of language – rather than one involving languages of different kinds.

Deacon's sculpture, then, works with two very different versions of autonomy. One, we might call

Kiss and Tell
1989
Epoxy, plywood, steel, timber
176 × 226 × 170 cm
Collection, Arts Council of Great
Britain, London

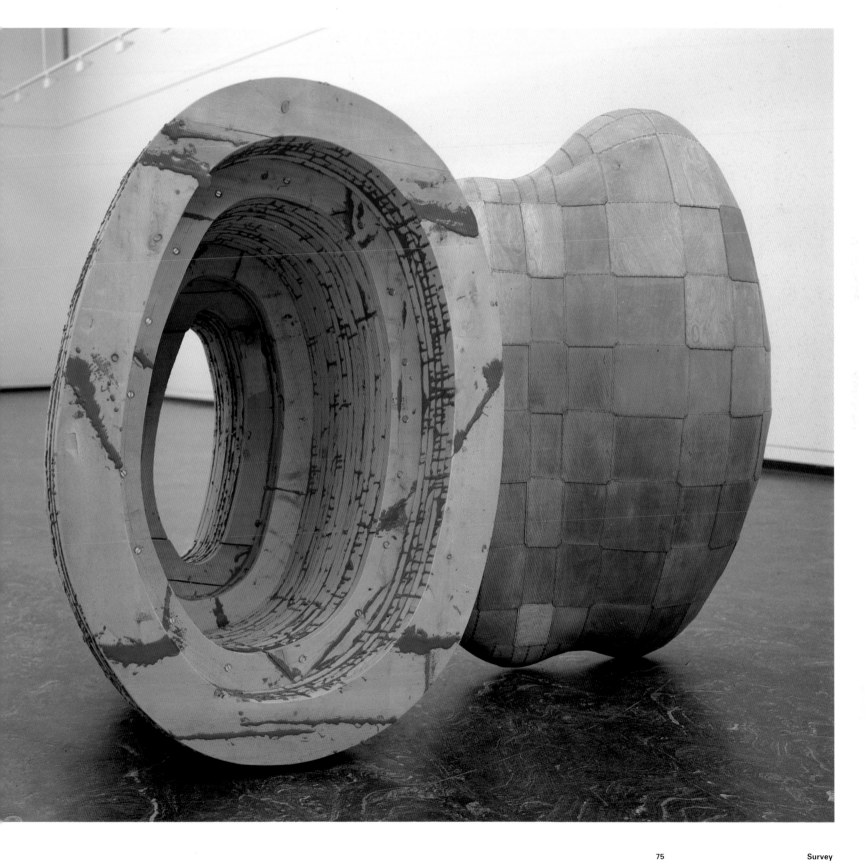

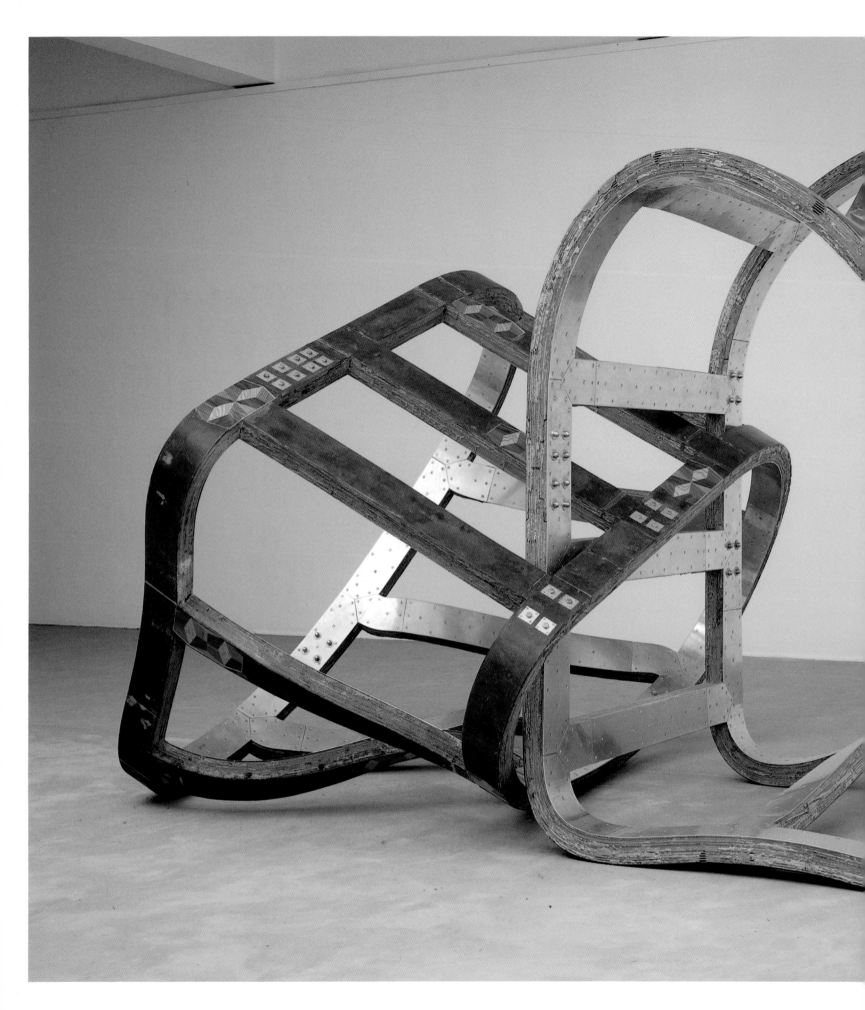

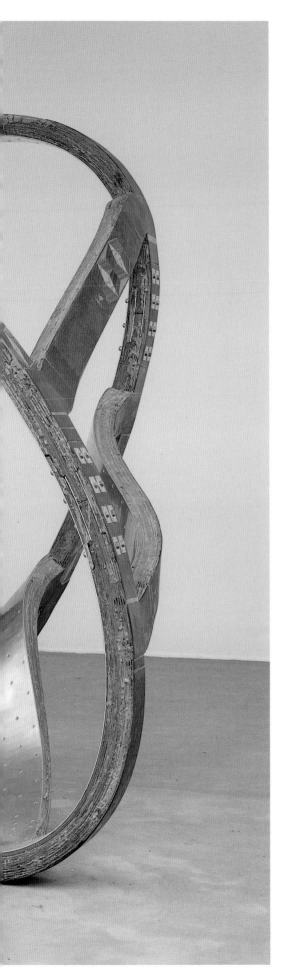

Lock
1990
Laminated hardboard, aluminium,
vinyl
242 × 382 × 301 cm
Collection, Weltkunst Foundation,
Zurich

'the autonomy of the Orphic head' and the other, demonstrated clearly in the way in which he attaches titles, we might describe as an erasure of the background noise of language. The first of these reveals itself through an attitude to forming which denies even the vestiges of the secure anchorage which, in its least disguised form, figured historically as the plinth. In most cases Deacon's sculptures consist of 'rolling' forms which are shown in particular configurations but which always carry with them the suggestion that they might have fallen to the ground differently. This quality is most apparent in a work like *Lock* made in 1990. But it is also present to some degree in the sculptures which are clearly built in relation to the ground-plane, of which *Border*, 1991, is a good example, or the more architectural *The Interior Is Always More Difficult G* first exhibited at the Lisson Gallery in 1992. In both cases the turning of the base-edge of the work proposes an independence or even a separation from the ground which is entirely opposite to the causal, gravitational relationship which governs most sculpture. The second form of autonomy is one of nomination: privileging certain carefully selected words or phrases in such a way as to detach them from customary patterns of language and usage, thereby creating a 'meaningful' silence around them which allows them to be floated across the gap between language and object. The initial separation in both of these strategies occurs in relation to context. One gives the sculpture as object something of the character of an event, the surprising nature of which subsists in its sense of something having just occurred in this place and no other. The other – the

The Back of My Hand No 5
1986
Galvanized steel, mixed media
250 × 150 × 20 cm

The Interior Is Always More Difficult G
1992
Aluminium, polycarbonate
239 × 350 × 50 cm

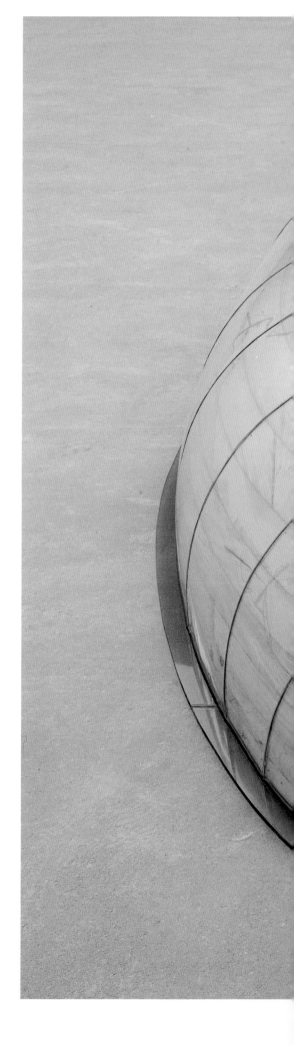

Border
1991
Wood, welded PVC
48 × 335 × 171 cm
Collection, Fonds National d'Art
Contemporain, Paris

nominative – casts the sculpture as an emergence,
a coming into focus as a bearer of specific meaning,
detached from the general flux of meaning given
by language.

This insistence upon the play between the
sculpture as object and name, and context as an
interactive social space, sets Deacon very much
apart from the rest of the sculptors of his own
generation. Most especially it has provided him
with real social and philosophical grounds for
intervening in the public space and the large-scale.
Publicly commissioned works like *Nose to Nose,
Beginning to End* made for the Glasgow Garden
Festival in 1988, and *Moor*, 1990 commissioned for
the Victoria Park bridge Plymouth, as part of the
'New Work for Different Places: Four Cities' project,
take the idea of public sculpture far beyond that of
the decorative addition to plaza architecture.

Deacon's public works function as a real and
highly provocative intervention in relationship both
to architecture and landscape. They are not easy
on the eye, neither do they carry the affirmation
of the monument. They tend to focus more upon
issues arising out of the context itself, to function
contrapuntally in relationship to factors like social
dereliction and urban decay.

Deacon has been described as the inheritor
of the tradition of British sculpture represented
historically by Barbara Hepworth and Henry
Moore, and his increasing involvement in public
commissions has contributed to this attribution.
But we can see from what has gone before that
this connection is at best superficial and at worst
downright misleading. His work stands very much
apart from the tradition of high abstraction

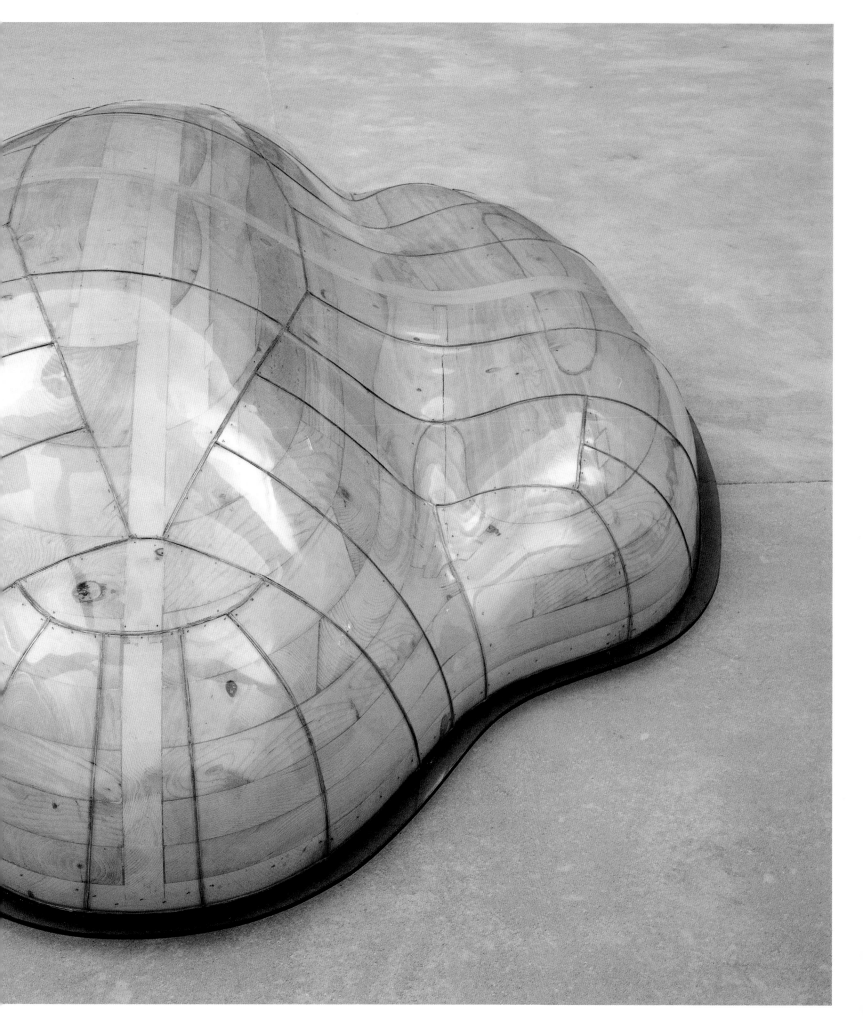

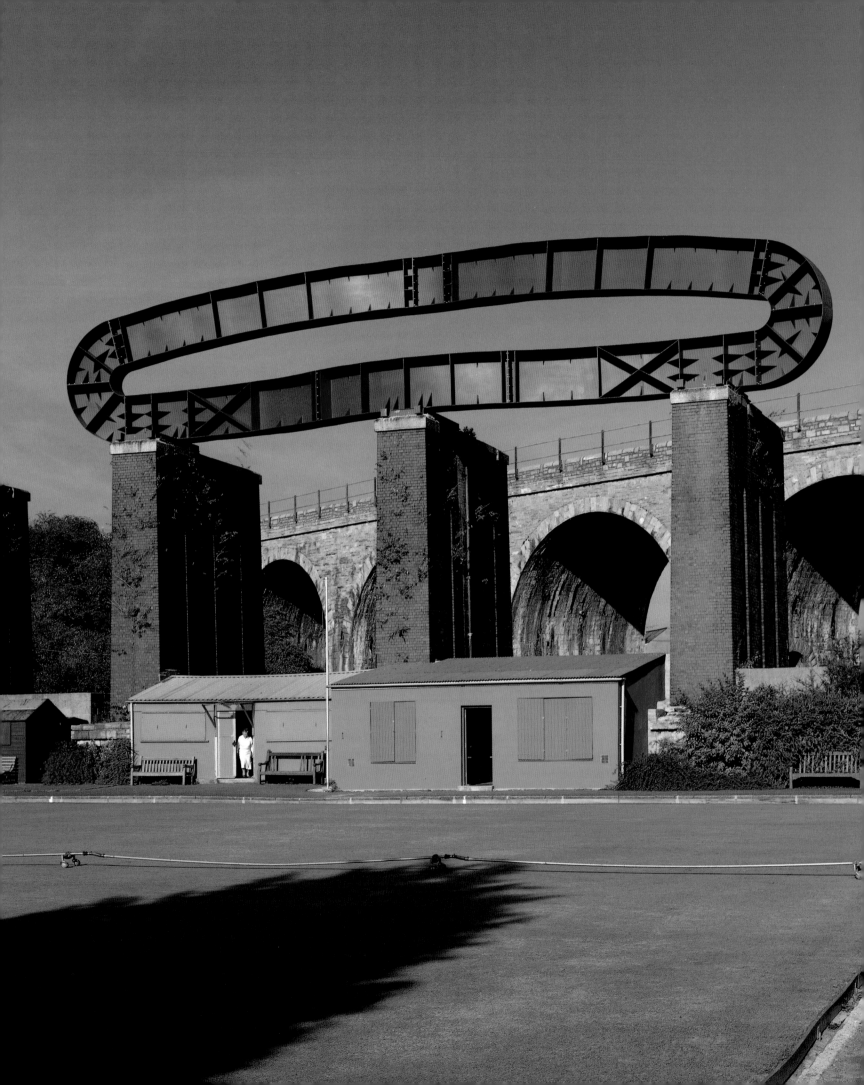

or
0
nted mild steel
× 247.5 × 350 cm
mmissioned for TSWA Four Cities
ject
talled, Victoria Park, Plymouth

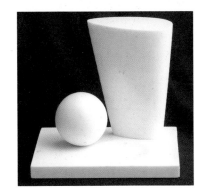

far left, **Naum Gabo**
Spiral Theme (Penetrated Version)
1937-40
Bronze
Collection, Tate Gallery, London

left, **Barbara Hepworth**
Conoid, Sphere and Hollow II
1937
Marble

espoused by Hepworth, and in radical opposition to the 'picturesque', nature-focused abstraction we associate with Moore. If there is a link to be made, it is best negotiated through the influence on British sculpture of the constructivist Naum Gabo. Like Deacon, Gabo was interested in a wide range of different discourses bridging the gap between art and science: philosophy; mathematics; architecture; design; and most especially advances in the social and natural sciences. And these interests helped shape the conceptual ground as well as the material look of his work. Like Deacon also, there is a clear dialectic of contrasting languages at work in Gabo's objects linking the poetic with the technical: a very refined 'sensual' side to the work and a more rigorous 'hard' side. In this respect, a sculpture like *Spiral Theme (Penetrated Variation)*, 1937-40, worked on by Gabo over a three year period, in its attitude to the making of sculptural form and by the way in which Gabo opens up the centre of the form bears some comparison with a Deacon work like *Body of*

Thought, 1988, or with *Under My Skin* made in 1990. Gabo's *Red Stone*, 1964-65 seems to share some of the sculptural concerns addressed by Deacon in works like *Skirt*, 1989, and *Coat*, 1990. There are some grounds for connecting him with the constructive lineage of modern sculpture as it is represented by a figure like Gabo – certainly Deacon would identify closely with Gabo's much quoted dictum, 'the images man constructs determine the shape of the universe about us'. Furthermore the early influence of artists like Phillip King and more especially William Tucker, who himself taught alongside the British constructivist Kenneth Martin at Goldsmith's College prior to his time at St. Martin's, might be seen as reinforcing this connection. However, we must be careful not to tie his work into it too directly. Constructivism is pre-eminently a part of the Modernist, scientific utopian view.

Deacon, on the other hand, is quintessentially the Postmodern artist. He belongs to no tendency or movement. He shares no stylistic concerns even

Nose to Nose, Beginning to End
1988
2 steel parts on concrete base
160 × 190 × 120 m
Installation, Glasgow Garden
Festival

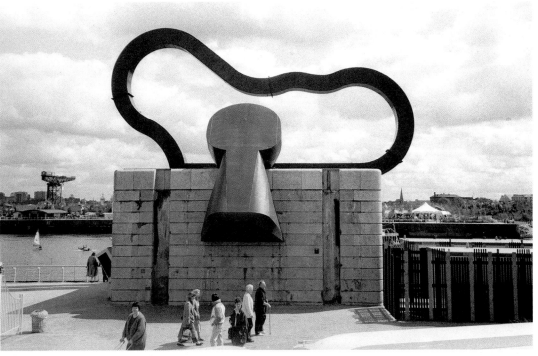

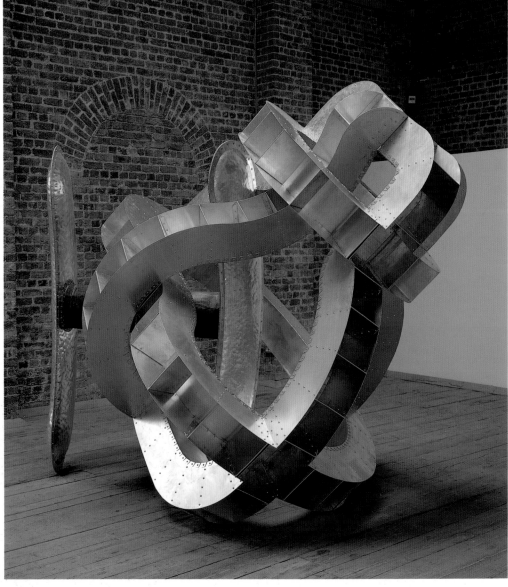

Body of Thought No 1 (detail)
1987-88
Aluminium, screws
280 × 864 × 419 cm

Body of Thought No 2
1988
Aluminium, cardboard, galvanised
steel, copper, rivets
248 × 300 × 258 cm
Collection, Museum van
Hedendaagse Kunst, Antwerp

with the British sculptors of his own generation: Tony Cragg, Anish Kapoor, Bill Woodrow, Richard Wentworth and the rest. It is intrinsic to the condition of Postmodernity that artists, freed from the progressive, programmatic aspect of Modernism, are at liberty to choose their own style. Nowhere was this freedom of choice more clearly demonstrated than at the re-opening of the Middelheim sculpture park in Antwerp, when Deacon was shown alongside five other European sculptors who, with the exception of the Belgian artist Panamarenko, were of his own generation: the Spanish sculptor Juan Muñoz; the Germans Harald Klingelholler and Thomas Schütte, and the Danish painter and sculptor Per Kirkeby. At the level of content there were connections to be made. For example, Deacon might be said to share an interest in the interface between technology and the natural sciences with Panamarenko; a concern for language with Klingelhöller and Schütte; an interest in architecture with Kirkeby; an intention to activate social space with Schütte and Muñoz. But these shared interests manifest themselves in radically different sculptural forms. There is no evidence of a collegiate working method or sculptural style. There is no over-arching idea about what art or more particularly sculpture should be or looks like. The climate of ideas he inhabits is very much after structuralism and after what has been called 'the linguistic turn' in modern philosophy. If he were to believe in utopia at all, it would most likely be a utopia of the Barthian kind, a utopia of discourse. If he were to permit himself to dream, it would be a Barthian dream in which the fragmentation which characterizes contemporary

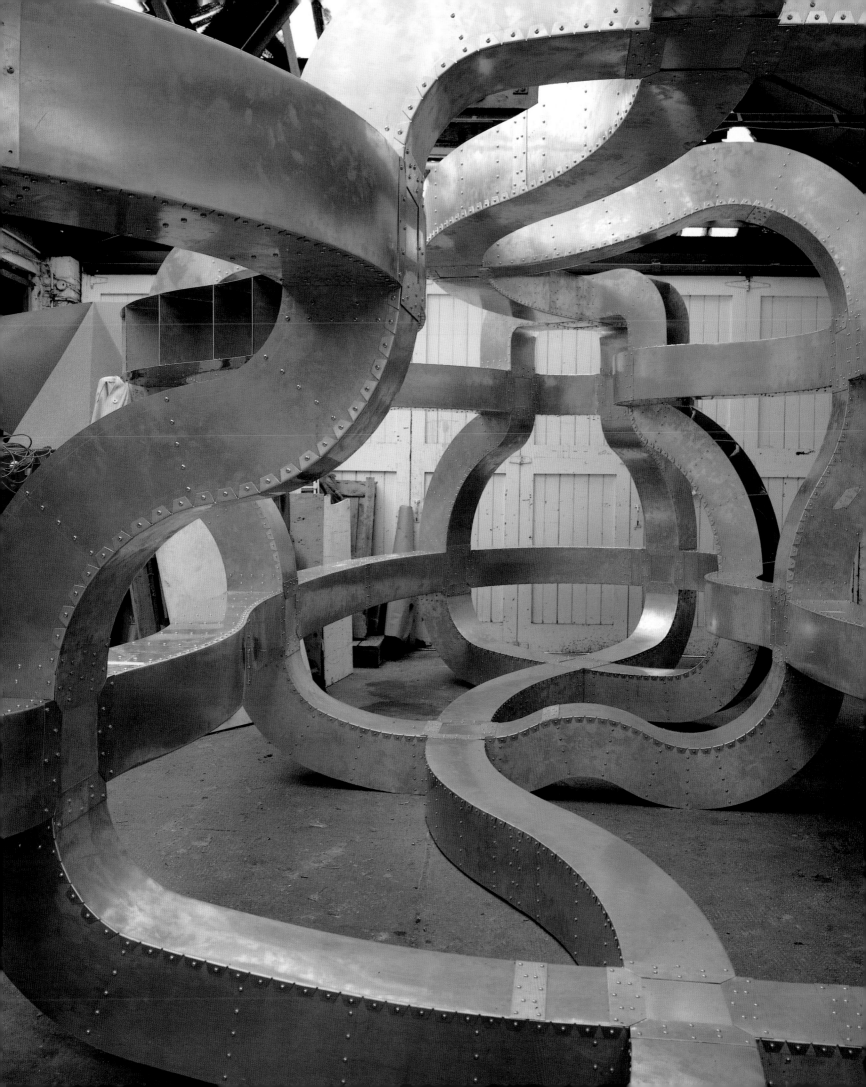

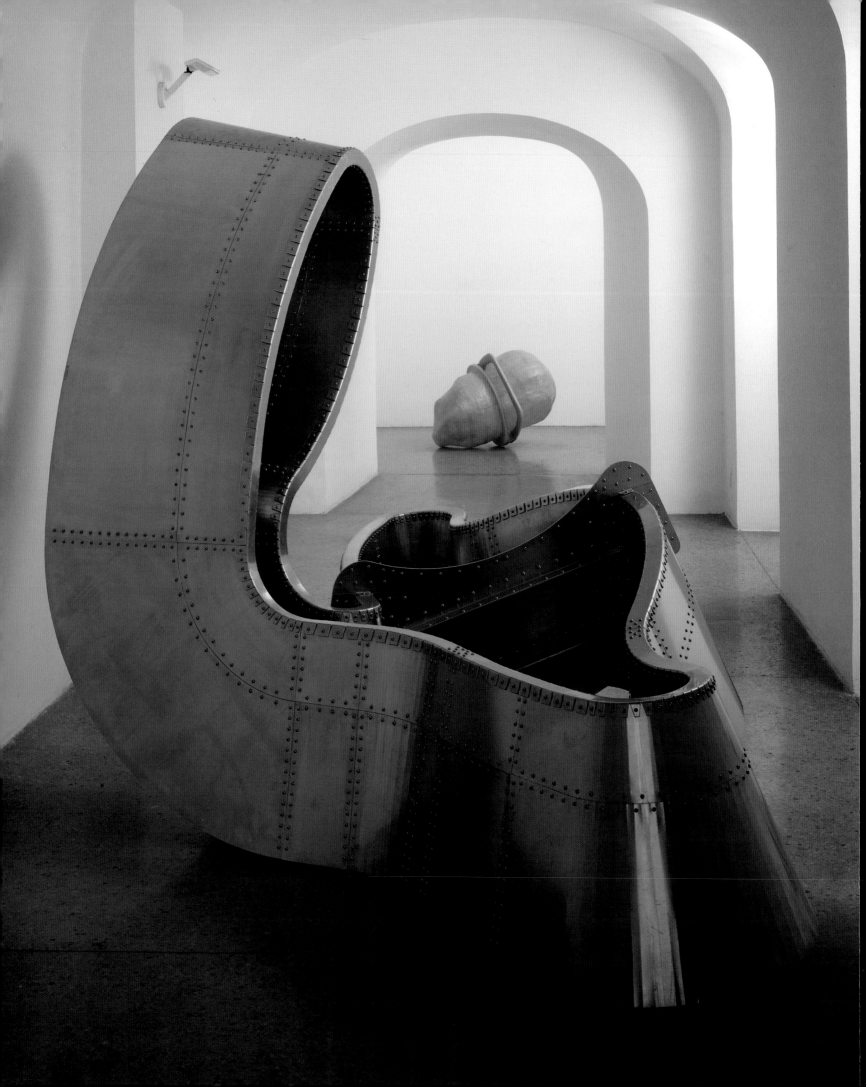

tallation, Galleria Locus Solus,
oa
0
ground, **Under My Skin**, 1990
kground, **Band of Gold**, 1990

Cover
1990
MDF, copper
182.8 × 335.2 × 122 cm
Collection, Akron Art Museum,
Ohio

below, **Thomas Schütte**
Casino
1990
Wood, acrylic, 25 gouache on
paper drawings
Table, 172 × 172 × 102 cm
Casino, 122 × 110 × 100 cm
Gouache drawings,
50 × 65 cm each

bottom, **Harald Klingelhöller**
Die Furcht verläßt ihren
Gegenstand und geht über in Hass
(Fear Leaves Its Object and Turns
into Hate)
1993
Installed, Open-Air Museum of
Sculpture Middelheim

culture would be dissolved into a unifying play of language. More importantly, in the more specialized context of contemporary art, Deacon is very much a post-Minimal artist – using the term literally rather than art historically – throughout his writings he casts his work in a critical relationship to artists like Carl Andre and Donald Judd. In some respects he sees himself working to correct some of the reductive errors of Minimalism, especially with regard to its formal strictures and its endemic 'materialism'.

But Deacon's contribution to contemporary sculpture goes a great deal further than can be summed up by reference to a slender thread of art historical argument. As we have seen he is first and foremost a thinking artist who is determined to keep a lot of difficult historical, social and theoretical issues in play. He wishes to hold onto the notion of sculpture as an exemplary practice given to him out of its tradition and its history, but he wants at the same time to maintain it as a strong site for innovation. He sees it as part of his responsibility as an artist to connect his practice to the 'horizontal culture'[26], rather than being content to sit comfortably within the protective fold of a privileged discourse. Before all else he wants to take account of the post-critical debate without losing the sculpture as object to the shifting sands of fashionable discursive practices.

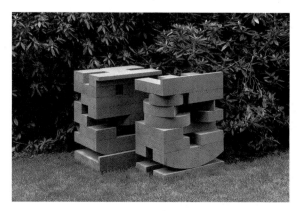

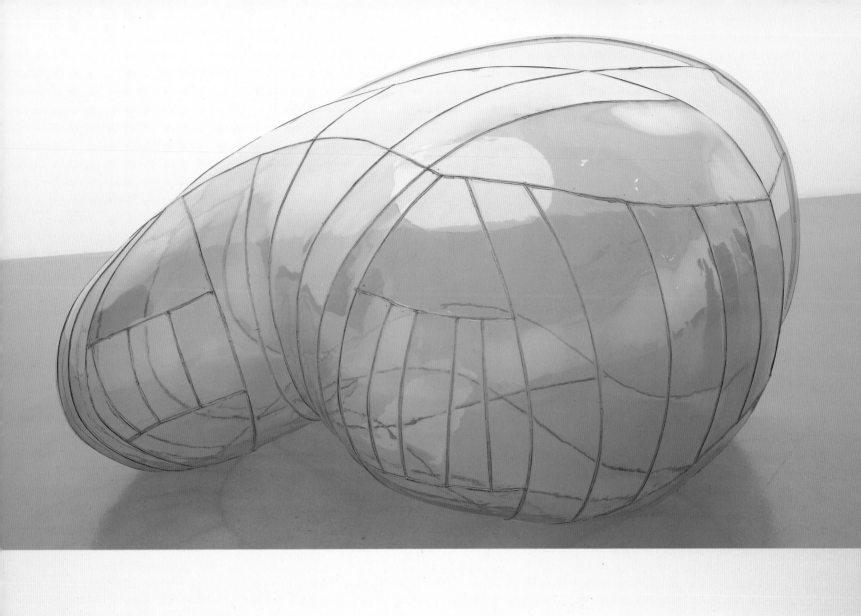

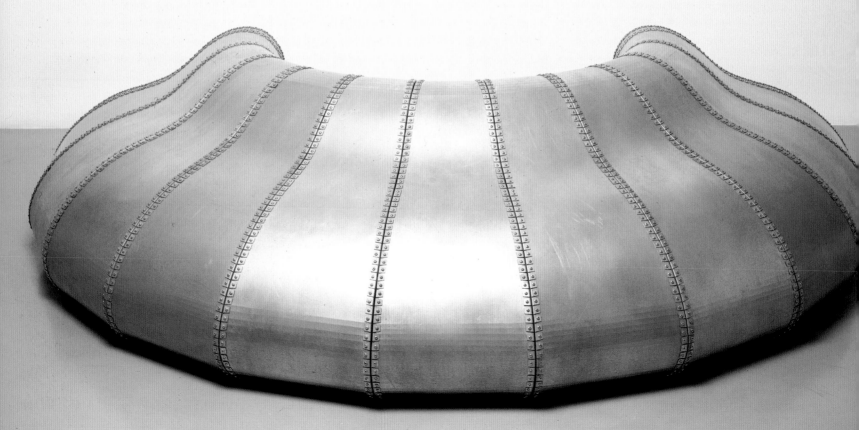

ed plastic
× 213.3 × 182.8 cm

1 Roland Barthes, *The Rustle of Language*, Basil Blackwell, Oxford, 1986, title essay

2 Richard Deacon, Kunstverein Hannover, 1993. Catalogue appended Workbiography

3 Ibid

4 Ibid

5 Ludwig Wittgenstein, *Philosophical Investigations*, Basil Blackwell, Oxford, 1962

6 Roland Barthes, *Collected Papers*, University of Leiden, 1969

7 Lynne Cooke, *Richard Deacon*, catalogue essay, Whitechapel Art Gallery, London, 1988

8 Charles Altieri, 'The Dilemma of Modernity', conference paper, unpublished, University of Michigan, 1993

9 Marjetica Potrc, 'Interview', *M'ARS*, Ljubljana, Vol 2, No 4, 1990

10 Rainer Maria Rilke, *Selected Works* Vol 2, Trans. J.B. Leishman, Hogarth Press, London, 1980

11 *Richard Deacon*, Kunstverein Hannover, 1993

12 I was teaching at St. Martin's at the time and these are examples of the books that were passed around amongst the staff as well as the students.

13 *Richard Deacon*, Kunstverein Hannover, 1993

14 Ibid

15 Georg Wilhelm Friedrich Hegel, *Phenomenology of Spirit*, Trans. A. V. Miller, Oxford University Press, 1977

16 Stephen Mellville, *Philosophy Beside Itself*, Manchester University Press, 1986

17 Confirmed in a conversation with Richard Deacon

18 Martin Heidegger, *Poetry, Language, Thought*, Trans. A. Hofstadter Harper and Row, London, 1970

19 Ludwig Wittgenstein, *Zettel*, Basil Blackwell, Oxford, 1967

20 *Richard Deacon*, Kunstverein Hannover, 1993

21 Ibid

22 Immanuel Levinas, *The Levinas Reader*, Edit. S. Hand, essay 'Time and Other', Basil Blackwell, Oxford, 1989

23 *Richard Deacon*, Kunstverein Hannover, 1993

24 Ibid

25 Lynne Cooke, *Richard Deacon*, op. cit.

26 The term 'horizontal' culture used by the Italian political philosopher, Vincenzo Sparagna. It means the ground of social life as opposed to the mechanisms of cultural validation which he describes as 'vertical'.

Three Small Works
1990
Epoxy coated paper, steel tea tray

t
9
anized steel
353 × 185 cm
ection, Fundacion Caixa de
siones, Barcelona

Contents

Interview Pier Luigi Tazzi in conversation with Richard Deacon, page 6. Survey Jon Thompson

Thinking Richard Deacon, Thinking Sculptor, Thinking, Sculpture, page 38. Focus Peter Schjeldahl Deacon's Faith,

page 88. Artist's Choice Mary Douglas Purity and Danger, 1966, page 98. Artist's

Writings Richard Deacon Selections from Stuff Box Object, 1971-72, page 110. Artist's Statement, 1982, page 114.

Silence, Exile, Cunning, 1986-88, page 116. What Car? Correspondence with Lynne Cooke, 1992, page 120. What You See Is What

You Get, 1992, page 132. Design for Replacing, 1987, page 138. Design for Factory, 1993, page 139. Reading: A Project de Tom,

Grand, 1993, page 140. In Praise of Television, 1996-97, page 144. Interview with Ian Tromp, 1999, page 158.

Update Penelope Curtis The Interior is Always More Difficult, page 168. Chronology

page 192 & Bibliography, List of Illustrations, page 209.

'What's that, then? Is it ducting?' one man said to another in London in 1985. The questionable object was a metal sculpture that Richard Deacon was assembling outside the Serpentine Gallery. 'Nah,' the other man answered, 'it's art. Look at the way it's put together.'

Deacon told me happily of the overheard conversation. I used it in another essay I wrote about his work. Now having agreed to discuss a single piece of Deacon's – I have selected *Keeping the Faith* – I think again of a casual exchange that touches the heart of his sculptural poetic.

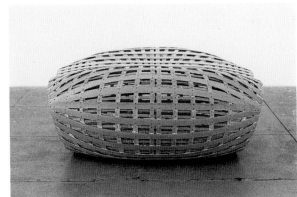

Keeping the Faith
1992
Beechwood, epoxy
75 × 175 × 170 cm

'What's this, then? A bunch of lattice?'

'Must be a form for something.'

'Looks like a jet engine.'

'A squashed sort of one.'

'It's not finished, whatever it is.'

'Can't be. Wants cladding.'

My imaginary flâneurs are less canny than Deacon's real ones. 'Art' is not an explanation that occurs to them. I made sure of it so I could hear them out.

Keeping the Faith (it is often wise to postpone contemplating Deacon's subtle titles, which reward rather than direct attentive looking) is a bentwood framework riddled with holes left by the screws that held it together for gluing. Its form is symmetrical on the left-right axes of its length and breadth while asymmetrical on the up-down axis of its height, which thus feels distorted ('squashed'). It does not look like a finished thing, but rather like the completed phase of a fabrication process.

The nearest word for the work's type of form is 'pod'. Viewed from the side, it might well evoke a jet engine – or a Janus-headed fish of the bottom-feeding variety that has an underslung mouth or a Janus-hooded racing car with an air-scoop grill. Wrecking these associations is the odd hump in the middle of its bottom. I can't relate this eruption to anything imaginably functional.

The crease along the top and the hump in the bottom of the piece make sense together if you picture a small symmetrical pod in some pliable material, such as clay, grasped evenly with the fingertips of both hands and squeezed. Your fingers would make the crease, your thumbs the hump. To think of this while looking at the sculpture is to

Keeping the Faith
1992

trigger a scale shift, summoning the fantasy of a King Kong-sized manipulator.

Viewed from either end, the work presents the graphic outline of an oval pinched in the middle, a shape with a biological or caricatural air: a diagram of cells separating or the mouth of a comic-strip character crying 'Waaah!' Also suggested is a figure eight or the infinity sign. Anyone looking at photographs of *Keeping the Faith* might deem such graphic resemblances primary. But they are the last aspects one notes in the structure's actual presence, where the bent maple slats and oozing yellowish glue exert an imperious matter-of-factness.

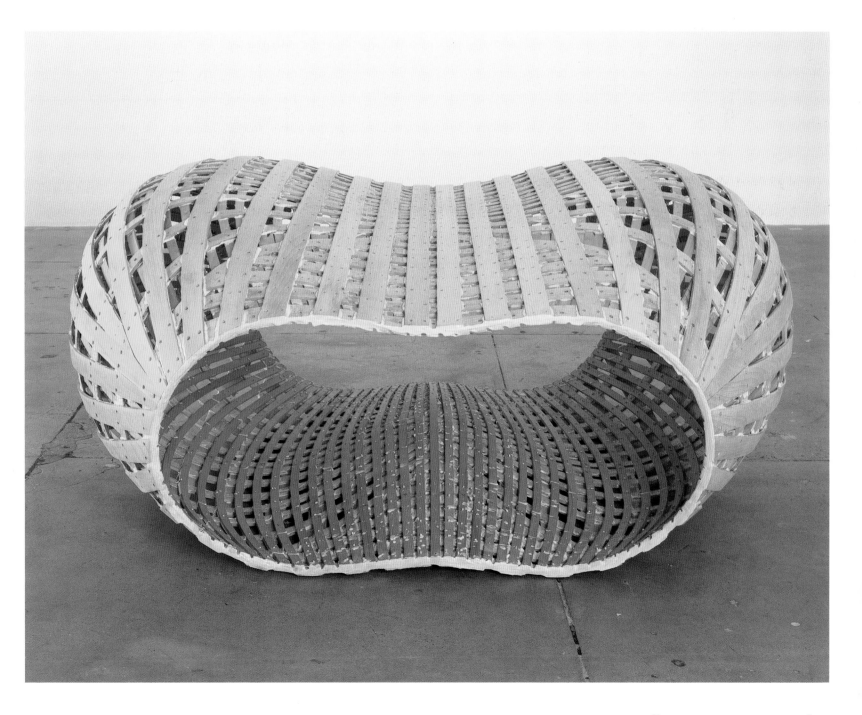

As a framework, the piece might seem to anticipate a completed hollow object that is either solid-walled (if a mold were the next, still transitional stage) or clad in form-fitting sheets of anything from riveted metal to kite paper. It is impossible that the pod could become a merely component part of some other form or that any additions to it (on the outside, at least) would significantly alter its shape. You would not go to the trouble of perfecting those streamlined contours and then jam something else onto them.

The making of *Keeping the Faith*'s unknowable object has halted at the framework stage where any fabrication yields the maximum of information about itself. Think of a house that is under construction, when everything is in place except wallboard and siding. What you see is the total quiddity of 'house' minus the idea of what it is for: habitation. The next phase of work will humiliate the structure into amenity.

Before concentrating on the sculpture's literal makeup, I return to its evocation of a jet engine or a racing car, as something to keep in mind. The form says *whoosh*. It looks like a product of exhaustive testing in a wind tunnel. Justifying its immobility is just its Janus-facedness, incurring stalemate by trying to zoom off in opposite directions simultaneously. To marry itself to speed seems the work's narcissistic fixation. (Everything Deacon makes can seem self-obsessively preoccupied with some action or other that it is somehow prevented from performing.)

I am moved – ravished, really – by the sculpture's extravagant investment of exacting toil in the execution of a design that had to be smackdab perfect in advance. Did Deacon work the form out on a computer? I can picture webbed traceries of pixel light rotating this way and that on a screen, adjusted by the hummingbird of a cursor. Whatever the process, one stage of it was necessarily a set of terrifically precise plans and measurements that presumed extreme technical knowhow and discipline. This thought lends a complicated poignance.

What do we require physically of any sculpture, beyond that it not spontaneously fall apart? It seems to me an article of sophisticated taste, tested in the experimental history of modern art, that the minimum criterion of sturdiness and elaboration in an artwork should be close to identical with the maximum criterion. That is, we view excessive craftsmanship in art as a vulgarity fully as distracting as shoddiness. An artwork should be made exactly and only as well as it must be for its idea to be realized.

Deacon has violated this principle relentlessly. Indeed, a powerful impression of over-the-top craftsmanship is a keynote of his poetic – of the Deaconian. It amounts to an original sculptural diction that is both formally impressive and comical, like an Armani suit on a horse. Elsewhere I have called this quality of Deacon's art 'the tone of labour'. It is a high tone, a toniness, a showy expenditure, and yet innocent of pretension. The labour is of an old-fashioned, artisanal, small-industrial-shop kind, and its motive feels earnest rather than gratuitous. It conveys a certain anxiety, as if afrighted by visions of probably physical ordeals in a world less considerate of art that we assume ours to be.

There are hundreds of screw holes. (Where are those proletarian screws today? Have they moved on to serve other projects, or have they joined the reserve army of the unemployed?) There is a profligate amount of glue, bleeding from the joints and buttered around the edges of the two ends (making those edges read as 'lips'). (You know that the sculpture is right-side-up, by the way, by observing the glops and speckles of glue that fell on the interior humped expanse.) And the slats!

They are beautiful forms in themselves, some of the slats that must bend severely in both longitude and latitude to follow the overall contour. If you could hold just one of these in your hands, knowing nothing else about the sculpture, you would have an accurate sense of the strength, precision and grace of the object it was engineered to be part of. Deacon's use of the slats' thin, naked maple celebrates the talent and, when in skilled and respectful hands, the eager obligingness of wood.

There are three layers of slats: forty wide ones running lengthwise outside, a lesser number of somewhat narrower ones hugging the circumference underneath, and about a hundred rib-like ones, narrower still, forming the inner wall. The strength of the crisscross, which gathers into an hourglass-shaped mesh from end to end across the top, is obviously

formidable. (Basketry is not evoked, by the way: no interweaving.) Assuming that the glue is sufficiently tenacious, nothing at all should happen if you jump on the sculpture. (Don't, though.)

Keeping the Faith crouches low to the floor, coming up to just above knee level. This disposition feels vaguely aggressive, as if the thing considered biting you in the ankle. But the threat is never imminent. The form looks more aggressive – more whooshy and tigerish – the farther from it you are. It is energized by distance. Up close, as you look down at it, it may suggest a surreally gawky item of furniture, a funhouse coffee table, if it suggests anything. More likely, you will be lost in contemplating details of the construction – like brushstrokes when you step within the inner limit of a painting's pictorial illusion.

So there is a doubleness of aspect: what the form suggests and how the form is put together. Is such doubleness intrinsic to all and any art? Exactly. Its routine emphasis in Deacon's work helps to explain why he is a major artist. He renders dramatically specific in each art object things that are true of art objects generally. He brings to exacerbated consciousness at the same time idiosyncratic feeling and aesthetic phenomena. Major artists are philosophers of art. Deacon is a philosopher of art.

Where would you put *Keeping the Faith* if you owned it? It would hardly matter so long as the site afforded access to the work in the round. I have seen it in a gallery and in a warehouse. It looked identically fine and awkward in both places – fine because it engaged me in its protocols of meaning and awkward because it felt essentially oblivious to its surroundings, where it seemed less architecturally installed than parked and 'in the way'. I love all of Deacon's work for its reliable independence of the gestalts of institutional space. In any space, it seems to be on my side, to know how I feel, even to be like me: a citizen never quite comfortable in the world.

To commune most frankly with the sculpture, you will squat down as you do when conversing with a small child. At eye-level, the pinched-oval, wailing mouth confides its message in a rush. The message is the package of negative space, of nothingness, inside the two-chambered pod that may seem no longer shaped from without but swelled from within, like lungs or a bellows. The hump in the bottom may suddenly suggest an instrument of speech: a glottis. The glue-lipped mouth forms a syllable that means exactly so much space configured in just this way.

Some religious people speak of emotional emptiness as 'a God-shaped hole'. It is a lovely idea even if you don't believe it: that we contain spiritual cavities into which God fits like a key. I confess to knowing the empty feeling, an inner void – a core of nothing – that, lacking all sensation, can be more awful than pain. I take fleeting comfort in the God-shaped-hole metaphor, which redescribes the emptiness from an affliction to a capacity.

I am pretty sure of going beyond, in this, what Deacon had in mind for his sculpture, if indeed he had something in mind. Not 'to have in mind', passively, but 'to mind', actively, is what a good artist does, making through selfless concentration on the actual work an unprejudiced medium for the expression of whatever is there to be expressed in the artist's or viewer's unconscious, or in the air. But by choosing for his title the phrase 'keeping the faith', Deacon indicates that he notices something about his idea, and the associative process thus begun emboldens my interpretation.

In vernacular use, 'keep the faith' is an injunction to stay loyal to a value or a cause. It was popularized in the 1960s by an old-time Harlem politician, Adam Clayton Powell Jr., whose insolently loose morals, outraging the middle class, targeted him for destruction in government circles and the press. 'Keep the faith, baby', he would say, appealing to a constituency meant to understand his essential oneness with them beneath corrupt appearances. Powell's 'faith' was an invisible integrity.

So is any faith, defined as confidence in the reality of something rationally unprovable. *Keeping the Faith*, the sculpture, goes to tremendous trouble to form and to preserve – to keep – a strangely shaped quantity of air. The effort symbolizes the importance of keeping. Faith is not symbolized. It is a fact or it isn't, understood or not understood, meaningful or nonsensical. Its proposition does not brook argument. What you get from the sculpture is the sheer, mere urgency of something unseen. What your heart does with that is your heart's affair.

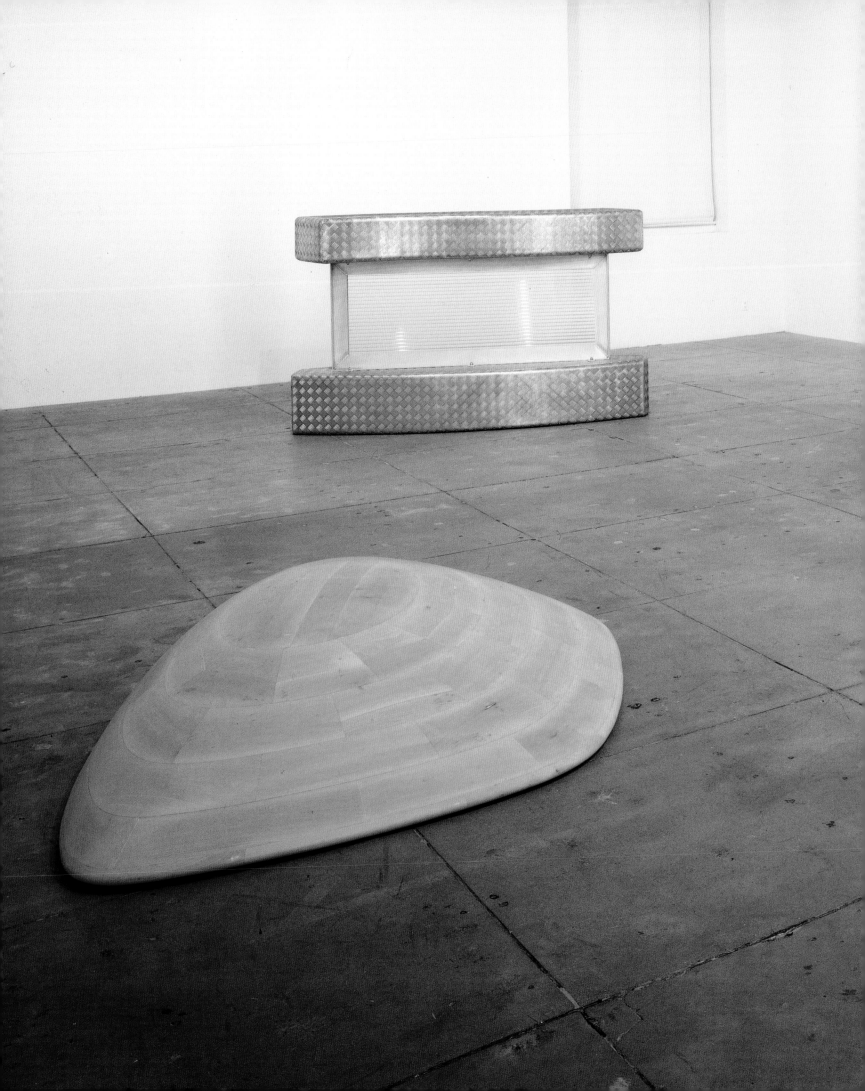

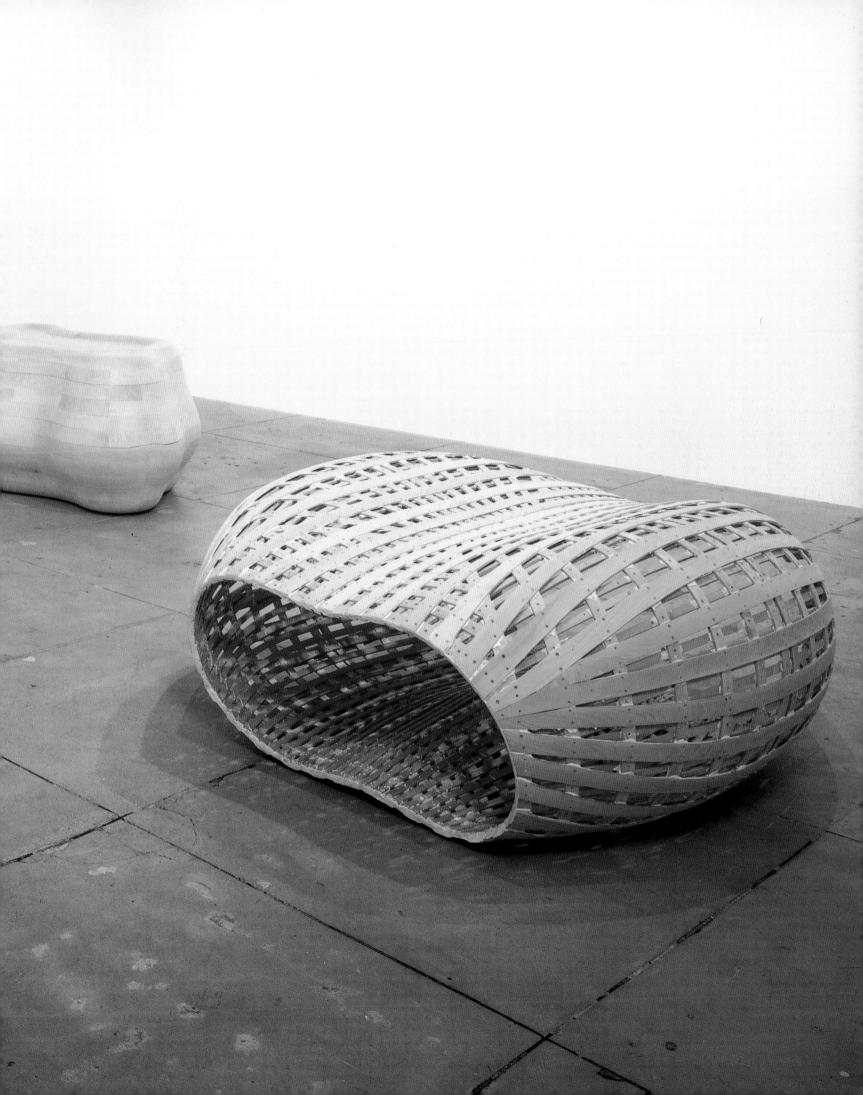

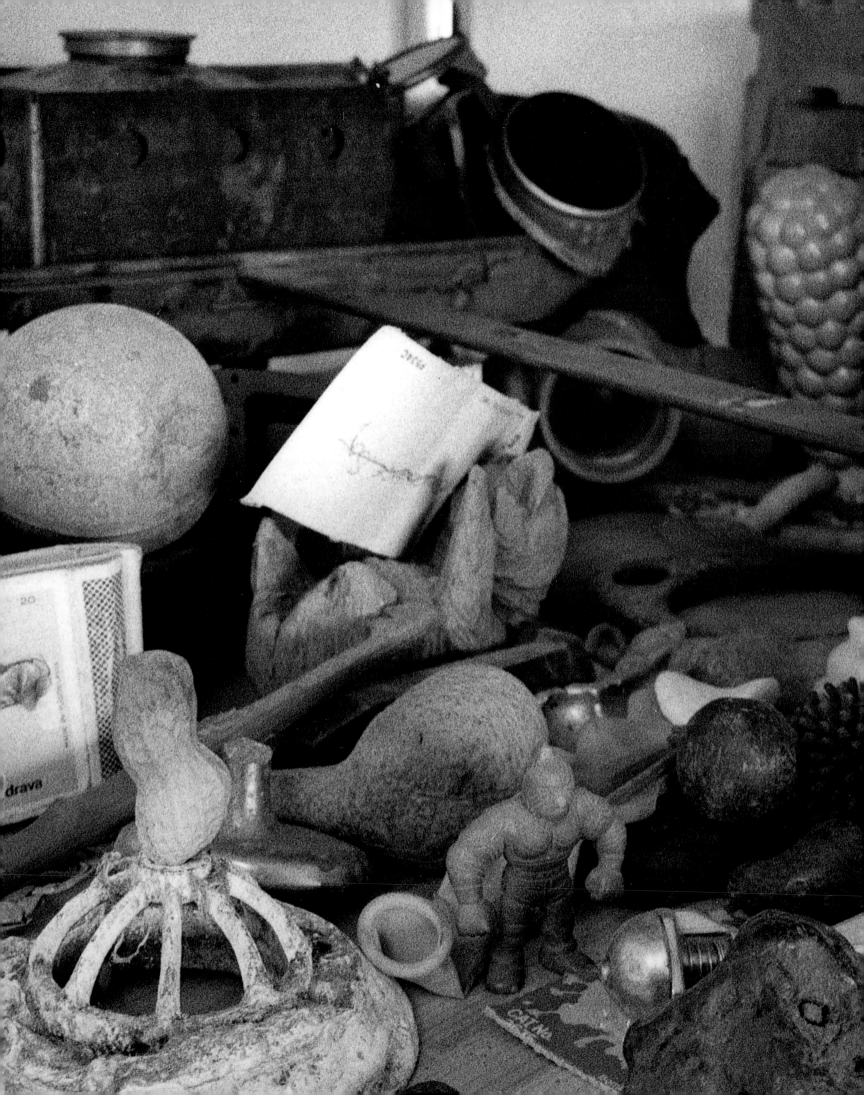

Contents

Interview Pier Luigi Tazzi in conversation with Richard Deacon, page 6. Survey Jon Thompson

Thinking Richard Deacon, Thinking Sculptor, Thinking Sculpture, page 36. Focus Peter Schjeldahl Deacon's Faith,

page 88. Artist's Choice Mary Douglas Purity and Danger, 1966, page 98. Artist's

Writings Richard Deacon Selections from Stuff Box Object, 1971-72, page 110. Artist's Statement, 1982, page 114.

Silence, Exile, Cunning, 1986-88, page 116. What Car? Correspondence with Lynne Cooke, 1992 page 120. What You See Is What

You Get, 1992, page 132. Design for Replacing, 1987, page 138. Design for Factory, 1993, page 139. Reading: A Propos de Toni

Grand, 1993, page 140. In Praise of Television, 1996–97, page 144. Interview with Ian Tromp, 1999, page 158.

Update Penelope Curtis The Interior is Always More Difficult, page 168. Chronology

page 192 & Bibliography, List of Illustrations, page 209.

Now to confront our opening question. Can there be any people who confound sacredness with uncleanness? We have seen how the idea of contagion is at work in religion and society. We have seen that powers are attributed to any structure of ideas, and that rules of avoidance make a visible public recognition of its boundaries. But this is not to say that the sacred is unclean. Each culture must have its own notions of dirt and defilement which are contrasted with its notions of the positive structure which must not be negated. To talk about a confused blending of the Sacred and the Unclean is outright nonsense. But it still remains true that religions often sacralize the very unclean things which have been rejected with abhorrence. We must, therefore, ask how dirt, which is normally destructive, sometimes becomes creative.

First, we note that not all unclean things are used constructively in ritual. It does not suffice for something to be unclean for it to be treated as potent for good. In Israel it was unthinkable that unclean things, such as corpses and excreta, could be incorporated into the Temple ritual, but only blood, and only blood shed in sacrifice. Among the Oyo Yoruba where the left hand is used for unclean work and it is deeply insulting to proffer the left hand, normal rituals sacralize the precedence of the right side, especially dancing to the right. But in the ritual of the great Ogboni cult initiates must knot their garments on the left side and dance only to the left (Morton-Williams, p. 369). Incest is a pollution among the Bushong, but an act of ritual incest is part of the sacralization of their king and he claims that he is the filth of the nation: '*Moi, ordure, nyec*' (Vansina, p. 103). And so on. Though it is only specific individuals on specified occasions who can break the rules, it is still important to ask why these dangerous contacts are often required in rituals.

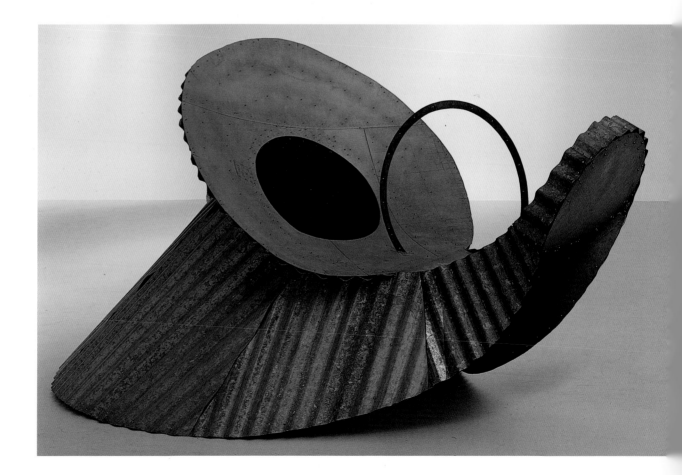

If the Shoe Fits
1981
Galvanized corrugated sheet
steel, screws
152 × 331 × 152 cm

Boys and Girls
1982
Linoleum, plywood
91.5 × 183 × 152.5 cm
Collection, The British Council,
London

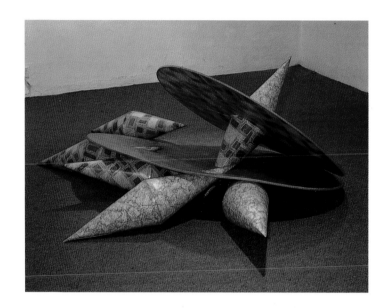

One answer lies in the nature of dirt itself. The other lies in the nature of metaphysical problems and of particular kinds of reflections which call for expression.

To deal with dirt first. In the course of any imposing of order, whether in the mind or in the external world, the attitude to rejected bits and pieces goes through two stages. First they are recognizably out of place, a threat to good order, and so are regarded as objectionable and vigorously brushed away. At this stage they have some identity: they can be seen to be unwanted bits of whatever it was they came from, hair or food or wrappings. This is the stage at which they are dangerous; their half-identity still clings to them and the clarity of the scene in which they obtrude is impaired by their presence. But a long process of pulverizing, dissolving and rotting awaits any physical things that have been recognized as dirt. In the end, all identity is gone. The origin of the various bits and pieces is lost and they have entered into the mass of common rubbish. It is unpleasant to poke about in the refuse to try to recover anything, for this revives identity. So long as identity is absent, rubbish is not dangerous. It does not even create ambiguous perceptions since it clearly belongs in a defined place, a rubbish heap of one kind or another. Even the bones of buried kings rouse little awe and the thought that the air is full of the dust of corpses of bygone races has no power to move. Where there is no differentiation there is no defilement.

> They outnumber the living, but where are all their bones?
> For every man alive there are a million dead,
> Has their dust gone into earth that it is never seen?
> There should be no air to breathe, with it so thick,
> No space for wind to blow or rain to fall:
> Earth should be a cloud of dust, a soil of bones,
> With no room even for our skeletons.
> It is wasted time to think of it, to count its grains.
> When all are alike and there is no difference in them.

S. Sitwell, *Agamemnon's Tomb*

In this final stage of total disintegration, dirt is utterly undifferentiated. Thus a cycle has been completed. Dirt was created by the differentiating activity of mind, it was a by-product of the creation of order. So it started from a state of non-differentiation; all through the process of differentiating its role was to threaten the distinctions made; finally it returns to its true indiscriminable character. Formlessness is therefore an apt symbol of beginning and of growth as it is of decay.

On this argument everything that is said to explain the revivifying role of water in religious symbolism can also apply to dirt:

> In water everything is 'dissolved', every 'form' is broken up, everything that has happened ceases to exist; nothing that was before remains after immersion in water, not an outline, not a 'sign', not an event. Immersion is the equivalent, at the human level, of death at the cosmic level, of the cataclysm (the Flood) which periodically dissolves the world into the primeval ocean. Breaking up all forms, doing away with the past, water possesses this power of purifying, of regenerating, of giving new birth ... Water purifies and regenerates because it nullifies the past, and restores – even if only for a moment – the integrity of the dawn of things

Eliade, 1958, p. 194

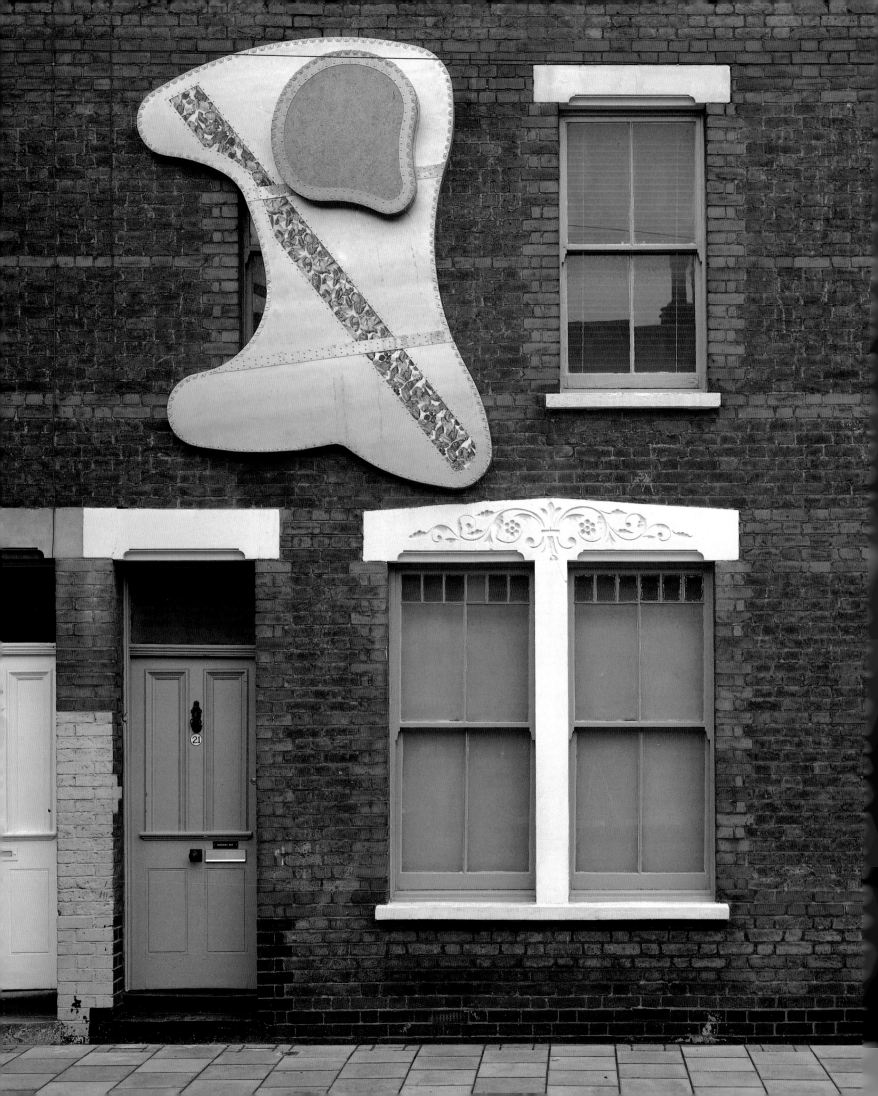

opposite, **The Back of My Hand**
No 1
1986
Galvanized steel, linoleum
366 × 244 × 46 cm
Installation, Interim Art, London

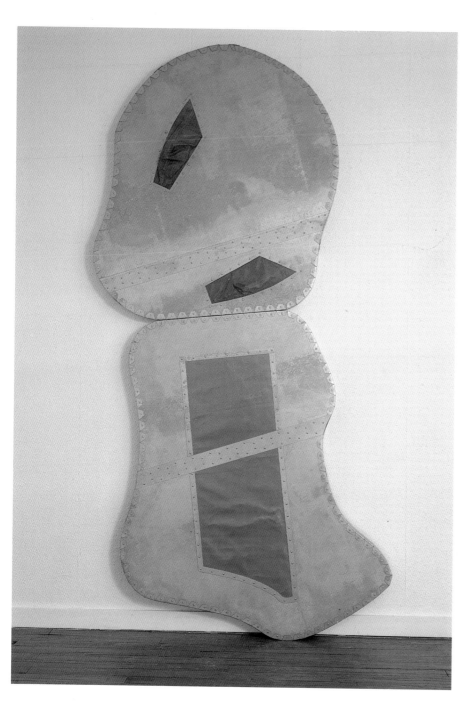

above, **The Back of My Hand No 4**
1986
Galvanized steel, leather, PVC
sheet
180 × 150 × 20 cm
Collection, Centre Georges
Pompidou, Paris

In the same book Eliade goes on to assimilate with water two other symbols of renewal which we can, without labouring the point, equally associate with dust and corruption. One is symbolism of darkness and the other orgiastic celebration of the New Year (pp. 398-9).

In its last phase then, dirt shows itself as an apt symbol of creative formlessness. But it is from its first phase that it derives its force. The danger which is risked by boundary transgression is power. Those vulnerable margins and those attacking forces which threaten to destroy good order represent the powers inhering in the cosmos. Ritual which can harness these for good is harnessing power indeed.

So much for the aptness of the symbol itself. Now for the living situations to which it applies, and which are irremediably subject to paradox. The quest for purity is pursued by rejection. It follows that when purity is not a symbol but something lived, it must be poor and barren. It is part of our condition that the purity for which we strive and sacrifice so much turns out to be hard and dead as a stone when we get it. It is all very well for the poet to praise winter as the

Paragon of art,
That kills all forms of life and feeling
Save what is pure and will survive.

Roy Campbell

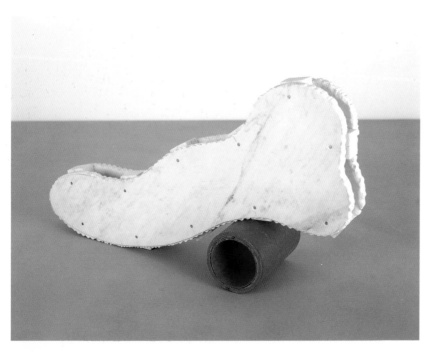

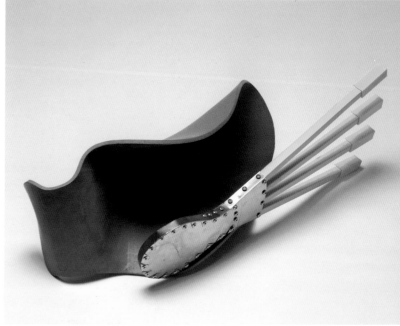

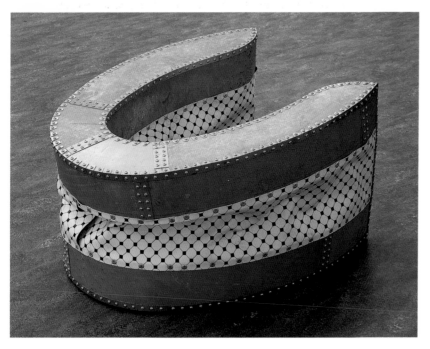

osite

, Art for Other People No 22

5

s, galvanized steel, screws

× 105 × 15 cm

eft, top, Art for Other People

15

5

ole, linoleum

× 122 × 30 cm

, Art for Other People No 21

6

inless steel, plastic

× 60 × 15 cm

eft, bottom, Art for Other

ple No 24

7

vanized steel, vinyl

× 92 × 75 cm

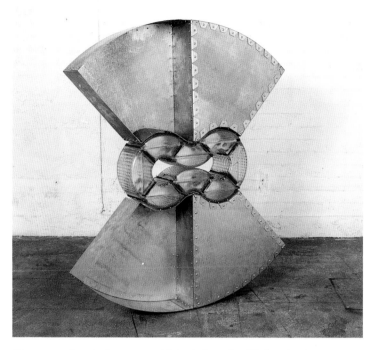

It is another thing to try and make over our existence into an unchanging lapidary form. Purity is the enemy of change, of ambiguity and compromise. Most of us indeed would feel safer if our existence could be hard-set and fixed in form. As Sartre wrote so bitterly of the anti-semite:

> How can anyone choose to reason falsely? It is simply the old yearning for impermeability ... there are people who are attracted by the permanence of stone. They would like to be solid and impenetrable, they do not want change: for who knows what change might bring? ... It is as if their own existence were perpetually in suspense. But they want to exist in all ways at once, and all in one instant. They have no wish to acquire ideas, they want them to be innate ... they want to adopt a mode of life in which reasoning and the quest for truth play only a subordinate part, in which nothing is sought except what has already been found, in which one never becomes anything else but what one already was. (1948)

This diatribe implies a division between ours and the rigid black and white thinking of the anti-semite. Whereas, of course, the yearning for rigidity is in us all. It is part of our human condition to long for hard lines and clear concepts. When we have them we have to either face the fact that some realities elude them, or else blind ourselves to the inadequacy of the concepts.

The final paradox of the search for purity is that it is an attempt to force experience into logical categories of non-contradiction. But experience is not amenable and those who make the attempt find themselves led into contradiction.

Where sexual purity is concerned it is obvious that if it is to imply no contact between the sexes it is not only a denial of sex, but must be literally barren. It also leads to contradiction. To wish all women to be chaste at all times goes contrary to other wishes and if followed consistently leads to inconveniences of the kind to which Mae Enga men submit. High-born girls of seventeenth century Spain found themselves in a dilemma in which dishonour stood on either horn. St. Theresa of Avila was brought up in a society in which the seduction of a girl had to be avenged by her brother or father. So if she received a lover she risked dishonour and the lives of men. But her personal honour required her to be generous and not to withhold herself from her lover, as it was unthinkable to shun lovers altogether. There are many other examples of how the quest for purity creates problems and some curious solutions.

One solution is to enjoy purity at second hand. Something of a vicarious satisfaction gave its aura, no doubt, to the respect for virginity in early Christendom, gives extra zest to the Nambudiri Brahmins when they enclose their sisters, and enhances the prestige of Brahmins among lower castes in general. In certain chiefdoms the Pende of the Kasai expect their chiefs to live in sexual continence. Thus one man conserves the wellbeing of the chiefdom on behalf of his polygamous subjects. To ensure no lapse on the part of the chief, who is admittedly past his prime when installed, his subjects fix a penis sheath on him for life (de Sousberghe).

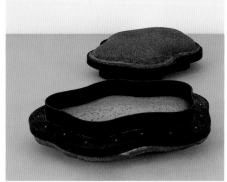

left, **Art for Other People No 26**
1987-88
Galvanized steel, PVC, butyl
rubber, canvas
10 × 62 × 62 cm

right, **Art for Other People No 28**
1990
Steel, foam, polyester resin
2 parts, 15.2 × 76.2 × 61 cm each

Sometimes the claim to superior purity is based on deceit. The adult men of the Chagga tribe used to pretend that at initiation their anus was blocked for life. Initiated men were supposed never to need to defecate, unlike women and children who remained subject to the exigency of their bodies (Raum). Imagine the complications into which this pretence led Chagga men. The moral of all this is that the facts of existence are a chaotic jumble. If we select from the body's image a few aspects which do not offend, we must be prepared to suffer for the distortion. The body is not a lightly porous jug. To switch the metaphor, a garden is not a tapestry; if all the weeds are removed, the soil is impoverished. Somehow the gardener must preserve fertility by returning what he has taken out. The special kind of treatment which some religions accord to anomalies and abominations to make them powerful for good is like turning weeds and lawn cuttings into compost.

This is the general outline for an answer to why pollutions are often used in renewal rites.

Whenever a strict pattern of purity is imposed on our lives it is either highly uncomfortable or it leads into contradiction if closely followed, or it leads to hypocrisy. That which is negated is not thereby removed. The rest of life, which does not tidily fit the accepted categories, is still there and demands attention. The body, as we have tried to show, provides a basic scheme for all symbolism. There is hardly any pollution which does not have some primary physiological reference. As life is in the body it cannot be rejected outright. And as life must be affirmed, the most complete philosophies, as William James put it, must find some ultimate way of affirming that which has been rejected.

If we admit that evil is an essential part of our being and the key to the interpretation of our life, we load ourselves down with a difficulty that has always proved burdensome in philosophies of religion. Theism, wherever it has erected itself into a systematic philosophy of the universe, has shown a reluctance to let God be anything less than All-in-All ... at variance with popular theism (is a philosophy) which is frankly pluralistic ... the universe compounded of many original principles ... God is not necessarily responsible for the existence of evil. The gospel of healthy-mindedness casts its vote distinctly for this pluralistic view. Whereas the monistic philosopher finds himself more or less bound to say, as Hegel said, that everything actual is rational, and that evil, as an element dialectically required, must be pinned in, and kept and consecrated and have a function awarded to it in the final system of truth, healthy-mindedness refuses to say anything of the sort. Evil, it says, is emphatically irrational, and not to be pinned in, or preserved or consecrated in any final system of truth. It is a pure abomination to the Lord, an alien unreality, a waste element, to be sloughed off and negated ... the ideal, so far from being co-extensive with the actual, is a mere extract from the actual, marked by its deliverance from all contact with this diseased, inferior, excrementitious stuff.

Here we have the interesting notion ... of there being elements of the universe which may make no rational whole in conjunction with the other elements, and which, from the point of view of any system which those elements make up, can only be considered so much irrelevance and accident – so much 'dirt' as it were, and matter out of place. (p.129)

Out of the House
1983
Galvanized steel, rivets, linoleum
122 × 61 × 152.5 cm

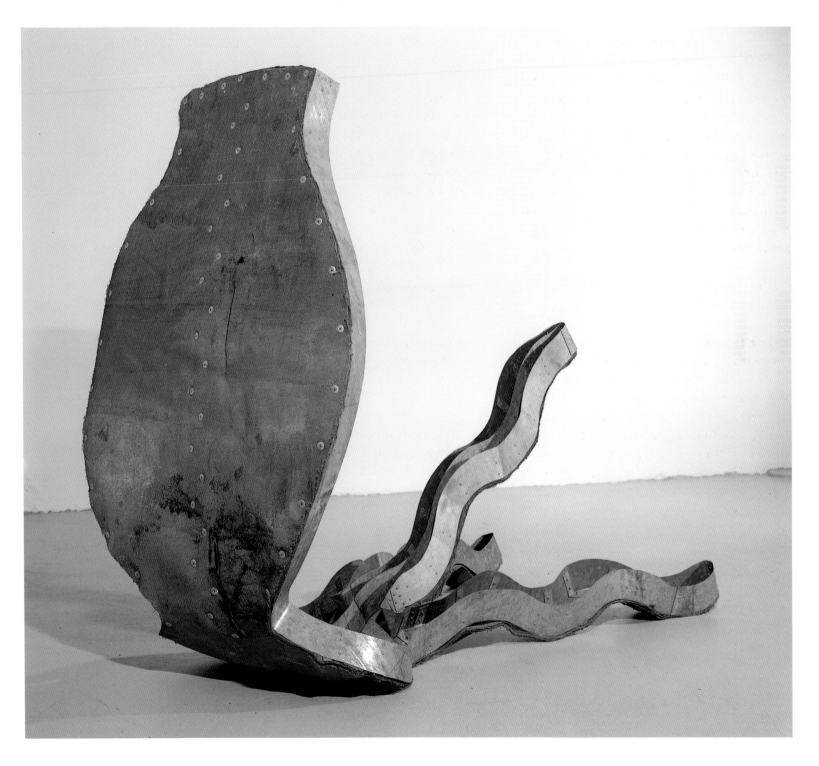

BUTTER

OIL

VINEGAR

WASHING POWDER

SHALLOTS

PASTA

SALAD STUFF

(TONIGHT) BBQ

Interview Pier Luigi Tazzi in conversation with Richard Deacon page 6 Survey Jon Thompson

Thinking Richard Deacon, Thinking Sculpture, Thinking of Sculptors page 36 Focus Penelope Curtis page 88

Artist's Choice Mary Douglas Henry James from Italian Hours page 88

Artist's Writings Richard Deacon Selections from Stuff Box Object, 1971-72, **page 110**. Artist's Statement, 1982, **page 114**.

Silence, Exile, Cunning, 1986-88, **page 116**. What Car? Correspondence with Lynne Cooke, 1992 **page 120**. What You See Is What

You Get, 1992, **page 132**. Design for *Replacing*, 1987, **page 138**. Design for *Factory*, 1993, **page 139**. Reading: A Propos de Toni

Grand, 1993, **page 140**. In Praise of Television, 1996–97, **page 144**. Interview with Ian Tromp, 1999, **page 158**.

Update Penelope Curtis The Interior is Always More Difficult page 168 Chronology

page 192 & Bibliography, List of Illustrations, page 205

Stuff Box Object
1970-71

I shovelled the Stuff into the wall half of the area, creating a bank eight feet long, two wide and one high and fixed a plank along the front to prevent it spreading.

When the Stuff was soft and well mixed I built a container around and over it – three feet high by eight by two – made of old floorboards nailed vertically onto a frame of thick planks.

I held the pounder handle in both hands, lifted it high and drove it down on top of the Stuff, walking around from place to place inside the container.

I took to pieces the container surrounding the Stuff, which remained in a solid block. I removed all of the nails from the wood and stacked it with the two tools. A mouse ran out.

On that evening Ted suggested that he and I exchange locations and materials, each of us leaving things as they were and proceeding to the other's location. I agreed to the exchange. I undertook a responsibility towards the condition of the Stuff that I placed in the exchange. In handing it over to Ted I expected him to attend to its care. My responsibility was extended towards the things that I received from the exchange. I received a large wooden Box, an amount of raw Flax joined by strips of Fibre Glass, Straw, Chicken Shit and scraps of Wood. The Box dominated the exchange. Its base was two and a half by three feet. It stood just over three feet high. Into the top, which was not attached and could be lifted, were screwed two large Butt-Hinges and two long Bolts. The inside of the Box was coated with Lard, which had soaked in and was starting to rot the Wood. The Box smelt rancid.

On Monday January 19 I began to prepare the Box. In the centre of each side and in the top I drilled five holes, one hole in the dead centre and the other four forming a square around it – the pattern used to indicate a five on a die. I mounted a light inside the top, the flex going out to a socket through the central hole. I set a bolt inside the top, screwed two hasps onto the outside and padlocked the Box shut.

On the morning of Friday January 23, watched by Peter Atkins and Robert Bell and wearing a White Boiler Suit, I unlocked the Box and opened the top. I placed inside a knife, a hammer, a bag of tacks, a roll of carpet and a clock. I turned on the light and climbed inside, closing and bolting the top behind me.

Inside, I adopted a foetal position on first closing the top; body curled, head bent over, legs together, knees drawn up against my chest. In this position I fitted my body across the Box between diagonally opposed corners. I turned over. It was only possible to turn from side to side and not to do a full turn – either by going head-over-heels or by rolling lengthwise. By pushing parts of my body against the sides while relaxing and moving others I moved around the Box. It was hot and greasy inside and I started to

f Box Object
0-71

Stuff Box Object
1970-71

sweat heavily. Turning from one side to the other I became careless and my left leg smashed the light bulb in the top. I slid the bolt back, opened the top, climbed out, shut and padlocked the Box and left.

18/5/71; 10:20. I change into the Boiler Suit, fetch an old sheet of hardboard and lay it on the floor beside the Object. I fill a bucket with sand, carry it across and tip it out on the hardboard. From the bag of cement standing next to the bag of sand I measure out half a bucket, carry it across to the hardboard and tip the cement into the sand. I turn the two together with a spade and fetch water in two buckets, a pint in one and the other full. I tip a pint of Uni-Bond (bonding adhesive) into the first and use the water from the other bucket to wet the cement. When the cement is ready I improvise a board and trowel some cement onto it. Resting the board against the Object and being careful that the cement does not slip to the floor, I pick up a paint brush and the bucket of bond and paint one edge of the Object. I place the bucket on the floor, stand the paint brush in it, pick up the trowel and the loaded board and cement the wet edge, squaring and levelling the corner. I finish, place the board and trowel down on top of the Object, pick up the bucket and brush and paint a second edge with bond. I place the bucket on the floor, cut out a piece of sacking, wet it and lay it over the first edge. I trowel more cement onto the Board and commence squaring and levelling the second edge. I continue until all the edges are done. I inspect the whole surface of the Object, painting over faults in the cement with bond and filling them. I cover the Object completely with damp sacking and clean up – scrape the floor free of excess cement, push the waste into a pile then throw it into a dustbin, take the piece of hardboard off the floor and stack it against a wall, wash the trowel, the board and the spade free of cement and put them away. I wash out the paint brush and cover the bucket of bond, remove the Boiler Suit and wash my hands.

3:45. I remove the covers and nail a skirting board around the bottom of the Object. As I nail several large pieces of cement fall off the corners. At 6:00 I replace the covers on the object, clean up the floor and leave the Studio.

19/5/71; 11:30. I change into the Boiler Suit, take up what remains of the bond, uncover the Object and paint over the damaged sections of the cement. I lay the piece of hardboard out on the floor next to the Object, tip a bucketful of sand and half of cement onto it and mix the two together. When the dry mix is ready I wet it. I take up the trowel and board and use the trowel to scrape the board free of dry cement. I trowel some cement onto the board and commence repairing the damage. After finishing there is cement left, so I paint bond onto the sides of the object shown by the skirting board to be irregular and finish off the cement by building up depressed areas. I finish at 1:10,

Stuff Box Object
1970-71

clean around the Object, stack the hardboard up, wash the trowel and the spade free of cement, remove the Boiler Suit, wash my hands and go to lunch.

20/5/71; 2:10. I scrape down the surface of the Object, removing any flakes of cement and preparing the surface for plastering. I make a board to hold plaster and paint one side of the Object with bond. I put on the Boiler Suit, open a bag of siraptite plaster and mix up wet plaster in a bowl. I fetch the trowel and start plastering the painted end of the Object. I find the plaster sticky and stiff to the trowel, harder to work than cement. I have almost finished the side when Ted comes up and tells me how to do it. He says that I am laying the plaster on too thick, that I should be quick with the trowel, moving it rapidly across the surface being plastered and that I should keep the plaster surface very wet so that I can move it around with ease. I give him the trowel and he shows me how, indicating the direction of stroke with the trowel and the right wetness and thickness of plaster to be using. I watch everything that Ted does. At 3:45 we run out of plaster. I wash the trowel, the board and the bowl and remove the Boiler Suit. We go to tea.

21/5/71; 10:15. I put on the Boiler Suit, fetch some water in the bowl, pick up a bag of plaster and sprinkle some into the water in the bowl, mixing it up. I take up the trowel and the board, wet them both and trowel some plaster onto the board. I wet one of the two unplastered sides of the Object and start plastering. I work upwards and outwards from the middle of the side at the bottom, where the cement level is depressed. I use the plaster wetter and lay it down thinner and faster than previously. I finish the mixed plaster and buy some more, mix up a fresh batch, wet the final side and commence plastering, again working upwards and outwards from the centre at the bottom. I finish and examine the Object. The side that Ted and I plastered between us is fully covered, but the finish is bad and needs cleaning up. The other three sides are much neater but each needs more plaster to level and cover it. I wash the trowel, the board and the bowl, remove the Boiler Suit and wash my hands. Using a cold chisel I start scraping down and tidying the first side plastered. I stop after a short time and decide to wait until the plastering is finished before continuing.

21/6/71; 9:45. I change into the Boiler Suit, remove my shoes and step into a pair of boots. I take up the bucket and remove from it the hammer and chisel, the trowel, the paint brush, a ball of string and a nail tied to a short piece of string, placing them all on the floor. I fill the bucket with water, pour some into the bowl and place the bucket on the floor beside the Object. I place the bowl beside the sack of plaster, take plaster from the sack and sprinkle it into the water in the bowl, mixing the two together. I carry the bowl of wet plaster to the end of the Object furthest from the door and face it, holding the

bowl in my left hand. I tilt the bowl away from me, plunge my right hand into the plaster and flick it out towards the Object, transferring plaster to the surface. I flick from the left to right across the top, drop the bowl and my hand about six inches and flick from the right to left back. I continue working back and forth across the surface until the bowl is empty. I wash my right hand in the water in the bucket, tip water into the bowl, rinse it around and leave the bowl on the floor. I pick up a length of wood and, holding it horizontally, stand facing the plastered end of the Object. I bend my knees and apply the wood across the runners at the bottom. I straighten my legs and run the wood up along the runners, keeping it pressed hard against them. Fresh plaster projecting beyond the plane of the runners is scraped off and builds up on the wood. I pick the plaster off the wood and stuff it into holes in the plaster surface. When the wood ceases to gather plaster on its run, I rest it against the Object, wash the bowl and my hands and empty the bucket. I place the bowl and the bucket down on the floor, the bucket inside the bowl, remove the Boiler Suit and hang it up, change my boots for my shoes.

22/6/71; 2:05. I fetch a rasp from the sculpture department stores and use it on the two 'flicked' ends of the Object. The plaster has built up dry on both of these beyond the level set by the runners and the wood is forced away and ceases to establish a true surface in use. I use the rasp for five minutes, working on the end of the Object nearest the door, place it on top and fetch the hammer and chisel from the floor at the opposite end. I chisel down the plaster, working from top to bottom and checking the level by looking across the runners. I get the level right for the top six to nine inches, place the hammer and chisel on top of the Object and pick up the rasp to smooth the surface. I work on the end for half an hour, finally check the level by running a piece of wood between the runners, place the rasp beside the hammer and chisel and leave the Studio.

St. Martin's School of Art, London, 1971-72. Re-edited and published by the Chapter Arts Centre, Cardiff, 1984

Stuff Box Object
1970-71

ff Box Object
0-71

Artist's Statement 1982

Jacqui (Poncelet) and I moved to Brixton in April 1976. In November of the same year Acme was provisionally granted a lease on the factory at 52 Acre Lane and work began on making the building watertight, restoring services and dividing up the studios. By February 1977 I was using my studio. In January 1978 my son was born. That September we went to the United States for a year, returning to the same house and the same studio. In August 1978 and again in June 1980 I used the gallery which has become incorporated into the Acre Lane studios to show my work.

These seem to me to be important facts of my life over the past six years. I don't know what relation the work I have done has to them. There are certain things – the light and space in my studio are important to me, it is a place that I enjoy going to; a great deal of the material that I have used has been scrap salvaged from the conversion of the factory, collected and stored; the gallery at the studios is a liberating facility. And there are people – I have felt a strong sense of community with the individual artists who occupy the studio at Acre Lane, particularly at the beginning when we were all trying to make the building work and trying to make studios for ourselves; Peter Venn, who had the studio next to mine before he moved to Norfolk, and Bill Woodrow who lives near and also has a studio at Acre Lane are both old friends with whom, in different ways, I feel a strong kinship; Matt Rugg whom I met through the studios is another; I could go on to talk about neighbours and friends who live nearby. More intangibly South London in general and Brixton in particular seems to me to be a very open place, I have found the opportunity to do what, at an individual level, matters very much and to find support for doing it. I have come to feel that I belong here.

There are also the crushing realities of urban decay, economic deprivation, unemployment and racism. In the face of these facts I am less optimistic, less sure.

The South Bank Show (cat.), South Bank Centre, London, 1982

Only the Lonely, exhibition with
Bill Woodrow, Chisenhale Gallery,
London, 1993
l. to r., **Wooly Bully**, 1993;
Only the Lonely, 1993;
Democratic Process, 1990;
Night and Day, 1992;
Thought It Was a Duck, 1992;
Whatcha Goin' to Do About It,
1993;
Doin' the Do, 1992

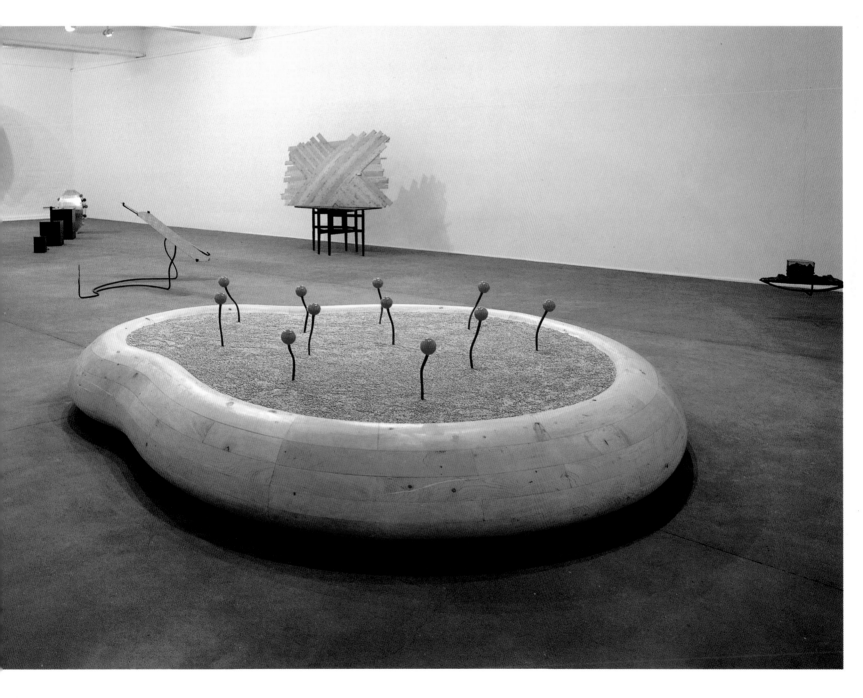

Silence, Exile, Cunning (extract) 1986-88

It's Orpheus When There's
Singing No 7
1979
Oil pastel, graphite on paper
112 × 147.5 cm
Collection, Weltkunst Foundation,
Zurich

In December 1978 I went to the United States for a year. I left London with a happy feeling in my heart and a sense of optimism. Up until that point, I had done a certain number of things, but was still feeling dissatisfied by what I had accomplished. Going somewhere else seemed to offer a situation where familiarity, habit and expectation could be left behind, and I could become what I wanted to be. Going was as much leaving as arriving. In the States I would be faced with deciding what to do.

For some years previously I'd been reading Rilke, mainly his letters and his essay on Rodin. In New York, and indeed on the plane to New York, I began to read his *Sonnets to Orpheus*. I read them time and time again over the next five months. I began to make drawings, and at some point it became apparent that what I was drawing had a very distinct relationship to what I was reading. But elucidating exactly what the relationship was is more difficult.

The first thing that attracted me to the *Sonnets*, I remember, was the way in which Rilke wrote of speech and, particularly, of song and of praise. Song and praise here are *US* and, at the same time, that which shapes the world:

song is existence. For the god unstrained

But when shall we exist? ...

The elements of the Orphic myth – the singer whose song can charm the beasts, cause the rocks and the trees to move, and draw Eurydice back from the dead; and whose body is torn apart and scattered by the Maenads, his head floating off still singing – provide a peg on which these reciprocating ideas can be hung.

Raise no commemorating store. The roses

shall blossom every summer for his sake.

For this is Orpheus. His metamorphosis

is this one and that. We should not make

searches for other names. Once and for all,

it's Orpheus when there's song. He comes

and goes.

Is it not much if sometimes, by some small

number of days, he shall outlive the rose.

To sing or to praise not only describes the world but brings it into being – as if to say the right name by some resonance shapes the stuff of the world into this or that thing – or at least allows the particular thing to be distinguished. If this is so, then language – the place where speaking occurs – is itself our world.

At the same time, there is no speaking without listening, hearing is a part of singing.

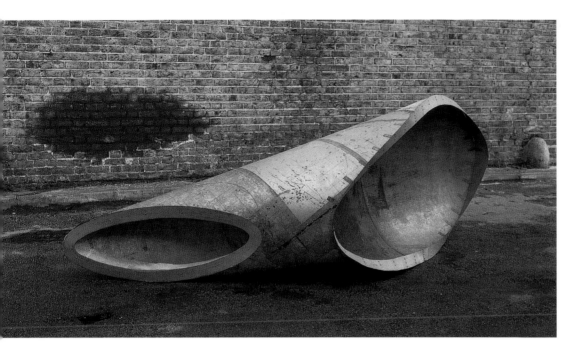

…itled

…0

…vanized steel, concrete

… × 345 × 125 cm

We are both listeners and speakers; we are of and in language.

> *Though they destroyed you at last and*
> *revenge had its will,*
> *sound of you lingered in lions and rocks*
> *you were first to*
> *enthral, in the trees and birds. You are*
> *singing there still.*
>
> *O you god that has vanished. You infinite*
> *track.*
> *Only because dismembering hatred*
> *dispersed you*
> *are we hearers today and a mouth which*
> *else Nature would lack.*

Reciprocity and reflexivity are at the heart of the drawings, which are by no means literal representations of aspects of the poems. The entire suite is collectively titled *It's Orpheus When There's Singing*. All the drawings have an enclosure, an enclosing line, with, at some point, an aperture circumscribed by the enclosure. The aperture and the whole enclosure can be thought of as the head of Orpheus. In the world there are a large number of items you come across frequently – shoes, hats, pots, pans, cups, jugs, shells, bags, pockets, gloves, etc. – which have a similar form – an enclosure with a small opening. Rather than being straightforward images of a head, the drawings referred to the other things, sometimes very obviously.

There are also the questions of what an enclosure is, and what an opening is. An enclosure is a formation, a clarification, actuality; an opening is a possibility. Singing and listening are reciprocal activities. Mouths and ears are openings in the head. Both seem to imply resonance: sound comes out of and goes into hollowness. The dog on the His Master's Voice recording label can listen *and* bark.

There was no object being drawn, so in order to get to a point where I could draw what I wanted, it seemed necessary to have rules. These were a means of avoiding some decisions about the appearance of the drawing as it developed. The drawings were constructed using a string, a pin and a pencil – this was the rule. All the curves were then built up from arcs or segments of circles of varying radii. This construction created a very fine mesh of marks, from which a final form slowly emerged, almost as if it had been captured.

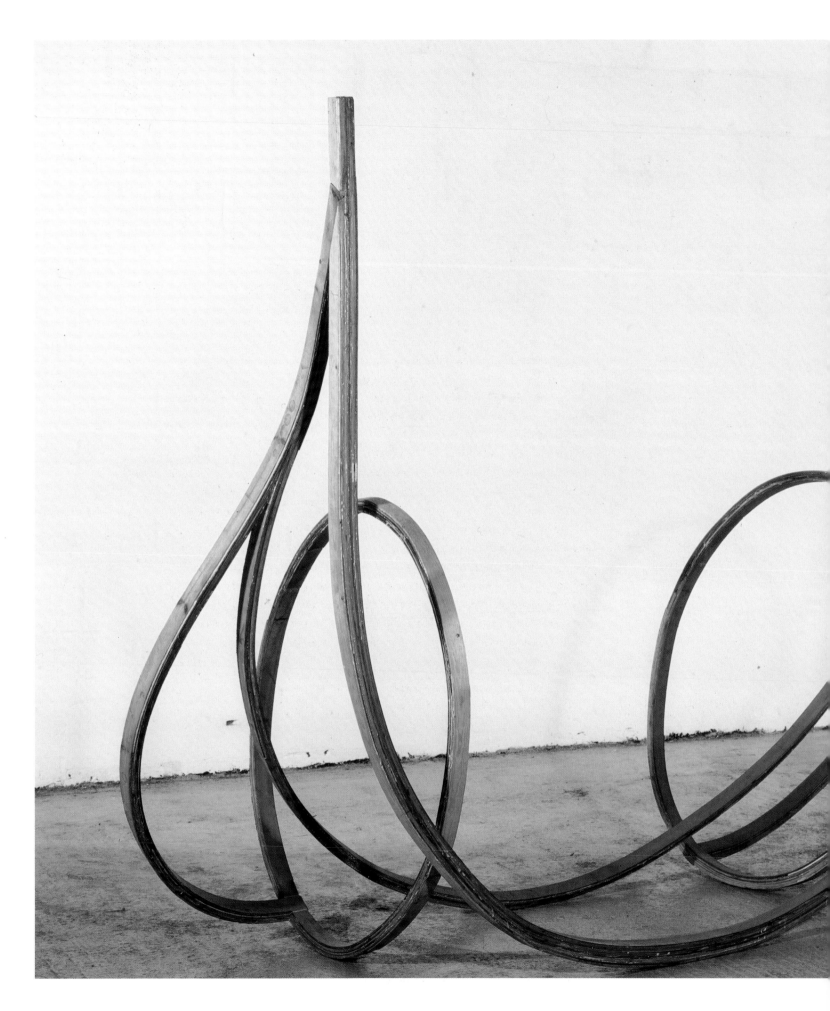

Untitled
1981
Laminated wood
140 × 305 × 216 cm
Collection, Fonds National d'Art
Contemporain, Paris

While the first drawings were concerned with a parallel between an enclosure and a human head, the later ones were concerned with aspects of picturing, recognition and identification implicit in the line being constructed. I think that a part of the fruitfulness of these drawings in respect to other work has to do with their method of being built: they are not pictures or plans, but rather constitute something like a grammar. Somehow, they were 'in anticipation'.

Since speech is constitutive of ourselves as human, to speak is both to cause the world to be and to be oneself. At the same time, speech is not a thing, but rather a product of community, built bit by bit in discourse. Speech is not nature, like stone or rock; it is manufactured. To make is also to bring into being, to cause there to be something.

When I returned to England, I had these drawings in mind as being potentially important for the sculpture that I might make. Of course, making a drawing is different from making a sculpture. The drawings seemed to show that what was enclosed had a relationship to the contour. This functioned like a skin over the interior, and the interior remained a hollow resonant space. But both 'skin' and 'interior' remain separate and mute, though the elements of language, appearance, community, building, speaking, listening, production and manufacture all seem to be involved.

A tree ascending there. O pure transcension.
O Orpheus sings. O tall tree in the ear.
All else is suspended, yet in that suspension
what new beginning, beckoning, change appear.

Creatures of silence pressing through the clear
disintricated wood from lair and nest;
and neither cunning, it grew manifest,
had made them breathe so quietly, nor fear,

But only hearing. Roar, cry, bell they found
within their hearts too small. And where before
less than a hurt had harboured what came thronging,

a refuge tunnelled out of dimmest longing
with lowly entrance through a quivering door,
you build temples in their sense of sound.

Richard Deacon (cat.), Carnegie Museum of Art, Pittsburgh, 1988

What Car? Correspondence with Lynne Cooke, 1992

Richard Deacon, 20 February, 1992

A car stands in front of a glazed, bland but convoluted building. A pared down, corporate, late modernist exterior. Surrounding buildings are amongst the welter of reflections and self-reflections in the glass. The glazing pattern of the building is in turn reflected in the car windscreen. The plaza is stepped, the paving detailed with stripes. A fragment, an inverted 'V' shape, is visible to one side behind the car. This is possibly a sculptural, possibly a structural element. Behind this a piece of movable security fencing has been placed across a (side?) doorway. Another doorway is visible to the rear of the image, again closed and visually obstructed by the stepped detailing of the plaza. These are the only visible entrances to the building, both closed. Within the car's interior it is possible to make out the four seat headrests and to know that there is no-one inside. The driver's door is presented to the spectator, the prominent side mirror at the very centre of the image. Reflections in the windscreen marry car and building; to be inside the one is to be inside the other; to be outside is to be outside them both. The car seems to occupy a place in a corporate plaza that, most frequently in North America, Japan or Germany, would be taken by an artwork. The copy says 'The Chairman's Statement', a nice conjunction of the form of address within a shareholders meeting with, given the clues from the rest of the image, the idea of artistic utterance. The corporate high flyer is joined to the personalized and individualistic values associated with the artist and artwork. The raising of a vehicle to iconic or symbolic status should come as no surprise yet the device by which that is accomplished in this particular case is worth marking. The plaza, even a corporate one, is a public place. Sculpture has been used to both adorn that space and to celebrate its publicness. Although as Richard Serra has discovered there are limits, freedom of expression belongs in the public domain. There is also a sense in which the implicit act of patronage is celebrated.

There are no people in the picture and half of the population are non participators.

Lynne Cooke, 14 March, 1992

This pristine, newly-minted car astride the corporate plaza usurps, as you say, Richard, the place that would, if occupied, normally be taken by an art-object. What makes the substitution so provocative is, it seems to me, the way that the vehicle usurps the place but not necessarily the role of the artwork; indeed it seems actively to embrace that very role. To the degree that it succeeds it becomes an interlocutor not an impostor.

Much twentieth-century sculpture in the public domain, which increasingly means the corporate as much as state or municipal environs, simply adorns its environment. Seeking to

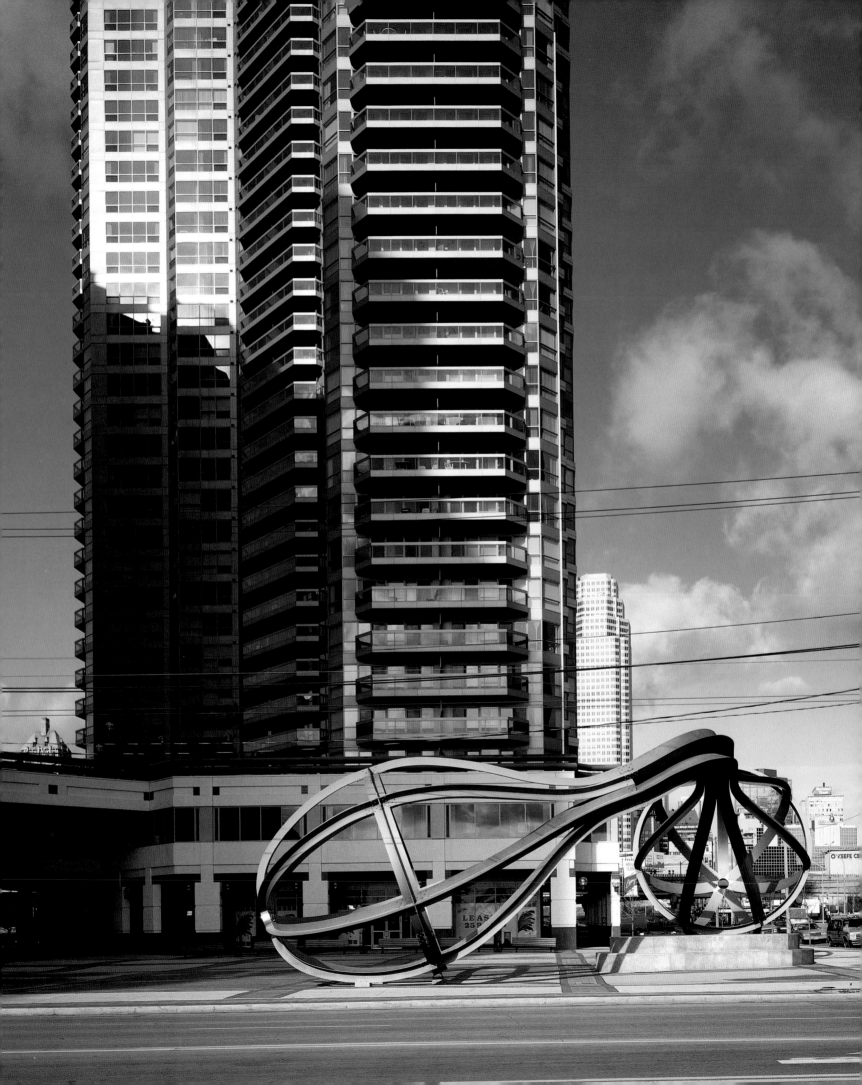

Between the Eyes
1990
Mild painted steel, stainless steel,
cement, granite base
800 × 1900 × 700 cm
Yonge Square, Toronto

ameliorate the visual cacophony of street signs and 'furniture' that make up the urban space, to embellish or otherwise provide a respite from this clamour, only rarely does the sculpture escape being commandeered as a logo, a sign naming the site in shorthand. Seldom does it manage to offer a counterstatement or even an explicit commentary on the values enshrined in that locale, as Richard Serra's *Tilted Arc* so effectively, if provocatively, did (...)

The functions assumed by the car are thus virtually equivalent, albeit pervertedly so, to those traditionally accorded the monument: to educate, elevate and decorate (in that order). The monument is usually realized in the form of a statue of a heroic figure who is commemorated, even celebrated, for the exemplary character of his (or her) actions, and therefore as a source of moral authority and as a model for civic virtue (or valour). Ironically, and this is something that has not escaped the attention of the advertisers, in contemporary urban society the chairman of the corporation has assumed, even at times seized, such a role. That the values that he (not she, as the image makes only too apparent) embodies revolve around money, power, exclusivity, surface style, mobility and transience, that they are essentially private, and that their sphere and manner of operation is being celebrated here is the message disseminated by the image. That responsibility for this in part lies, as Richard Sennett has persuasively argued, in the fall of public man, that is, in the withering away of the civic roles formerly adopted by the citizen, is a conclusion hard to escape. Similarly, the deduction that public space is merely a fiction, that it has long been occupied by private interests, is one that is hard to deny (...)

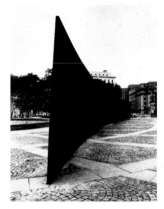

Richard Serra
Tilted Arc
1981
Cor-ten steel
345.6 × 3,456 cm

Richard Deacon, 17 March, 1992
The car is not parked, it is there deliberately; the driver has not strode inside for a meeting. It is important that we (those of us whose gender allows this little fantasy) realize this, that availability (ownership?) is a possibility, though vicarious. However it is also true that this is an artifice, the public space exists in this case through a piece of image making. You are also right to expand your frame of reference to take in the whole photograph. I hadn't remarked the poignancy of 'Bush Road' over the rubbish bags but I had noticed the piles of garbage, the graffiti, the brutality of the rendered gable end and that this was an occupied place. Did you ever read a book that came out sometime around 1986, a study of territory in housing estates, particularly the blocks from the sixties with their public walkways, communal areas, etc.? I'll have to try and find the title. The argument was that lack of definition of those communal areas was a strong contributing factor to social breakdown in the blocks. Paradoxically, the best of intentions, by confusing public and private, had engendered alienation and social

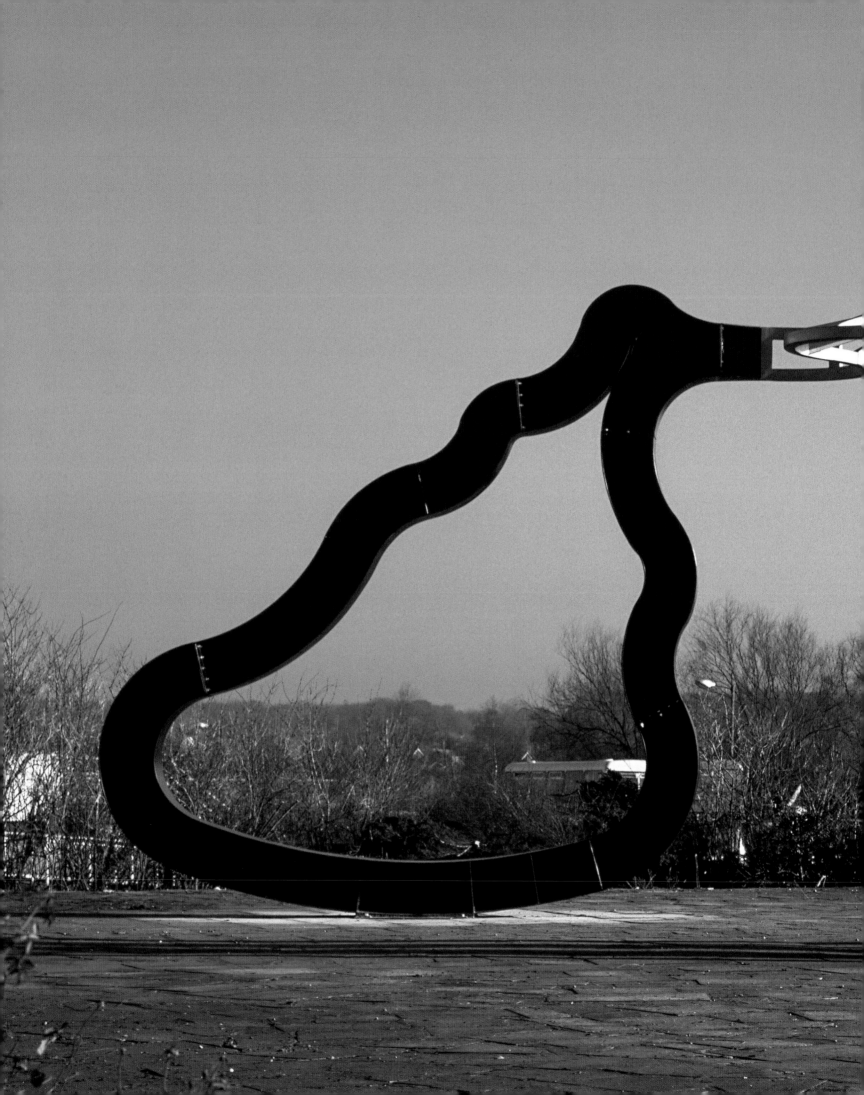

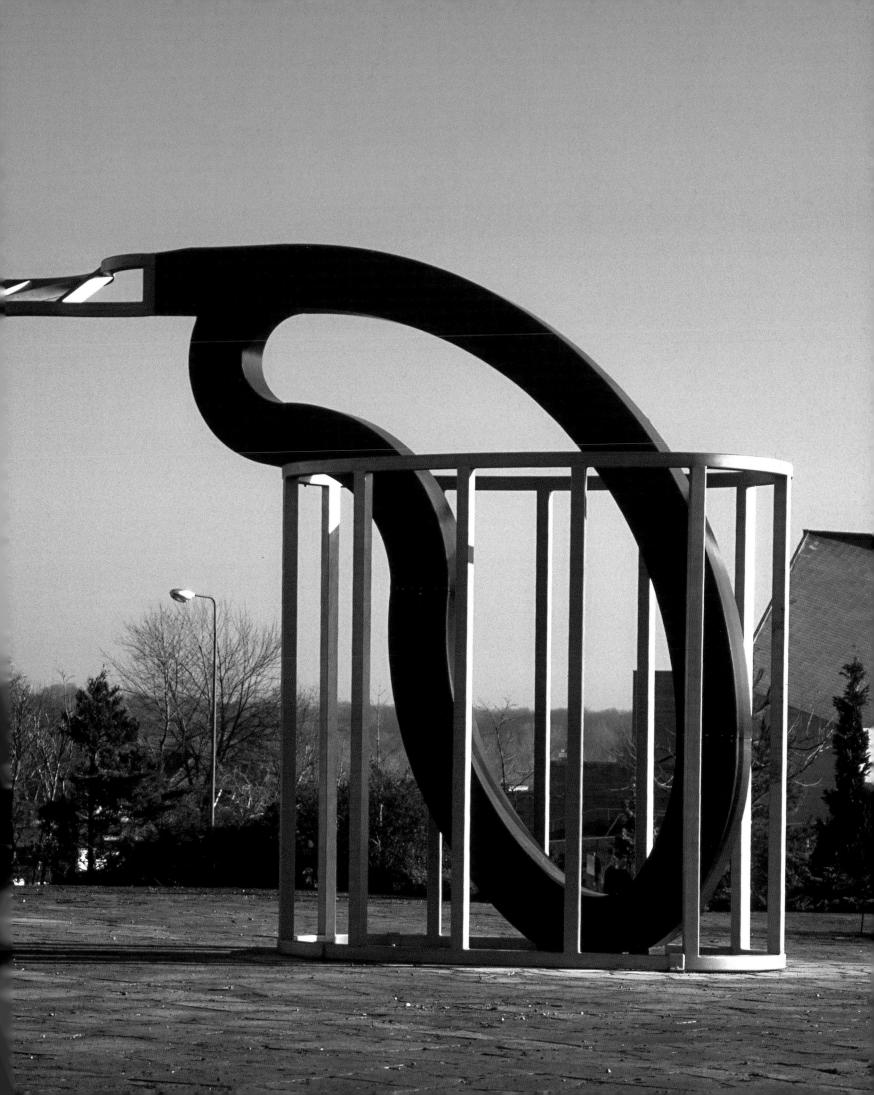

previous pages, **Let's Not Be**
Stupid
1991
Stainless steel, painted mild steel
545 × 1380 × 450 cm
University of Warwick, Coventry

confusion, the very symptoms that the architects and the local authorities were trying to alleviate. Against these blocks were contrasted suburban developments of the interwar years, rows of individual houses where the distinction between public and private is absolutely clear. And where, furthermore, bay windows at the front gave an occupier a means of surveillance. The zones of responsibility for maintenance etc. being clearly established, anti-social behaviour is suppressed. The book was quite successful, its recommendations becoming quite influential. The redefinition of occupied space by removal of walkways, addition of gates, abolition of communal areas is being actively pursued by many local authorities. While hopefully this ameliorates the quality of life for residents, it does so by eliminating one sort of public space – the networks of alleys, walkways, stairs and open spaces to which all had access and none had charge. There is an intriguing paradox in the photograph we are considering in that the billboard proposes (suggests) a public space, recognizable as such – the message relies on that recognition – at the same time the photograph itself shows the absence of conditions in which such publicness could endure.

Lynne Cooke, 21 March, 1992
(...) So, fortuitously perhaps but nonetheless tellingly, your photograph counterpoints an image of an uninhabited pristine public space containing a brand new luxury car with actuality, with, that is, a populated mundane street corner at which is parked a utility vehicle, an ordinary commercial van. Both of these are clearly urban sites; the former (supposedly) recently constructed, the latter an unplanned aggregate that has accumulated over time. If one is therefore the paradigmatic architecturally designed location, the other might be characterized as an adventitiously formed fragment of the built environment: where one is seamless, ordered and cohesive the other betrays the ruptures, oppositions and asynchronicity, the margins and transitions that in fact make up the totality of most urban environments.

In certain respects these antithetical sites could be read as two models for the kinds of public spaces currently made available for public sculpture. In neither instance is it easy to recognize that social spaces like these are indeed collectively constructed. Nor can it be easy for the contemporary sculptor to acknowledge, define and perhaps manifest in his or her work, the complexity of the social experience inherent in, or integral to, any such space.

Richard Deacon, 26 March, 1992
'Look at this,' Joe said. In the living room, he sat on the bed, his small suitcase beside

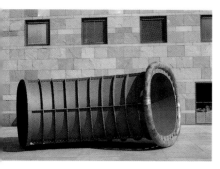
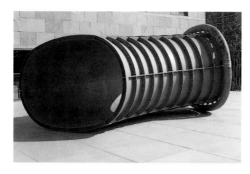

ance No Object

ed steel, copper

× 579 × 381 cm

ction, San Francisco Museum

odern Art

him; he had opened it and brought out a ragged, bent book which showed signs of much handling. He grinned at Juliana. 'Come here. You know what somebody says? This man'. He indicated the book. 'This is very funny. Sit down'. He took hold of her arm, drew her down beside him. 'I want to read to you. Suppose they had won. What would it be like? We don't have to worry; this man has done all the thinking for us'.
Philip K. Dick, *The Man in the High Castle*

The first chapter of Rosalind Krauss's book *Passages in Modern Sculpture* begins with a description of a scene from Eisenstein's film *October*. It is the opening scene and starts with the camera exploring in detail a statue of Czar Nicholas II, ending with a crowd bursting into the square that the statue occupies, fixing ropes around the statue and dragging it to the ground. This act of iconoclasm through which Eisenstein celebrates the coming of a new age and which Krauss uses as a way of arriving at a view of Rodin, has become once again familiar this last year. But what would it be like if it were the other way around, if we had witnessed the triumph of soviet communism? Crowds on the streets of Hamburg, Cologne and Bonn. Queues of people desperate to enter East Germany, Austrians flocking into Poland and Hungary. A wild night in Berlin when the wall came down. Disintegration of the European Community and NATO. The United States swiftly reduced to independent republics – Utah, Alaska, Texas, California, Hawaii, The Confederacy, Navajo, Crow, Dakota. The Union itself a small group of North Eastern states and Maryland (...)

The crowds have burst into the square, the symbols of an outmoded authority are being thrown to the ground. What are they? Does the Washington monument totter? Is the Lincoln memorial destroyed? The Statue of Liberty blown up? Perhaps it would only be a matter of overturning a few police cars. Or maybe the works of Oldenburg, Serra, Moore, Picasso, Miró?

Lynne Cooke, 30 March, 1992
What would it mean for the works of Oldenburg, Serra, Moore, Picasso and Miró to survive desecration and destruction unlike, say, the statues of Lenin, Stalin and others? Would it indicate that their meanings are porous, that they are malleable and hence capable of a rereading or manipulation, that, in short, they are politically correctable in the way that the national flags flying in Bucharest in December 1990 were filleted, their central symbols cut out leaving only the country's colours surrounding gaping holes? Would it mean that they could remain present as monuments if they were, as signs, rendered (or considered)

mute? In a celebrated dictum now perhaps hackneyed but nonetheless pertinent, Robert Musil contended that a monument is immune to public attention and thus invisible. A monument in his definition is not, therefore, a sign (...)

During the Cold War the United States Government used Abstract Expressionist painting as a cultural weapon to further spread its political ideology. Today, multinational corporations do a far more effective job utilizing advertising signage. Perhaps it is inconceivable that when the crowds burst into the squares – Piccadilly Circus, or Times Square, say – that their first targets will prove to be the spectacolour boards devoted to Coke, Sony, and Marlboro ... But, almost certainly, Alfred Gilbert's *Eros*, like the statue of Father Francis P. Duffy on 42nd Street in New York City, will be bypassed in the excitement, ignored, unremarked ...

Richard Deacon, 2 April, 1992

'Now, Kitty, let's consider who it was that dreamed it all. This is a serious question, my dear, and you should not go on licking your paw like that – as if Dinah hadn't washed you this morning! You see, Kitty, it must have been either me or the Red King. He was part of my dream, of course – but then I was part of his dream, too!'
Lewis Carroll, *Through the Looking Glass*

It's interesting to suppose that the reasons for the United States government supporting Abstract Expressionist paintings are the very same reasons that our crowds might ignore the works of Picasso, Serra, Moore, Oldenburg, Miró etc. That is, the individuality, privacy, hermeticism, idiosyncrasy, even apparent meaninglessness of those works. It's contradictory isn't it? On the one hand a patronage, based in ideology, that understands freedom or liberty – high order values – as being expressed by the, if you like, extreme pursuit of individuality, of privacy. On the other hand something like ineffability, porosity in your word. Thus at the time of the bombing of Pan Am flight 103 over Lockerbie in 1988, one appalled commentator, desperately seeking ways of describing the scene of mindless destruction which confronted him, said of the twisted fragments of metal scattered across the ground that they were 'like modern sculpture' (...)
These are certainly questions about meaning, but they are also about 'public'. Thus we started by my description of the car, an interlocutor, in your phrase, in the corporate plaza, occupying a place that might be taken by an art work. The one precedes the other and, in general, it is publicness of space which is thought of as the container for works of art in public. But what if this were not the case, what if it were the other way round – that

e, Jochen Gerz and
er Shalev-Gerz,
Monument Against Fascism
-93

Juan Muñoz
led

ee Gardens, London

it was 'publicness' in the art work which enabled a space to be public?

Lynne Cooke, 6 April, 1992

The question of whether the publicness is brought into being in and through the object, or whether it preexists it and pertains to the space itself brings up the issue of the relationship between the modernist sculpture, the monument and the memorial. It's my hunch that the monument and the memorial being recognizable and identifiable typologies in themselves are integrally public in address whereas the proper home of the autonomous modernist sculpture is the museum, for there self-referentiality is most securely in place. When it is placed outdoors the modernist sculpture seems to require that the site be read as an extension of the museum, as, in effect, a surrogate museum space of the kind exemplified in a sculpture park. In such venues the forms of address are implicitly in place before the work is encountered. By contrast when the character of the space is not sharply designated or where it has a hybrid identity, as in a corporate atrium, the work often runs the danger of being commandeered, and forced into embellishing the site and/or the patron (…)

Recently it has functioned in both active and passive ways, that is, firstly in ways that attempt to counter the loss of meaning, and secondly in ways that seek to profit from it. The gradually disappearing column, *Hamburg Monument Against Fascism*, which Jochen Gerz and Esther Shalev-Gerz constructed in Hamburg and that will ultimately become invisible is an instance of the former. The converse is found in a recent work by Juan Muñoz. This is a seemingly anonymous cenotaph, a memorial devoid of inscription, erected on the banks of the Thames in London. Modelled along the lines of the well known example of this monument found nearby, Muñoz's work was designed to meld directly into its milieu in such a way as to become virtually unnoticeable from the moment of its inception (…)

Richard Deacon, 17 April, 1992

Baudelaire's assumption, expressed negatively in his Salon criticism of 1846 ('tiresome') and positively in his Salon criticism of 1859 ('divine role') was that sculpture was necessarily primitive and close to nature: that is to say, incapable of becoming civilized, as painting is, without losing necessity and virtue. A central plank of Rilke's interest in and writing about Rodin was puzzlement bordering on awe that something made as art could dispense with its maker and exist in the world of things. Judd in his text *Specific Objects* suggests the possibility of an art which borders on the ordinary and the matter of fact. This 'like 1, 2, 3' is a way of seeing the world. For all three of these writers, despite vast differences, the object is situated in the world where the subjectivity of the

spectator is engaged. This is a limit for Baudelaire, a source of existential questioning for Rilke and a means of demystification for Judd. It is without question for any of them that both the site of engagement is in the world and that what is engaged is the product of a human agent. There is no question of privacy. Whatever it is that all these three writers are considering, whether or not we want to call it sculpture, is in public, out there in the world. Like language it is neither yours nor mine and also like language, it is uncontained. What 'it' is and what constitutes 'the world' may not always be quite so clear.

I don't subscribe to Henry Moore's suggestions that the proper place for sculpture is outside. No more do I believe that the 'proper home of the autonomous modernist sculpture is the museum'. That seems to put the cart before the horse to me and carries with it a whiff of the prescriptive that I cannot let pass. This may be a matter of dogma to me, I don't know, since I recognize the truth, Lynne, in your comments about the sculpture park and the corporate atrium (…)

I've often begun discussions about my work by telling the following joke, it helps to break the ice.

Q. What do you get if you cross a centipede with a parrot?

A. A walkie-talkie.

I don't know how it is in French, but in English I find the compression wonderful. The question brings together two unlike organisms whose commonality is revealed by the answer. The two first organisms, one an insect (a creepy crawly) and the other a bird, are functionally anthropomorphized (anything with a 'hundred' feet can do nothing but walk, we repeat what we have learnt 'parrot fashion' as if talking could be divorced from understanding). The two single actions are very specific and the conjunction of walking and talking is somehow special. Their focus in the popular name of an artefact brings it, Pygmalion like, to life – 'she's a walking, talking, living doll' (Adam Faith – *Living Doll*). The combination of nature and culture thus achieved is very particularly human and language is the medium and the mechanism by which the conjunction is wrought. There is an external frame, a public net, provided by language yet it is within our own consciousnesses that understanding and appreciation takes place. We may laugh together but the cause of the laughter is deep within our own psyches. Thus it seems to me, the joke is an example of criss-crossing of not only categories of things but also of the barrier between the self and the world, where world is meant in the sense that it is a place occupied by human speakers (…)

Richard Deacon, Editions du Regard, Paris, 1992

Between Fiction and Fact
1992
Mild steel
480 × 1155 × 360 cm
Collection, Musée d'art moder
Villeneuve d'Ascq

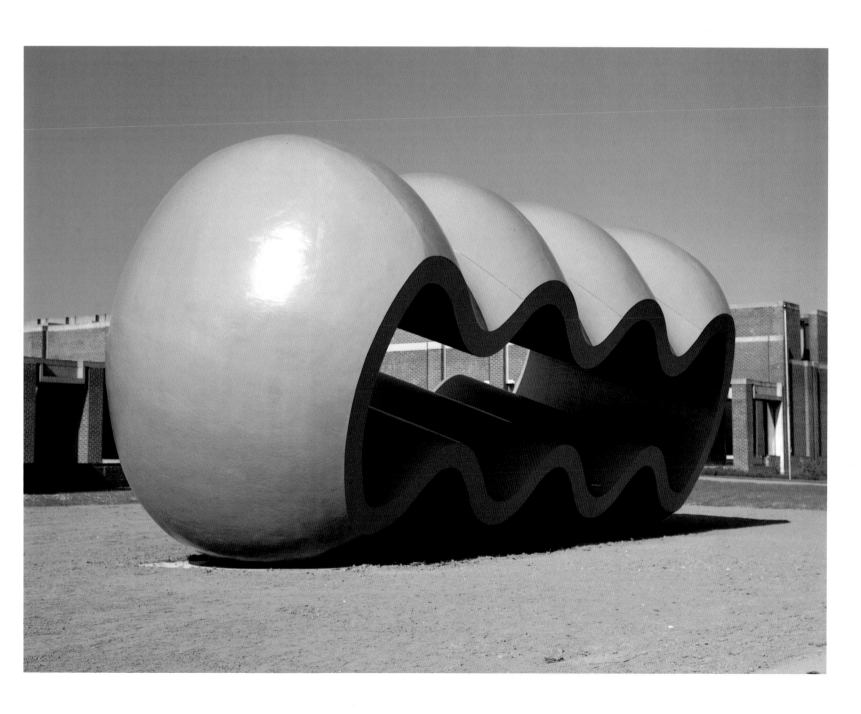

What You See Is What You Get 1992

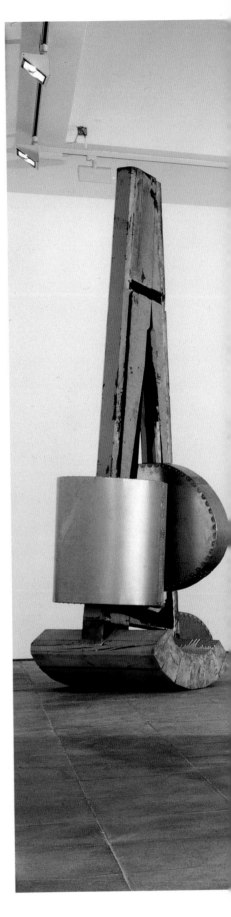

... 'Oh Kitty! how nice it would be if we could only get through into Looking-glass House! I'm sure it's got, oh! such beautiful things in it! Let's pretend there's a way of getting through into it somehow, Kitty. Let's pretend the glass has got soft like gauze, so that we can get through. Why, it's turning into a sort of mist now, I declare! It'll be easy enough to get through —' She was up on the chimney piece while she said this, though she hardly knew how she had got there. And certainly the glass was beginning to melt away, just like a bright silvery mist.'
Lewis Carroll, *Through the Looking Glass*

One of the things that I really liked about the Vechte at Nordhorn, from the first time I visited, was that it reminded me of a stretch of the river Stour I had known well as a boy. The Stour, in some ways a much more rural river, ran through the water meadows. Weeds and lilies floated on its surface, pulled by the current. We children swam in the deep water just above the weir. It was only ever the sunlit surface that was warm, underneath the river ran on cold and dark, weeds occasionally wrapping your legs like a warning if you dived down deep beneath the surface. Below the weir, the river divided in two, one half slow and steady going on into the flour mill, where it drove the grinding wheels before falling turbulently into the mill pond and drifting out to join its other half which all the while had been rushing and bouncing along. I preferred this quicker half, the water was shallower, you could see more – especially from the cattlebridge. Leaning over the rails you could watch the swinging weeds and the darting life in the eddying river below. The mill reach was always dark, overshadowed by chestnut trees along the bank and which the surface reflected back, black against the sky. At the end of the reach the river plunged mysteriously through a grill into the noisy mill. This grill kept the largest floating debris from interfering with the machinery turning the grinding wheels as the water passed through the mill. The track from the village led over the water meadows, crossed the lower branch of the river and passed by the mill itself on a walkway over this grill. It was always interesting to look down and see what flotsam had been creamed off the water's surface, mostly twigs and branches but also bits of crates and boxes and, occasionally, dead fish. Once there was a dead cat. There were two other bridges in the water meadows, curiously abandoned, bridges over nothing, but whose purpose became clear when the winter floods made the river spread across the water meadows, reopening old pathways for itself. Then these bridges kept the track to the mill open.

Summer mornings I could never sleep and would go out, leaving the sleeping

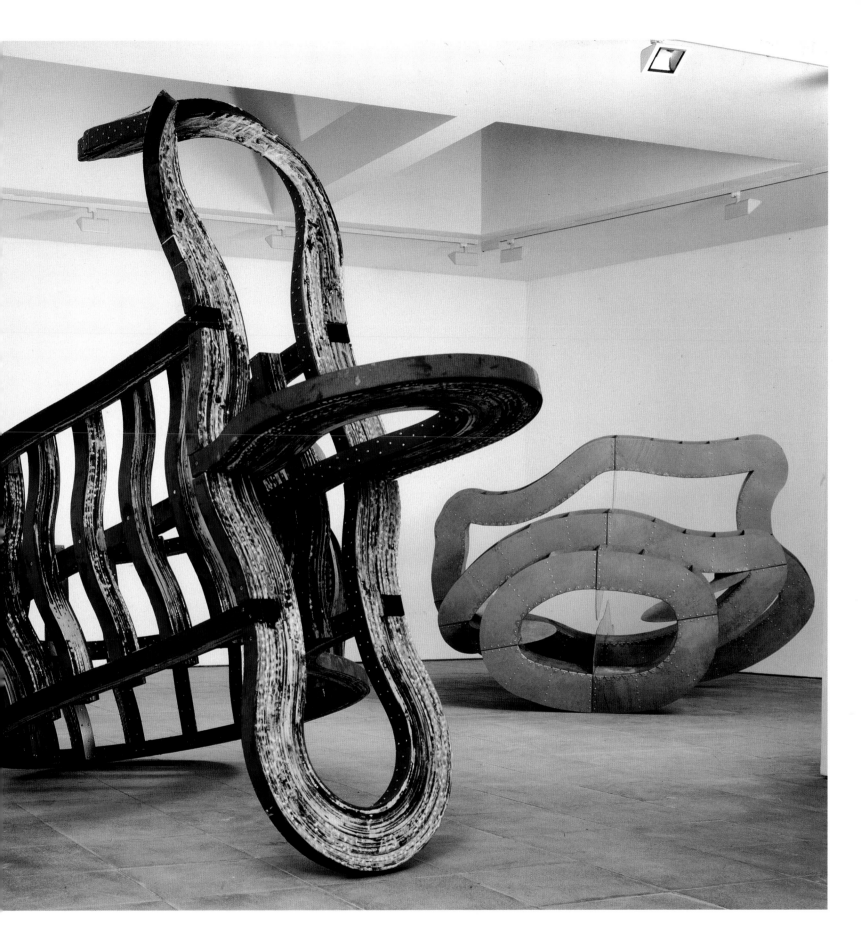

Installation, Lisson Gallery,
London
1987
l. to r., **Troubled Water**, 1987; **Fish
Out of Water**, 1986-87; **Feast for
the Eye**, 1986-87

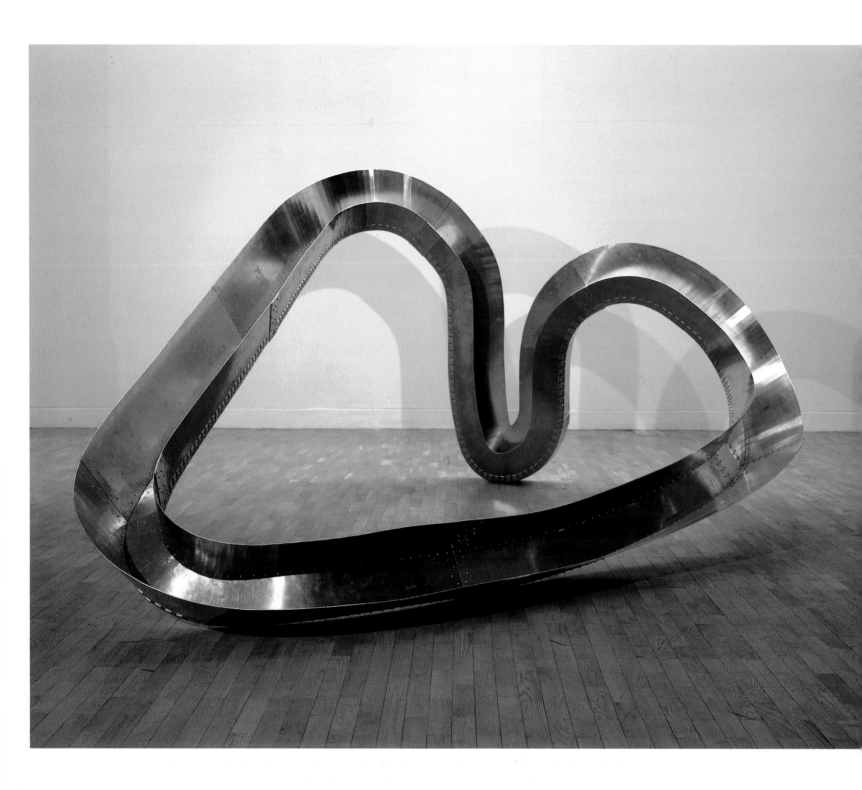

house and walking across the wet fields to the river. Fish interested me. I was endlessly fascinated by the grey shapes I could see flitting from clump to clump of the weed beds or, on a hot afternoon, floating in the sunlit surface water. I'd begun to learn that different patches of water had different inhabitants; nervous dace darting where the water was shallow and ran rippling over the bed; roach in slightly deeper water, running in the channels between the weeds, the weeds themselves flicking lazily to and fro as the current swung and eddied; perch where the water was deeper still and the brown river began to hide the bottom; pike lurking in the deepest waters, prowling amongst the stems of the lily pads, an unseen, hunting presence advertised by the occasional panicky eruption of tiny fish from the surface.

I was often fishing. I wasn't much good at it and later gave it up because I no

itled

ninium, screws

× 375 × 285 cm

longer liked it, but at the time I was keen. One morning, in a favourite spot I began to notice a fish different from the rest just visible in the dark patch under some floating weeds, hanging back but occasionally snapping something floating past. Finally recognizing it as a brown trout – the roundels I could make out on its back were a giveaway – I began to fish for it. It was a discovery, the fish seemed to be a secret which I wanted to unlock. Every morning I would be up and out trying every bait I knew or had heard of, wet flies, worms, maggots, larvae, minnows, bread, cheese; a whole diet drifted past the fish's nose. Occasionally it would grab at something, only to spit the baited hook out almost instantly. My tackle got lighter and lighter until finally there was just a light line and a tiny hook with whatever bait I was trying floating down the river whilst I tried to keep contact without jerking the line. Finally catching the fish made me proud, but was also perhaps disappointing. The connection that I had made between out of the water and in the water had been electrifying, almost as if I'd been talking, but with the fish in my hand it was gone. I'd lost the guide that carried me into the river.

In the film, *The War of the Worlds*, at one point the optical extension of one of the Martian invaders is linked to a video monitor. 'Now let's see what a Martian sees!' says one of the actors, as if seeing and cognition were separated acts. One of my favourite school textbook diagrams used to be that which explained the fish eye view. The fish looking upwards, out of the water, is only able to see through the surface within a narrow circle. Beyond that circle light is internally reflected and an image of the river or sea bottom replaces that of the bank or shore. The fish has a window which moves around with it. The greater the depth the smaller the window. Similarly from the land, looking down from above the water can be seen through whereas at an acute angle the water reflects rather than refracts light and an image of sky, clouds, trees – the surroundings – appears in the surface. These of course are mechanical explanations, fish might as well be Martians. Nevertheless what's interesting about this textbook diagram is the notion that the surface is *occasionally* transparent, *occasionally* penetrable, depending on viewpoint. My hunting the trout seemed to involve opening that window through the surface.

Surface is both the extent of our looking and that which constitutes appearance. How do I look? is the question we ask others of ourselves. The body is at the same time behind the appearance, its substance. *The Man with the X-Ray Eyes* changed his receptivity to the electromagnetic spectrum by means of a chemical treatment, eye drops. In optical examination eye drops are often used to dilate the pupil and the feeling afterwards is often of too much light entering the eye, of somehow seeing too much, so

Feast for the Eye
1986-87
Galvanized steel
100 × 80 × 350 cm

One Step, Two Step
1992
Stainless steel
Commissioned by Stadt Nordhorn,
Germany
Landspitze

there is some logic to the use of eye drops as the means of expanding the range of perception. To begin with the treatment has salacious results – at a party it appears to him that no-one is wearing any clothes. Then this increased capacity becomes a diagnostic miracle as he is able to look through a girl's skin and detects the presence of a malignant but operable tumour. After an accident he is stripped of his research funding and outcast both from the hospital and from the scientific community. Isolated and alone he continues the dosage that transforms his vision, earning money in a circus performing tricks of mind reading, a mental freak. Finally and tragically he can no longer see anything except colour and pattern since there is no longer any barrier to his vision. He sees everything and nothing, receptivity destroys all objects, there are no longer any surfaces. There is no more world. The marvellous membrane which is the water surface seems to me to be on the edge of appearance, an outerlimit of objecthood. It's another world down there.

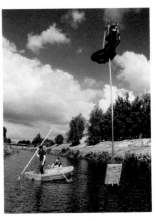

Installing **One Step, Two Step**
1992

> *I see a black bird up a tree,*
> *I see him and he sees me...*
> (Traditional song)

The second thing to try and write about at Nordhorn is why two? In some ways the proposal to have two parts to the work is a fairly natural development from being interested in the water. The original site, Landspitze, is the point where two streams of the same river meet. Since there is a point where they come together, there is also a place where they part. To me this was an immediate question – where does the stream split? A connection was always clear though the consequences of making the connection were not. In many ways the two places, Neumarkt where the stream splits and Landspitze where the two streams reconnect, allow a between, make a space, a before and after, a beginning and end. Nordhorn lies *between* the two points. I'm only a tourist so it's fair to say that this is a Nordhorn of mind, something that I have imagined. Nevertheless this Nordhorn is a single place, a node or fixed point in space. The river on the other hand is clearly in both places, Landspitze and Neumarkt, at the same time. It is not therefore fixed in space. A visitor is always only ever in one place at one time and a part of the experience of the work lies in going from one part to the other. In going from one to the other the work becomes confused with the visitor's experience, a combination of that which comes from the place and that which is brought to it.

One Step ... Two Step (cat.), Stadtgalerie Nordhorn, 1994

Replacing 1987

Replacing
1987
Set design for Rambert Dance Co.

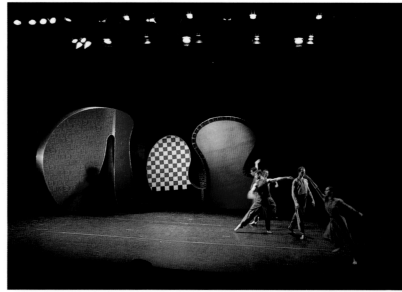

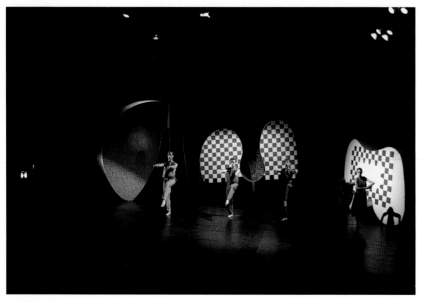

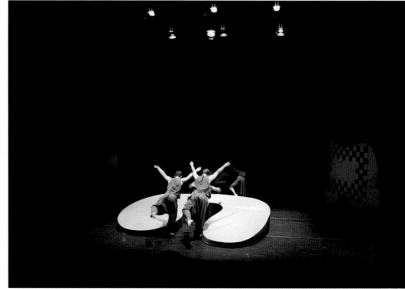

Factory 1993

tory
3
design for Marietta Secret

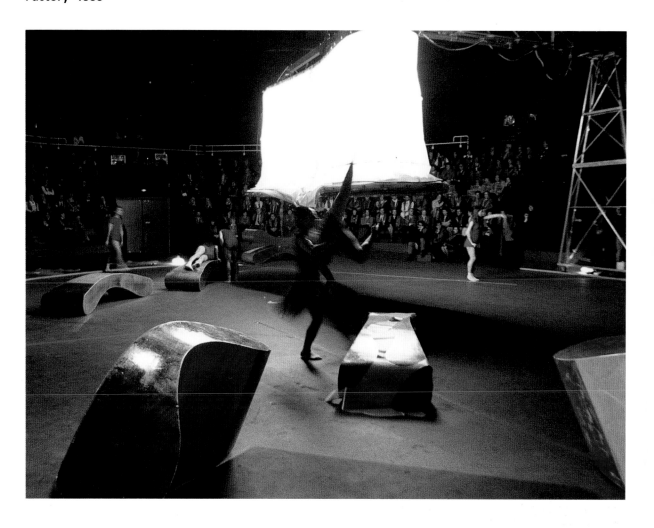

Reading: A Propos de Toni Grand 1993

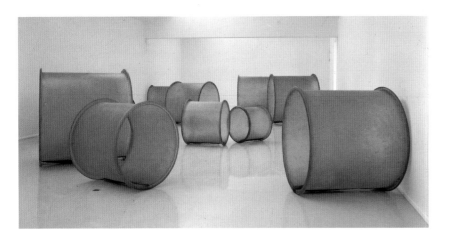

Turning a Blind Eye Again
1988
Laminated hardboard, plywood,
aluminium, mild steel
138 × 201 × 289 cm
Collection, Art Gallery of Ontario,
Toronto

Toni Grand
Du simple au double
1993
17 elements, fish, fibreglass
Dimensions variable

In Mircea Eliade's book Myth & Reality *one chapter is titled, 'Time Can be Overcome'. It is a basic purpose of mythic ritual and sacrament to overcome time. Horselover Fat found himself thinking in a language used two thousand years ago, the language in which St. Paul wrote. 'Here time turns into space' (Wagner, Parsifal). Fat told me another feature of his encounter with God: all of a sudden the landscape of California, USA, 1974 ebbed out and the landscape of Rome of the first century C.E. ebbed in. He experienced a superimposition of the two for a while, like techniques familiar in movies. In photography. Why? How? God explained many things to Fat but he never explained that, except for this cryptic statement: it is journal listing #3. 'He causes things to look different so it would appear time has passed'. Who is 'he'? Are we to infer that time has not in fact passed? And did it ever pass? Was there once a real time, and for that matter a real world, and now there is counterfeit time and a counterfeit world, like a sort of bubble growing and looking different but actually static?*

Horselover Fat saw fit to list this statement early in his journal or exegesis or whatever he calls it. Journal listing #4, the next entry goes:
'Matter is plastic in the face of the Mind'.
Phillip K. Dick, *Valis*

Fish is different from meat. Except for tuna. I've seen Japanese fishmongers, working in the big market in Tokyo changing the frozen carcasses of tuna into meat. The conversion is done by progressively slicing into smaller pieces. The frozen bodies are difficult to handle, heavy and awkwardly shaped, slipping a bit on the band saw bench. The first cut is longwise, into halves, the saw blade passing to one side of the back bone. After this it's easier, there's a flat surface to run on the saw table. The next cut is also longwise, quartering the body. Thereafter the cuts go across, producing blocks about as long as they are deep or a bit longer. These go into the fridges of other dealers and are sliced smaller and smaller as they thaw and as the fish is sold, red chunks, blocks and cubes; splinters of the whole body.

The second time I saw tunny, many years later, was in Spain on the Basque coast. This time it was a smaller species, Thunnus alalunga, which the French call germon and the Americans albacore, the prized white tunny, the only one allowed to be sold as white meat tunny in the USA. Fat fisherwomen were pulling these tight skinned shapes over the quays of the small port of Llanes. Natural slime and blood greased the way so that they survived the brutal handling unblemished. We did not eat tunny for dinner that night.

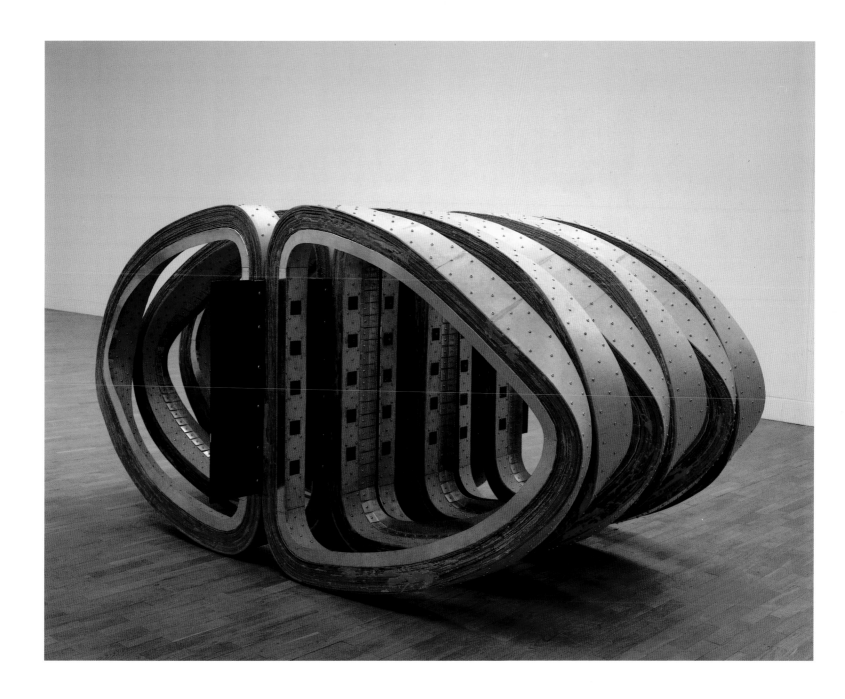

Next day we were glad to blot out that over-truthful image with a visit to the cave of Pindal where a palaeolithic tunny swims gracefully on the wall. One has to step up on to a stone to make out the engraved lines. And all the time the smell of sea and wild flowers hangs about the cave. I suppose that women have been lugging these meaty, full skinned fish over the ground hereabouts for 25,000 years and longer.
Jane Grigson, *Fish Cookery*, p. 201–202

At dusk in the autumn months starlings congregate in large numbers, chattering loudly and chaotically from their roost. All at once the whole flock will erupt skywards, joining other flocks forming a vast congregation swirling around the sky. The organization of these enormous numbers seems inexplicable. What keeps the flock together? Why don't they crash into one another? What is the significance of the elaborately changing patterns in the vibrant mass? As the light fades, the display stops as suddenly as it has begun and the birds return chirping and muttering to their perches for the night. Watching, there is a sense that these patterns can be read, as a sign of tomorrow's

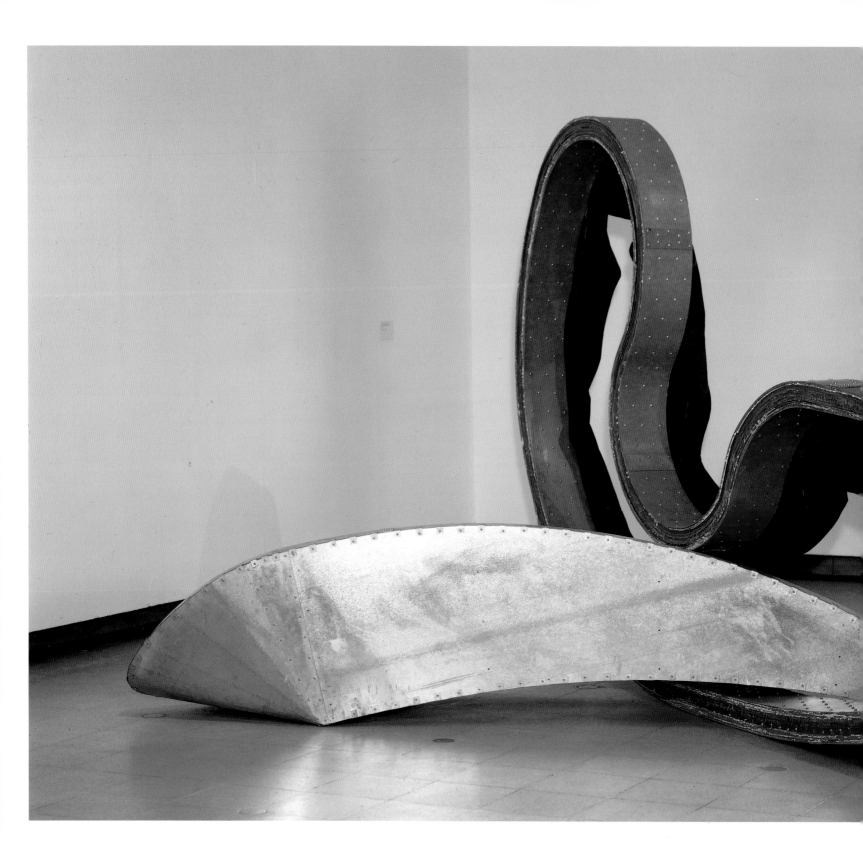

This, That and the Other
1985
Laminated hardboard, canvas,
galvanized steel
230 × 400 × 190 cm
Collection, Tate Gallery, London

weather perhaps or as a portent. They can be scanned, as we scan the clouds, for images to read, as are tea leaves in a cup, for clues to the future. The great silver shoals of herring that once occurred in the North Sea must have inspired similar musings. Where have they come from? Where are they going? What can they tell us? On land, the wildebeest wandering across the Serengeti plain form the last awesome herd that ebbs and flows with this same mysterious organization, the individual by virtue of number reduced to a particle in a fluctuating pattern.

Pattern is evidence of structure – at all levels from the twist of DNA to spiralling galaxies we read pattern as the evidence or consequence of structure; of forces, laws or interactions. Thus we infer that pattern in the flock, shoal or herd must in some way be consequent. This habit is very hard to break. A part of the difficulty is the specifics of the particles. Animals, fish or birds are volitional in ways that we don't believe stars or genetic material to be, so that in seeing pattern (and this is particularly so in collections of vast numbers) it is that much harder not to treat it as evidence of 'grand design'. Or as a sort of communication. The intensity of this difficulty, of the relationship between the part and the whole, is provocative in the work of Toni Grand, a provocation that is intensified by the absolute precision of titling adopted in the works of 1988-92 – *Sans titre* followed by a date, day, month, year. The relatively simple structures of these works are formed from units of great particularity – individual fish – units whose identity is almost erased by the encrusting resin. At Knaresborough, near Harrogate in West Yorkshire is the cave of Mother Shipton, a local hermit and prophet of some (eighteenth century) repute. In the cave various objects have been (and still are) put under the drips of water continually seeping through cracks in the limestone pavement above. The leached calcium comes out of solution and gradually encrusts the objects. The process is continuous, so that the oldest of them are by now little more than peculiarly shaped lumps, their identity effaced. In the more recent both the lump and its underlying object are visible, a kind of double, one becoming the other. The activity of the prophet pushes forward in time, reading into the future. The steady drip of the calcifying water marks the passage of the future into the past 'Here time turns into space' (or matter). Such doubles seem to be an essential component in the sculpture of Toni Grand, whether in the individual components; in the relation of part to whole; of structure to design; of object to matter; or of time to space.

Toni Grand (cat.), Musée du Jeu de Paume, Paris; Camden Arts Centre, London, 1994

In Praise of Television: Television and Representation 1996–97

Art for Other People No 30
1993
Rigid polyethylene
13 × 60 × 23 cm

I like television and watch it quite often, but grew up in Britain where initially television was not ubiquitous. When I was five my father's job in the airforce took him to Sri Lanka and the family went with him. Before we left we had lived outside Plymouth in the south west of the country. As far as I know the transmitter had not yet been constructed so the spread of broadcast television had not yet reached the south west.

There was no television in Sri Lanka although there was a cinema on the air base, called the Astra. My brother went, and saw *The Dam Busters* and *Godzilla* as I recall. I refused, never having been to the cinema but not thinking it was worth giving up daylight hours for. We returned to Britain after two and a half years, going by the same route but this time docking in Liverpool rather than Southampton. On our return we spent six months in a Dorset village where my parents had a cottage. I attended the village school. There were two classes in the school, senior and junior, with perhaps thirty children, all from the local area. Before our move to Sri Lanka the cottage we lived in had not been connected either to the electricity supply or to main drainage. A soil removal truck toured the village weekly, emptying the chemical toilets. We had a cold water tap but our next door neighbour drew water from a hand pump in the lane between the houses. Things had changed somewhat on our return; there was electric light, a flush toilet. The earth floor in the back, where the chemical toilet had been, was concreted over to make a bathroom. These pockets of rural Dorset were always among the last to be connected to services and the spread of broadcast television still had not reached them. For my contemporaries at the village school, their families only recently connected up for water, sewage and electricity, visiting the market town a couple of miles away was a major outing. For them, my family, coming from Sri Lanka, may as well have come from Mars. My slightly older brother bore the brunt of the resulting antagonism. From Dorset we returned to Plymouth and, unusually for an airforce family, went back to the same house. While we had been away broadcast had spread across the country and television was everywhere. Everything else had remained the same, but the one thing that had changed, changed everything. We did not immediately have a set; I went next door and watched a neighbour's, but soon I knew the schedules and became distraught at missing my favourite programmes. It was an addiction, but a passing one. I don't remember when a television arrived in our house and the aerial was fitted to the chimney, but it was within a year of our arrival. As a teenager I was less interested in watching and stopped when I went to art school, deliberately missing the moon landing, for example. I started watching again when my own children were in nursery school some thirteen years later, enjoying the ritual of sitting and watching

Five (Art for Other People No 36)
1997
Polyester resin, glass fibre
10 × 120 × 120 cm

children's programmes with them. Now I mostly watch television late at night. I don't have strong preferences, I don't particularly like game or chat shows or soap operas but will watch them when I'm travelling. It doesn't seem to make much difference whether I can or cannot understand what is being said.

The point of this is to say that, in my life, there is a *before*. This is different from a life where television has always been present. I don't think of television as being a part of existence. It is for me an additional existence, more exotic in some ways than the jungles of Sri Lanka or the fish in the Indian Ocean, less familiar than a house with earth floors and no services. You should not think I was technologically naive; my father flew aeroplanes and drove fast cars, my mother was a doctor and had been a surgeon. I'd had X-rays and seen radar – although as children we also listened to music on a wind-up gramophone and heard stories from an enormous radio with a glowing dial and cloth covered speakers. No, the point about television is that at first it was nowhere and then it was everywhere […]

One of the late 1950s programmes that I watched was a DIY programme presented by Barry Bucknell. Although the medium was developing rather fast, this was still relatively primitive studio-based live television. The sophistication and range of camera movements was restricted. It was monochrome. The format was frontal, played to the camera, following a standard sequence. At the start a project was suggested – make a simple piece of furniture, a telephone table, a magazine rack or spice shelf for example. Alternatively it was a simple DIY task, wallpapering a room or hanging a door. Materials were specified and tools demonstrated. It is not incidental that the late 1950s saw the introduction of reasonably priced, hand powertools into the domestic market. The exigencies of time and television broadcasting meant that despite a carry over from one week to the next no task was really ever carried to completion. Each stage was started and then replaced as the work at hand was pushed aside and a more finished substitute retrieved from under the desk. The programmes were totally stupid. No one could possibly have wanted to make the items displayed or was willing to wait week after week to finish them. And the television was not portable; you needed an external aerial. Converting the front room into a workshop seems impractical though a pleasant thought: thousands of dust sheet-covered rooms, trestle tables laid out with tools and materials. And it was impossible to keep up. No stock of pre-prepared bits lay with the viewer. For a ten year-old watching, however, it was fascinating stuff, particularly the demonstration of the action of tool on material to be immediately followed by a result. Each stage opened certain possibilities; you can do

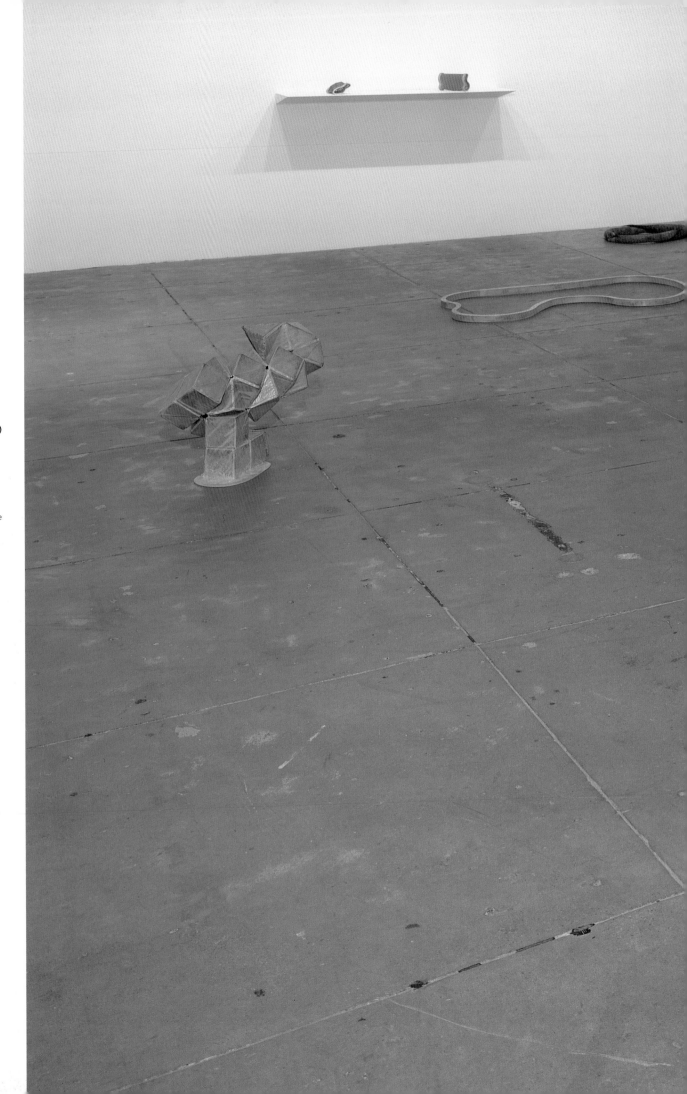

overleaf, Installation, Marian Goodman Gallery, New York, 19xx
background, l. to r., **One (Art for Other People No 32)**
1996
Cardboard, epoxy resin
52 × 71 × 32 cm

Four (Art for Other People No 35)
1997
Steamed beech, aluminium
3.5 × 156 × 92 cm

Pet
1995
Felt, animal hair
6 × 76 × 56 cm

Three (Art for Other People No 34)
1997
Oak, epoxy resin
2 × 100 × 74 cm

Seven (Art for Other People No 38)
1997
Steamed beech
56 × 168 × 92 cm

Two (Art for Other People No 33)
1996
Polycarbonate
31 × 73 × 75 cm

foreground, **Plant**
1995
Epoxy resin, nylon net, glass fibre
37 × 78 × 36 cm

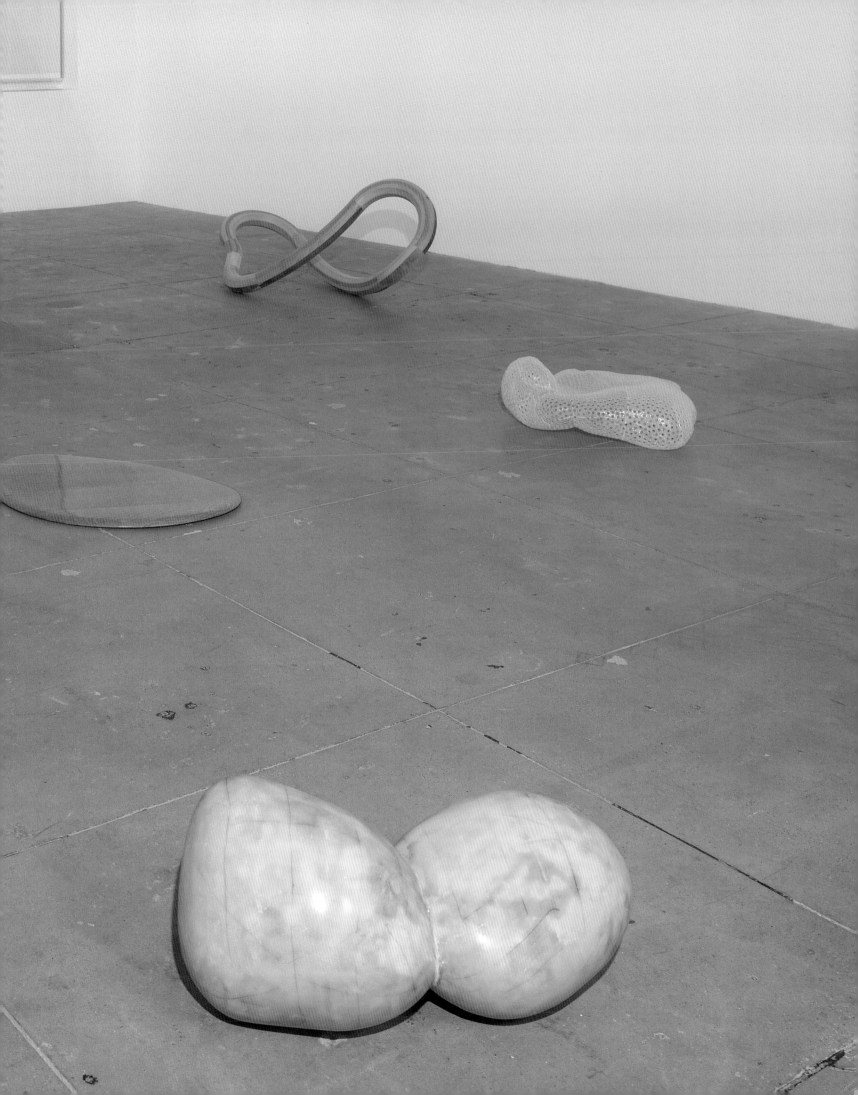

this and you can also do this. Although there was an end in view, the progressive abandonment of uncompleted stages along the route and the substitution of one stage for another implicitly multiplied the product. This meant that the end was not prioritized as the sole orientation. There was an end, and that was that.

What was and is fascinating to me about television is its marvellous closeness to, yet simultaneous distance from the world […] What television introduces, and in this sense Barry Bucknell's programme seems paradigmatic, is a device for looking at the world that transcends or fragments the boundaries of sequence, time and space while subverting the established social and political processes. In this, and this is the point of the story, looking at television is very close to the experience of making art.

Ambiguity and ideas of the future

This text started with a small group of pictures that I had begun to use at the end of talks about my work. The pictures were a parallel to the sculpture and were aids in my wishing to discuss issues such as depth, complexity, ambiguity, meaning, text, reading and reference in my work. The pictures were also a way of referring the work shown back to things seen or experienced. The number of pictures began to grow and I started to collect them together in various groups and various ways. Some became a photographic project called *This Is Not a Story* (several images from which are incorporated in the series of prints *Show & Tell*, 1997).

The first picture shows a cloud in the sky, the second burning fields seen from an aeroplane. The cloud in the first could also be the smoke in the second. The third image is a view of Dubrovnik after shelling, the pall of smoke from burning buildings adding a darker twist to the cloud/smoke from the first two images. The gesture of the statue in the foreground of the third image is repeated in the fourth, which is of a journalist putting up her hands to protect herself against water thrown by the soccer player Paul Gascoigne's mother. The water itself forms an amorphous shape at the centre of the image which is echoed in the fifth by the momentary shape of a flock of starlings photographed over a Yorkshire town. The flock itself is only a blur but the swarm of bees in the sixth image shows a quantity of individuals gathered together and making a shape by virtue of their number, as do the crowds in the seventh image, swirling around a square enclosure at the centre during the funeral of Ayatollah Khomeini in Iran.

Clouds, smoke, water, flocks of birds, swarms of bees and crowds all have transient, shifting forms. The eighth image shows branches moving in the wind, the blurred branches becoming a photographic manifestation of the invisible, of flux and

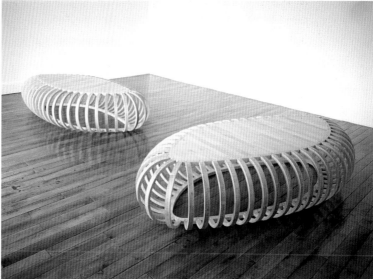

movement. The next three images are somewhat metaphorical, representing aspects of the ways in which the initial images have been constructed, as well as their interconnectedness.

The woven branches in the ninth image manifest a complex spatial interrelationship. The warp and weft of weaving is a paradigm for construction and storytelling, a pattern appearing in and through time. In the tenth image the illustrations from the cheap melodramas displayed outside a Viennese newsagent tell a story. However, the same illustrations are displayed in different sequences, so the story changes even though its parts remain the same. Images tell stories, suggest contexts, and the burning car on the billboard in the eleventh image, a picture telling a story, refers by quotation to the smoke at the beginning of the sequence. The twelfth image is again of clouds, bringing the sequence full circle.

This sequence is constructed by association, one thing leading to another in a variety of ways. The images, of complex shapes and of momentary or indefinite events, allow this kind of associative interconnecting. Complex and allusive patterns have often been used as signifiers or portents, whether of the weather or of the gods; of the actions of armies or of individuals. Clouds, smoke, entrails, the flight of birds, the fall of sticks, the spread of tea leaves, the scatter of dust: such patterns are divined, the future is guessed. Randomness (or complexity) allows for reading, opens a horizon of possibility. There is thus an aspect of optimism in the undetermined, a willingness to read into that opening which has a public place. Both in social and in individual terms alternatives are declared possible. However, one can also be a 'slave to superstition'.

Mary Douglas, in her book *Purity and Danger*, suggests that the unformed or undifferentiated always lies at the beginning, and that the task of knowledge or belief has to do with differentiation. The abominable nature of ambiguity is always a problem for rigid systems of value. In Douglas' view the unformed or undifferentiated, ur-matter, by virtue of both negativity (not being something) and potential (about to become something else) is dangerous (that is, polluting) yet highly potent. Dirt, by being precisely that which is free of form or location (matter out of place) is not only profane but, at the same time, deeply sacred. Thus the polluted may be intrinsically holy and need very careful management. This ambiguity is embedded within all belief systems. The deviant or transgressive are both better managers of contradiction and also less dependent on authority than the fanatic and may therefore be more effective agents of transformation [...]

above, left, Installation, 'Richard Deacon: Show and Tell', Musée de Rochechouart, France, 1997
l. to r.,
Art For Other People No 41
1997
Wood, epoxy resin
40 × 32 × 43 cm

Art For Other People No 39
1997
Nylon net, linen thread, MDF
77 × 22 × 10 cm

Art For Other People No 43
1997
Cardboard, polyester resin, glass fibre
28 × 28 × 112 cm

Art For Other People No 42
1997
Wood, epoxy resin
14 × 32 × 25 cm

above, right, **Table A**, **Table B**
1997
Steamed beechwood
54 × 239 × 130 cm each

Show & Tell
1997
Silkscreen on paper
60 × 89.5 cm; 89.5 × 60 cm each
Series of 12 prints

right, **Ants No 1**
1998
Colour photograph, ink drawing
51 × 61 cm

below, **Hominid footprint trail,**
Laetoli, Northern Tasmania
Black and white photograph from
the artist's archive

Teufelstritt (Devil's Kick),
Munich Cathedral
Black and white photograph from
the artist's archive

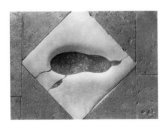

Truth, proof, reading and resemblance

Starting from a simple news story published in *The Guardian* in 1995, that Turner's fingerprint on a painting establishes, by a forensic rather than art-historical process, that he was the author of a particular work, I want to discuss the complex issues raised by the connection between maker and mark: as evidence, as substitute, as representation, as guarantee and as truth.

Mary Leakey's discovery in the early 1970s of the hominid footprint trail in Laetoli, Northern Tanzania is proof that there were hominids 3.6 million years ago in this part of Africa. The trail was made by three individuals walking side by side across a stretch of wet volcanic ash which a subsequent eruption covered and conserved. There is a poignancy to these marks left behind, an identification which comes from their having been caused by somebody alive, an empathy which is far greater than that with the bare bones. They walked the walk and perhaps, since they were walking side by side, talked the talk.

A newspaper description of the discovery by Jean-Marie Chauvet in December 1994 of a hitherto undisturbed cave in southeast France was particularly evocative, talking about the footprints on the floor as if the inhabitants had just left. There was a palpable sense that just beyond the probing light of the exploring archaeologist the last Cro Magnon were slipping away, leaving their footprints behind. The story, in connecting the explorer's light, the paintings on the cave wall and the footprints on the floor, nods in the direction of Plato (as if the Cro Magnon were the inhabitants of his cave) whose world we know only by shadows.

Footprints then are compelling evidence of presence, indubitable markers. Such evidence can, of course, be used for an imaginative construction. The *Teufelstritt* (*Devil's Kick*) – a footprint-shaped defect in the stone of Munich Cathedral – is not necessarily proof that there is a devil, that he has a physical presence and kicks angrily against the walls of God's house. However it is relatively easy to reconstruct this thought process, the idea that such a mark must have been made by something.

Theories about the origin of art have two main directions; one is that painting derives from copying or tracing outlines of shadows so that the image stands for, looks

Ants No 2
1998
Colour photograph, ink drawing
51 × 61 cm

like or, literally, represents the absent person. Shadow prints such as those on the walls of caves at Altamira in Spain, Peche Merle in France or Kakadu in northern Australia are produced by putting a hand against the rock wall and spraying or blowing pigment from the mouth, thus leaving a shadow impression of the masking hand. Such negative marks stand in for their absent executors. However, once unleashed, the idea of resemblance takes on a life of its own so that, as in the case of the *Teufelstritt* natural resemblance, the chance configuration of marks or representations supplies super-natural evidence of God's handiwork or provides proof of the physical existence of benign or malign presences.

There is an ineluctability to reading likenesses that runs the gamut from sympathetic magic and witchcraft through the supernatural to the merely curious – media reports of a sliced tomato revealing the name of Allah inscribed in the pattern of its seeds and a bun bearing a likeness to Mother Theresa of Calcutta being recent manifestations […]

The writing-like marks on the Runamo rock in Sweden were transcribed by the Icelandic scholar Finn Magnusson in 1833 and translated, having been identified as an epic five-poem cycle in an ancient metre. Subsequent research by Swedish geologists found the marks to be natural fissures in the rock. Magnusson's work was thus discredited, though one can also look at it as a triumph of translation and remember, as Marina Warner has pointed out,[1] that 'cracks on oracle bones, produced by priests applying a hot instrument, may constitute the first written script and reading may have begun with the need to decipher these enigmas'.[1]

Twentieth-century psychology exploits such imaginative reading as a diagnostic device. The patient is shown an ink blot and asked to describe what the image is of. It is an invitation to read the random pattern, to construct an image, to translate the marks. This description is then correlated against standard test responses, disturbance being indicated by variation from that standard. The test is rarely used now because of its inherent subjectivity.

The second direction taken by theories of art's origins of art is the assumption, related to sympathetic magic, that likeness is a more powerful connection between

things than mere appearance. The handprint stands in for the man and, in the same way that resemblance is a two-way street, so the image can be thought to have a magic link with its source. Image-making is then directed towards control, management or manipulation […]

Resemblance, replication, representation and mimicry are a part of the way the world works. In *Beyond the Pleasure Principle,* for example, Freud suggests that imitative play is a means of mastering the external environment. Much of mediaeval science is based on similarity, on the principle of likeness implying some kind of affinity. Modernity is based on articulating difference.

William Harvey's light-hearted nineteenth-century maps identify place and stereotype: Germany as an educated spinster, Ireland as a rural peasant with her baby. From a different context Belgium becomes her symbolic lion. These images propose a link between place, symbol and kind, introducing reflexivity, that the image as in Arcimboldi's paintings may be made by that which it is an image of, that a man may be made by the objects of his occupation. The Agricultural building at the Chicago World's Fair of 1893 used a classical archetype, a Hellenic Greek temple, but the columns supporting the building were made of grain. The building was reflexive, a representation of itself. The state of Ohio in its pavilion at the same World's Fair presents a picture of the prairie made from its grasses.

Mimicry occurs frequently in nature. Insects may mimic their predators to escape predation or mimic their habitat as camouflage. A plaice is able to transform the patterns on its skin to approximate the pattern on the bottom surface of the sea, externalizing or retranslating that perceptual information back onto its own skin as if it were looking at itself from outside.

Plants mimic insects, the bee orchid mimics the female bee and uses the duped male as a pollinator, carrying pollen from one frustrated encounter to the next. The Darwinian mechanism of reinforcement is clear – orchids looking vaguely like female bees spread more pollen, the bee itself producing the pressure that over time modifies the flower's form. It is, however, a remarkable plant-insect interaction. Humans mimic their gods in order to talk with them, and safely tell their stories.

The oldest woman in the world
This was the title of an artefact seen displayed in the Israel Museum in 1994. The accompanying display panel read as follows: 'This figurine unearthed at the archaeological site of Berekhat Ram in the Golan Heights belongs to the Acheulean

culture of the early Stone Age in Israel and predates the earliest previously known sculptures by hundreds of thousands of years.'

Image is always intentional and to a degree is in the eye of the beholder. The claim is that the pebble has been intentionally modified to produce an image of a large breasted, big buttocked female form similar to that of the Upper Paleolithic 'Venuses'. To my eyes it looks like a lumpy pebble. The association of the find with very ancient deposits (the archaeological horizon is between 233,000 and 800,000 years BC) implicitly pushes the existence of a figurine (and the associated cultural ramifications) back from, at the earliest, 30,000 years BC for the Upper Paleolithic, to perhaps 300,000 years BC. A dating this extreme is out of kilter with the date for the emergence of *Homo Sapiens* in Africa, 100,000 years ago. Whoever made it was like us but not 'one of us' [...]

There are always arguments about origins, beginnings are hazy and history is written backwards. However, if material and symbolic culture does not appear with the emergence of *Homo Sapiens* but has a very much older, less specific history, then, for example, the mimicry of plants and fishes becomes something that we barely understand.

As image processing, digitalization and data processing techniques have improved, it has been possible to look deeper and deeper into space at fainter and fainter sources. In effect, since distance in space is measured in time (so many light years away), this looking is also a looking backwards in time to earlier states of things. By focusing on background microwave radiation from a very narrow area of sky uninterrupted by near stars or distant galaxies, it has been possible to produce an image of space from shortly after the Big Bang. That is, from shortly after the beginnings of space and time themselves. The image is muzzy, the protean nature of the source reinforced by indistinctness of the image, by its translatability, ambiguity or amorphousness. To make the point one only has to speculate if the same image but clearly geometric would be credible.

'*Our representation of things, as they are given, does not conform to these things as they are in themselves, but that these objects as appearances conform to our mode of representation.*' – Immanuel Kant.

1 Marina Warner, 'Making Secret Visions Visible', *Inner Eye: Art Beyond the Visible* (cat.), London, 1996.

'In Praise of Television: Television and Representation', Association des Amis du Musée Départmental de Rochechouart, 1998. Revised 2000.

opposite, **William Harvey**
Map of Germany, from
Geographical Fun or Humorous Outlines of Various Countries
1869
Hodder and Stoughton, reprinted by Wychwood Editions, 1990
From the artist's archive

Colour Changes in Flatfishes
Platophrys podas
The same individual on two different grounds
British Museum (Natural History) postcard from the artist's archive

Figurine from Berekhat Ram
Date unknown,
c. 30,000–300,000 BC
Stone
h. 3.5 cm

left, **Cambridge telescope image showing traces of the Big Bang**
Photograph published in *The Independent* newspaper, 29 March 1996
From the artist's archive

London No 4
1998
Photograph, ink on paper
51 × 61 cm

Lisbon No 2
1998
Photographs, ink on paper
51 × 61 cm

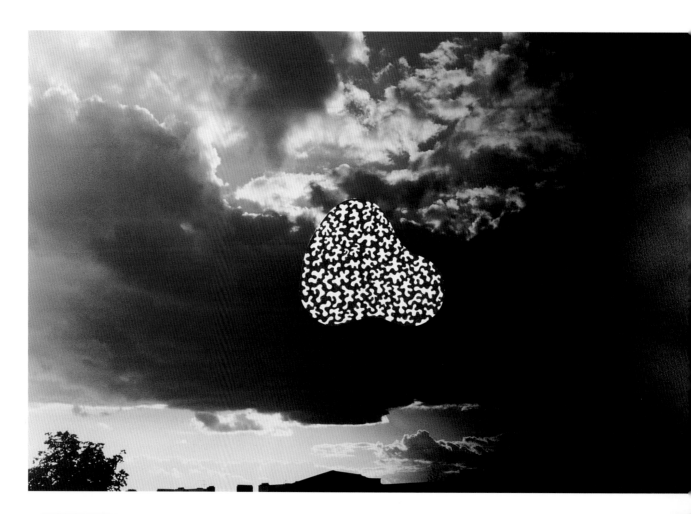

Caithness No 2
1999
Photographs, ink on paper
57 × 85 cm

Caithness No 7
1999
Photographs, ink on paper
57 × 85 cm

Interview with Ian Tromp 1999

Ian Tromp You have described your series of drawings, *It's Orpheus When There's Singing* (1978-79), as 'intentionally extremely representational', yet you go on to say that you have difficulty in 'deciding what they are representations of'.

Richard Deacon **The question for me is whether resemblance can be detached from objects. That quote was connected with trying to work out whether the conjunctions of resemblance, reminding of, referring to, are simple associative categories or whether they refer to something else. Metaphor is an example of a way in which objects can be put into relationship without them having any necessary resemblance. Two things are put into conjunction and then you see the one in the other. It was the ability to evoke a similar kind of response that I was trying to create. This requires a certain level of ambiguity, of giving and taking away at the same time.**

Tromp You've also discussed the importance of deliberately placing yourself in a situation where you don't know what you are doing.

Deacon **Yes, idleness is quite productive in that sense.**

Tromp You are interested in chaos theory, which is concerned with the appearance of form in the world. One basis of chaos theory is in chance, but it seems also to be procedural, as for instance in computer-generated images that are outcomes of mathematical procedures. You've just been speaking about chance, but have you also been affected by procedural or systems thinking in your form-making?

Deacon **Originally my interest in chaos theory was in the idea of interconnectedness that it implies; then I became attracted to its notion that order comes out of disorder. Now I'm more engaged with ideas around emergence, which relate more to complexity theory, in which it is seen as inevitable, in any sufficiently complex system, that order will emerge. Between two kinds of systems you have an interface, along which an ordered complexity emerges. The classic example is the turbulent flow in certain liquids: there's a point where the liquid is moving too fast for there to be anything coherent about it and another point where the liquid is moving slowly and it's entirely coherent. But there is also a point between these two at which ordered pattern emerges, in the form of vortices, ripples and eddies. This is what interests me, this openness that emerges between those two states – it's not to do with generating a**

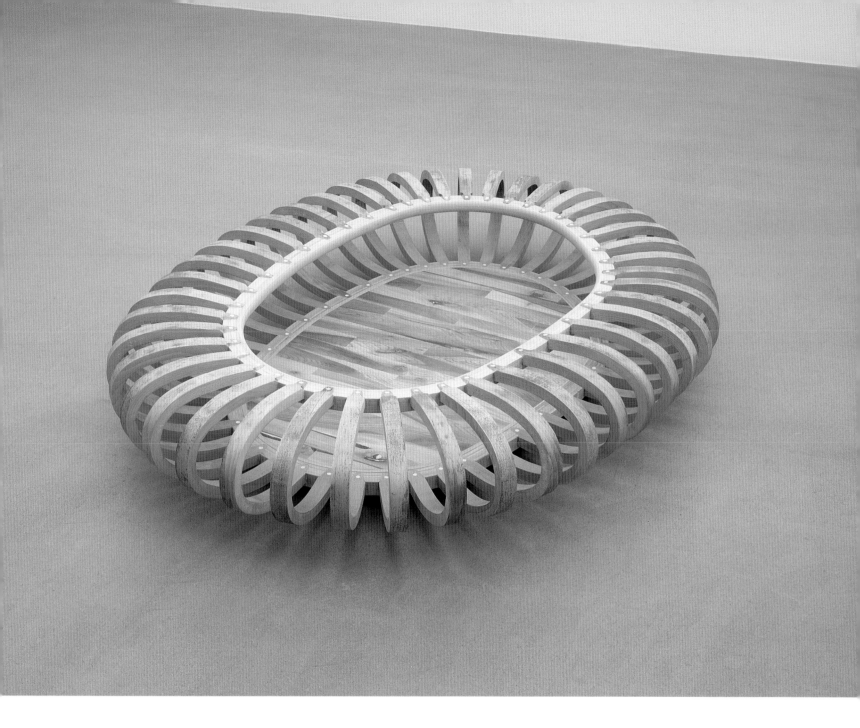

pattern from a mathematical programme, it's to do with a point of transition between order and disorder, where different kinds of ordering emerge.

Tromp In looking closely at your work I was impressed by what I recognize as signs of making, unmaking and remaking in different stages. For instance, *What Could Make Me Feel This Way (A)* looks as though it was joined together differently at some time to the way that it presently is. I assume this is due to individual sections being made separately and subsequently jointed together – there are holes where screws seem to have been.

Deacon **Some screws are taken out and some are not. Screws are used to hold pieces in place; they come in and go out and they locate things. In that work the diagonal strips were bent on the work, rather than off it; it was its own mould and its own former in a way that the other two large bent wood sculptures aren't. I tend to keep the screws in at the ends of bits of wood because that's where the joints are most fragile. I have in the past taken them all out, or left them all in. I want to make them work in a way that isn't purely instrumental or functional, so that either they appear as a part of**

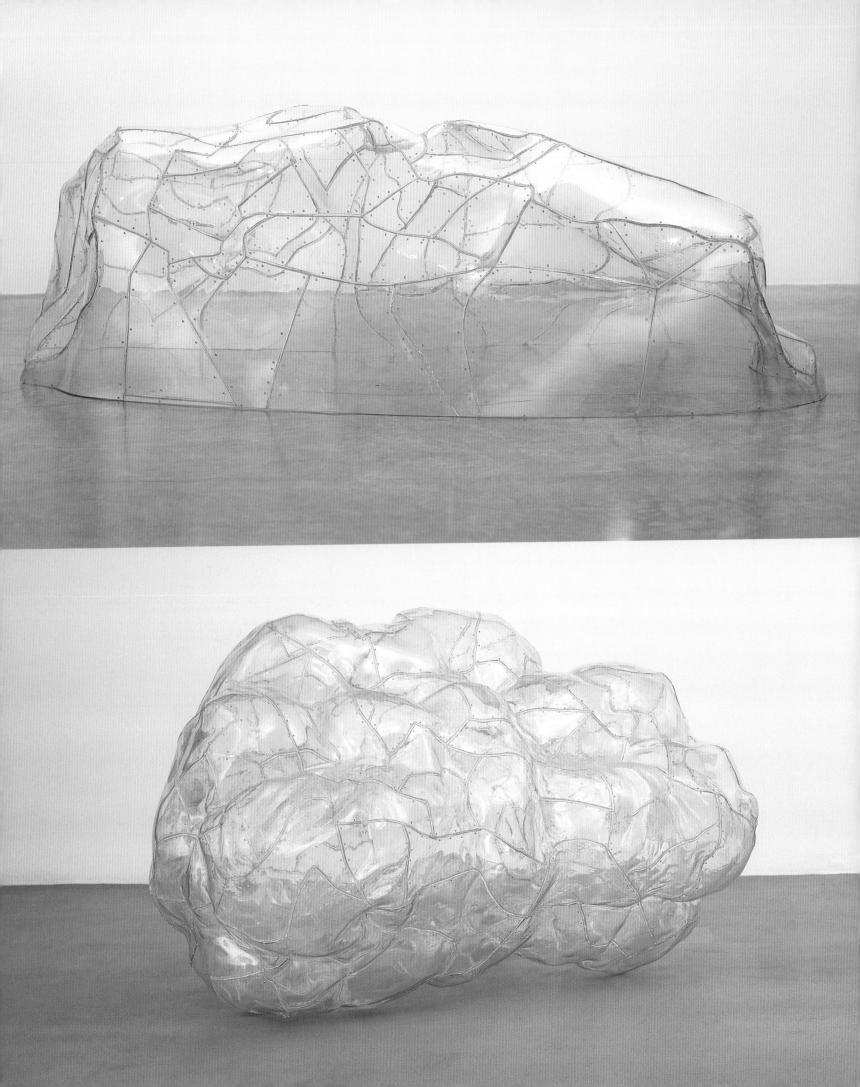

pattern or excess, or their absence becomes notable.

Tromp At your retrospective (Tate Gallery Liverpool, 1999) you responded to a question about the finish of your works by saying you leave things neat or untidy on the basis of a judgement as to what level of attention that feature is going to get.

Deacon **It's not so much the level of attention that the thing gets as the level of attention that it needs – or a combination of the two. One of the reasons for skirting boards is to hide the awkward gap between the floor and the wall; they allow for a level of craftmanship which doesn't pay particular attention to articulating the gap more directly. But if you specify no skirting board then you really need to attend to that. In most of my sculptures the finish, irrespective of whether you see it or not, is consistent throughout the piece. So the 'point of attention' receives the same kind of articulation where the joints are hidden from view. The question referred to the small work *Table E* (1999) and its difference from the larger-scale *After* (1998). Why was the jointing more elaborate on the smaller than on the larger sculpture? The answer is that these are two different kinds of object and the convergence of the ribs is actually a different matter in each. Whereas the ribs on *Table E* converge around a form, there's a sense of unfocused sequence in *After*; you see each joint sequentially in *After*, but in *Table* they gather around a middle. The question was also connected with the way the joint was housed: in a kind of dovetailed detail on *Table E*, but just butted up on *After*. The butting up articulates continuity around a shape rather than focusing in on a part, whereas due to the size of *Table E* it's much clearer to see it as a whole object; I was trying to give it a sense of completeness.**

Tromp Another aspect of making and unmaking is seen in some of the plastic works such as *Almost Beautiful* (1994) and *From Tomorrow* (1996), in which there are drill hole marks, suggesting that the plastic sections had been sewn together at some time.

Deacon **Those works are made over formers. I've been using plaster formers and mapping the surface in order to eliminate three-dimensional bends in any of the pieces. I take templates of that mapping with pieces of paper which are then used to cut the small pieces of rigid plastic. Once heated, the rigid plastic becomes malleable and is located on the surface to its corresponding pencil-mark. But because it's quite hot when it comes out and it's a manual process of pushing down and shaping over the**

Not Yet Beautiful
1994
Welded polycarbonate
70 × 210 × 120 cm

From Tomorrow
1996
Welded polycarbonate
102 × 156 × 134 cm
Collection, Museum of Modern Art, Sarajevo, Bosnia/Herzegovinia

161 Artist's Writings

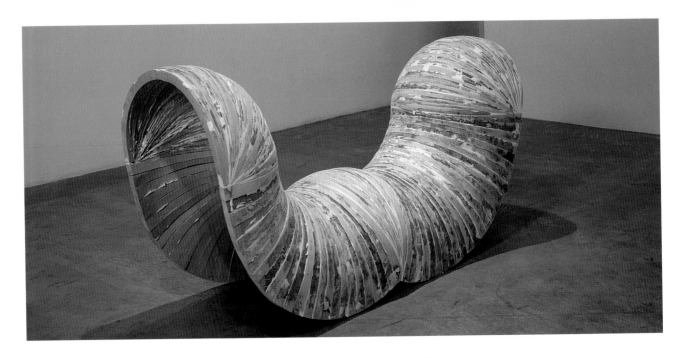

surface, we devised a system of screw-pegs which hold the plastic down, screwed into the plaster and then a wooden peg that grips the edge. So the first piece you put down abuts on all sides to plaster – when you hold it down the piece of plaster is perforated. There is a conundrum which arises in that the next piece you put down has some of its edges butting up to a piece of plastic that's already laid in. For fear of loss of alignment, rather than removing that and putting it back again, we drill through those sheets of plastic to provide a point to pull the edge of the hot one. You can't drill into the hot plastic, because it's soft, so you have to pull it down with a peg. So as the work goes on, you end up with corresponding holes in the work which are a function of this business of holding down, and as it's built up the sections are welded together into a complex sheet. However, they're not completely welded together – there's a larger division of the form into however many parts will separate to allow you to take the solid away subsequently. And so if there are ten pieces, each piece made up of fragments, those little holes become very useful because they enable us to do exactly what you described, to sew them. Using wire loops we sew the plastic back together prior to making the final weld and then cutting the wire. I liked what the holes did because they were quite like what we've said about the screws. I liked their absence. I did make one commissioned piece without making holes in it, just to see what it was like to do it without holes. It is a very different surface. It was very elaborate to make – we had to make the pieces oversized and cut them back to fit. It does get quite complicated, because I think that in a way the more you finish things, the more the material disappears. It's particularly so with picturesque materials like wood, which become more beautiful the more you finish them. They tend to erase their materiality. The transparent material for the plastic works is probably most beautiful when it first arrives – no amount of work you put into it actually improves it.

Tromp Do you approach sculpture primarily from the point of view of material and form and the viewer's body meeting the body of the sculpture, or is there an affective or imaginative level on which your sculpture works?

Deacon It's difficult to distinguish form from the imaginative ways in which one constructs it. I think that when a sculpture is successful the material, form, structure and associations are all present and the sense or possibility of meaning is also present. What I think gives the sculpture its drive or potency is a tension between what you can see and what you can't see, what you imagine, picture, construct, refer to or associate

with. The sculpture retains its physicality while allowing a richness of readings, but it never ceases to be an identifiable physical object made of a particular material.

Tromp You seem very interested in materials.

Deacon **Yes, I'm interested in the continuity between the world and materials; they are of the world but also sustain an imaginative response, so that they point in two directions at once. I'm not less interested in the imaginative response, but it's often more difficult precisely to discuss its nature.**

Tromp Most of the small works you make are in the ongoing series *Art for Other People*. When did you start making these? Was the seed for them a kind of democratic urge?

Deacon **I began making them in 1982. In an interview I was making a real hash of discussing a group of works I'd made, and when I came out afterwards I thought, 'I don't need to do this, I can make sculpture that does this.' So they were made, in a way, like writing letters to people. They were intended to work non-contextually, so that you could take them anywhere and they could function anywhere. Also most of them are not particularly gravity-dependent, so that they can be lifted up and placed on different kinds of surfaces. What I also found interesting is that if you call something 'art for other people', when you look at it as a viewer you don't think it's for you, and you wonder who the other people are.**

Tromp Do you make drawings as art objects in themselves, or as a stage in making sculpture?

Deacon **It goes in phases. Every five years I seem to come up with a group of drawings. When I was at school I made a lot of drawings. I loved to draw, I drew obsessively and continually. When I went to St Martin's, I stopped drawing completely and started writing. In a funny way drawing and writing are very similar. Partly, it was a contrary attitude, because I was starting to have quite strong beliefs about how you should and shouldn't make things, and what it was that I wanted sculpture to be. I definitely didn't want it to be workshop practice. The idea that you drew something and then made the thing you drew seemed to me not what I was interested in doing at all and I stopped drawing in order to not do that. Then I did a lot of performance work and there was a**

overleaf, **After**
1998
Wood, stainless steel, aluminium
169 × 960 × 346 cm
Installation, 'New World
Order/Richard Deacon', Tate
Gallery Liverpool, 1999

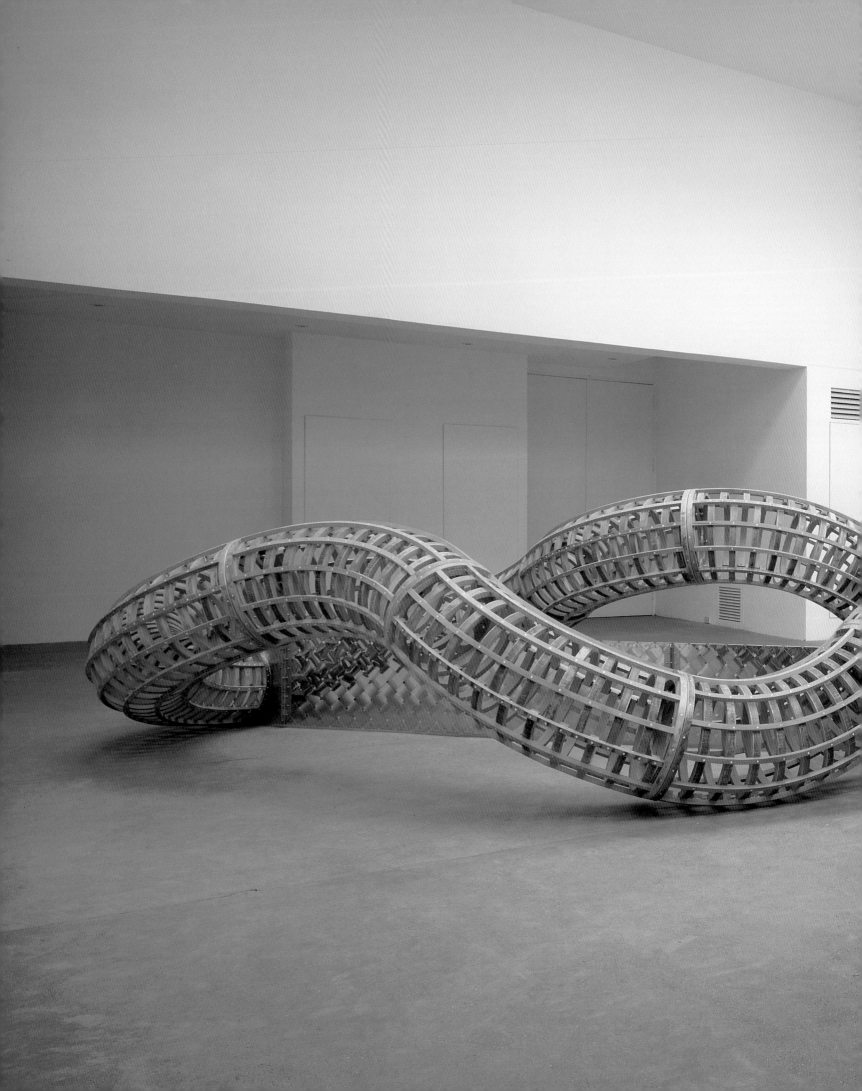

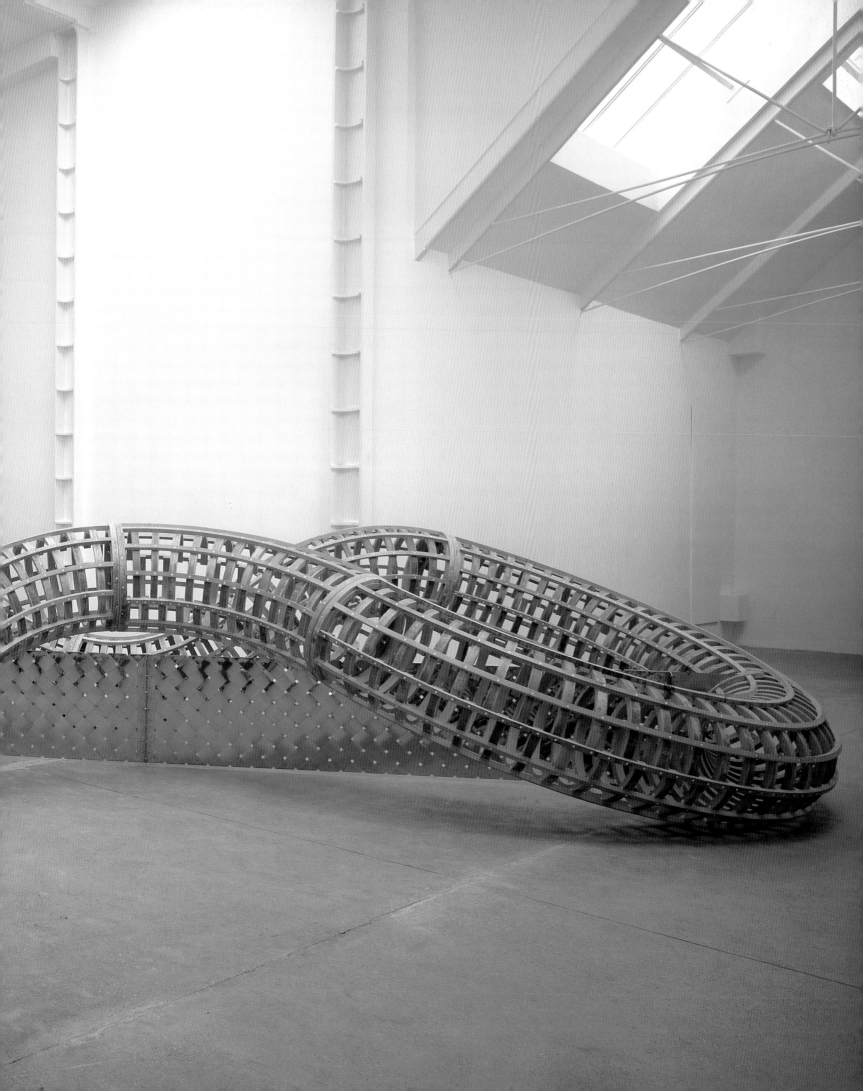

right, **You**
1998
Wood, cloth, epoxy resin
130 × 143 × 35 cm

opposite, **However Jack**
1998
Paper, card, cotton thread, epoxy
21 × 450 × 15 cm

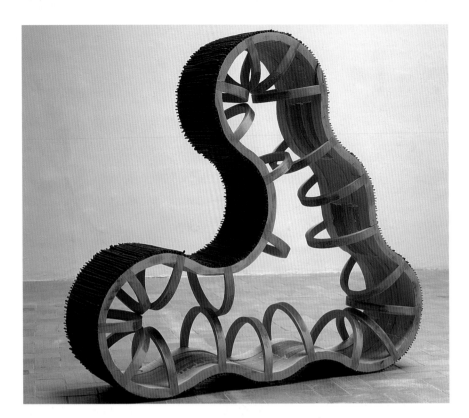

period before and just after I started at the Royal College when I began drawing quite extensively. That rehearsed a way that I started to make sculpture at that time. I was searching for form that had ambiguity and multiple referents, so what we said earlier about representation applies here. Some years later I was working on a commission and wondered what it would be like to have someone make something that I'd designed. So I tried to draw something completely, to describe something in drawing so that someone else could make it. It was a long process. And then I started to use drawing in a slightly different way because we were starting to work with quite a lot of steel; I drew things and then used the drawings as templates, so that they started to disappear into the work. There was another group of drawings in 1990 in two sets; one set was concerned with the relationship between shape and line. The second was more concerned with detail, texture and line. Both sets were paired with photographs and became an artist's book called *Atlas*. For a while now, the way I have been drawing has been fairly consistent – black, non-tonal drawing.

Tromp There are distinct styles within that: comic book, biological, medical and architectural.

Deacon **One of the interesting things about drawing is that it is used in a number of different ways of dealing with the world – science, archaeology – it refers to and also represents the ways those disciplines see the world.**

Tromp All the time we've been talking you've been playing with an elastic band – is that another way of drawing?

Deacon **[*Laughs*] I am planning to use this. It's on the table for a purpose.**

Tromp Yes, it describes forms – at one moment it reminded me of elements in *What Could Make Me Feel This Way (A)*. So do you do that to come up with forms?

Deacon **I play with things. Like I say, I think idleness is a rich source.**

First published in *Sculpture*, Washington DC, November, 1999. Revised 2000.

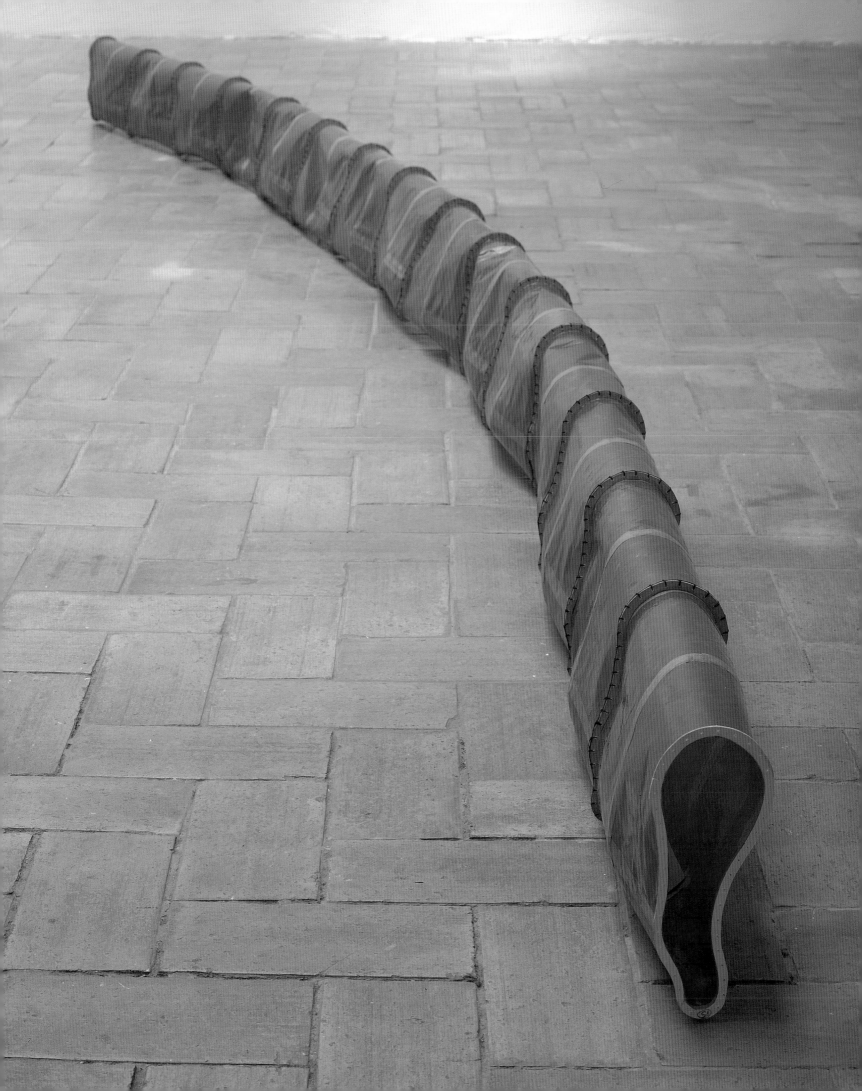

ontents

Interview Pier Luigi Tazzi in conversation with Richard Deacon, page 6 Survey Jon Thompson

Thinking Richard Deacon, Thinking Sculptor, Thinking Sculpture, page 36 Focus Peter Schjeldahl Deacon's Faith,

page 88. Artist's Choice Mary Douglas Purity and Danger, 1966, page 98. Artist's

Writings Richard Deacon Selections from Stuff Box Object, 1971–72, page 110. Artist's Statement, 1982, page

114. Silence, Exile, Cunning, 1986–88, page 116. What Can?, Correspondence with Lynne Cooke, 1992, page 120. What You See Is

What You Get, 1992, page 132. Design for Replacing, 1987, page 138. Design for Factory, 1993, page 139. Reading: A Propos de

Tom Grand, 1993, page 140. In Praise of Television, 1996–97, page 144. Interview with Ian Tromp, 1999, page 158.

Update Penelope Curtis The Interior is Always More Difficult, page 168. Chronology

page 192 & Bibliography, List of Illustrations, page 209.

The first edition of this monograph was published in 1995. In more ways than one, its timing might be regarded as marking a watershed in Richard Deacon's career. During the 1980s, he had made work with 'tremendous ease', a facility celebrated in his solo exhibition of work at the Kunstverein, Hannover in 1993. During the two years that followed, things became more difficult. Deacon began to realize that he didn't know what to do next and was ready to accept that this was good for him. He has often characterized himself as 'contrary' by nature; now, however, not doing the obvious thing was becoming less a matter of choice than necessity. This situation was no novelty to Deacon, who had experienced similar problems in the 1970s. Nor was it necessarily unwelcome: he was ready to accept that it was good for him, and the extent to which his difficulty was self-willed, though hard to estimate, is central to a discussion of this period.

I first visited Richard Deacon in 1995. To me he was an established artist I was getting to know late in the day. Understanding how an artist with a reputation for a certain kind of work creates space in which to reconsider his practice is the background to this text. How does one go about introducing new questions alongside existing experience and knowledge? Can experimental new work co-exist alongside an established idiom?[1]

The watershed had several aspects. Working on this publication from 1993–94 took up much of Deacon's time, and such an intensive review of his own production inevitably promoted self-reflection. It would have been easy to go on selling the kind of work for which he had become well known, but making it no longer seemed so simple. Deacon therefore chose not to go down that road, foregoing the financial advantages and opting instead for a smaller outfit, where he felt that he would be making the crucial decisions on the direction his work should take. This process of decision-making has taken time to emerge, so that it is only now that its full import can be realized.

By 1992-93, the demand for Deacon's work was so great that he would have needed to set up a production line to supply it. However, he realized he wasn't temperamentally suited to managing this kind of production and was conscious that such a practice could tend towards repetition. He both admires and fears the production line, intrigued by the possibilities of the traditional sculptural 'machine'. He has articulated his interest in Rodin as an example of someone who met the demand for his work while simultaneously creating private space, and has also described the methods of his contemporary Tony Cragg as a way of buying time in order to be creative.

Whether or not it was a matter of deliberate choice for Deacon to eschew the large-scale works that have marked much of the output of his British contemporaries in the 1990s, he would in any case assert that he had already made plenty of work on this scale, and was thus, in a sense, one step ahead. By the mid 1990s, the kind of practice to which he felt more psychologically suited was smaller scale and dedicated to 'material diversity'. A conscious concern at the time was to move on to new materials in the knowledge that this would necessitate a different kind of collaboration.

A further significant change, with both

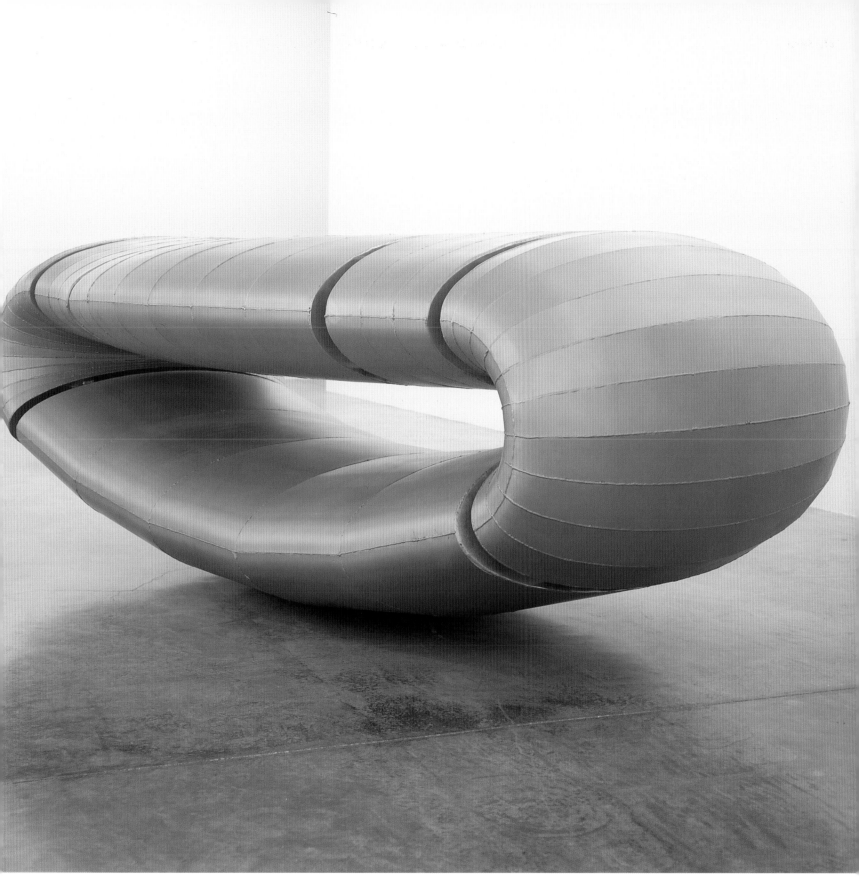

Nothing Is Allowed
1994
Stainless steel
120 × 28.5 × 140 cm

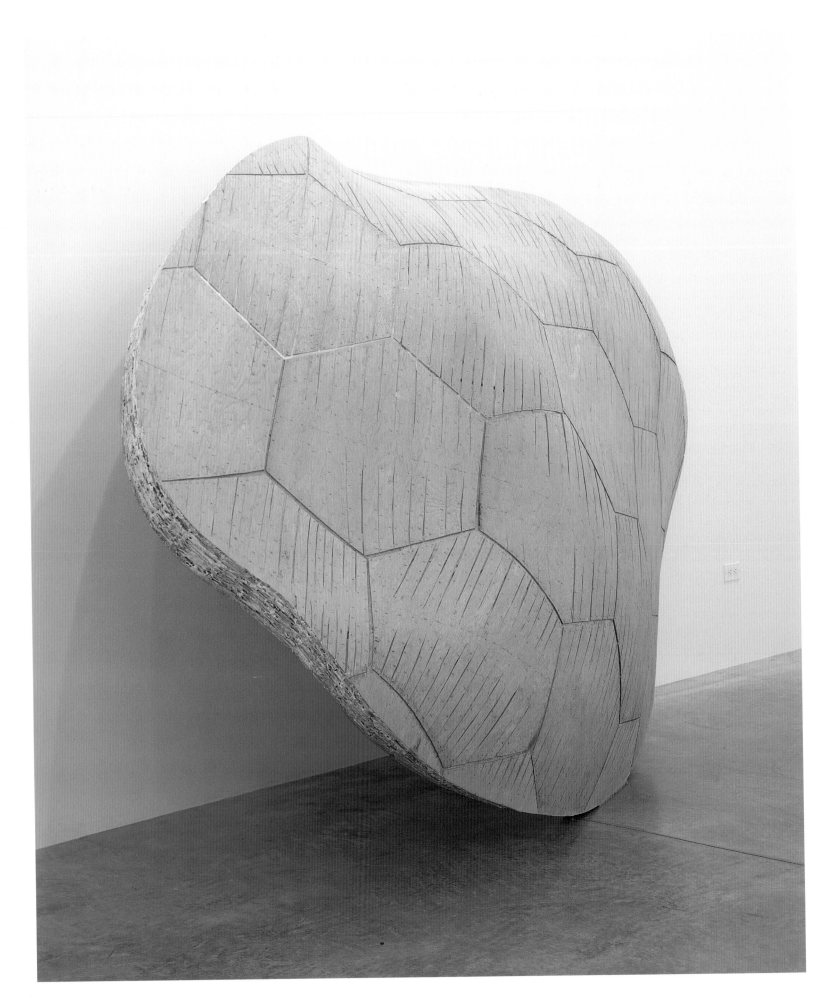

physical and conceptual implications, was Deacon's move in 1995 from his studio in Acre Lane near the centre of Brixton in South London, which he had occupied for the previous eighteen years. In moving to a new industrial estate further out in the South London suburbs, Deacon left behind an environment that had become associated with particular collaborations, and which was full of visual diversity. The walk to his new studio, by contrast, is high and dry, like a cross between a forgotten seaside promenade and Van Gogh's paintings of the railway junctions of nearby West Norwood. The industrial estate itself could be anywhere in the southern English hinterland off the M25 motorway – anonymous, new and very clean. Most of its tenants are involved in packaging and distribution; next to a dairy without any cows, Deacon's studio is easily the most industrial on the estate.

In the autumn of 1995, Deacon moved into a concentrated period of working with graphics. He made lithographs and monoprints at the Curwen Press, and during a period when he was teaching in Vienna, made little drawings, followed by larger ones, which were used for the series of screenprints *Show & Tell* (1997) developed with

Charles Booth Clibborn in autumn 1996.[2] Also in Vienna, Deacon began to present a lecture that later developed into the text 'In Praise of Television' (1996-97, see this volume, pages 144-157). In the course of this lecture, he showed photographs of dispersed images such as clouds, birds or burning stubble. Deacon calls these 'TINAS' ('This Is Not a Story'). What is not a story? Fragmented particles; or signs which read as almost biblical symbols for cataclysm and change but are not fragments of a larger story, even if we wish they were? Deacon presents us with the part and asks us to read it as whole; an insistence we shall encounter again.

The move to the new studio involved sorting out the materials that Deacon had collected in recent years – his own photos and other imagery, mainly from newspapers. This provided him with the opportunity to take stock of what was there, to establish some analytical perspective on what he'd been interested in and why. He sorted the images into categories: *Trees*; *Walls and Things*; *Landscape*; *Animal/Vegetable*; *Bodies*; *TINAS*; *Surface and Water*; *Formation*; *Sky*; *Path and Drawing (schema)*; *Flowers*. In these titles we can detect something of what he was looking for: the shape and how it is

opposite, **Nothing Is Forbidden**
1994
Laminated wood, glue, steel staples
240 × 290 × 95 cm

below, from l., **The Interior Is Always More Difficult (E)**, **(C)** and **(D)**
1991
Paint, vinyl on plastic sheet, aluminium frames
234 × 348.5 × 6.2 cm
233 × 361.5 × 6.2 cm
232 × 278.5 × 6.2 cm
Installation, 'New World Order/Richard Deacon', Tate Gallery Liverpool, 1999

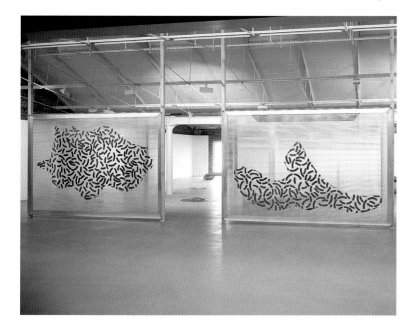

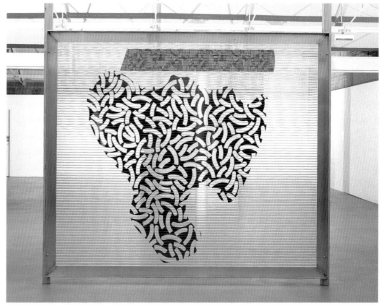

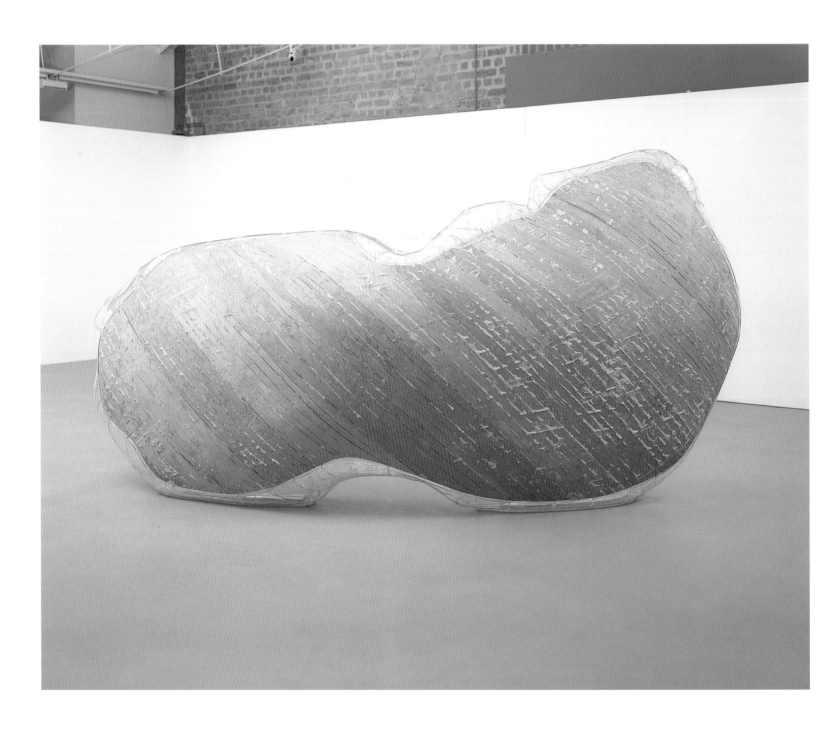

fixed, the image found in matter, the unstable threshold between deformation and formation. This done, these subjects then began to enter his work more actively – as the photographic backgrounds, for example, which house the drawings *Show & Tell*, produced as screenprints with Paragon Press – each more or less representing one of the new-found categories.

Such a methodology – looking at how imagery could help to explain spatial concerns – was foreshadowed by the way in which Deacon used photos in the late 1970s and early 1980s. At this time, they had helped him to explore where a shape ends, how it is 'contained' by its profile at the same time as slipping from it, and how we experience inside and outside.[3] Broadly speaking, it could be said that Deacon engages with photography when sculpture becomes difficult: that the problem of the sculpture is the problem of the image. The fit, or misfit, between the two- and three-dimensional was a difficulty for making sculpture first encountered in the 1970s, then revisited in the period from around 1993 to 1997 represented here.

If anything then, Deacon associates his work of the late 1990s with graphics: with film, television, drawing and printing. This may well have had something to do with the new double-storey studios in which he preferred making drawings on the upper level to making sculpture downstairs. In this light industrial architecture, the most interesting and dominant feature was the view through a screen of window frames. It symbolized a more solitary practice, at one remove from collaborators and colleagues. The use of the frame

or screen as an element that holds imagery while cutting its viewer off is signalled by *The Interior Is Always More Difficult* (in which the drawing disappears from the face of the screen) shown at the Lisson Gallery, London, in 1992 and then in Los Angeles in 1995. It had also been fore-shadowed by Deacon's seminal work in the Mies van der Rohe houses in Krefeld in 1991. Both present a notion of deep and shallow space within two dimensions, in which there are at least two scales available; both suggest an interiority and an exteriority on either side of the screen.

In Krefeld, Deacon had fronted Mies' Haus Lange with painted 'drawings' on vinyl sheeting, extending the formal tension already expressed in the architecture between the apertures and their means of support. Looking into the house from the outside led to the sense that Deacon's sculptures were somehow imprisoned inside. The dichotomy between full and empty, previously articulated by Deacon's work in terms of monumental, linear sculptures filled out by the density of the urban landscape in which they stood, was here expressed by the very forwardness of the works, assertively occupying the limits of the house. No longer did open-work sculpture allow the viewer to be simultaneously in and out; now the sculpture suggested the binary nature of permeable space. By separating out surface and support, plane and line, focusing our attention on each sequentially, Deacon required us to choose our position and how to read it.

Not Yet Beautiful (1994) was the first work made in the new London studio, the first finished piece in polycarbonate, and the first collaboration

with Marcus Kistner, who worked with Deacon on a series of such sculptures through to 1996. Leaving Acre Lane thus coincided with a change in Deacon's relationship to Mathew Perry, with whom he had collaborated particularly on the development of the laminated wood pieces, and who, both agreed, would now work more strictly as a technician, executing designs provided by the artist (while continuing to research their material realization). Perry's close collaboration with Deacon had resulted in an ever-more focused material production; the change in register would now allow for more wide-ranging experimentation.

Not Yet Beautiful was shown as one of six works in Los Angeles in late 1994. The next in the series, *Almost Beautiful* (1994), was shown in the new Museum of Contemporary Art in Helsinki in early 1995 and subsequently acquired for their collection. In this work, Deacon's developing interest in overlaying graphics and shifting surface emerges more clearly. This is seen in the modulation of, and tracery upon, the plastic skin, just as it appears in the overlaying of image on image, whether through technical or physical montage (or inlay), in the graphics he made around this time.

That spring, at the Lisson Gallery in London, Deacon showed a surprise installation, *Them and Us*, made in collaboration with the German sculptor Thomas Schütte. Deacon's contribution, rolled felt pods, was in itself the result of an unexpected encounter with Takehiko Sanada, a textile and felt specialist, taking time out from working with the fashion designer Issey Miyake, and based in the same industrial estate as Deacon.

The pieces of felt took on a pod shape as they were rolled, which they retained thereafter. Thus, though these works may have looked random and flexible, in fact they held their acquired form with great fidelity. This was a shaping of the 'non-shape', an idea that Deacon was following closely.

Deacon's collaboration with Schütte had emerged from their mutual experience as subjects of films by documentary filmmaker Martin Kreyssig. Kreyssig's notion of making a film about artists that featured no artists appealed to them both, and their collaboration at the Lisson was something like its scenario.[4] Schütte's small silvered men, cast in aluminium from wax 'doodles', were built up in a manner similar to the felt pods. Pairs of these figures engaged in different ways with the pods, either with apparent familiarity or consternation, using them, picking them up, or confronting their advance. Some pods rested on small conical plinths; some of the men were protected behind plastic shields. Regarding this scenario taking place at floor level, one was uncertain who represented 'Them' and who should be identified as 'Us'. Who was in control of whom? With these scenes unfolding below their viewers' knees, one was uncertain where to draw the dividing line.

As with many of Deacon's works, an ostensibly divisible title is actually indivisible; the part is also the whole. *Them and Us* belong together, just as, upstairs at the Lisson, *Beauty and the Beast* (1995) also presented an oppositional pairing, with each work bearing the same double title. The juxtaposition of one piece in clear and glistening polycarbonate with another made up of almost

leathery spines of lacquered cardboard triangles encouraged us to identify the former as 'Beauty' and the latter as 'Beast', but in fact each work – and there were to be two more in this vein – is both at once.[5]

Them and Us struck me as the work of an artist determined to surprise himself as much as his viewers. It was a hard work to take in; its very modesty perhaps deliberately pathetic, but unostentatiously so. Was it, I wondered, partly provoked by its 'stage'? By its British audience of 'home viewers' who follow Deacon's work – at once the most critical and the most tolerant – and by the space of the Lisson Gallery, which Deacon has said is one that encourages installation making, its sequential plan suggesting narrative possibilities. Whatever the truth of this, it is clear that Deacon was, at this time, conscious of thwarting his audience's expectations, and thus of somehow, as he says, 'evading the issue'. The audience's good-humoured response to this collaboration with Schütte, like that with Bill Woodrow, was read by Deacon as tantamount to asking, 'So, when are you going to do a real show?' This was only to be resolved, in his eyes, by the retrospective show at Tate Gallery Liverpool in 1999.

But if for four years Deacon feels himself to have been represented more by what one might call 'marginalia' than by core works, it is important to look at that marginalia and ask how those margins relate to, and influence, what is going on at the centre. And what, in fact, is this centre? The easy answer is that it is work at his 'middle scale': that which he calls 'sculpture sculpture' – the type of work he feels himself particularly and unusually

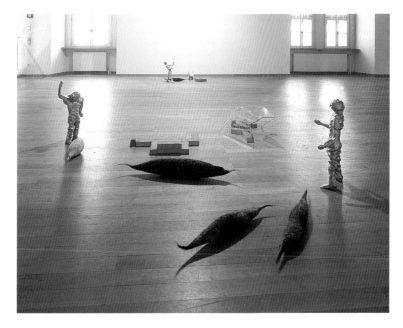

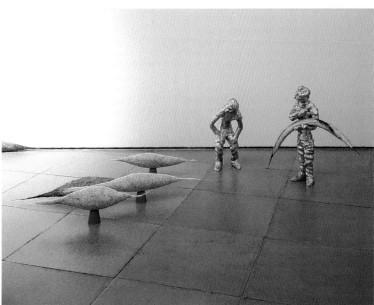

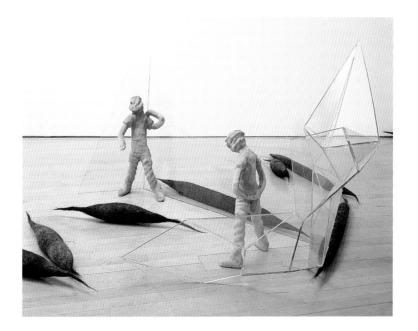

Them and Us, with Thomas Schütte
1995

top, Installation, 'Thomas Schütte', Städtische Galerie, Wolfsburg, 1996
foreground, **Them and Us (I)**
Cast aluminium, PVC, polycarbonate, felt, animal hair
48 × 173 × 108 cm
background, **Them and Us (IX)**
Cast aluminium, PVC, felt, animal hair
47 × 164 × 69 cm

middle, **Them and Us (II)**
Cast aluminium, PVC, felt, animal hair
50 × 152 × 84 cm

bottom, **Them and Us (XI)**
Plastic, polycarbonate, felt, animal hair
80 × 244 × 237 cm

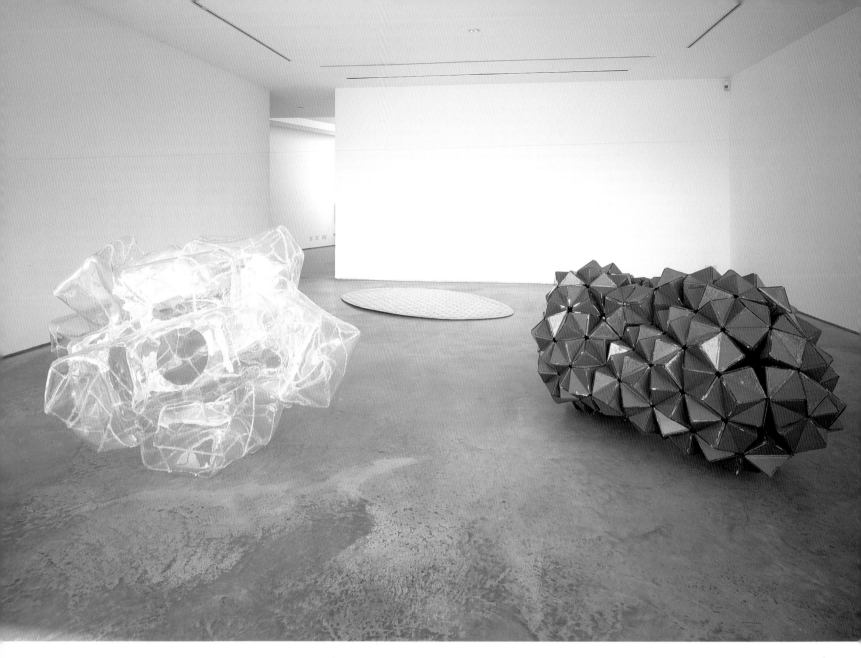

Installation, 'Richard Deacon and
Thomas Schütte', Lisson Gallery,
London, 1995
left, **Beauty and the Beast (A)**
1995
Welded polycarbonate
98.5 × 103 × 158 cm
centre, **Time after Time**
1992-95
Stainless steel
1.5 × 142.5 × 222 cm
right, **Beauty and the Beast (B)**
1995
Cardboard, epoxy resin
79 × 182.5 × 152.5 cm

well able to make, but which he found most
problematic after 1993.[6] The more difficult answer,
and one that Deacon himself seems strangely slow
to acknowledge, is that the centre has shifted, and
that he has made it shift by opening up space in
his practice. Thus we must enquire whether the
artist was not, in several senses, deliberately
setting out to deny expectations, and why he could
not fully accept that he might have succeeded in
doing so.

If he found the middle-scale difficult, this
might imply that the large and the small scale were
coming more easily. Was it in these scales that
Deacon found himself able to develop his growing
interest in the 'non-shape' in a way that was easier
than at the middle scale? Understanding Deacon's
non-shape is not a simple matter, for his
definitions are various. They include forms with
obvious definition, such as the knot,[7] which we see
increasingly developed in drawings from this time,
as well as the more nebulous forms of the cloud.[8]
Somehow, in-between the two lies the single shape
repeated, held together in loose association (like
a flock of birds) or in tight formation (as if, as

Deacon says, 'kebabed' together). Deacon's interest in the different forms of dispersal of nearly identical elements is found in horizontal sections reminiscent of axiometric drawings, in vertical sections like an insect's carapace, and in repetition across the face of the two-dimensional page. Whether these last, in particular, could in themselves create form, without outline, has been a consistent line of enquiry in recent years.

In 1994-95, Deacon failed to secure a commission for the Atlanta Olympics, losing it to Tony Cragg. He quite understands why this happened,

being unable to show the judges exactly how he would realize his idea (though he was able to propose that it should be made from steel tubing). But this was part of its point. The series of drawings that Deacon presented to the jury – Xeroxes from his pocket sketchbook – show a tangled swarm of lines that seem deliberately to deny legibility. How was he to make something whose interest lay in its very indistinctness?[9] However, this project allowed Deacon to develop his ideas about knotting. Departing from the concept of a shape that was universally connected

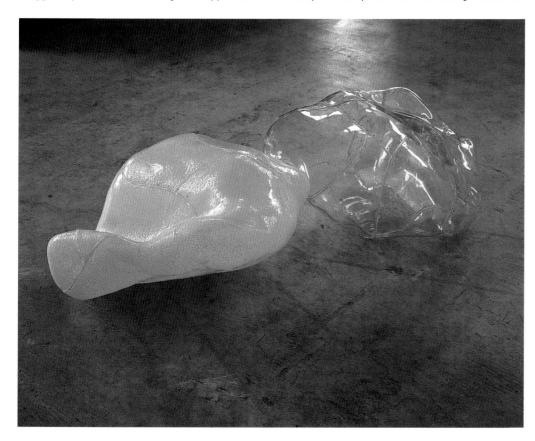

Beauty and the Beast (C)
1995
Welded polycarbonate
42 × 148 × 71 cm

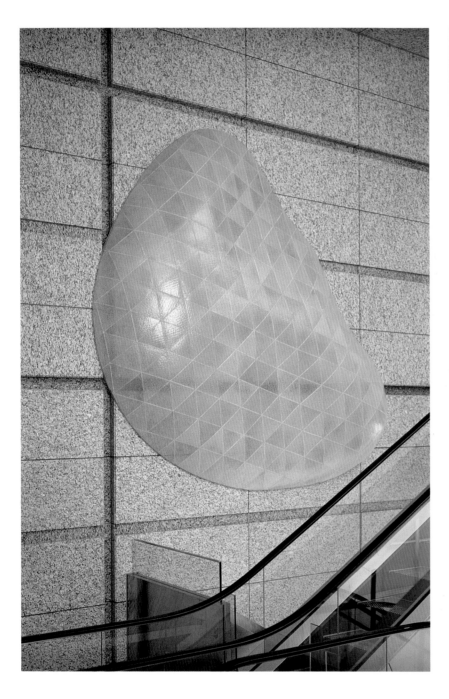
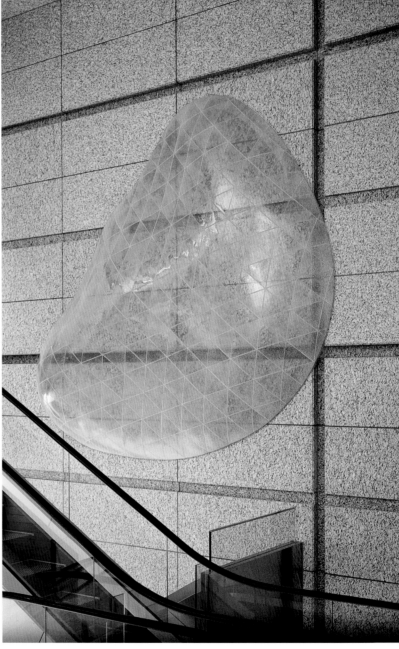

One Is Asleep, One Is Awake
1996
Polycarbonate
Two parts, 375 × 273 × 46.5 cm
each
Permanent installation, Tokyo
International Forum

led him to the three-dimensional weave, a way of making a shape that was more hole than solid, 'more weave than basket'. The commission itself may have come to nothing, but the idea of constructing a weave fed into an important series of woven wood works beginning with *Laocoon*, which was developed after the Lisson show in 1995.[10]

Deacon describes his interest in balancing volume and space as knitting. But it is rather more structured than this might imply. He is interested in the relationship – or non-relationship – between the vertical and the horizontal, the supporting grid – which lies, more or less, structurally underneath most composition – and the surface that lies on top. To reveal the underlying grid, which supplies height, width and depth, means excavating a 'hole' that is fully three-dimensional. For Deacon, this contrasts with the hole in Henry Moore's work, which is primarily two-dimensional, a pictorial hole or frame. Moore's hole frames space, whereas Deacon wanted to make a hole that sucked space in, constructing a kind of spatial envelope around and within the sculpture. The 'hole' is rather particular to twentieth-century English sculpture and it is not going too far to say that Deacon plays on that tradition. He seems to try to pack the hole into the space; that is, to lend the form and frame of the 'hole' – something now so definite that it has acquired structure and delineation – to the emptiness of space.

A grid speaks at once of structure and of emptiness. Deacon links his interests in knitting, the grid and the clouds. Each has emptiness and interconnection. The oddness of this view is perhaps emphasized by the fact that instead of painting the sky, Deacon drew it. He attempted to give shape and structure to that which was purely atmosphere, searching out its interconnectedness. By any account, the sky is difficult to draw. And Deacon finds drawing immensely difficult. We know that many artists are concerned to 'unlearn' their facility in drawing, but Deacon has never felt that he had this facility.[11] He describes his drawings as getting worse the closer they get to the sculpture, benefiting instead from a hiatus between the two. He is prepared to countenance that his drawings look 'adolescent' and 'underconfident', but he is also prepared to show them. Why?

An important aim over recent years, and one that Deacon feels he successfully achieved at the Liverpool show in 1999, is to open up different spaces for viewing; different modalities or ways of being and seeing. Thus, though the drawings may lack authority, this in itself is not important. What is crucial is that the drawings open up an alternative. For Deacon, alternation has offered a way of proceeding since the 1970s. This is one of the reasons why he doesn't confine himself to one material, a way of preventing 'carry-over' and of ensuring more effective closure at any given stage. The drawings haven't changed the sculptures: their difference is additional rather than influential. They authorize in what they allow the sculptures, which have almost without exception continued to carry seemingly effortless authority. Alongside them, the drawings, laboured, over-determined and yet indeterminate, offer a parallel space that disconcerts a viewer used to seeing in Deacon a

from top, **Untitled, Nos 19, 6, 7**
1995-96
Ink on paper
41 × 46 cm each

knowing competence.

The *Show & Tell* prints were a more successful way of displaying Deacon's graphics, their technical means avoiding the *pentimenti* that troubled the drawings, and providing for much greater unity. The background photographs were Deacon's own, taken over a long period of time, while the drawings came from a much more recent and concentrated period. Here, in black and white, the drawings and photographs were brought together without any of the overlaps or mounts involved in the previous juxtaposition of two graphic images at different scales, unified but resolutely different. Again, we encounter the two modalities: two ways of seeing, sharp and vague, close-up and far-off, moving and still. One tries to make links, looking for cause and effect. Some pairings suggest this as a possibility, others hint at its foolishness.

One Is Asleep, One Is Awake (begun in January 1996 and installed in the autumn), another pair of works, installed on either side of the escalator in the Tokyo International Forum building, was partly a way of funding further work on *Laocoon*. It also involved Perry and Kistner in intensive modelling of a 'quilt' of polycarbonate triangles and thus extending the attempt to develop a more plastic surface. Deacon has mixed feelings about it, sensing that it involved more work than it deserved, yet pleased with the way in which some initially chance results (the opacity of one work as opposed to the transparency of the other) were extended not only by the working process but also by the site, so that an authoritative viewing is rendered impossible. In the next work in

polycarbonate, made with Kistner, Deacon was ready to push the material further, whatever the distortion. *From Tomorrow* (1996) was the result, a work donated to the collection of the future Sarajevo Museum of Contemporary Art and given its name after Kistner's death.

In late 1996, *Laocoon* was finished, and shown privately at the Lisson. It bore a relationship to Gotthold Lessing's seminal seventeenth-century text, 'Laokoon',[12] to the antique sculpture from which that text took its name, and to other artistic works in its lineage (such as Tony Cragg's *St George and the Dragon*, rather than Cragg's own *Laocoon*) which combine straight and twisted forms. Lessing's 'Laokoon' was an essay on the distinctive limits of painting and of poetry. Its binary nature, contrasting the visual with the verbal, the instantaneous with the successive, language as communication with language as poetry, was perhaps bound to appeal. Lessing's doctrine of the 'pregnant moment' especially interested Deacon, who extended the question to ask how art, and sculpture in particular, could show the future in the present by anticipating the unfolding of its movement. In his own *Laocoon*, he felt he had produced something of a solution by separating out the contradictory elements of the original. Rather than representing rigidity and fluidity within one material volume, Deacon's *Laocoon* is rigid in its material but fluid in its hole. The sculpture struggles, but is still; its potential for movement literally arrested.

In 1997, at the Marian Goodman Gallery in New York, Deacon showed a series of works that he titled *One to Nine* (as if, he tells me, 'I'd begun

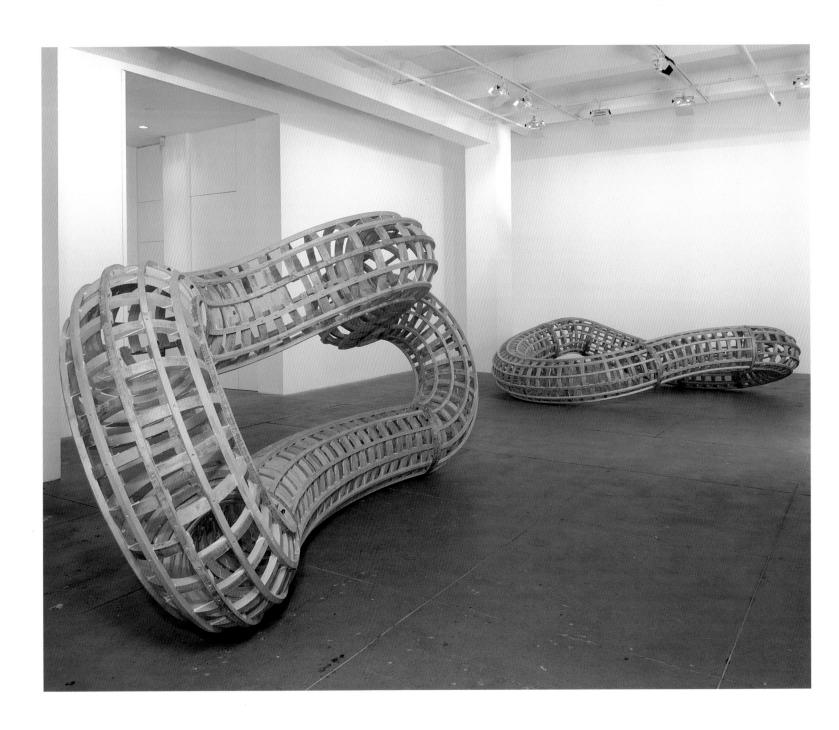

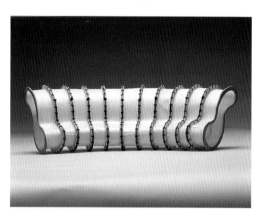

again'). The way in which this show was put
together preconfigures the Liverpool retro-
spective: small works were grouped on the floor
(as if it were a horizon) and two-dimensional and
three-dimensional works were shown together.
The small paper conjunctions ... *So* ..., ... *If* ... and
... *But* ..., were placed on white shelves, and *Eight*
and *Nine* – constructed wooden 'basket-works' –
writhed above the floor, looking as if they were
condemned to a kind of perpetual but fruitless
motion, like a man in a straitjacket. This admixture
was continued in his installation at the Musée de

Rochechouart in 1997, where the *Show & Tell* prints
were placed in-between *Art for Other People*, on
the floor and on a table. *Table A* and *Table B*,
traditional 'medium-sized' sculpture-sculptures,
occupied their space unassumingly, but at the
centre of the galleries, like a giant in its lair, or like
the Minotaur in the labyrinth, *Laocoon* gently
flexed its muscles.

One to *Nine* perhaps constituted something of
a false start; *One* to *Seven* were later renumbered,
integrated into the *Art for Other People* series,
which goes back to 1982. *One* thus became *Art for*

Other People No 32 and so on. Art that was 'for other people' had itself existed in another mode: work made in-between other, larger, projects. The series has its own rules in terms of scale, an impromptu conception, a lack of pre-planning, a particularity of finish. Its 'Otherness' was more familiar than strange: this was art to give to other people, and which took its place happily within a domestic environment. Variety was brought together within the unity of the series title. *Art for Other People* continues, sporadically, to the present day, and now numbers nearly fifty sub-species.

In April 1997, Deacon showed *One, Two, Tree* in front of the Serpentine Gallery in London, then undergoing refurbishment. Curiously, in documentary photos of the piece, the installation seems far stronger than it did in actuality. This speaks eloquently of the way in which Deacon was taken by the site, and by the fact that the gallery building was renewing itself from bottom-up, as if sending up a replica. As in his graphic work, *One, Two, Tree* is an image in front of an image, echoing the trees that frame it from behind, and standing in front of the 'new' gallery, which is its own chimera. Moreover, Deacon had built in another repetition: his raw materials were the model trees that he had used for his installation in the same gallery and its garden in 1985.

One, Two, Tree consisted of scaled-up versions of those earlier models, set upon two of the many steel sections on which the gallery was then resting – in its jacked-up condition. This, in turn, was set upon a replica of the plinth that bore the first free-standing sculpture to be erected in Germany in the post-Classical era, a bronze statue

in Braunschweig representing Henry 'the Lion', the first ruler of a united Germany. This is a complex history for such a small work, which struck the visitor more by its extreme slightness than by its erudite sourcing. In addition to this meta- and micro-historical referencing, was Deacon interested in confounding the audience, who would have expected a large new outdoor work on this site? He would accept that he was, and that the work is more successful as an image. This would suggest that Deacon was perhaps ready to risk failure, and in accepting that it did fail to a degree as a work on site, was starting to allow for failure as part of his project.

For the 1997 Skulptur Projekte in Münster, Germany, Deacon made a further attempt at an 'unassuming outdoor work'. Instead of holding up a work, in a fragile way, to measure itself against reality, as he had at the Serpentine, now Deacon tried for a low horizontal work that seemed to seek to blend itself with its ground. This was a sculpture that was scarcely there but, to be there at all, had to be precisely made. To allow the shape to emerge out of the road, like a pool in the tarmac, Deacon had prescribed a crisp finishing, which should have allowed the work to be lower but more delineated. The detailing was not executed as Deacon would have wished, and the Münster work (*After Poussin*), based on the study of Nicolas Poussin's painting *Landscape with a man killed by a snake* (1648)[13] joins the Serpentine work as a promising, if not entirely successful, treatment of outdoor sculpture. Since then, Deacon has realized almost no outdoor work, although he has submitted proposals.

Nothing may be quite like making sculpture,

but Deacon has had to find alternatives at different times, and the ones he values particularly include the text for *Stuff Box Object* (prepared for publication in 1982), the *Orpheus* drawings (1978-79), the sets for the *Factory* dance production (1993) and the text 'In Praise of Television', given as a finished lecture in Leeds in 1996 and published in France in 1997. And even in a period in which sculpture-making has been difficult, Deacon, in his own estimation, has produced three indisputably major pieces: the large wooden works *What Could Make Me Feel This Way (A)* (1993), *Laocoon* (1996), and *After* (1998). It would seem that these three pieces, in which the linearity of the preceding decade was developed as far as it could be, are waiting for their partners, in which the notion of the skin can be pushed equally far. And photography in Deacon's work has potential still waiting to be realized.

In his 1999 show at the Lisson, Deacon showed *Infinity* – a series of aluminium shapes leaning against the wall, all different but from the same family – along with more of the photoworks first shown in 1997 in New York, in which drawings are inset into photographed skies.[14] Both pick up on the idea of a non-hierarchical list with the potential to be comprehensive. As noted, this essay covers a period that began with, and has been marked by, sorting and listing. This stocktaking was clearly a point of departure, yet Deacon counsels against allowing the public to take too full a cognisance of such re-evaluation.

While I was writing this essay, Deacon and I both spoke at a conference on Rodin. Deacon's talk dwelt mainly on the question of Rodin's

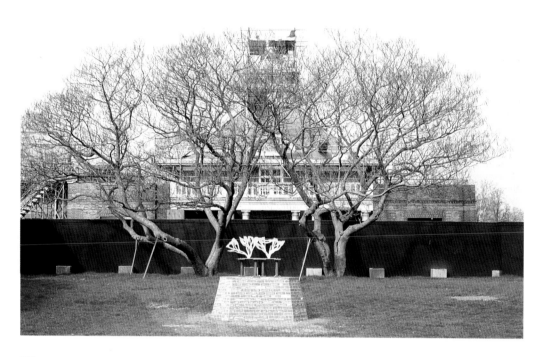

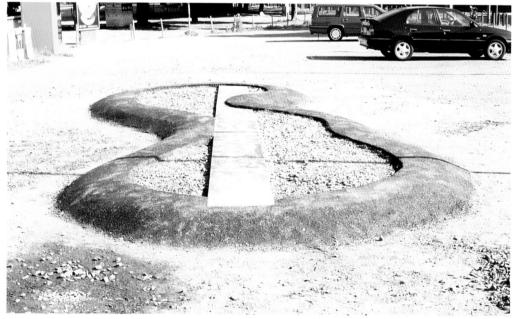

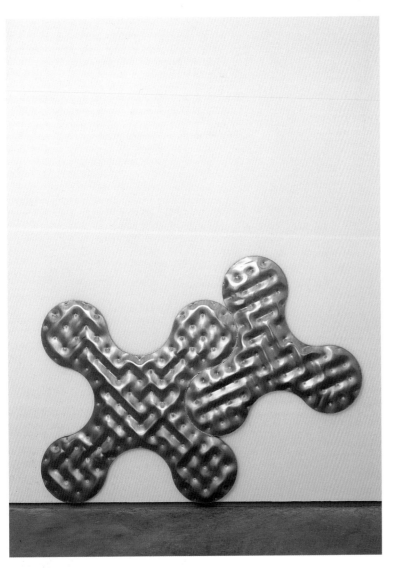

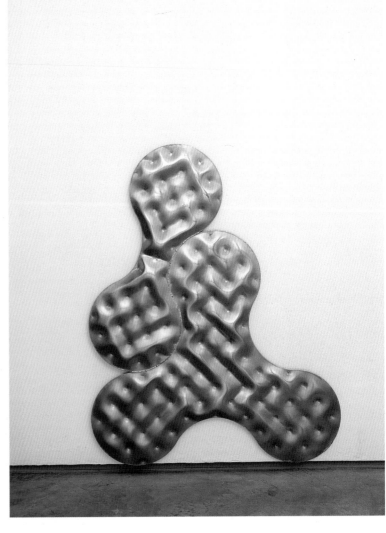

above, left, **Infinity No 4**
1999
Stainless steel
124 × 90 × 2.5 cm

above, right, **Infinity No 6**
1999
Stainless steel
124 × 90 × 2.5 cm

opposite, Installation, 'Richard
Deacon', Lisson Gallery, 1999
l. to r.,
Infinity No 7
1999
Stainless steel
98 × 128 × 2.5 cm
Infinity No 5
1999
Stainless steel
49.5 × 102 × 2.5 cm
Infinity No 8
1999
Stainless steel
110 × 97 × 2.5 cm

production: of how to 'put it out there', while retaining room for invention. It seems that this has been the question that Deacon has also posed for himself in the last decade: how to be a successful sculptor without getting bogged down in fabrication – without even, necessarily, making sculpture. Rodin vastly extended his workforce and material processes to deal with this problem; Deacon has taken an almost opposite approach in looking for other ways to think about sculpture.

Deacon is also interested in Rodin's holding together of private and public. He suggested that Rodin invites rejection while demanding acceptance. This may be something that Deacon – who, after all, represents himself as 'contrary' – wants for himself. But inviting rejection is a big step, and Deacon was talking about Rodin's work, rather than Rodin himself. Being willing to entertain the possibility of rejection is a hard decision for a sculptor to make at mid-career. Though Deacon may not have been ready to be quite that up-front about it at the date when this essay was begun, I believe he went some way down that path. Recognizing that he did so is something that the sculptor, and his audience, may only now be ready to accept.

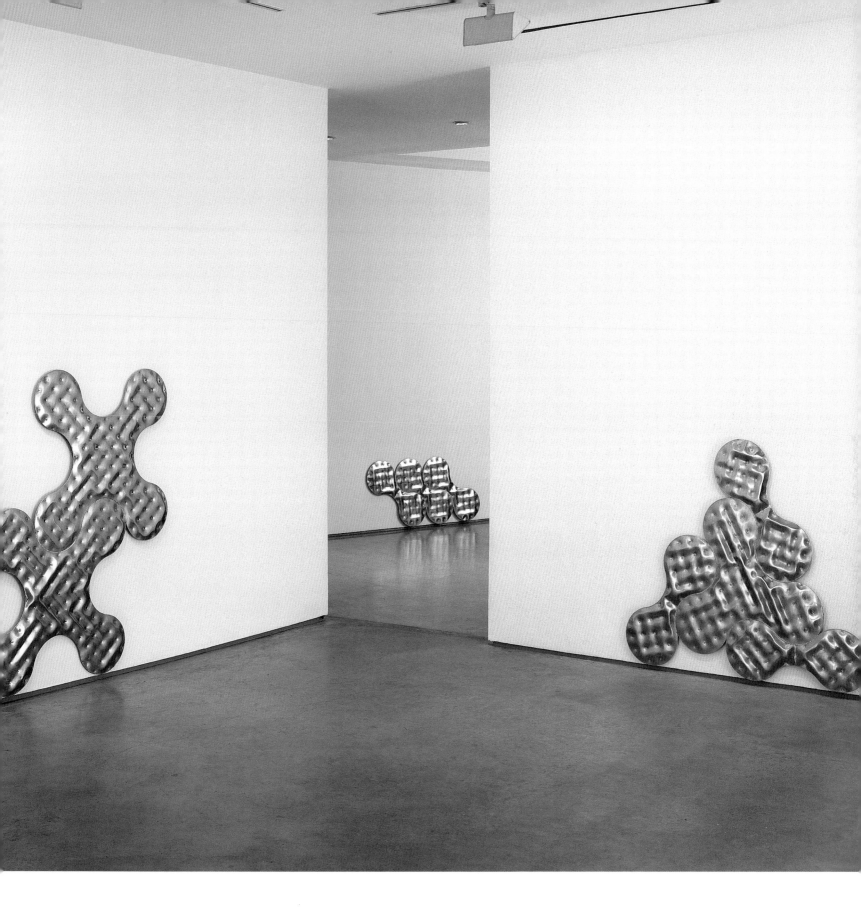

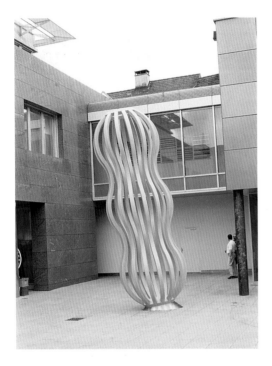

above, **No Stone Unturned**
1999
Stainless steel, painted mild steel
460 × 230 × 56 cm
Permanent installation, Platz vor
UBS, Liestal, Switzerland

opposite, Installation, 'New World
Order/Richard Deacon', Tate
Gallery Liverpool, 1999
l. to r., **Blow**
1999
Spun aluminium
84 × 108 × 108 cm

After
1998
Wood, stainless steel, aluminium
169 × 960 × 346 cm

Laocoon
1996
Steamed beech wood, aluminium,
steel bolts
435 × 360 × 350 cm

1 This essay draws on four conversations with Richard Deacon, August to October 1999. I am grateful to Richard for the time and care he has taken in attempting to provide accurate accounts of his work.

2 One might list the graphic work which preceded this as follows: prints for Margaret Roeder (1987) in New York; the *Atlas* artist's book (1990) produced for a show in Norway and incorporating drawings from 1987 and 1989; the 'Curious Vegetable' prints (1991-92) made also for Roeder and shown at Deacon's 'Foursome' show at the Lisson; the drawings made for *Atlanta* (1994–95). Deacon's work at the Curwen Press in collaboration with experts in lithography and monoprinting allowed him greater technical means of expressing the non-shape. 20 pages of four small drawings (making a total of 80) joined the travelling British Council show in Cuba in 1996.

3 The interest in making and collecting images also connects to list-making and categorization.

4 *Them and Us* became a four minute film, but was never released.

5 *Beauty and the Beast (A)* and *(B)* were shown at the Lisson Gallery, London, *(C)* and *(D)* in the British Council travelling show which opened in Venezuela in April 1996 and then travelled to Cuba, Argentina, Chile and Mexico.

6 See this volume, p. 00

7 In 1996 Deacon made gates and railings for the Customs House at South Shields which show a simple, almost two-dimensional use of the endless knot motif.

8 Deacon's father was an RAF pilot. Though he was not allowed to go up in the air with him, the family home had plenty of books with images of clouds.

9 This interest is not merely formal. Deacon was taken by the fact that Jimmy Carter and Martin Luther King had funded institutions in the vicinity of the site which represented the belief that change was possible and desirable, if necessarily indeterminate in form.

10 *Laocoon* was developed with the space of the Remise in Vienna in mind. It was to have been shown along with *Bikini* and a large plastic piece; a strongly contrasted selection of three large pieces in different materials. The Remise went out of business after showing

Gormley's *Critical Mass*, and so *Laocoon* lost its immediate home.

11 Though the *Orpheus* drawings are known for a rigorous beauty, theirs is surely a hard won beauty; studied, rather than instinctively fluent.

12 Gotthold Ephraim Lessing's incomplete *Laokoon* was first published in 1766, and took its name from the antique group of statuary (1st century; Vatican Collection) disinterred in 1506 which showed the eponymous Trojan priest being crushed by the serpents from which he had tried to deliver his sons. This work was assumed to be that which Pliny had called 'the greatest perfection of art'. It was well preserved, but some elements were missing, and their restoration has generally been seen as faulty. In 1906 a further discovery of an ancient Laocoon arm holding a snake's coil suggested that the father's arm should have been bent back over his head. Lessing had never in fact seen the *Laocoon* as sculpture, even in a plaster cast – unlike Goethe, for instance – but only in engravings, and his essay is the weaker for its distance from actual visual experience, and indeed for its slight differentiation between painting and sculpture.

13 The title derives from Deacon's study of Poussin's *Landscape with a man killed by a snake* (1648, National Gallery, London) which in turn relates back to *Laocoon*. In this painting the man killed by the snake lies prostrate to one side of the action, which is carried forward by a man running towards a woman with outstretched arms who occupies the centre of the painting. The running man looks at the dead man rather than at the woman, who cannot see what has happened. The painting, which represents past, present and future at one and the same time, is an example of the compression of the stages of narrative time, and of the viewer's foreknowledge, which had interested Deacon in the *Laocoon*.

14 The *Infinity* group goes back to *One Step, Two Step* of 1992, which lay, slightly submerged, in the water, and to *Time after Time* (1992-95) shown, horizontally, at the Lisson in 1995 and *Tickle Him Under There* (1994) also shown horizontally, in Los Angeles in 1995. These all had similarly puckered steel surfaces, as if very slightly inflated, but held together from side to side like a mattress.

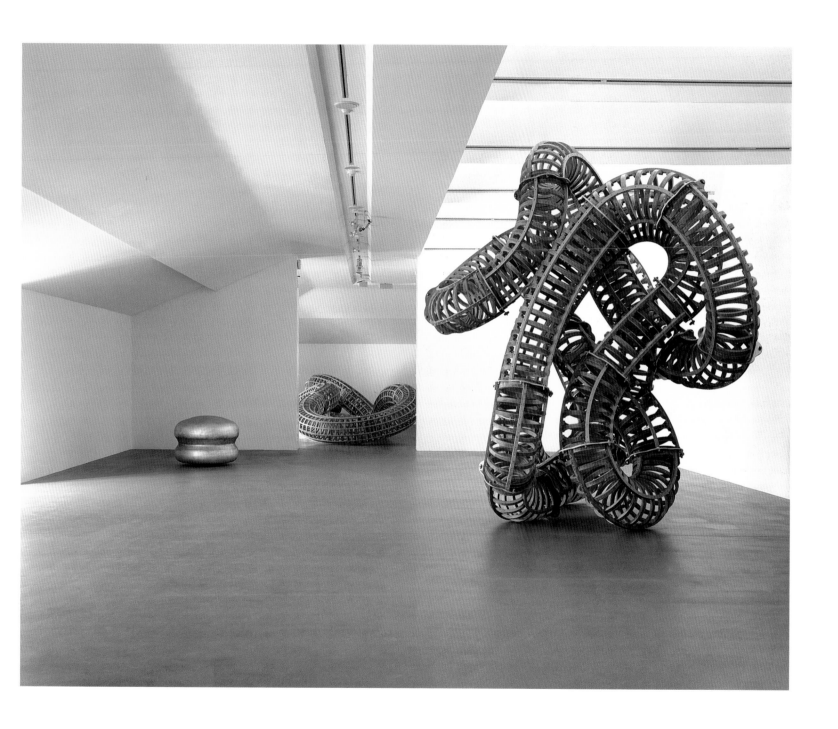

Contents

Interview Pier Luigi Tazzi in conversation with Richard Deacon, page 6. **Survey** Jon Thompson

Thinking Richard Deacon: Thinking Sculptor, Thinking Sculpture, page 36. **Focus** Peter Schjeldahl Deacon's Faith,

page 86. Artist's Choice Mary Douglas Purity and Danger, 1966, page 98. Artist's

Writings Richard Deacon Selections from Stuff Box Object, 1971-72, page 110. Artist's Statement, 1982, page 114.

Silence, Exile, Cunning, 1986-88, page 116. What Car? Correspondence with Lynne Cooke, 1992, page 120. What You See Is What

You Get, 1992, page 132. Design for Replacing, 1987, page 138. Design for Factory, 1993, page 139. Reading, A Propos de Toni

Grand, 1996, page 140. In Praise of Television, 1996-97, page 144. Interview with Jan Tromp, 1999, page 158.

Update Penelope Curtis The Interior is Always More Difficult, page 168. **Chronology**

page 192 & Bibliography, List of Illustrations, **page 209**.

Selected exhibitions and projects
1968-81

1968
Foundation Course, **Somerset College of Art**, Taunton
(Teachers incl. John Hilliard, Ian Breakwell, Rose Finn-Kelcey)

1969-72
B.A. Sculpture, **St. Martin's School of Art**, London
(Teachers incl. Peter Kardia, William Tucker, Garth
Evans, Gareth Jones)

1970
'New Arts Lab' (with C. Walters and I. Kirkwood)
London (performance)

'Stuff Box Object',
St. Martin's School of Art, London
Re-edited and published as catalogue by the Chapter
Arts Centre, Cardiff, 1984

1972-73
Students and staff of St. Martin's, form 'Manydeed'
group to provide forum for collective activities

1972
Essex University (performance)

1973
Travels through USA, attends Grotowski's acting
classes, Art Institute of Chicago

1974
'Artists' Meeting Place' (with Manydeed group),
London (performance)

1974-77
M.A. Environmental Media, **Royal College of Art**,
London (under Peter Kardia)

1975-76
Royal College of Art Galleries, London (solo)

1977
Text, 'Notes on a Piece of Sculpture', *Royal College of
Art Journal*, No 1

History of Art, **Chelsea School of Art**, London

Teaches, **Central School of Art**, London (-1983)

1978
'Studio Exhibition',
The Gallery, Brixton, London (solo)

1978-79
Lives and works in New York

1980
'Spring Programme',
The Gallery, Brixton, London (solo)

Teaches, **Sheffield Polytechnic** (-1984)

1981
Sheffield City Polytechnic Gallery (solo)

Text, *Jacqui Poncelet: New Ceramics* (Cat.), Crafts
Council, London

Selected articles and interviews
1968-81

Sack Event, Somerset College of Art, March 1969

Project with Andrew Rice, St. Martin's School of Art, 1971

'A Course', St. Martin's School of Art, 1972

Performance, Richard Deacon and Clive Walters
May 1972

1980
Cooke, Lynne, 'Carolyne Kardia at Felicity Samuel,
Richard Deacon at The Gallery, Brixton', *Artscribe*, No
24, London

1981

Selected exhibitions and projects
1981-83

'Objects and Sculpture',
Institute of Contemporary Arts, London, **Arnolfini Gallery**, Bristol (group)
Cat. *Objects and Sculpture*, Institute of Contemporary Arts, London; Arnolfini Gallery, Bristol, texts Lewis Biggs, Iwona Blazwick, Sandy Nairne and interviews with the artists

Installation, 'Objects and Sculptures', Institute of Contemporary Arts, London

1982
Teaches, **Bath Academy of Arts** (-1985)

Teaches, **Chelsea School of Art**, London (continues)

'Englische Plastik Heute/British Sculpture Now',
Kunstmuseum, Luzern, Switzerland (group)
Cat. *Englische Plastik Heute/British Sculpture Now*, Kunstmuseum, Luzern, Switzerland, texts Martin Kunz and Michael Newman

'Objects and Figures: New Sculpture in Britain',
organized by the Scottish Arts Council, Edinburgh
Fruitmarket Gallery, Edinburgh, toured to **John Hansard Gallery**, Southampton (group)
Cat. *Objects and Figures: New Sculpture in Britain*, The Scottish Arts Council, Edinburgh, text Michael Newman

1983
Lisson Gallery,
London (solo)

Orchard Gallery, Derry, Northern Ireland (solo)
Cat. *Richard Deacon: Sculpture*, Orchard Gallery, Derry, text Lynne Cooke

'New Art',
Tate Gallery, London (group)
Cat. *New Art*, Tate Gallery, London, text Michael Compton

'The Sculpture Show',
Hayward Gallery, London; **Serpentine Gallery**, London (group)
Cat. *The Sculpture Show*, Hayward Gallery, London; Serpentine Gallery, London, texts Kate Blacker, Fenella Crichton, Paul De Monchaux, Nena Dimitrijevic, Stuart Morgan, Deanna Petherbridge, Bryan Robertson and Nicholas Wadley

'Transformations: New Sculpture from Britain',
organized by the British Council, London
XVII Bienal de São Paulo, Brazil, toured to **Museo de Arte Moderna**, Rio de Janeiro; **Museo de Arte Moderna**, Mexico, **Fundacao Calouste Gulbenkien**, Lisbon (group)
Cat. *Transformations: New Sculpture from Britain*, The British Council, London, texts Lynne Cooke, John Roberts, Nicholas Serota, Lewis Biggs, Stuart Morgan, Mark Francis and John McEwan

Selected articles and interviews
1981-83

Francis, Mark, 'Objects and Sculpture', *Art Monthly*, No 48, London
Roberts, John, 'Objects and Sculpture', *Artscribe*, No 30, London
Biggs, Lewis, 'Objects and Sculpture', *Arnolfini Review*, Bristol, June/July

1982

Fisher, Peter, 'Moore und die Erben - Die Neue Englische Plastik', *Nurnberger Zeitung*, Nurnberg, 12 June
Faure-Walker, Caryn, 'Interview with Richard Deacon', *Aspects*, No 17, London
Newman, Michael, 'New Sculpture in Britain', *Art in America*, New York, September

1983

Cooke, Lynne, 'Richard Deacon: Lisson Gallery', *Art Monthly*, No 64, London
Miller, Sanda, 'Richard Deacon, Galerie Lisson', *Art Press*, No 70, Paris

Donnely, Micky, 'Richard Deacon Sculpture, Orchard Gallery', *Circa*, No 11, Dublin

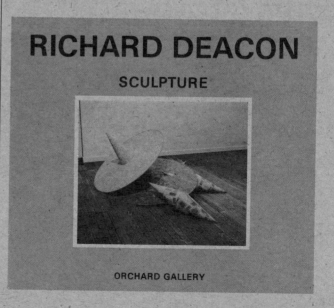

Newman, Michael, 'Figuren en Objecten', *Museum Journaal*, No 2, Amsterdam
Cooke, Lynne, 'Reconsidering the New Sculpture', *Artscribe*, No 42, London

Selected exhibitions and projects
1984-85

1984
Riverside Studios, London (solo)

Chapter Arts Centre, Cardiff (solo)
Cat. *Stuff Box Object, Richard Deacon 1972/73*, Chapter
Arts Centre, Cardiff, text Richard Deacon

'Richard Deacon: Sculpture 1980-1984',
Fruitmarket Gallery, Edinburgh, toured to **Le Nouveau
Musée**, Lyon/Villeurbanne (solo)
Cat. *Richard Deacon. Sculpture 1980-84*, Fruitmarket
Gallery, text Michael Newman

'Turner Prize Exhibition',
Tate Gallery, London (group)

'An International Survey of Recent Painting and
Sculpture',
The Museum of Modern Art, New York (group)
Cat. *An International Survey of Recent Painting and
Sculpture*, The Museum of Modern Art, New York, text
Kynaston McShine

1985
'Contemporary Sculpture',
Donald Young Gallery, Chicago (solo)

'Nouvelle Biennale de Paris',
Paris (group)

'Five Recent Sculptures',
Tate Gallery, London (solo)
Cat. *Richard Deacon, Talking About Those Who Have Ears
No 2 and Other Works*, Patrons of New Art, Tate Gallery,
London, texts Richard Deacon and Richard Francis

'Beyond Appearances: Sculpture for The Visually
Handicapped and Sighted to Share',
Castle Museum, Nottingham (group)

'Three British Sculptors: Richard Deacon, Julian Opie,
Richard Wentworth',
Israel Museum, Jerusalem (group)

'Place Saint Lambert Investigations',
Espace Nord, Liège, Belgium (group)

'Blind, Deaf and Dumb', (with Richard Rogers and John
Tchalenko)

Selected articles and interviews
1984-85

1984
Januszczak, Waldemar, 'Richard Deacon', *The
Guardian*, London, 7 February
Miller, Sanda, 'Richard Deacon', *Art Press*, No 80, Paris
Collier, Caroline, 'Richard Deacon at the Riverside
Studios', *Studio International*, No 1004, London
Cooke, Lynne, 'Richard Deacon at the Riverside
Studios', *Art in America*, New York, September
McEwan, John, 'London Round Up, Richard Deacon',
Art in America, New York, November

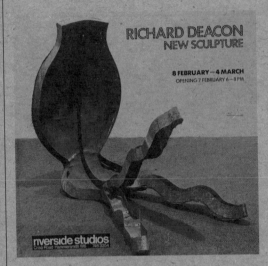

Newman, Michael, 'Discourse and Desire, Recent
British Sculpture', *Flash Art*, Milan, January
Newman, Michael, 'Le Spectacle de la Melancolie dans
la Consommation de Masse: Signification et Objectifs
dans la Sculpture Britannique Actuelle', *Artistes*, Paris,
No 18
Dimitrijevic, Nena, 'Sculpture after Evolution', *Flash
Art*, Milan, April/May

1985
Kirshner, Judith Russi, 'Tony Cragg, Richard Deacon at
Donald Young Gallery, Chicago', *Artforum*, New York,
Summer

Author unknown, 'Maison de Verre. Blind, Deaf and
Dumb', *Building Design*, London, 4 October

Selected exhibitions and projects
1985-86

Serpentine Gallery, London (solo)
Film, *Wall of Light*, in collaboration with Richard
Rogers and John Tchalenko

'1985 Carnegie International',
Carnegie Museum of Art, Carnegie Institute,
Pittsburgh (group)
Cat. *1985 Carnegie International*, Carnegie Museum of
Art, Carnegie Institute, Pittsburgh, texts Jack Lane,
John Caldwell, et al.

'Transformations in Sculpture: Four Decades of
American and European Art',
Solomon R. Guggenheim Museum, New York (group)
Cat. *Transformations in Sculpture: Four Decades of
American and European Art*, Solomon R. Guggenheim
Museum, New York, text Diane Waldman

'The Poetic Object: Richard Deacon, Shirazeh
Houshiary and Anish Kapoor',
Douglas Hyde Gallery, Dublin, toured to **Arts Council
Gallery**, Belfast (group)
Cat. *The Poetic Object: Richard Deacon, Shirazeh
Houshiary and Anish Kapoor*, Douglas Hyde Gallery,
Dublin, text Richard Francis

'The British Show',
Art Gallery of Western Australia, Perth, toured to
Gallery of New South Wales, Sydney; **Queensland Art
Gallery**, Brisbane; **The Exhibition Hall**, Melbourne;
National Art Gallery, Wellington, New Zealand (group)
Cat. *The British Show*, Art Gallery of New South Wales,
Sydney, text Waldemar Januszczak

1986
'Out of Line. Peter Moores Liverpool Project',
Walker Art Gallery, Liverpool (group)

'Skulptur-9 Kunstnere Fra Storbrittanien',
Louisiana Museum of Modern Art, Humlebaek,
Denmark (group)
Magazine, *Louisiana Revy*, Humlebaek, Denmark,
March, text various authors

'Falls the Shadow: Recent British and European Art',
Hayward Gallery, London (group)
Cat. *Falls the Shadow*, Arts Council of Great Britain,
London, texts Barry Barker and Jon Thompson

'Entre el Objeto y la Imagen. Escultura Britanica
Contemporanea',
Palacio Velasquez, Madrid; **Fundacion Caja de
Pensiones**, Barcelona (group)
Cat. *Entre el Objeto y la Imagen. Escultura Britanica*

Selected articles and interviews
1985-86

Allthorpe-Guyton, Marjorie, 'Richard Deacon,
Serpentine Gallery', *Arts Review*, London, 25 October
Garlake, Margaret, 'Ruszkowski, Deacon, Jones',
Art Monthly, No 101, London

Richard Deacon and Tony Cragg, Chicago, Spring

Lyn, Victoria, 'Six British Sculptors', *Art and Australia*,
Australia, December

Bickers, Patricia, 'A Conversation with Richard
Deacon', *Art Monthly*, No 83, London
Newman, Michael, 'Richard Deacon, La Face des
Choses', *Art Press*, Paris, March
Thompson, Jon, 'Richard Deacon in Conversation with
Jon Thompson', *Lo Spazio Umano*, No 3, Milan, August/
September

1986
Hilton, Tim, 'Mixed Offering', *The Observer*, London, 2
February
Murdoch, Lothian, 'Peter Moores', *The Guardian*,
London, 12 February
Henri, Adrian, 'Figuring Out the Common
Denominator', *Daily Post*, London

Newman, Michael, 'Tigenes Ansigt. Tilgenet mindet om
min faber', *Louisiana Revy*, Humlebaek, Denmark,
March

FALLS
THE
SHADOW
RECENT BRITISH
AND
EUROPEAN ART
THE HAYWARD ANNUAL
1986

Selected exhibitions and projects
1986-87

Contemporanea, The British Council, London;
Ministerio de Cultura, Spain, texts Jon Thompson,
Lewis Biggs and Juan Muñoz

'Sonsbeek '86',
Arnhem, The Netherlands (group)
Cat. *Sonsbeek '86*, Arnhem, texts Saskia Bos,
Mariannne Brouwer, Antje von Graevenitz, et al.

'Prospect 86. Eine Internationale Austellung Aktueller
Kunst',
Kunstverein, Frankfurt (group)
Cat. *Prospect 86. Eine Internationale Austellung
Aktueller Kunst*, Kunstverein, Frankfurt, text Peter
Weiermair

'Correspondentie Europa',
Stedelijk Museum, Amsterdam (group)
Cat. *Correspondentie Europa*, Stedelijk Museum,
Amsterdam, text Alexander Van Grevenstein

Marian Goodman Gallery, New York (solo)

'Sculpture for Exterior and Interior',
Interim Art, London (solo)

'For Those Who Have Eyes. Richard Deacon Sculptures
1980-86',
Aberystwyth Arts Centre, Wales, toured to **Glynn
Vivian Gallery**, Swansea; **Turner House, National
Museum of Wales**, Cardiff; **Mostyn Art Gallery**,
Llandudno; **Warwick Art Centre; City Museum and Art
Gallery**; Stoke on Trent (solo)
Cat. *For Those Who Have Eyes. Richard Deacon
Sculptures 1980-86*, Aberystwyth Arts Centre, Wales,
text Richard Deacon

Galerie Arlogos, Nantes, France (solo)
Cat. *Richard Deacon*, Galerie Arlogos, Nantes, text
Michel Enrici

1987
'A Quiet Revolution: British Sculpture Since 1965',
Museum of Contemporary Art, Chicago; **San Francisco
Museum of Modern Art**, toured to **Newport Harbour
Art Museum**, Newport Beach, California; **Hirshhorn
Museum**, Washington DC; **Albright-Knox Art Gallery**,
Buffalo (group)
Cat. *A Quiet Revolution: British Sculpture Since 1965*,
Museum of Contemporary Art, Chicago; San Francisco
Museum of Modern Art, text Mary Jane Jacob

'Current Affairs: British Painting and Sculpture in the
1980s',
Museum of Modern Art, Oxford, toured to

Selected articles and interviews
1986-87

Brenson, Michael, 'Richard Deacon at Marian
Goodman', *The New York Times*, 16 May
Cameron, Dan, 'Armleder, Martin, Deacon', *Flash Art*,
No 130, Milan
Adams, Brook, 'Richard Deacon at Marian Goodman',
Art in America, New York, January

Phillipson, Michael, 'Richard Deacon at Interim Art',
Artscribe, London, January/February, 1987

Giquel, Pierre, 'Exposition Richard Deacon, Galerie
Arlogos, Nantes', *Art Press*, Paris, February

Harrison, Charles, 'Sculpture, Design and Three-
Dimensional Work', *Artscribe*, No 58, London
Newman, Michael, 'Fallen Haloes', *Artscribe*, No 58,
London
Cooke, Lynne, 'Impresa', *Flash Art*, No 130, Milan
Cooke, Lynne, 'What is Modern Sculpture?', *Artscribe
International*, No 60, London

1987

Selected exhibitions and projects
1987-88

Mucsarnok, Budapest; **National Gallery**, Prague;
Zachenta, Warsaw (group)
Cat. *Current Affairs: British Painting and Sculpture in the
1980s*, Museum of Modern Art, Oxford, text Andrew
Brighton

Lisson Gallery, London (solo)

'Brjtannia. Paintings and Sculptures from the 1980s',
organized by the British Council, London
Liljevalchs Konsthall, Stockholm; **Sara Hilden Art
Museum**, Tampere, Finland (group)
Cat. *Britannia. Paintings and Sculptures from the 1980s*,
The British Council, London, texts Richard Francis, et al.

'Juxtapositions: Recent Sculpture from England and
Germany',
P.S.1, The Institute for Art and Urban Resources Inc.,
New York (group)
Cat. *Juxtapositions: Recent Sculpture from England and
Germany*, P.S.1, The Institute for Art and Urban
Resources Inc., New York, texts Alanna Heiss and
Joshua Decter

'Skulptur Projekte in Münster',
Münster (group)
Cat. *Skulptur Projekte in Münster*, DuMont, Cologne,
texts Klaus Bussmann, Kasper König, et al.

Replacing (with Rambert Dance Company,
choreographed by Lucy Bethune)
Riverside Studios, London

'Turner Prize Exhibition',
Tate Gallery, London (group)

Awarded Turner Prize, London

'Richard Deacon. Recent Sculpture 1985-1988',
Bonnefanten Museum, Maastricht, toured to
Kunstmuseum, Luzern; **Fundacion Caja de
Pensiones**, Madrid; **Museum van Hedendaagse
Kunst**, Antwerp (solo)
Cat. *Richard Deacon. Recent Sculpture 1985-1988*,
Bonnefanten Museum, Maastricht, texts Charles
Harrison, Alexander van Grevenstein and Martin Kunz

Richard Deacon and George Melly at the Turner Prize
presentation

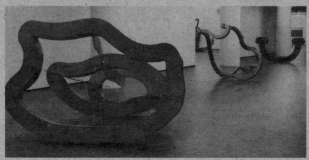
Installation, Bonnefanten Museum, Maastricht, 1987

1988
'The Analytical Theatre: New Art from Britain',
organized by Independent Curators Inc., New York,
Akron Art Museum, Ohio; **Alberta College Art Gallery**;
Art Museum, University of California; **Institute of
Contemporary Art**, Philadelphia (group)
Cat. *The Analytical Theatre: New Art from Britain*,

Selected articles and interviews
1987-88

Author unknown, 'The Critic's Way - Münster',
Artforum, New York, September
Auty, Giles, 'The Stamp of Official Approval', *The
Spectator*, London, 5 December

Tilroe, Anna, 'Deacon, Gijsbers en Schouten', *de
Volkskrant*, Amsterdam, 27 November
Jarque, Fietta, 'Richard Deacon establece un dialogo
continuo entre las esculturas y sus titulos', *El Pais*,
Madrid, 11 April
Trenas, Miguel Ángel, 'Richard Deacon: Mis esculturas
no esconden, permiten conocer su piel', *La
Vanguardia*, Spain, 12 April
Dobbels, Daniel, 'Deacon, après le déluge', *Libération*,
Paris, 18 April
Author unknown, 'Richard Deacon: Disciplina Inglesa',
Epoca, Madrid, 2 May

Baker, Kenneth, 'A Revolution in British Sculpture', *San
Francisco Examiner*
Cornall, John, 'Very Like a Whale: Meaning in the
Sculpture of Richard Deacon', *Alba*, Edinburgh, Winter
Van Dorgu, Edna, 'Lectures on Sculpture', *De Appel*,
No 2, Amsterdam
Cork, Richard, 'Cragg, Woodrow and Deacon: Three
Individuals', *Arts and Design*, No 11/12, London

1988

Like a Snail, in progress, 1987

Independent Curators Inc., New York, text Michael Newman

Marian Goodman Gallery, New York (solo)
Cat. *Richard Deacon*, Marian Goodman Gallery, New York, text Peter Schjeldahl

'Schlaf Der Vernunft',
Museum Fridericianum, Kassel (group)
Cat. *Schlaf Der Vernunft*, Museum Fridericianum, Kassel, text Hubertus Gassner

Carnegie Museum of Art, Pittsburgh, Pennsylvania toured to **Museum of Contemporary Art**, Los Angeles; **Art Gallery of Ontario**, Toronto (solo)
Cat. *Richard Deacon*, Carnegie Museum of Art, Pittsburgh, Pennsylvania, texts Lynne Cooke, Richard Deacon, Michael Newman, Peter Schjeldahl and John Caldwell

'Starlit Waters: British Sculpture, An International Art 1968-1988',
Tate Gallery, Liverpool (group)
Cat. *Starlit Waters*, Tate Gallery, Liverpool, texts Lewis Biggs, Ian Chambers, Lynne Cooke, Richard Francis, Charles Harrison and Martin Kunz

'Art in the Garden: The Glasgow Garden Festival 1988', Glasgow (group)
Cat. *Art in the Garden Installations*, Glasgow Garden Festival 1988, Edinburgh, text Graham Murray

'Rosc '88',
Guinness Hop Store, Dublin (group)
Cat. *Rosc '88*, Guinness Hop Store, Dublin, texts Aidan Dunne, Olle Granath and Patrick Murphy

'Brittanica: 30 ans de Sculpture',
Musée des Beaux Arts André Malraux, Le Havre; **École d'Architecture de Normandie**, Rouen; **Musée de l'Evreux; Musee van Hedendaagse Kunst**, Antwerp (group)
Cat. *Brittanica: 30 ans de Sculpture*, Musée des Beaux Arts André Malraux, Le Havre; École d'Architecture de Normandie, Rouen; Musée de l'Evreux, Evreux, texts Françoise Cohen, Lynne Cooke and Catherine Grenier

Whitechapel Art Gallery, London (solo)
Cat. *Richard Deacon*, Whitechapel Art Gallery, London, texts Marjorie Allthorpe-Guyton, Lynne Cooke and Catherine Lampert

Brenson, Michael, 'Richard Deacon's Sculptures at the Marian Goodman Gallery', *The New York Times*, 14 March

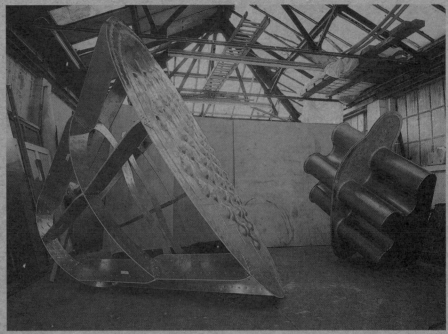
Studio, work in progress

Fonce, Jan, 'For Those Who Have Eyes', *Artefactum*, Antwerp, September/October

Shone, Richard, London, 'Whitechapel. Sculpture by Richard Deacon', *Burlington Magazine*, London, February
Archer, Michael, 'Review, Whitechapel', *Art Monthly*, London, March
Feaver, William, 'Richard Deacon, Whitechapel Art Gallery', *ARTnews*, New York, April
Hatton, Brian, 'Richard Deacon, Whitechapel', London, *Flash Art*, Milan, May/June
Harrison, Charles, *Arts Magazine*, New York, No 109, March
Durand, Regis, 'Richard Deacon: le grand "fabricateur"', *Art Press*, Paris, 134
Hilton, Tim, 'A Visiting Aggression', *The Guardian*, London, 23 November
Graham-Dixon, Andrew, 'Riveting Stuff', *The Independent*, London, 3 December

Installation, Whitechapel Art Gallery, London

Selected exhibitions and projects
1988-90

'Richard Deacon. Distance No Object',
Museum of Contemporary Art, Los Angeles (solo)

1989
'Richard III',
Galerie Arlogos, Nantes (group)

'Richard Deacon: 10 Sculptures 1987/89',
Musée d'art moderne de la ville de Paris (solo)
Cat. *Richard Deacon: 10 Sculptures 1987/89*, Musée
d'art moderne de la ville de Paris, texts Suzanne Pagé
and Jérôme Sans

'Sculpture Chicago '89',
Cityfront Center, Chicago (group)
Cat. *Sculpture Chicago '89*, Cityfront Center, Chicago,
text John Neff

'Skulpturen fur Krefeld I',
Museum Haus Esters, Krefeld, Germany (group)
Cat. *Skulpturen fur Krefeld I*, Museum Haus Esters,
Krefeld, text Julian Heynen

1990
'Richard Deacon: Nye Arbeiter/New Works',
Kunstnernes Hus, Oslo (solo)
Artist's book, *Atlas: Gondwanaland and Eurasia*,
Kunstnernes Hus, Oslo

Lecture, 'Contemporary Art Practice', Laing Art
Gallery, Newcastle upon Tyne

'Frank Auerbach, Lucian Freud, Richard Deacon',
Saatchi Collection, London (group)
Cat. *Frank Auerbach, Lucian Freud, Richard Deacon*,
Saatchi Collection, London, text Joanna Skipwith

'Sculpture',
Marian Goodman Gallery, New York (solo)

Galleria Locus Solus, Genoa (solo)

Lecture, *M'ARS*, Ljubljana, Slovenia, No 4, Summer

'British Art Now: A Subjective View',
organized by the British Council, London
Setagaya Museum, Tokyo; **Fukuoka Art Museum**;
Nagoya City Museum; **Tochigi Prefectural Museum of
Fine Arts**; **Hyogo Prefectural Museum**; **Hiroshima
City Museum** (group)
Cat. *British Art Now: A Subjective View*, British Council,
London, texts Junichi Shioda, Andrew Graham-Dixon
and Akio Obigone

'New Works for Different Places: Four Cities Project',
Victoria Park, Plymouth (group)
Cat. *New Works for Different Places: Four Cities Project*,
TSWA - Four Cities Project, London/Plymouth, texts

Selected articles and interviews
1988-90

Puvogel, Renate, 'Richard Deacon', *Kunstforum*,
Cologne, April/May
Anderson, Michael, 'Richard Deacon at the Museum of
Contemporary Art', *Art Issues*, Los Angeles, April, 1989

Ferbos, Catherine, 'Sculptures in Between -
le paysage', *Artstudio*, Paris, Autumn
Paul, Frédéric, 'Richard Deacon, un exercise d'auto-
critique d'art', *Artstudio*, No 10, Paris

1989

Thomas, Mona, 'Richard Deacon: Portrait', *Beaux-Arts*,
No 66, Paris
'L'interview Richard Deacon', *Art Press*, No 134, Paris
Enrici, Michel, 'Richard Deacon: Un Pan de Labeur,
Inestimable', *Galeries Magazine*, No 30, Paris

Author unknown, 'Richard Deacon', *Atelier*, Japan,
October

1990

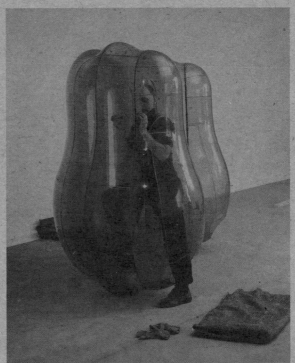

Pack, in progress

Furse, John, 'Richard Deacon', *Art Monthly*, No 132,
London
Furse, John, 'TSWA: Plymouth Update', *Art Monthly*, No
141, London

Selected exhibitions and projects
1990-91

Tony Foster, Jonathan Harvey and James Lingwood

Permanent installation, *Once Upon a Time ...*,
Former Redheugh Bridge Abutment, Gateshead,
England (commissioned by Gateshead Metropolitan
Borough Council)

Permanent installation, *Between the Eyes*,
Yonge Square International Plaza, No 1 Yonge Street,
Toronto (commissioned by Camrost Developments
Corporation)

Moderna Galerija, Ljubljana, Slovenia; **Mala Galerija**,
Ljubljana, Slovenia (solo)
Cat. *Richard Deacon*, Mala Galerija, Ljubljana; Moderna
Galerija, Ljubljana, Slovenia, text Michael Newman

Lecture, 'Ambiguous Gestures',
University College, London

'Weitersehen',
Museum Haus Esters, Krefeld; **Museum Haus Lange**,
Krefeld (group)
Cat. *Weitersehen*, Museum Haus Esters and Museum
Haus Lange, Krefeld, text Julian Heynen

1991
'Devil on the Stairs: Art from the 80s',
Institute of Contemporary Art, Philadelphia, toured
to **Newport Harbor Museum**, Newport Harbor (group)
Cat. *Devil on the Stairs: Looking Back on the Eighties*,
Institute of Contemporary Art, Philadelphia, texts
Robert Storr, Judith Tannenbaum

'Skulpturen und Zeichnungen',
Museum Haus Lange and **Museum Haus Esters**,
Krefeld (solo)
Cat. *Richard Deacon*, Museum Haus Lange und Haus
Esters, Krefeld, interview Julian Heynen
Video, *The Interior is Always More Difficult*, 30 min.,
VHS, directed by Martin Kreyssig, produced by Richard
Deacon

'Inheritance and Transformation',
Irish Museum of Modern Art, Dublin (group)
Cat. *Inheritance and Transformation*, Irish Museum of
Modern Art, Dublin, texts Declan McGonagle and John
Hutchinson

Permanent installation, *Nobody Here But Us*,
Office Tower Plaza, 135 Albert Street, Auckland, New
Zealand (commissioned by ASB Properties Limited and
Albert Street Developments Limited, Auckland)

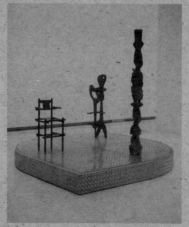

'Carnegie International 1991',
Carnegie Museum of Art, Pittsburgh (group)
Cat. *Carnegie International 1991*, Carnegie Museum of
Art, Pittsburgh, texts Lynne Cooke, Mark Francis, Philip
Johnston, Fumio Nanjo and Zinovy Zinik

Galerie Konrad Fischer, Düsseldorf (solo)

Installation, Carnegie International, 1991

Selected articles and interviews
1990-91

Usherwood, Paul, 'Deacon and Wodiczko on Tyneside',
Art Monthly, No 144, London, 1991

Potrc, Marjetica, and Zidar, Dusan, 'Interview', *M'ARS*,
Vol 2, No 4, Slovenia
Potrc, Marjetica, 'As the Experience of a Perspectively
Arranged World Comes to an End', *M'ARS*, Vol 2, No 4,
Slovenia

Jocks, Heinz-Norbert, 'Weitersehen', *Kunstforum*, Vol
111, Germany, January/February

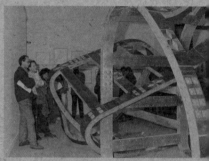

Private view at Mala Galerija, Ljubljana, 1990

Baker, Kenneth, 'Physical Precision, Notes on Some
Recent Sculpture', *Artspace*, September/October

1991

Frese, Hans Martin, 'Deacon in Krefeld', Von Laokoon
zu Theseus, *Rheinische Post*, Germany, 16 May
Meschede, Friedrich, 'Richard Deacon im Museum Haus
Lange/Haus Esters, Krefeld', *Kunstbulletin*, Germany,
July/August
Restorff, Jörg, 'Richard Deacon, Museen Haus Lange
und Esters, Krefeld', *Kunstforum*, Cologne, July/
August

Author unknown, 'Sculpture takes up its space', *New
Zealand Herald*, 22 June

Kuoni, Carin, 'Pittsburgh: Carnegie International',
Kunstbulletin, Cologne, December
Archer, Michael, 'Harmony and Dislocation', *Art
Monthly*, London, February, 1992

Selected exhibitions and projects
1991-92

'Drawings 1974-91'
Mead Gallery, University of Warwick, Coventry (solo)
Cat. *Let's Not Be Stupid*, texts Katherine Eustace and
Michael Newman

Permanent installation, *Let's Not Be Stupid*,
Former Air Hall Site, University of Warwick, Coventry
(commissioned by the University of Warwick, Coventry)

Text, 'A Sculptor's View, Living in a Material World', *The
Non-Objective World* (Cat.), South Bank Centre
Publications, London

1992
'Foursome',
Lisson Gallery, London (solo)

Let's Not Be Stupid, in progress

'Allegories of Modernism, Contemporary Drawing',
The Museum of Modern Art, New York (group)
Cat. *Allegories of Modernism*, *Contemporary Drawing*,
The Museum of Modern Art, New York, text Bernice
Rose

'Three Recent Works',
Economist Building Plaza, London (solo)

'Art for Other People',
Musée d'art moderne, Villeneuve d'Ascq, France
(solo)
Cat. *Art for Other People*, Musée d'art moderne de la
Communité Urbaine de Lille, Villeneuve d'Ascq, texts
Joëlle Pijaudier and Jean De Loisy

Permanent installation, *Between Fiction and Fact*,
Musée d'art moderne, Villeneuve d'Ascq
(commissioned by the Ministry of Culture and the
Urban Community of Lille, Villeneuve d'Ascq)

'The Interior Is Always More Difficult',
École Regionale d'Art de Dunkerque (solo)

Permanent installation, *Building from the Inside*,
Voltaplatz, Krefeld, Germany (commissioned by the
Krefelder Kulturstiftung, Krefeld, Germany)

Permanent installation, *This Is Not a Story*,
Museum der Stadt, Wailingen (commissioned by the
Region of Stuttgart)
Cat. *This Is Not a Story*, Stadt Waiblingen, Hugo
Mathaes, Verlag, Stuttgart

'Documenta IX',
Kassel, Germany (group)
Cat. *Documenta IX*, Documenta GmbH, Kassel, texts

Richard Deacon Building from the Inside

Selected articles and interviews
1991-92

Cork, Richard, 'Grand Motto for Life', *The Times*,
London, 4 February
Bickers, Patricia, 'Interview with Richard Deacon about
his Recent Public Sculpture', *Art Monthly*, London,
October

Cassim, Julia, 'Deacon's Tear Resonates', *The Japan
Times*, 16 June

1992
Cork, Richard, 'Guessing Games and Cheeky Jokes', *The
Times*, London, 14 February
Hall, James, 'Organs of Desire', *The Independent*,
London, 18 February
Bevan, Roger, 'Richard Deacon in London, Krefeld and
Pittsburgh', *Modern Painters*, London, Spring
'Richard Deacon', *Nikkei Art*, No 4, Japan
Dexter, Emma, 'United Kingdom, Richard Deacon,
Lisson Gallery', *Sculpture*, Washington DC, May/June

Schjeldahl, Peter, 'Drawing Blood, Allegories of
Modernism: Contemporary Drawing', *The Village Voice*,
New York, 3 March
Kaeppelin, Olivier, 'Richard Deacon', *Galeries*, Paris,
April/May

RICHARD DEACON
FOURSOME
31 JANUARY TO 14 MARCH 1992

PRIVATE VIEW
Thursday, 30 January 1992, from 6 to 8pm

LISSON GALLERY
67 Lisson St & 52-54 Bell St, London NW1
Telephone: 071 724 2739

Border 1991. Photo Volker Döhne

Minne, Michele, 'Villeneuve d'Ascq, Richard Deacon',
Art et Culture, France, June
Popelier, Bert, 'Een postmodernistische Brit', *De
Artsenkrant*, Germany, 23 June
'Richard Deacon in museum van Villeneuve d'Ascq', *De
Morgen*, Germany, 27 June
Foveau, Pascal, 'Le fabricateur', *Liberte-Dimanche*,
France, 28 June

Renton, Andrew, 'Richard Deacon, Overwrought Iron',
Flash Art, Milan, May/June
Dusinberre, Deke, 'Sticky Comparisons?', *Art Monthly*,
London, July/August

Between Fiction and Fact, in progress, 1992

Heynen, Julian, 'Die schwierige Stadt und die
öffentliche kunst-momente eines Konfliktes', *Die
Stiftung der Sparhasse Krefeld*, Krefeld, Germany, May

Archer, Michael, 'Documenta IX', *Art Monthly*, London,
July/August

Selected exhibitions and projects
1992-93

Jan Hoet, Denys Zacharopoulos, Pier Luigi Tazzi and Bart de Baere
Book, *Richard Deacon*, Centre National des Arts Plastiques and Editions du Regard, texts Lynne Cooke and Richard Deacon

Marian Goodman Gallery, New York (solo)

'Transform',
Kunstmuseum, Basel; **Kunsthalle**, Basel (group)
Cat. *Bild Objekt Skulptur im 20 Jahrhundert*, Kunsthalle, Basel; Kunstmuseum, Basel, text Julian Heynen

Permanent installation, *One Step, Two Step*,
Landspitze, Nordhorn; **Nieuwmarkt**, Nordhorn (commissioned by Stadt Nordhorn)

One Step, Two Step, in progress

1993
Galerie Arlogos, Nantes (solo)

Permanent installation, *Zeitweise*,
Mexicoplatz, Vienna (commissioned by Stadt Wien, Vienna)

'New Sculptures/Nieuwe Beelden',
Middelheim Park, Antwerp (group)
Cat. *New Sculptures/Nieuwe Beelden*, Middelheim Park, Antwerp, texts Michael Tarantino, et al.

'Factory', dance collaboration with Hervé Robbe, set designed by Richard Deacon, costumes designed by Richard Deacon and Dominique Fabrègue; performed by La Companie le Marietta Secret at
La Ferme Du Boisson, Paris, toured France

'Only the Lonely and Other Shared Sculptures: Bill Woodrow and Richard Deacon',
Chisenhale Gallery, London, toured to **Aspex Gallery**, Portsmouth (group)
Cat. *Only the Lonely and Other Shared Sculptures*, Chisenhale Gallery, London, texts Richard Deacon and Bill Woodrow

'Skulpturen 1987-1993',
Kunstverein, Hannover; **Orangerie**, Herrenhauser Garten, Hannover (solo)

Selected articles and interviews
1992-93

Melrod, George, 'Richard Deacon at Marian Goodman', *Art in America*, New York, February, 1993

Berg, Stephen, 'Transform', *Kunstforum*, No 120, Germany

'Richard Deacon', *Mizue*, Summer
Aoki, Hiroshi, 'Artmuseums' New Collection's - Tochigi Prefectural Museum of Fine Art', *Bijutsu Techno*, Tokyo, August
Francis, Richard, 'Richard Deacon and Engels; Three Footnotes', *Forum International*, Belgium, November/December
Potrc, Marjetica, 'From an Interview with Richard Deacon', *Kunst and Museum Journaal*, Vol 4, No 3, Amsterdam
Author unknown, 'Richard Deacon', *Art Watching (Freestyle)*, Japan, Winter
Kurtz, Bruce D., *Contemporary Art 1965-1990*, Prentice Hall, New Jersey
Blazwick, Iwona, 'Living in a Material World (Madonna 'Material Girl' 1985)', *Kunst and Museum Journaal*, Vol 4, No 3, Amsterdam

1993

Messler, Norbert, 'New Sculptures', *Artforum*, Vol 32, No 7, New York
Bustard, James, 'Antwerp: The Cultural Tally after a Year', *The Art Newspaper*, London, January, 1994

Frétard, Dominique, 'Mariages dans L'Espace', *Le Monde*, Paris, 18 March
Louppe, Laurence, 'États de corps, états d'espaces', *Art Press*, No 179, Paris
Arvers, Fabienne, 'Factory à la Ferme', *Libération*, France, 30 April

McEwan, John, 'From Shadows to Furrows Lit by Neon', *The Sunday Telegraph*, London, 30 May

Schwarz, Karin, 'Zum Sehen un Zum Tasten', *Nobilis*, Germany, October
'Wasser und Dschungel', *Stern*, No 42, Germany

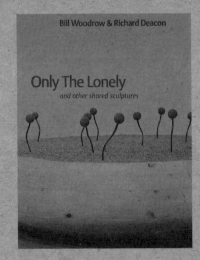

Bill Woodrow & Richard Deacon

Only The Lonely
and other shared sculptures

Selected exhibitions and projects
1993-95

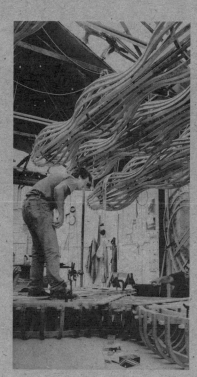

What Could Make Me Feel This Way A, in progress

'Richard Deacon and European Silver Tea and Coffeepots',
Feuerle, Cologne (solo)

'What Could Make Me Feel This Way'
British School at Rome (solo)
Cat. *What Could Make Me Feel This Way*, British School at Rome, text Pier Luigi Tazzi

'Kiss and Tell',
South Bank National Touring exhibition (solo)
Cat. *Kiss and Tell*, South Bank Centre, London, text Richard Cork

1994
Text, 'A propos de Toni Grand', *Toni Grand* (Cat.) Musée Jeu de Paume, Paris and Camden Arts Centre, London

'Only the Lonely and Other Shared Sculptures' (with Bill Woodrown),
Sabine Wachters, Brussels (group)

'Till Brancusi',
Mälmo Konsthall, Sweden (group)
Cat. *Till Brancusi*, Mälmo Konsthall, Sweden, text Sune Nordgren

'Not Yet Beautiful',
L.A. Louver Gallery, Los Angeles (solo)

'Re Rebaudengo Sandretto Collection',
S. Antonio di Susa, Turin (group)

1995
'Atlas + This is Not a Story',
Customs House, South Shields (solo)

'Richard Deacon, Esculturas 1984–95',
organized by the British Council, London,
Museo de Arte Contemporáneo de Caracas Sofía Imber, Caracas, Venezuela, toured to **Centro Wifredo Lam**, Havana; **Museo de Arte Moderna**, Buenos Aires; **Museo Nacional des Bellas Artes**, Santiago; **Museo Rufino Tamayo**, Mexico City (solo)
Cat. *Richard Deacon, Esculturas 1984–95*, British Council, London, texts Dawn Ades, Mónica Amor and Andrea Rose

'Public/Private: ARS 95',
Ngkgtaiteen Museo, Helsinki (group)
Cat. *Public/Private: ARS 95*, Ngkgtaiteen Museo, Helsinki, texts Maaretta Jaukkuri, et al.

Richard Deacon

THE INAUGURAL EXHIBITION IN OUR NEW BUILDING

Not yet beautiful

11 JANUARY - 11 FEBRUARY 1995

Reception for the artist
Thursday, January 12, 1995
6.00 - 9.00pm

valet parking

Selected articles and interviews
1993-95

von Radziewsky, Elke, 'Stahlpfütze und Gedankenkörper', *Die Ziet*, No 43, Germany
'Unter die Haut', *Der Speigel*, Germany, 25 October
Böer, Claudia, 'Kunstverein Hannover: Verschlungene Skulpturen von Richard Deacon', *Kieler Nachrichten*, Germany, 21 October
Thiede, Veit-Mario, 'Für Sinne, Verstand und Gefühle', *Straubinger Tageblatt*, Germany, 25 October
Winter, Peter, 'Auf der Achterbahn', *Donnerstag*, No 251, Germany, 28 October , Seite 37
Stoeber, Michael, 'Tausendfüßler und andere Monstrositäten', *Die Tageszeitung*, Germany, 16 November

1994

Lambrecht, Luk, 'Richard Deacon, Bill Woodrow: Sabine Wachters', *Flash Art*, Vol 27, No 176, Milan

1995

Knight, Christopher, 'Playful, Suggestive Sculptures From One of Today's Finest', *The Los Angeles Times*, 28 January

Wisotzki, Ruben, 'Arte industrial insolado', *El Nacional*, Caracas, 23 April, 1996
Torres, Vicglamar L., 'La obra de arte debe ser un objecto manipulable', *El Nacional*, Caracas, 23 April, 1996
Shaw, Edward, 'The Fine Art of Confinement', *Buenos Aries Herald*, 30 March 1997
Camacho, Antonio Ruiz, 'Un obsesionado de la autonomía del objeto', *Reforma*, Mexico City, 11 November, 1997

Richard Deacon and Bill Woodrow

Selected exhibitions and projects
1995-96

'Them and Us: Richard Deacon and Thomas Schütte',
Lisson Gallery, London (group)
Video, *Them and Us*, 5 min., 25 sec., produced by
Richard Deacon, Thomas Schütte and Martin Kreyssig

'Le domaine du diaphane',
Le Domaine de Kerguehennec, Centre d'Art
Contemporain, Bignan, France (group)

'Open House',
Kettle's Yard, Cambridge (group)

Factory, (with Hervé Robbe)
Riverside Studios, London

Them and Us

5th May–1st July 1995
Private View • 4th May, 6–8 pm

Richard Deacon
Thomas Schütte

LISSON GALLERY

Book, *Richard Deacon*, Phaidon Press, London, texts
Richard Deacon, Peter Schjeldahl, Pier Luigi Tazzi and
Jon Thompson

1996
Receives, Chevalier de l'Ordre des Arts et Lettres,
Ministry of Culture, France

Commission, *Gates and Railings*,
Customs House, South Sheilds

Permanent installation, *One Is Asleep, One Is Awake*,
Tokyo International Forum Building
Book, *Tokyo International Forum Art Collection: A Boat
of Diversity*, Tokimeki Festa Executive Committee,
Tokyo, texts Hara Toshio, Koike Kazuko, Oku Noriy and
Shinoda Tatsumi

'Un siècle de sculpture anglaise',
Jeu de Paume, Paris (group)
Cat. *Un siècle de sculpture anglaise*, Jeu de Paume,
Paris, texts Daniel Abadie and Alan Bowness

ART on the RIVERSIDE

The Customs House
Has pleasure in inviting you to the launch of
Artwork Commissioned for The Customs House building
on Wednesday 17th July at 12noon

Gates and Railings by Artist Richard Deacon
Foyer and Gallery Furniture by Craftsmen and Artist Stephen Downs
Banners from Textile Artist Jane Robertson
Alan Haydon of Northern Arts will launch the work

Celebrations on the day will include a Community Sculpture day at Mill Dam
and a light Buffet will be available in the gallery

'Sculptures: 7 Attitudes',
Casino Luxemburg, Forum d'Art Contemporain,
Luxemburg (group)

Lecture, 'In Praise of Television', as part of the lecture
series 'The Objects of Sculpture'
Department of Fine Art, University of Leeds

'Museum of Contemporary Art Sarajevo 2000',
Moderna Galerija Ljubljana, Sarajevo (group)
Book, *Museum of Contemporary Art: Sarajevo 2000*,
Moderna Galerija Ljubljana, Sarajevo, text Enrico R.
Coni

THE OBJECTS OF SCULPTURE

*A series of lectures at The University of Leeds
Spring 1996*

Selected reviews and articles
1995-96

Sanderson, Philip, 'Richard Deacon and Thomas
Schütte', *Art Monthly*, No 188, London, July/August
Searle, Adrian, 'Richard Deacon and Thomas Schütte',
Time Out, London, 24/31 May

le domaine du diaphane

Garnett, Robert, 'Open House', *Art Monthly*, No 185,
London, April

Gleadell, Colin, 'Footnotes to the October Calendar',
Art Monthly, No 190, London, October
Parry, Jann, 'Synergy on the Factory Floor', *The
Observer*, London, 15 October
Hall, Charles, 'Moving New Forms of Collaboration', *The
Times*, London, 17 October
Brown, Ismene, 'Dance's Fairy Godmother', *The Daily
Telegraph*, London, 12 October
Mackrell, Judith, 'Steps in the Dark', *The Guardian*,
London, 23 October
Piqué, Floriana, 'Factory e Talking Heads', *Flash Art*, No
195, Milan, December/January

Anson, Libby, 'A New Broom at Phaidon Books',
Untitled, No 10, London, Spring, 1996

1996

Penwarden, Charles, 'At Least the French Want Our
Sculpture', *The Daily Telegraph*, London, 1 June
Bevan, Roger, 'British Beef Goes to France', *The Art
Newspaper*, London, May
Hindry, Ann, 'Histoires anglaises', *Art Press*, No 214,
Paris, June
Gayford, Martin, 'Confusing For Les Rosbifs', *The Daily
Telegraph*, London, 12 June
Thomas, Mona, 'Les années 80–90, jeunes sculptures
anglaises', *Beaux Arts Magazine*, Jeu de Paume, Paris

ZA MUZEJ SODOBNE UMETNOSTI SARAJEVO 2
FOR THE MUSEUM OF CONTEMPORARY ART SARAJEVO

Selected exhibitions and projects
1997-98

1997
Marian Goodman Gallery, New York (solo)

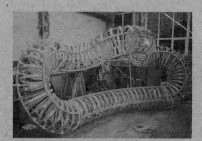

Serpentine Gallery Lawn, London (solo)

'Richard Deacon: Show and Tell',
Musée Departemental de Rochechouart, Haute-
Vienne, France (solo)

Invitation card, Marian Goodman Gallery, New York

'Material Culture: The Object in British Art of the 1980s
and 90s',
Hayward Gallery, London (group)
Cat. *Material Culture: The Object in British Art of the
1980s and 90s*, Hayward Gallery, London, texts Michael
Archer and Greg Hilty

'Skulptur Projekte in Münster',
Münster (group)
Cat. *Sculpture. Projects in Münster*, Gerd Hatje,
Ostfildern-Ruit, texts by Kasper König, Klaus Bussman,
Florian Matzner, et al.

Invitation card, 'Richard Deacon: Show and Tell', Musée
Departemental de Rochechouart, Haute-Vienne, France

1998
Elected as a member of the Royal Academy, London

'Richard Deacon, Toni Grand',
Galerie Arlogos, Paris (group)

'Anos 80',
Culturgest, Lisbon (group)

'Direcção Escultura',
Centro de Arte Moderna, Gulbenkian Foundation,
Lisbon (group)
Cat. *Direcção Escultura*, Centro de Arte Moderna,
Gulbenkian Foundation, Lisbon, texts Rui Sanchez and
Jorge Molder

SCAI the Bathouse, Tokyo (solo)

'Thinking Aloud',
Kettle's Yard, Cambridge, toured to **Corner House**,
Manchester; **Camden Art Centre**, London (group)

Text, 'It Cuts Both Ways', *Miroslav Perković, Milica
Lukić*, Circulo De Bellas Artes, Madrid

'Artist's Proof',
Kaiser Wilhelm Museum, Krefeld, toured to
Kunsthalle, Nürnberg (group)
Cat. *Artist's Proof*, Octagon, Cologne, text Gerhardt
Storck

Appointed professor, École nationale superieure des
beaux-arts, Paris

1999

Selected reviews and articles
1997-98

1997
Kuspit, Donald, 'Richard Deacon at Marian Goodman
Gallery', *Artforum*, New York, Summer
Heartney, Eleanor, 'Richard Deacon at Marian
Goodman', *Art in America*, New York, September

Dagen, Philippe, 'Le cabinet de curiosités de Richard
Deacon', *Le Monde*, Paris, 18 July
Sausset, Damien, 'Deacon joue à Laocoon', *L'Oeil*,
Laussanne, July/August

Stahtatos, John, 'Material Culture at the Hayward',
Untitled, No 1, London
Author unknown, 'Material Culture: The Object in
British Art of the 1980s and 90s and Sculpture.
Projects in Münster 1997', *contemporary visual arts*, No
14, London

Bonami, Francesco, 'Skulptur Projekte, Münster 1997.
An Interview with Kasper König, Curator', *Flash Art*,
Milan, March/April
Buchloh, Benjamin H.D., 'Sculpture Projects in
Münster', *Artforum*, New York, September

Cork, Richard; Curtis, Penelope; Serota, Nicholas;
McGonagle, Declan, *Breaking the Mould: British Art of
the 1980s and 1990s*, Lund Humphries, London; Irish
Museum of Contemporary Art, Dublin

1998

Author unknown, 'Richard Deacon', *Bijutsu Techo*,
Tokyo, 1 January

Selected exhibitions and projects
1999-2001

1999
Receives CBE award, London

Appointed Vice Chairman of the Baltic Centre for
Contemporary Art, Gateshead

'New World Order',
Tate Gallery Liverpool (solo)
Cat. *New World Order*, Tate Gallery, London, texts
Marjorie Althorpe-Guyton, Vikki Bell, Lewis Biggs,
Richard Deacon and Liam Gillick

Permanent installation, *No Stone Unturned*,
Bemalter Stahl, Platz vor UBS Liestal
Cat. *Richard Deacon: 1999 Liestal*, Kleingalerie
Kunstkeller, Liestal, texts Richard Deacon, Werner
Leupin and Andreas Ruegg

'Richard Deacon: Sculpture and Drawings',
Lisson Gallery, London (solo)

'Richard Deacon & Ian McKeever',
Galleri Susanne Ottesen, Copenhagen (group)

'At Home with Art: A Partnership between Homebase
and the Tate Gallery',
Tate Gallery, London (group)

'Am Horizont',
Kaiser Wilhelm Museum, Krefeld (group)

Installation, *How Much Does Your Mind Weigh?*,
Millenium Dome, Greenwich, London

2000
Permanent installation, *We Are Not Alone*,
Ocean Plaza, Cosco Corperation, Beijing

L.A. Louver Gallery, Los Angeles (solo)

2001
Dundee Contemporary Arts (solo)

P.S.1, New York (solo)

Selected reviews and articles
1999-2001

1999
Author unknown, 'Appointments', *Art Monthly*, No 226,
London, May

Biggs, Lewis, 'The Word Made Sculpture', *Tate
Magazine*, London, Spring
MacRitchie, Lynn, 'Bend Me, Shape Me, Glue Me', *The
Independent on Sunday*, London, 28 February
Cumming, Laura, 'Out of The Loop But Too Original to
Be Out of Fashion … ', *The Observer*, London, 28
February
Clark, Robert, 'Richard Deacon', *The Guardian*, London,
2 March
Cork, Richard, 'Power of A Snake Charmer', *The Times*,
London, 24 March
Rosenblum, Robert, 'Richard Deacon', *Artforum*, New
York, January
Lubbock, Tom, 'Don't Ask "Why", Ask "How"', *The
Independent*, London, 30 March
Perry, Frank G., 'Vem ser på vad? Vad ser på vem?',
Svenska Dagbladet, Stockholm, 27 March
Mehta, Nina, 'Richard Deacon: Tate Gallery, Lisson
Gallery', *Art Monthly*, London, July/August
Lambirth, Andrew, 'Organic Engineering', *The Royal
Academy Magazine*, No 62, London, Spring

Mehta, Nina, 'Richard Deacon: Tate Gallery, Lisson
Gallery', *Art Monthly*, London, July/August
Glover, Michael, 'Richard Deacon: Lisson Gallery',
ARTnews, New York, September

Irving, Mark, 'Home Is Where the Art Is?', *The Express*,
London, 16 October

Buck, Louisa, 'Answered Prayers, Art to Feed Body and
Soul', *The Art Newspaper*, London, March
Ian Tromp, 'Undetermined Pleasure and Unnecessary
Beauty: An Interview with Richard Deacon', *Sculpture*,
Vol 18, No 9, Washington DC, November

Abadie, Daniel, *Un siècle de sculpture anglaise*, Jeu de Paume, Paris, 1996

Ades, Dawn, *Richard Deacon, Esculturas 1984–95*, British Council, London, 1995

Allthorpe-Guyton, Marjorie, *Richard Deacon*, Whitechapel Art Gallery, London, 1988

Althorpe-Guyton, Marjorie, *New World Order*, Tate Gallery, London, 1999

Amor, Mónica, *Richard Deacon, Esculturas 1984–95*, British Council, London, 1995

Anderson, Michael, 'Richard Deacon at the Museum of Contemporary Art', *Art Issues*, Los Angeles, April, 1989

Angel Trenas, Miguel, 'Richard Deacon: Mis esculturas no esconden, permiten conocer su piel', *La Vanguardia*, Spain, 12 April, 1987

Anson, Libby, 'A New Broom at Phaidon Books', *Untitled*, No 10, London, Spring, 1996

Aoki, Hiroshi, 'Artmuseums' New Collection's – Tochigi Prefectural Museum of Fine Art', *Bijutsu Techno*, Tokyo, August, 1992

Archer, Michael, 'Review, Whitechapel', *Art Monthly*, London, March, 1988

Archer, Michael, 'Harmony and Dislocation', *Art Monthly*, London, February, 1992

Archer, Michael, 'Documenta IX', *Art Monthly*, London, July/ August, 1992

Archer, Michael, *Material Culture: The Object in British Art of the 1980s and 90s*, Hayward Gallery, London, 1997

Auty, Giles, 'The Stamp of Official Approval', *The Spectator*, London, 5 December, 1987

Baker, Kenneth, 'Physical Precision, Notes on Some Recent Sculpture', *Artspace*, September/ October, 1990

Barker, Barry, *Falls the Shadow*, Arts Council of Great Britain, London, 1986

Barrett, David, 'Open House', *Everything*, No 16, London, 1995

Bell, Vikki, *New World Order*, Tate Gallery Liverpool, 1999

Berg, Stephen, 'Transform', *Kunstforum*, Cologne, No 120, 1993

Bevan, Roger, 'Richard Deacon in London, Krefeld and Pittsburgh', *Modern Painters*, London, Spring, 1992

Bevan, Roger, 'Richard Deacon', *Burlington Magazine*, London, January, 1996

Bevan, Roger, 'British Beef Goes to France', *Art Newspaper*, London, May, 1996

Bickers, Patricia, 'A Conversation with Richard Deacon', *Art Monthly*, No 83, London, 1985

Bickers, Patricia, 'Interview with Richard Deacon about His Recent Public Sculpture', *Art Monthly*, London, October, 1991

Biggs, Lewis, *Objects and Sculpture*, Insitute of Contemporary Arts, London; Arnolfini Gallery, Bristol, 1981

Biggs, Lewis, 'Objects and Sculpture', *Arnolfini Review*, Bristol, June/July, 1981

Biggs, Lewis, *Transformations: New Sculpture from Britain*, British Council, London, 1983

Biggs, Lewis, *Entre el Objeto y la Imagen. Escultura Britanica Contemporanea*, British Council, London; Ministerio de Cultura, Spain, 1986

Biggs, Lewis, 'The Word Made Sculpture', *Tate Magazine*, London, Spring, 1999

Biggs, Lewis, *New World Order*, Tate Gallery, London, 1999

Blacker, Kate, *The Sculpture Show*, Hayward Gallery, London; Serpentine Gallery, London, 1983

Blazwick, Iwona, *Objects and Sculpture*, Institute of Contemporary Arts, London; Arnolfini Gallery, Bristol, 1981

Blazwick, Iwona, 'Living in a Material World (Madonna 'Material Girl' 1985)', *Kunst and Museum Journaal*, Vol 4, No 3, Amsterdam, 1992

Böer, Claudia, 'Kunstverein Hannover: Verschlungene Skulpturen von Richard Deacon', *Kieler Nachrichten*, 21 October, 1993

Bonami, Francesco, 'Skulptur Projekte, Münster 1997. An Interview with Kasper König, curator', *Flash Art*, Milan, March/ April, 1997

Bowness, Alan, *Un siècle de sculpture anglaise*, Jeu de Paume, Paris, 1996

Brenson, Michael, 'Richard Deacon at Marian Goodman', *The New York Times*, New York, 16 May, 1986

Brenson, Michael, 'Richard Deacon's Sculptures at the Marian Goodman Gallery', *The New York Times*, 14 March, 1988

Brighton, Andrew, *Current Affairs: British Painting and Sculpture in the 1980s*, Museum of Modern Art, Oxford, 1987

Brown, Ismene, 'Dance's Fairy Godmother', *The Daily Telegraph*, London, 12 October, 1995

Buchloh, Benjamin H.D., 'Sculpture Projects in Münster', *Artforum*, New York, September, 1997

Buck, Louisa, 'Answered Prayers, Art to Feed Body and Soul', *The Art Newspaper*, London, March, 1999

Caldwell, John, *Richard Deacon*, Carnegie Museum of Art, Pittsburgh, Pennsylvania, 1988

Camacho, Antonio Ruiz, 'Un obsesionado de la autonom'a del objeto', *Reforma*, Mexico City, 11 November 1997

Cameron, Dan, 'Armleder, Martin, Deacon', *Flash Art*, Milan, No 130, 1986

Clark, Robert, 'Richard Deacon', *The Guardian*, London, 2 March, 1999

Cohen, Françoise, *Brittanica. 30 ans de Sculpture*, Musée des Beaux Arts André Malraux, Le Havre, 1988

Collier, Caroline, 'Richard Deacon at the Riverside Studios', *Studio International*, Vol 196, No 1004, London, 1984

Compton, Michael, *New Art*, Tate Gallery, London, 1983

Cooke, Lynne, 'Carolyne Kardia at Felicity Samuel, Richard Deacon at The Gallery, Brixton', *Artscribe*, No 24, London, 1980

Cooke, Lynne, *Transformations: New Sculpture from Britain*, The British Council, London, 1983

Cooke, Lynne, 'Reconsidering the New Sculpture', *Artscribe*, London, No 42, 1983

Cooke, Lynne, *Richard Deacon: Sculpture*, The Orchard Gallery, Derry, 1983

Cooke, Lynne, 'Richard Deacon: Lisson Gallery', *Art Monthly*, London, No 64, 1983

Cooke, Lynne, 'Richard Deacon at Riverside Studios', *Art in America*, New York, September, 1984

Cooke, Lynne, 'Impresa', *Flash Art*, No 130, 1986

Cooke, Lynne, 'What is Modern Sculpture?', *Artscribe*, No 60, London, 1986

Cooke, Lynne, *Richard Deacon*, The Carnegie Museum of Art, Pittsburgh, Pennsylvania, 1988

Cooke, Lynne, *Starlit Waters*, Tate Gallery, Liverpool, 1988

Cooke, Lynne, *Richard Deacon*, Whitechapel Art Gallery, London, 1988

Cooke, Lynne, *Brittanica. 30 ans de Sculpture*, Musée des Beaux Arts André Malraux, Le Havre, 1988

Cooke, Lynne, *Richard Deacon*, Centre National des Arts Plastiques and Editions du regard, 1992

Cork, Richard, 'Cragg, Woodrow and Deacon: Three Individuals', *Arts and Design*, Nos 11/12, 1987

Cork, Richard, *Kiss and Tell*, South Bank National Touring Exhibition, London, 1993

Cork, Richard, 'Power of A Snake Charmer', *The Times*, London, 24 March, 1999

Cork, Richard, *Breaking the Mould: British Art of the 1980s and 1990s*, Lund Humphries, London; Irish Museum of Contemporary Art, Dublin, 1997

Cornall, John, 'Very Like a Whale: Meaning in Sculpture of Richard Deacon', *Alba*, No 6, Winter, 1987

Curtis, Penelope, *Breaking the Mould: British Art of the 1980s and 1990s*, Lund Humphries, London; Irish Museum of Contemporary Art, Dublin, 1997

Crichton, Fenella, *The Sculpture Show*, Hayward and Serpentine Galleries, London, 1983

Cumming, Laura, 'Out of The Loop But Too Original to Be Out of Fashion …', *The Observer*, London, 28 February, 1999

Dagen, Philippe, 'Le cabinet de curiosités de Richard Deacon', *Le Monde*, Paris, 18 July, 1997

de Chassey, Éric, 'Entretien avec Daniel Abadie, directeur de la galerie nationale du Jeu de Paume', *Beaux Arts Magazine*, Jeu de Paume, Paris, 1996

De Loisy, Jean, *Art for Other People*, Musée d'art moderne de la Communité Urbaine de Lille, Villeneuve d'Ascq, 1992

De Monchaux, Paul, *The Sculpture Show*, Hayward and Serpentine Galleries, London, 1983

Deacon, Richard, *Jacqui Poncelet, New Ceramics*, Craft Council, 1981

Deacon, Richard, *For Those Who Have Eyes. Richard Deacon Sculptures 1980-86*, Aberystwyth Arts Centre, Wales, 1986

Deacon, Richard, *Skulptur Projekte in Munster*, Du Mont, Cologne, 1987

Deacon, Richard, *Richard Deacon*, Carnegie Museum of Art, Pittsburgh, Pennsylvania, 1988

Deacon, Richard, *Britannia. Paintings and Sculptures from the 1980s*, The British Council, London, 1987

Deacon, Richard, Artist's Book; *Atlas: Gondwanaland and Eurasia*, Kunstnernes Hus, Oslo, 1990

Deacon, Richard, 'A Sculptor's View, Living in a Material World', essay in exhibition catalogue, *The Non-Objective World*, South Bank Centre, London, 1991

Deacon, Richard, *This Is Not a Story, 'Platzverführung'*, Stadt Waiblingen, Hugo Mathaes, Verlag, Stuttgart, 1992

Deacon, Richard, *Richard Deacon*, Centre National des Arts Plastiques and Editions du regard, 1992

Deacon, Richard, *Skulpturen/ Sculptures 1987-1993*, Kunstverein Hannover, 1993

Deacon, Richard, *Only the Lonely and Other Shared Sculptures*, Chisenhale Gallery, London, 1993

Deacon, Richard, *Stuff Box Object, Richard Deacon 1972/73*, Chapter Arts Centre, Cardiff, 1984

Deacon, Richard, 'A propos de Toni Grand', *Toni Grand*, Musée Jeu de Paume, Paris; Camden Arts Centre, London, 1994

Deacon, Richard, 'It Cuts Both Ways', *Miroslav Perković, Milica Lukić*, Circulo De Bellas Artes, Madrid, 1998

Deacon, Richard, *New World Order*, Tate Gallery Liverpool, 1999

Deacon, Richard, *Richard Deacon: 1999 Liestal*, Kleingalerie Kunstkeller, Liestal, 1999

Deblonde, Gautier, *Artists: Photographs by Gautier Deblonde*, Tate Gallery, London, 1999

Decter, Joshua, *Juxtapositions: Recent Sculpture from England and Germany*, P.S.1, The Institute for Art and Urban Resources Inc., New York, 1987

Deggiovanni, Piero, 'Arte Inglese Oggi', *Tema Celeste*, Nos 53/54, Milan, Autumn, 1995

Dexter, Emma, 'United Kingdom, Richard Deacon, Lisson Gallery', *Sculpture*, May/June, 1992

Dimitrijevic, Nena, 'Sculpture after Evolution', *Flash Art*, Milan, April/May, 1984

Dimitrijevic, Nena, *The Sculpture Show*, Hayward Gallery, London; Serpentine Gallery, London, 1983

Donnely, Micky, 'Richard Deacon: Sculpture, Orchard Gallery', *Circa*, No 11, Dublin, 1983

Durand, Regis, 'Richard Deacon: le grand "fabricateur"', *Art Press*, No 134, Paris, 1988

Enrici, Michel, 'Richard Deacon: Un Pan de Labeur, Inestimable', *Galeries Magazine*, No 30, Paris, 1989

Enrici, Michel, *Richard Deacon*, Galerie Arlogos, Nantes, France, 1986

Eustace, Katherine, *Let's Not Be Stupid*, Mead Gallery, University of Warwick, 1991

Faure-Walker, Caryn, 'Interview with Richard Deacon', *Aspects*, No 17, 1982

Feaver, William, 'Richard Deacon, Whitechapel Art Gallery', *ARTnews*, New York, April, 1988
Feaver, William, 'Little Boxes Made of Ticky-tacky', *The Observer*, London, 15 January, 1995

Ferbos, Catherine, 'Sculptures in Between – le paysage', *Artstudio*, Paris, Autumn, 1988

Fonce, Jan, 'For Those Who Have Eyes', *Artefactum*, Belgium, September/October, 1988

Foster, Tony, *New Works for Different Places: Four Cities Project*, TSWA, London, 1990

Francis, Mark, 'Objects & Sculpture', *Art Monthly*, No 48, London, 1981

Francis, Mark, *Transformations: New Sculpture from Britain*, The British Council, London, 1983

Francis, Richard, *Richard Deacon, Talking About Those Who Have Ears No 2 and Other Works*, Tate Gallery, London, 1985

Francis, Richard, *The Poetic Object: Richard Deacon, Shirazeh Houshiary and Anish Kapoor*, Douglas Hyde Gallery, Dublin, 1985

Francis, Richard, *Britannia. Paintings and Sculptures from the 1980s*, The British Council, London, 1987

Francis, Richard, 'Richard Deacon and Engels; Three Footnotes', *Forum International*, Belgium, November/December, 1992

Furse, John, 'Richard Deacon', *Art Monthly*, No 132, London, 1990

Gale, Iain, 'Iain Gale on Exhibitions', *The Independent*, London, 11 August, 1995

Garnett, Robert, 'Open House', *Art Monthly*, No 185, London, April, 1995

Gayford, Martin, 'The Subject Is Anything', *The Daily Telegraph*, London, 16 August, 1995

Gayford, Martin, 'Confusing For Les Rosbifs', *The Daily Telegraph*, London, 12 June, 1996

Gillick, Liam, *New World Order*, Tate Gallery, Liverpool, 1999

Gleadell, Colin, 'Footnotes to the October Calendar', *Art Monthly*, No 190, London, October, 1995

Gleadell, Colin, 'Little Jack Horner and The Wunder-barn Kid', *Art Monthly*, No 192, London, December/January, 1995
Glover, Michael, 'Richard Deacon: Lisson Gallery', *ARTnews*, New York, September, 1999

Grenier, Catherine, *Brittanica. 30 ans de Sculpture*, Musée des Beaux Arts André Malraux, Le Havre, 1988

Hall, Charles, 'Moving New Forms of Collaboration', *The Times*, London, 17 October, 1995

Hall, James, 'Organs of Desire', *The Independent*, London, 18 February 1992

Hall, James, 'Life under The Table Top', *Times Literary Supplement*, London, 2 April, 1999

Handley, Malcolm, 'Dali's Gone: Now For An Even Bigger Attraction', *Daily Post*, 20 February, 1999

Harrison, Charles, 'Sculpture, Design and Three-dimensional Work', *Artscribe*, London, No 58, 1986

Harrison, Charles, *Richard Deacon. Recent Sculpture 1985-1988*, Bonnefanten Museum, Maastricht, 1987

Harrison, Charles, *Arts Magazine*, New York, No 109, March, 1988

Harvey, Jonathan, *New Works for Different Places: Four Cities Project*, TSWA - Four Cities Project, London/Plymouth, 1990

Hatton, Brian, 'Richard Deacon, Whitechapel London', *Flash Art*, Milan, May/June, 1988

Headly, Gill, *British Art Now: A Subjective View*, British Council, London, 1990

Heartney, Eleanor, 'Richard Deacon at Marian Goodman', *Art in America*, New York, September, 1997

Heiss, Alanna, *Juxtapositions: Recent Sculpture from England and Germany*, P.S. 1, Institute for Art and Urban Resources Inc., New York, 1987

Heynen, Julian, *Richard Deacon*, Museum Haus Lange und Haus Esters, Krefeld, 1991

Heynen, Julian, *Skulpturen fur Krefeld I*, Museum Haus Esters, Krefeld, 1989

Heynen, Julian, *Weitersehen*, Museum Haus Esters and Museum Haus Lange, Krefeld, 1990

Heynen, Julian, 'Die schwierige Stadt und die öffentliche kunst-momente eines Konfliktes', *Die Stiftung der Sparhasse Krefeld*, Krefeld, May, 1992

Heynen, Julian, *Bild Objekt Skulptur im 20 Jahrhundert*, Kunstmuseum and Kunsthalle Basel, 1992

Hilton, Tim, 'Largely Immaterial', *The Independent on Sunday*, London, 13 April, 1997

Hilty, Greg, *Material Culture: The Object in British Art of the 1980s and 90s*, Hayward Gallery, London, 1997

Hindry, Ann, 'Histoires anglaises', *Art Press*, No 214, Paris, June, 1996

Hutchinson, John, *Inheritance and Transformation*, New Musuem of Contemporary Art for Ireland, Dublin, 1991

Irving, Mark, 'Home Is Where the Art Is?', *The Express*, London, 16 October, 1999

Ismene Brown, 'Pick 'n' Mix from the Old Master', *The Daily Telegraph*, London, 26 October, 1995

Jacob, Mary Jane, *A Quiet Revolution: British Sculpture Since 1965*, Museum of Contemporary Art, Chicago; San Francisco Museum of Modern Art, 1987

Jocks, Heinz-Norbert, 'Weitersehen', *Kunstforum*, Cologne, Bd. 111, January/February, 1990

Kaeppelin, Olivier, 'Richard Deacon', *Galeries Magazine*, Paris, April/May, 1992

Knight, Christopher, 'Playful, Suggestive Sculptures From One of Today's Finest', *The Los Angeles Times*, 28 January, 1995

König, Kasper, *Sculpture. Projects in Münster*, Hatje verlag, 1997

Kunz, Martin, *Englische Plastik Heute/British Sculpture Now*, Kunstmuseum, Luzern, Switzerland, 1982

Kunz, Martin, *Richard Deacon. Recent Sculpture 1985-1988*, Bonnefanten Museum, Maastricht, 1987

Kuoni, Carin, 'Pittsburgh: Carnegie International', *Kunstbulletin*, Germany, December, 1991

Kurtz, Bruce D, *Contemporary Art 1965-1990*, Prentice Hall, New Jersey, 1992

Kuspit, Donald, 'Richard Deacon at Marian Goodman Gallery', *Artforum*, New York, Summer, 1997

Lambirth, Andrew, 'Organic Engineering', *The Royal Academy Magazine*, No 62, London, Spring, 1999

Lambrecht, Luk, 'Richard Deacon, Bill Woodrow: Sabine Wachters', *Flash Art*, Vol 27, No 176, Milan, 1994

Lampert, Catherine, *Richard Deacon*, Whitechapel Art Gallery, London, 1988

Leupin, Werner, *Richard Deacon: 1999 Liestal*, Kleingalerie Kunstkeller, Liestal, 1999

Levy, Paul, 'British Artists Teach France a Lesson', *The Wall Street Journal*, London, 28 June, 1996

Lingwood, James, *New Works for Different Places: Four Cities Project*, TSWA - Four Cities Project, London, 1990

Louppe, Laurence, 'États de corps, états d'espaces', *Art Press*, No 179, Paris, 1993

Lubbock, Tom, 'Don't Ask "Why", Ask "How"', *The Independent*, London, 30 March, 1999

Lyn, Victoria, 'Six British Sculptors', *Art and Australia*, Australia, December, 1984

Mackrell, Judith, 'Steps in the Dark', *The Guardian*, London, 23 October, 1995

MacRitchie, Lynn, 'Bend Me, Shape Me, Glue Me', *The Independent on Sunday*, London, 28 February, 1999

McEwan, John, *Transformations: New Sculpture from Britain*, The British Council, London, 1983

McEwan, John, 'London Round up, Richard Deacon', *Art in America*, New York, November, 1984

McGonagle, Declan, *Inheritance and Transformation*, New Musuem of Contemporary Art for Ireland, Dublin, 1991

Mehta, Nina, 'Richard Deacon: Tate Gallery, Lisson Gallery', *Art Monthly*, London, July/August, 1999

Melrod, George, 'Richard Deacon at Marian Goodman', *Art in America*, New York, February, 1993

Meschede, Friedrich 'Richard Deacon im Museum Haus Lange/Haus Esters, Krefeld', *Kunstbulletin*, Cologne, July/August, 1991

Messler, Norbert, 'New Sculptures', *Artforum*, Vol 32, No 7, New York, 1993

Miller, Sanda, 'Richard Deacon', *Art Press*, No 80, Paris, 1984

Minne, Michele, 'Villeneuve d'Ascq, Richard Deacon', *Art et Culture*, France, June, 1992

Morgan, Stuart, *The Sculpture Show*, Hayward Gallery, London; Serpentine Gallery, London, 1983

Morgan, Stuart, *Transformations: New Sculpture from Britain*, The British Council, London, 1983

Muñoz, Juan, *Entre el Objeto y la Imagen. Escultura Britanica Contemporanea*, The British Council, Spain, 1986

Nairne, Sandy, *Objects and Sculpture*, Institute of Contemporary Arts, London; Arnolfini Gallery, Bristol, 1981

Neff, John, *Sculpture Chicago '89*, Cityfront Center, Chicago, 1989

Newman, Michael, *Englische Plastik Heute/British Sculpture Now*, Kunstmuseum, Luzern, Switzerland, 1982

Newman, Michael, *Objects and Figures: New Sculpture in Britain*, The Scottish Arts Council, Edinburgh, 1982

Newman, Michael, 'New Sculpture in Britain', *Art in America*, New York, September, 1982

Newman, Michael, 'Figuren en Objecten', *Kunst and Museum Journaal*, No 2, Amsterdam, 1983

Newman, Michael, *Richard Deacon. Sculpture 1980–84*, Fruitmarket Gallery, Edinburgh, 1984

Newman, Michael, 'Discourse and Desire, Recent British Sculpture', *Flash Art*, January, 1984

Newman, Michael, 'Le Spectacle de la Melancolie dans la Consommation de Masse: Signification et Objectifs dans la Sculpture Britannique Actuelle', *Artistes*, France, No 18, 1984

Newman, Michael, 'Richard Deacon, La Face des Choses', *Art Press*, Paris, March, 1985

Newman, Michael, 'Fallen Haloes', *Artscribe*, London, No 58, 1986

Newman, Michael, 'Tigenes Ansigt. Tilgenet mindet om min faber', *Louisiana Revy*, No 26/2, Denmark, March, 1986

Newman, Michael, *Richard Deacon*, Carnegie Museum of Art, Pittsburgh, Pennsylvania, 1988

Newman, Michael, *The Analytical Theatre: New Art from Britain*, Independent Curators Inc., New York, 1988

Newman, Michael, *Let's Not Be Stupid*, Mead Gallery, University of Warwick, 1991

Newman, Michael, *Richard Deacon*, Mala Galerija and Moderna Galerija, Ljubljana, Slovenia, 1990

Nordgren, Sune, *Till Brancusi*, Mälmo Konsthall, Sweden, 1994

Pagé, Suzanne, *Richard Deacon. 10 Sculptures 1987/89*, Musée d'art moderne de la ville de Paris, Paris, 1989

Parry, Jann, 'Synergy on the Factory Floor', *The Observer*, London, 15 October, 1995

Patrick, Keith, 'The Complex Web', *Royal Academy Magazine*, No 48, London, Autumn, 1995

Paul, Frédéric, 'Richard Deacon, un exercise d'auto-critique d'art', *Artstudio*, No 10, Paris, 1988

Penwarden, Charles, 'At Least the French Want Our Sculpture', *The Daily Telegraph*, London, 1 June, 1996

Perry, Frank G., 'Vem ser på vad? Vad ser på vem?', *Svenska Dagbladet*, Stockholm, 27 March, 1999

Petherbridge, Deanna, *The Sculpture Show*, Hayward Gallery, London; Serpentine Gallery, London, 1983

Phillipson, Michael, 'Richard Deacon at Interim Art', *Artscribe*, London, January/February, 1986

Pijaudier, Joëlle, *Art for Other People*, Musée d'art moderne de la Communité Urbaine de Lille, Villeneuve d'Ascq, 1992

Piqué, Floriana, 'Factory e Talking Heads', *Flash Art*, No 195, Milan, December/January, 1995

Potrc, Marjetica; Zidar, Dusan, . 'Interview', *M'ARS*, Vol 2, No 4, Slovenia, 1990

Potrc, Marjetica, 'As the Experience of a Perspectively Arranged World Comes to an End', *MARS*, Vol 2, No 4, Slovenia, 1990

Potrc, Marjetica, 'From an Interview with Richard Deacon', *Kunst and Museum Journaal*, Vol 4, No 3, Amsterdam, 1992

Puvogel, Renate, 'Richard Deacon', *Kunstforum*, Cologne, April/May, 1988

Renton, Andrew, 'Richard Deacon, Overwrought Iron', *Flash Art*, Milan, May/June, 1992

Restorff, Jörg 'Richard Deacon, Museum Haus Lange und Esters, Krefeld', *Kunstforum*, Cologne, July/August, 1991

Riley, Joe, 'Working wonders in wood', *Liverpool Echo*, 23 February, 1999

Roberts, John, 'Objects & Sculpture', *Artscribe*, No 30, London, 1981

Roberts, John, *Transformations: New Sculpture from Britain*, The British Council, London, 1983

Robertson, Bryan, *The Sculpture Show*, Hayward Gallery, London; Serpentine Gallery, London, 1983

Rose, Andrea, *Richard Deacon, Esculturas 1984–95*, British Council, London, 1995

Rose, Bernice, *Allegories of Modernism*, Contemporary Drawing, The Museum of Modern Art, New York, 1992

Rosenblum, Robert, 'Richard Deacon', *Artforum*, New York, January, 1999

Ruegg, Andreas, *Richard Deacon: 1999 Liestal*, Kleingalerie Kunstkeller, Liestal, 1999

Russi Kirshner, Judith, 'Tony Cragg, Richard Deacon at Donald Young Gallery, Chicago', *Artforum*, New York, Summer, 1985

Sanderson, Philip, 'Richard Deacon and Thomas Schütte', *Art Monthly*, No 188, London, July/August, 1995

Sans, Jérôme, *Richard Deacon. 10 Sculptures 1987/89*, Musée d'art moderne de la ville de Paris, 1989

Sausset, Damien, 'Deacon joue à Laocoon', *L'Oeil*, Laussanne, July/August, 1997

Schjeldahl, Peter, *Richard Deacon*, Marian Goodman Gallery, New York, 1988

Schjeldahl, Peter, *Richard Deacon*, The Carnegie Museum of Art, Pittsburgh, Pennsylvania, 1988

Schjeldahl, Peter, 'Drawing Blood, Allegories of Modernism: Contemporary Drawing', *The Village Voice*, New York, 3 March 1992

Schwarz, Karin, 'Zum Sehen un Zum Tasten', *Nobilis*, Germany, October, 1993

Searle, Adrian, 'Richard Deacon and Thomas Schütte', *Time Out*, London, 24/31 May, 1995

Serota, Nicholas, *Transformations: New Sculpture from Britain*, The British Council, London, 1983

Serota, Nicholas, et al., *Vision: 50 Years of British Creativity*, Thames and Hudson, London, 1999

Shaw, Edward, 'The Fine Art of Confinement', *Buenos Aries Herald*, 30 March 1997

Shone, Richard, London, 'Whitechapel. Sculpture by Richard Deacon', *Burlington Magazine*, London, February, 1988

Skipwith, Joanna, *Frank Auerbach, Lucian Freud, Richard Deacon*, Saatchi Collection, London, 1990

Stathatos, John, 'Material Culture at the Hayward', *Untitled*, No 1, London, 1997

Storr, Robert, *Devil on the Stairs: Looking Back on the Eighties*, Institute of Contemporary Art, Philadelphia 1991

Tarantino, Michael, *New Sculptures/Nieuwe Beelden, Middelheim Park*, Antwerp, 1993

Taylor, John Russell, 'The Big Show: Richard Deacon', *Metro*, London, 1999

Tazzi, Pier Luigi, *What Could Make Me Feel This Way*, British School at Rome, 1993

Thomas, Mona, 'Les années 80–90, jeunes sculptures anglaises', *Beaux Arts Magazine*, Jeu de Paume, Paris, 1996

Thompson, Jon, 'Richard Deacon in conversation with Jon Thompson', *Lo Spazio Umano*, No 3, Milan, August/September, 1985

Thompson, Jon, *Entre el Objeto y la Imagen. Escultura Britanica Contemporanea*, The British Council, London; Ministerio de Cultura, Spain, 1986

Thompson, Jon, *Falls the Shadow*, The Arts Council of Great Britain, London, 1986

Torres, Vicglamar L., 'La obra de arte debe ser un objecto manipulable', *El Nacional*, Caracas, 23 April, 1996

Tromp, Ian, 'Undetermined Pleasure and Unnecessary Beauty: An Interview with Richard Deacon', *Sculpture*, Vol 18, No 9, Washington DC, November, 1999

Usherwood, Paul, 'Deacon and Wodiczko on Tyneside', *Art Monthly*, No 144, London, 1991

van Dorgu, Edna, 'Lectures on Sculpture', *De Appel*, The Netherlands, No 2, 1987

van Grevenstein, Alexander, *Correspondentie Europa*, Stedelijk Museum, Amsterdam, 1986

van Grevenstein, Alexander, *Richard Deacon. Recent Sculpture 1985-1988*, Bonnefanten Museum, Maastricht, 1987

Wadley, Nicholas, *The Sculpture Show*, Hayward Gallery, London; Serpentine Gallery, London, 1983

Waldman, Diane, *Transformations in Sculpture: Four Decades of American and European Art*, Solomon R. Guggenheim Museum, New York, 1985

Weiermair, Peter, *Prospect 86. Eine Internationale Austellung Aktueller Kunst*, Frankfurter Kunstverein, Frankfurt, 1986

Wisotzki, Ruben, 'Arte industrial insolado', *El Nacional*, Caracas, 23 April, 1996

Woodrow, Bill, *Only the Lonely and Other Shared Sculptures*, . Chisenhale Gallery, London, 1993

Zidar, Dusan; Marjetica Potrc, 'Interview', *M'ARS*, Vol 2, No 4, Slovenia, 1990

Public Collections

Stedelijk Museum, Amsterdam
Museum van Hedendaagse Kunst, Antwerp
The High Museum of Art, Atlanta, Georgia
Auckland City Art Gallery, New Zealand
Fundacion Caja de Pensiones, Barcelona
Kunstmuseum, Basel
Museum of Contemporary Art, Chicago
University of Warwick, Coventry
Irish Museum of Modern Art, Dublin
Sprengel Museum, Hannover
Museum of Contemporary Art, Helsinki
Hiroshima Museum of Art, Japan
Louisiana Museum, Humlebaek, Denmark
The Israel Museum, Jerusalem
Berado Museum, Lisbon
Arts Council of England, London
The British Council, London
Contemporary Art Society, London
Tate Gallery, London
Museum of Contemporary Art, Los Angeles
Kunstmuseum, Luzern
Le Nouveau Musée, Lyon
Kaiser Wilhelm Museum, Krefeld
Bonnefantemuseum, Maastricht
Fundacion Caja de Pensiones, Madrid
Museo Nacional Centro de Arte Reina Sofia, Madrid
Open Air Sculpture Museum, Middelheim, Antwerp
Fondazione Prada, Milan
Walker Art Center, Minneapolis
Saint Louis Art Museum, Missouri
Art Gallery of New South Wales, Australia
The Museum of Modern Art, New York
Akron Art Museum, Ohio
Kunsternes Hus, Oslo
Museet for Samtidskunst, Oslo
Kröller-Müller Museum, Otterlo
ARC/Musée d'art moderne de la ville de Paris
Centre Georges Pompidou, Paris
Fonds régional d'art contemporain, Picardie
Carnegie Museum of Art, Pittsburgh
Fonds National d'Art Contemporain, Puteaux
Fonds Régional d'Art Contemporain, Rhône-Alpes
San Francisco Museum of Modern Art, San Francisco
Tochigi Prefectural Museum, Japan
Setegaya Art Museum, Tokyo
Tokyo Forum, Tokyo
Art Gallery of Ontario, Toronto
Musée d'Art Moderne, Villeneuve d'Ascq, France
Hirshorn Museum, Washington
Weltkunst Foundation, Zurich

Comparative Images

page 155, Cambridge telescope image showing traces of the Big Bang

page 18, Anthony Caro
Early One Morning
Tate Gallery, London

page 154, Colour Changes in Flatfishes *Platophrys podas*

page 154, Figurine from Berekhat Ram

page 81, Naum Gabo
Spiral Theme (Penetrated Version)

page 129, Jochen Gerz and Esther Shalev-Gerz
The Monument Against Fascism

page 27, Antony Gormley
Three Ways: Mould, Hole and Passage

page 140, Toni Grand
Du simple au double

page 182, Hagesandros, Polydoros and Athenodoros
Laokoon

page 154, William Harvey
Map of Germany

page 81, Barbara Hepworth
Conoid, Sphere and Hollow

page 152, Hominid footprint trail, Laetoli, Northern Tasmania

page 17, Donald Judd
Installation, Whitechapel Art Gallery, London

page 85, Harald Klingelhöller
Die Furcht verlasst ihren Gegenstand und geht über in Hass (Fears Leaves Its Object and Turns into Hate)

page 27, Henry Moore
Recumbent Figure

page 128, Juan Muñoz
Untitled

page 186, Nicolas Poussin
Landscape with a man killed by a snake

page 15, Ulrich Rückriem
Untitled

page 85, Thomas Schütte
Casino

page 123, Richard Serra
Tilted Arc

page 152, Teufelstritt (Devil's Kick), Munich Cathedral

List of Illustrated Works

pages 164-165, 191, After, 1998
page 187, After Poussin, 1997
page 174, Almost Beautiful, 1994
page 185, … And …, 1994
page 152, Ants No 1, 1998
page 153, Ants No 2, 1998
page 63, Art for Other People No 1, 1982
page 63, Art for Other People No 2, 1982
page 9, Art for Other People No 3, 1982
page 63, Art for Other People No 6, 1983
page 63, Art for Other People No 7, 1983
page 63, Art for Other People No 9, 1983
page 64, Art for Other People No 10, 1984
page 64, Art for Other People No 12, 1984
page 64, Art for Other People No 13, 1984
page 104, Art for Other People No 15, 1985
page 64, Art for Other People No 17, 1985
pages 40-41, Art for Other People No 20, 1986
pages 40-41, 104, Art for Other People No 21, 1986
page 105, Art for Other People No 22, 1986
page 104, Art for Other People No 24, 1987
page 106, Art for Other People No 26, 1987-88
page 106, Art for Other People No 28, 1990
page 144, Art for Other People No 30, 1993
page 149, Art For Other People No 39, 1997
pages 148, 149, Art for Other People No 41, 1997
pages 148, 149, Art for Other People No 42, 1997
page 149, Art For Other People No 43, 1997
page 102, The Back of My Hand No 1, 1986
page 103, The Back of My Hand No 4, 1986
page 77, The Back of My Hand No 5, 1986
page 84, Band of Gold, 1990
page 178, Beauty and the Beast (A), 1995
page 178, Beauty and the Beast (B), 1995
page 179, Beauty and the Beast (C), 1995
page 131, Between Fiction and Fact, 1992

page 122, Between the Eyes, 1990
page 10, Blind, Deaf and Dumb, Pre-production drawings, 1985
page 11, Blind, Deaf and Dumb A, 1985
pages 12-13, 51, Blind, Deaf and Dumb B, 1985
page 191, Blow, 1999
page 83, Body of Thought No 1, 1987-88
page 82, Body of Thought No 2, 1988
page 26, 78-79, Border, 1991
page 101, Boys and Girls, 1982
pages 60-61, Breed, 1989
page 22, Building from the Inside, 1992
page 185, … But …, 1997
page 157, Caithness No 2, 1999
page 157, Caithness No 7, 1999
page 86, Coat, 1990
page 85, Cover, 1990
pages 114-115, Democratic Process, 1990
pages 126-127, Distance No Object, 1988
page 71, Distance No Object No 2, 1989
pages 114-115, Doin' the Do, 1993
pages 58-59, Double Talk, 1987
page 72, Dummy, 1992
page 162, Eat Me, 1998
page 184, Eight, 1997
page 139, Factory, 1993
page 9, Falling on Deaf Ears No 1, 1984
page 132-133, 137, Feast for the Eye, 1986-87
page 74, 132-133, Fish Out of Water, 1986-87
page 145, Five (Art for Other People No 36), 1997
pages 146-147, Four (Art for Other People No 35), 1997
pages 9, 16-17, 56-57, For Those Who Have Ears No. 2, 1983
page 160, From Tomorrow, 1996
pages 28, 40-41, Heart and Mind, 1986
page 167, However Jack, 1998
page 185, … If …, 1997
page 100, If the Shoe Fits, 1981
pages 96-97, In the Flesh, 1992
page 48, In Two Minds No 2, 1986
pages 188-189, Infinity, Nos 4-8, 1999
page 25, The Interior Is Always More Difficult (C), (E) and (F), 1991
page 173, The Interior Is Always More Difficult (E), (C) and (D), 1991
page 77, The Interior Is Always More Difficult (G), 1992
pages 96-97, The Interior Is Always More Difficult (J), 1992

page 116, It's Orpheus When There's Singing, 1978-79
page 38, It's Orpheus When There's Singing No 3, 1978-79
page 38, It's Orpheus When There's Singing No 4, 1978-79
pages 90, 91, 93, 96-97, Keeping the Faith, 1992
page 75, Kiss and Tell, 1989
pages 183, 191, Laocoon, 1996
pages 124-125, Let's Not Be Stupid, 1991
pages 14, 16-17, 53, Like a Bird, 1984
page 20, Like a Snail A, 1987
page 19, Like a Snail B, 1987
pages 40-41, Listening to Reason, 1986
pages 76-77, Lock, 1990
page 156, London No 2, 1998
page 156, London No 4, 1998
pages 30-31, Mammoth, 1989
pages 28-29, 80, Moor, 1990
page 50, More Light, 1987-88
pages 34-35, 52, Never Mind, 1993
pages 114-115, Night and Day, 1992
page 184, Nine, 1997
page 190, No Stone Unturned, 1999
page 23, Nobody Here But Us, 1991
page 81, Nose to Nose, Beginning to End, 1988
page 160, Not Yet Beautiful, 1994
page 171, Nothing Is Allowed, 1994
page 172, Nothing Is Forbidden, 1994
pages 9, 16-17, On the Face of It, 1984
pages 146-147, One (Art for Other People No 32), 1996
page 180, One Is Asleep, One Is Awake, 1996
page 136, One Step, Two Step, 1992
page 187, One, Two, Tree, 1997
pages 114-115, Only the Lonely, 1993
page 14, Other Homes, Other Lives, 1984-85
page 39, Out of His Own Mouth, 1987-88
page 107, Out of the House, 1983
page 26, Pack, 1990
page 24, Pipe, 1991
pages 146-147, Plant, 1995
page 138, Replacing, 1987
pages 30-31, Seal, 1989
pages 146-147, Seven (Art for Other People No 38), 1997
pages 150-151, Show & Tell, 1997
page 86, Skirt, 1989
page 185, … So … , 1997

page 70, Struck Dumb, 1988
pages 46, 110, 111, 112, 113, Stuff Box Object, 1970-71
pages 96-97, Substance, 1992
page 149, Table A, 1997
page 149, Table B, 1997
page 159, Table E, 1999
pages 16-17, 45, Tall Tree in the Ear, 1983-84
pages 30-31, Tear, 1989
pages 14, 43, Tell Me No Lies, 1984
page 177, Them and Us, with Thomas Schütte, 1995
page 62, These Are the Facts, 1987-88
page 21, This Is Not a Story, 1992
page 142, This, That and the Other, 1985
pages 114-115, Thought It Was a Duck, 1992
pages 146-147, Three (Art for Other People No 34), 1997
page 87, Three Small Works, 1990
page 178, Time after Time, 1992-95
pages 40-41, Tooth and Claw, 1985
pages 132-133, Troubled Water, 1987
page 141, Turning a Blind Eye Again, 1988
pages 146-147, Two (Art for Other People No 33), 1996
pages 16-17, Two Can Play, 1983
page 84, Under My Skin, 1990
page 52, Untitled, 1975
page 52, Untitled, 1976
page 52, Untitled, 1977
page 52, Untitled, 1977-78
page 52, Untitled, 1978
pages 16-17, Untitled, 1980
pages 54, 55, Untitled, 1980
page 117, Untitled, 1980
pages 118-119, Untitled, 1981
page 134, Untitled, 1989
page 26, Untitled, 1991
page 181, Untitled, Nos 19, 6, 7, 1995-96
page 8, Untitled Sculpture in Two Parts, 1993
pages 114-115, Watcha Goin' to Do About It, 1993
pages 66, 67, 68-69, What Could Make Me Feel This Way A, 1993
page 66, What Could Make Me Feel This Way B, 1993
page 18, When the Land Masses First Appeared, 1986
pages 114-115, Wooly Bully, 1993
page 166, You, 1998
page 9, Zeitweise (Now and Then), 1993